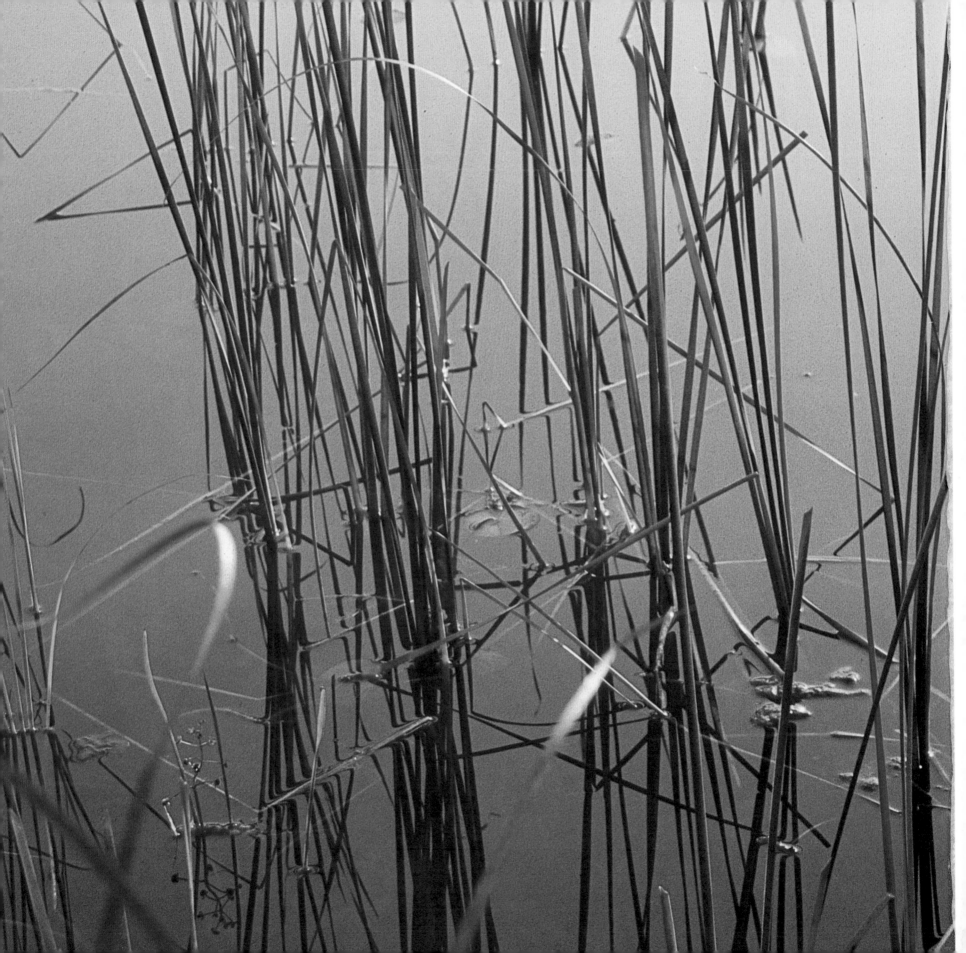

THE EASTERN SHORE
Chesapeake
GARDENS AND HOUSES

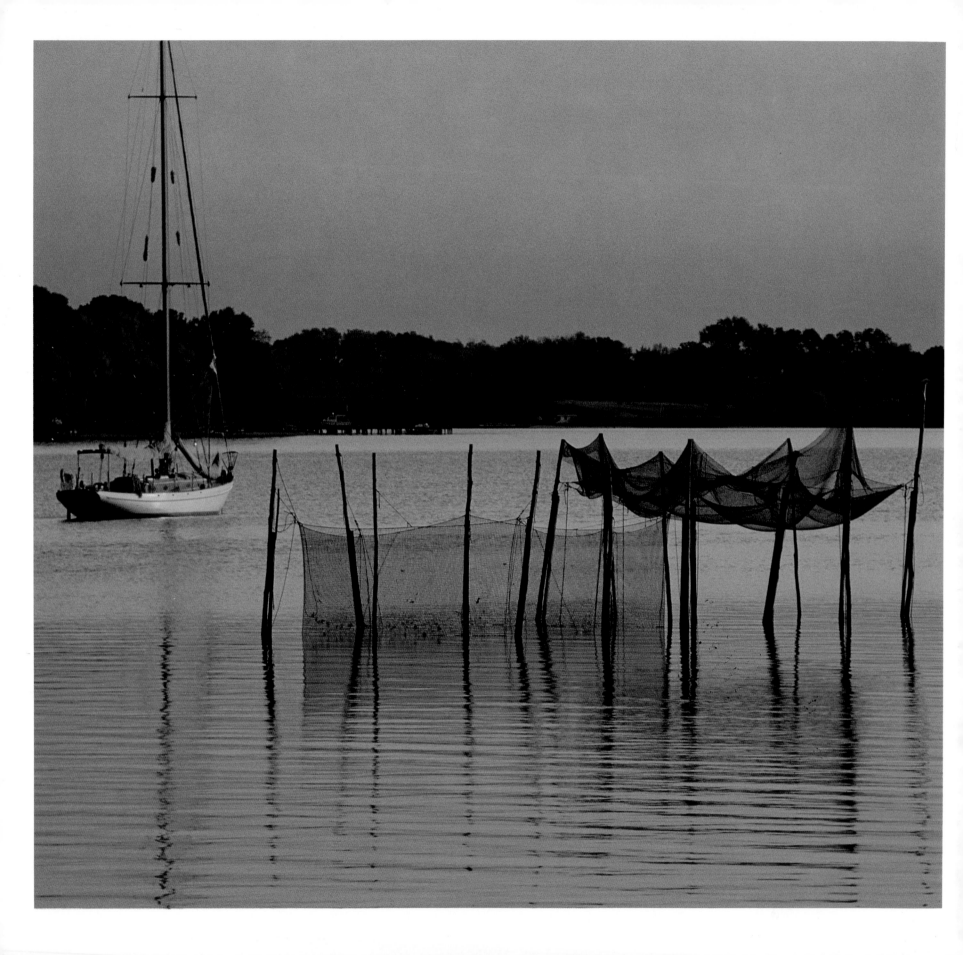

THE EASTERN SHORE

Chesapeake

GARDENS AND HOUSES

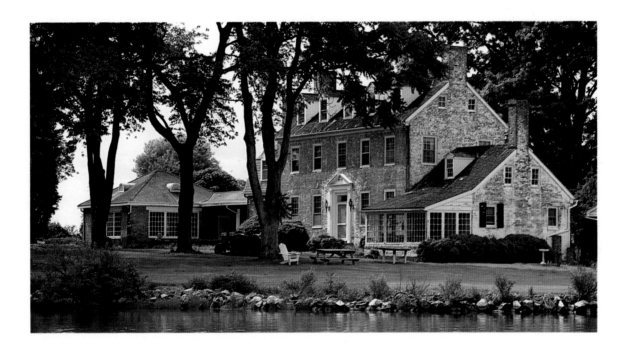

PHOTOGRAPHY BY TAYLOR LEWIS
TEXT BY CATHERINE FALLIN

Simon & Schuster

NEW YORK LONDON TORONTO SYDNEY TOKYO SINGAPORE

SIMON & SCHUSTER
Simon & Schuster Building
Rockefeller Center
1230 Avenue of the Americas
New York, New York 10020

Designed by Taylor Lewis and Abby Kagan

Manufactured in China

2 4 6 8 10 9 7 5 3 1

Library of Congress Cataloging-in-Publication Data

Lewis, Taylor Biggs.
Chesapeake, the eastern shore : gardens and houses / photography
by Taylor Lewis ; text by Catherine Fallin.
p. cm.
Includes bibliographical references (p.) and index.
ISBN 0-671-75857-8
1. Architecture, Domestic—Eastern Shore (Md. and Va.) 2. Interior
decoration—Eastern Shore (Md. and Va.) 3. Gardens—Eastern Shore
(Md. and Va.) I. Fallin, Catherine. II. Title.
NA7235.M32E284 1993
728′.37′097521—dc20 92-35045
 CIP

ISBN 0-671-75857-8

Acknowledgments

On our journey to produce this book, we have met and worked with many wonderful people, the most obvious of whom have been the gracious, charming, and exciting owners of the homes and gardens that appear on the following pages. To each and every one of them we extend our deepest gratitude for allowing us to invade their homes—and sometimes control their lives, albeit for the briefest of moments. We hope that the friendships established will continue and flourish in years to come.

The unseen side of book production is comprised of people who rarely, if ever, receive the kudos they so justly deserve, for they are truly the cogs, without whom the wheels would never turn. To our ever tolerant editor Patty Leasure and our long-suffering agent Patricia Breinin; our copy editor Erin Clermont for saving us from embarrassment of syntax; our proofreaders Susan Groarke, Nancy Inglis, and Pauline Piekarz, who have eyes in the back of their heads as well as their fingertips; our ever-careful and precise designer Abby Kagan, we are eternally grateful not only for your professionalism but also for your friendship. A special note of thanks to good friends Michael

Bertollini, for checking copy for fact vs. fiction of detail; Peggy Schwier and Jan Alspach, for squinting at transparencies to verify garden and plant material.

A special thanks to those who introduced us to special people and places we might never have otherwise met or seen: Bronwen Anderson and Georgia Adler of the Historical Society of Talbot County; Bob Shannahan for finding and keeping a roof over our heads; Kippy Requardt, Pam Gardner, Susan Pyles, Caroline Benson, Virginia Sappington, Nancy Jane Reed, Chris Havemayer, Louise Hayman, Jack and Martha Graham, Breene and Shery Kerr, Katherine Mears, and Furlong Baldwin for the generosity of your time, that commodity of which we never have enough. To Jonathan and Lee D. McLane gratitude for many things, especially your moral support.

And finally to our photographic assistant, Greg Hadley, who has suffered the slings and arrows of often outrageous requests and circumstances and who has survived the experience battered but unbroken, our deepest thanks.

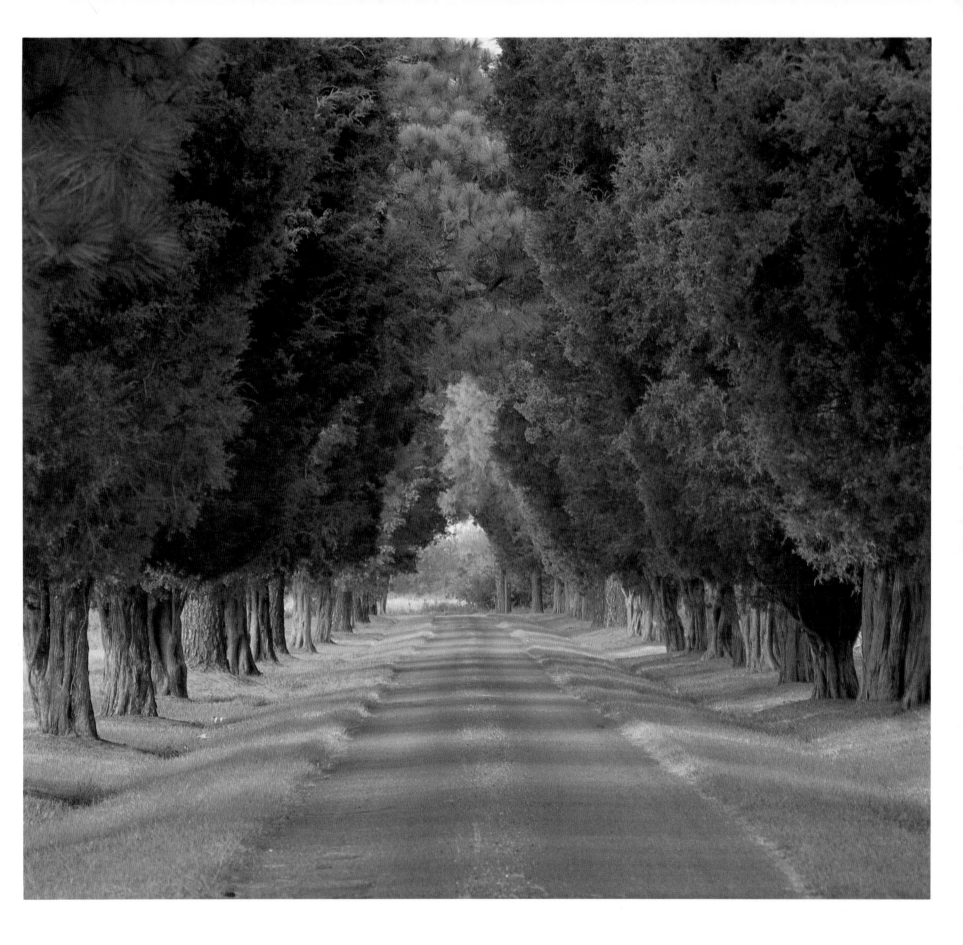

INTRODUCTION

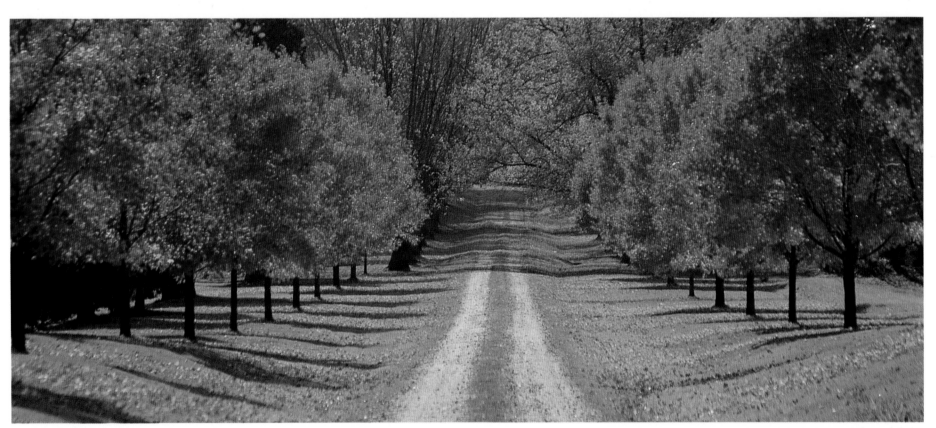

The Chesapeake's Eastern Shore was among the earliest settlements in the country. In 1608, John Smith sailed from Jamestown on an expedition up Chesapeake Bay to map the shore and its islands. Soon after, the first land grants and patents were given to those who would come and settle here. The first settlement on the Virginia Shore was in 1620; the first on the Maryland Shore was on Kent Island in 1631. By the mid-1600s many of the new arrivals had begun to clear land and establish farms. From Indians living on the Eastern Shore who were hunters, fishermen, and planters, the settlers learned how to use fish skeins to trap fish, build log canoes, tong for oysters, catch crabs, and trap muskrat and beaver for food and pelts—all pursuits that have sustained a life of plenty on the Eastern Shore up to the present day. The land was flat and easy to clear, with arable soil, a somewhat temperate climate, and good rainfall—all of which made it ideal for growing tobacco, the early cash crop. Not surprisingly, large tobacco plantations flourished, and most of the tobacco was shipped to England. Large sailing ships brought manufactured goods into the Eastern Shore ports of Oxford, Snow Hill, Chestertown, and Whitehaven and loaded up with tobacco to take back to the mother country. A whole economy grew with the establishment of customs houses and port activities such as outfitting ships with provisions, warehousing of tobacco and goods. After the Revolution, tobacco gave way to wheat and other grains, corn, and other food crops. To this day, the Eastern Shore is one of the richest producing argicultural areas in the country, with vegetable farming for tomatoes, potatoes, melons, corn, and soybeans as well as poultry raising and processing.

Following right behind tobacco as an early source of commerce were fish, crabs, and oysters. The Eastern Shore is traversed by copious waterways, some broad and flat, others deep and navigable almost to the ocean, and all teeming with marine life. It is easy to understand why the harvesting of fish and shellfish has always been a major part of the Shore's economy. Generations of watermen

have plied the rivers, streams, and bays, dredging for oysters in flat-bottomed, shallow-draft skipjacks and bugeyes. These beautiful sailing vessels are still found moving ponderously but gracefully up and down the bay. Oyster tonging and crabbing are done from smaller work boats. From the early 1800s, when steamboats began crossing the Chesapeake Bay to Baltimore and Washington, the bay's harvest of seafood graced the tables of an ever-growing audience; and with the advent of a railroad from the tip of Virginia to Wilmington, the Eastern Shore's most sought after crops found their way to the markets of Philadelphia, New York, Chicago, and beyond.

Another indigenous source of income for the Eastern Shore for many years was boatbuilding, from the beautiful Baltimore clippers that were constructed in St. Michaels to wooden towing barges

a limit on the number of birds taken and the duration of the hunting season. Nonetheless, the Eastern Shore remains a leading destination for shooting and viewing waterfowl. It is a nesting ground for the great blue heron, osprey, bald eagle, egret, tern, and others. Canada geese, over twenty-five species of ducks, and upward of 40,000 tundra swans winter there. The wetland marshes of Dorcester County's Blackwater National Wildlife Refuge alone are a winter home to 80,000 Canada geese and 30,000 ducks of all species. The marshes are also home to muskrats, terrapins, otters, beavers, red fox, and deer.

Because of its accessibility to the water, ports, and goods from abroad, life on the Eastern Shore was quite civilized, though still rural, in its early days. The area has in fact always enjoyed the luxury of being isolated geographically—and thus historically—

and work boats of all sizes. Boat yards were plentiful through World War I.

The wetlands of Chesapeake Bay are a major stopover point on the Atlantic Flyway for migrating shore birds. Although it is world-renowned as a bird hunter's paradise, conservation efforts have put

from the rest of the country. It is some two hundred miles from the mouth of the bay to its head in the north and between five and thirty miles across. The only access from the Western Shore was by ferry across the bay or by rail or car through Wilmington until 1952, when the first span of the Chesapeake Bay Bridge

opened, connecting Annapolis to the Eastern Shore. Not until the opening of the more than 17-mile-long Chesapeake Bay Bridge-Tunnel in 1965, was there a connection between Norfolk and the southern tip of the Virginia Shore.

Since the advent of the steamboat in 1813, vacationers and weekenders have been fleeing the heat and congestion of the big cities across the bay. Always an area of tranquil beauty with its thousands of miles of coastline, its many harbors and deep rivers have long been a haven for sailors, from pirate and merchant ships to pleasure craft. Boaters cherish it for its beautiful protected waters, quick access to ports, and lovely anchoring spots up the many creeks and coves.

Eighteenth- and nineteenth-century houses of incomparable

The gardens of the Eastern Shore are magnificent. Brick-walled formal gardens date from the nineteenth century, and some of the formal grounds around the large plantations in Talbot County comprise dozens of acres. Flowering trees, shrubs, and perennials thrive on the moderate climate of the bay. The growing season is long, with a soft, lingering spring that arrives as early as February when the first daffodils appear and lasts through June with flowering crabapples, cherries, pears, quince, redbuds, dogwood, lilacs, and roses—shrub roses, climbing roses, old English roses, hybrid tea roses, and more. Magnolias, azaleas, rhododendrons, crape myrtle, and hedges of box, laurel, and privet of every variety abound. Lush foliage and beautiful old trees shade broad expanses of lawns, which nearly everywhere are bounded by the water. Talbot County alone

beauty stand along the length of the shore, their architecture changing from redbrick town houses and huge plantation manor houses, in the northern part, to the frame construction—clapboard front and back with brick ends—in southern Maryland. Virginia homes were mostly wood with brick fireplaces.

has over six hundred miles of coastline. Traveling south along the Eastern Shore, the gardens change with the climate, oriented to hot summers and late falls. Some years there is no killing frost and blooms continue throughout the winter.

A major destination point for people from all over the world,

the coastline of the Chesapeake Bay has captured the imagination of one-time visitors and lifelong residents alike. Parts of the Eastern Shore are frozen in time by intent, with laws to preserve nearly three hundred years of tranquility. The town fathers of Oxford, for instance, will not allow large supermarkets or hotels to be built there and permit only historic inns and bed-and-breakfasts. Life generally moves at a slower pace on the Eastern Shore than it does in the large metropolises on the other side of the bay, so it attracts people who seek a similar lifestyle.

Those who have sailed the shore and have seen the magnificent and intriguing homes along the water, or have driven the back roads and imagined what wonderful treasures lie at the end of those tree-lined allées, leave with a magical sense of timelessness. We

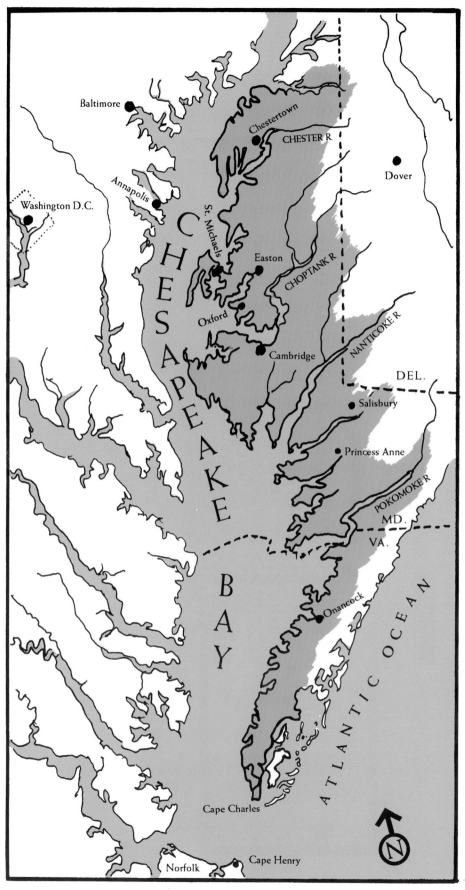

have attempted to capture these elusive feelings in this visual tour of some of the best homes and most enticing gardens of the Eastern Shore.

THE UPPER
MARYLAND SHORE

KNIGHTLY

Situated on Leeds Creek off the Miles River, the property known as Knightly is a two-story brick manor house with a front hall and side stairs. It was built in 1810 as a wedding present for Edward S. Winder and Elizabeth Tayloe Lloyd, daughter of Edward Lloyd V of the Lloyd family dynasty, which dominated the economic and social life of much of the Eastern Shore for close to two centuries. Edward Lloyd, a Puritan from Virginia, acquired several land grants in the mid-1600s. By the late 1700s, the family owned land in five counties. The son of Edward S. and Elizabeth Lloyd Winder, Charles S. Winder, was a brigadier general and right hand to Stonewall Jackson during the Civil War. The house passed through several families and was finally abandoned. There was even a time when grain was stored in the parlor and dining room. Fortunately the Georgia pine floors were still intact after years of grain being shoveled from them.

In 1972 Caroline and Chuck Benson bought Knightly and began renovations. They designed the gardens with local horticulturist Kathleen Cowgill, who planned many of the gardens in Talbot County. The English boxwood was started by Caroline's grandmother, Nancy F. Ames, in Boston. Caroline and Chuck added the large porch room and refurbished the interiors. In addition to operating a professional landscape business and a garden shop in Easton, Caroline breeds and raises thoroughbreds on the farm.

RIGHT: The stately redbrick house is surrounded by beautiful old trees that gracefully shade it and the property in summer. The glass-enclosed porch room is one of the additions made by the Bensons.

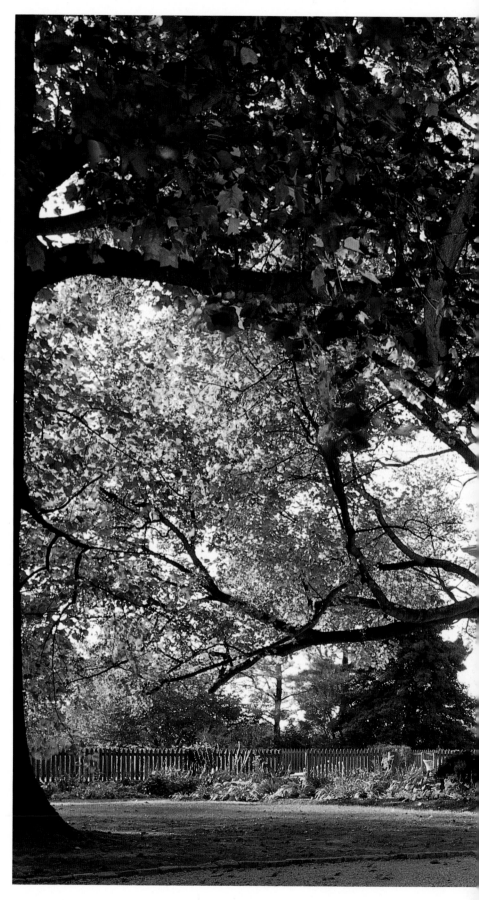

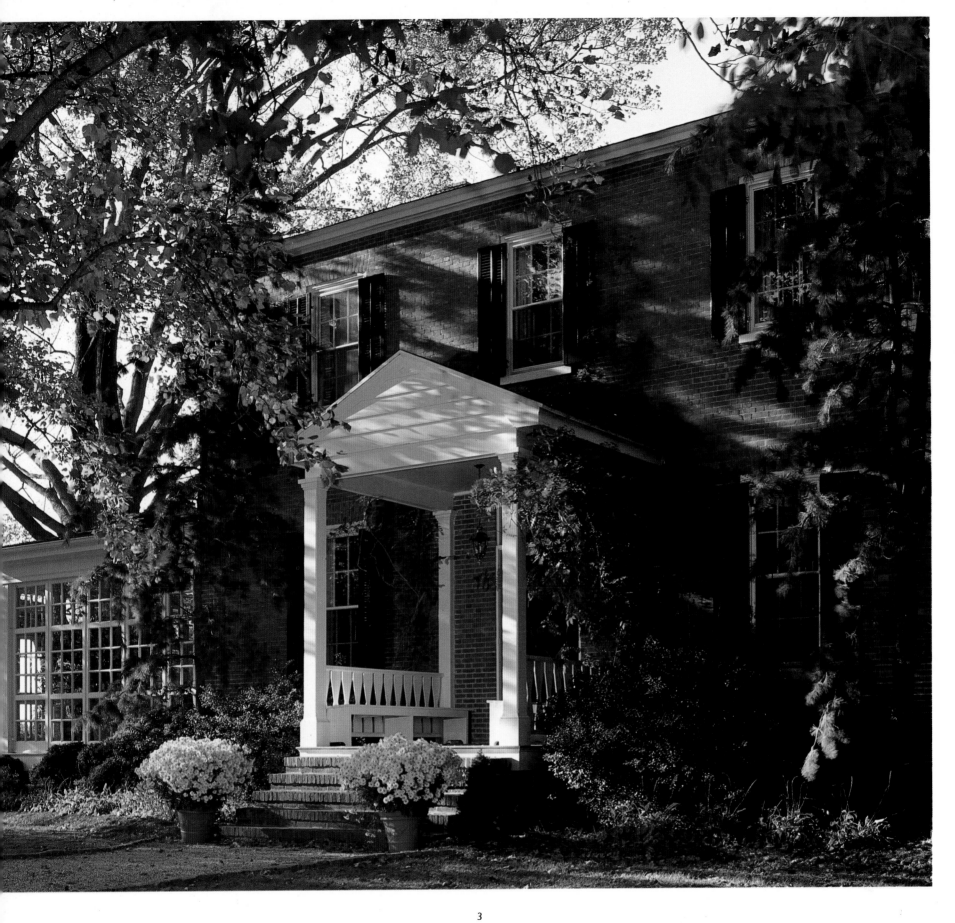

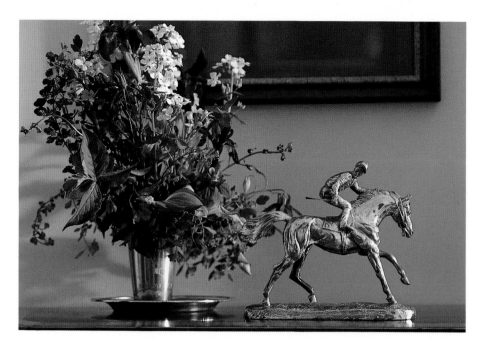

LEFT: An English silver jockey statue graces the front hall table.

RIGHT: Massachusetts mahogany chairs, c. 1760, with seats needlepointed by Caroline's grandmother, flank the door leading to the red fox room. The four 1850 English hunt prints around the door are by F. C. Turner.

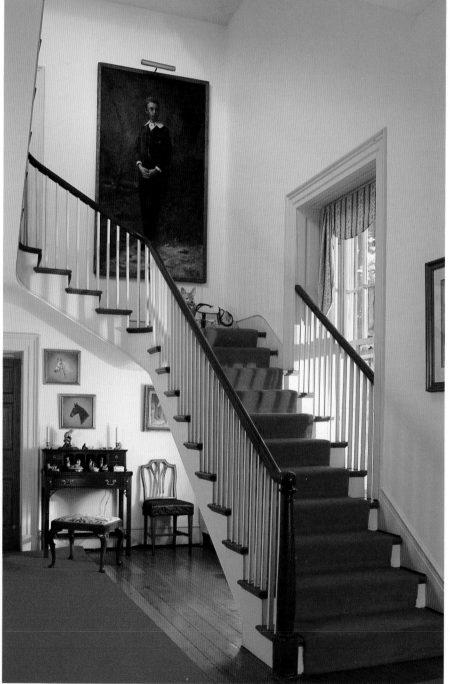

RIGHT: The portrait on the stairs is of Caroline's grandfather William Leland Thompson as a boy. Beneath the staircase is a George III ladies' writing desk and two portraits of horses' heads—Caroline's first two thoroughbreds, painted by an English artist.

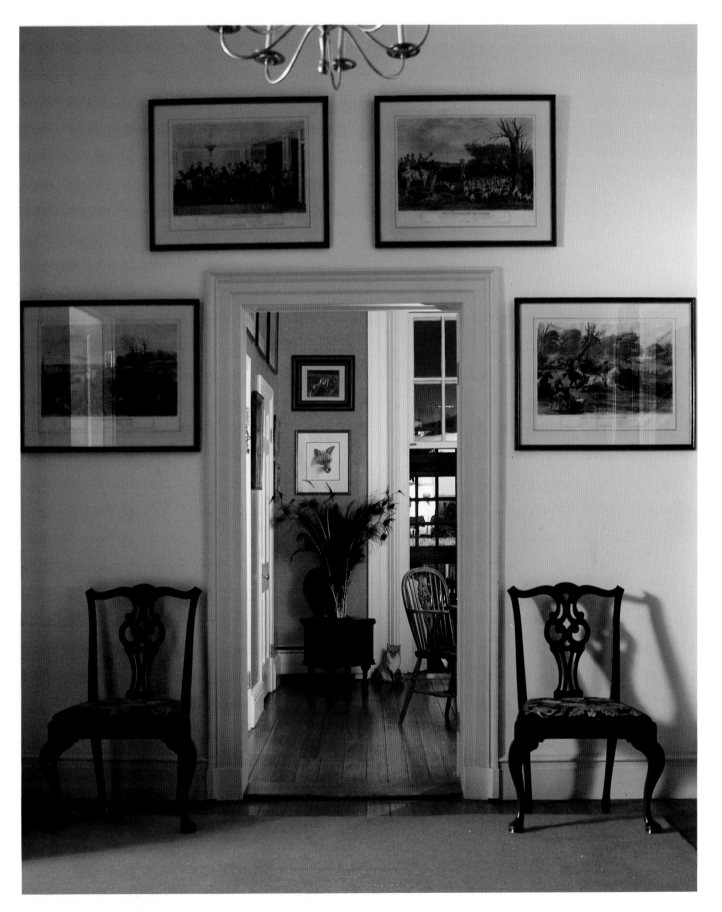

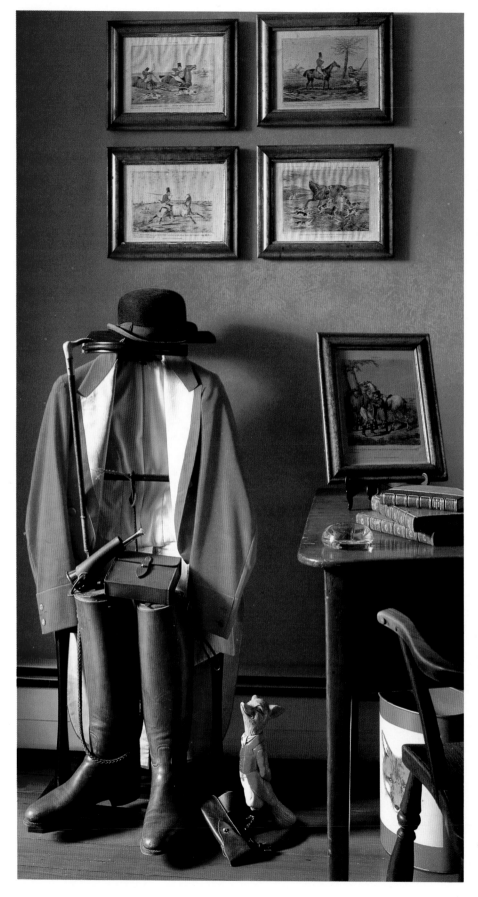

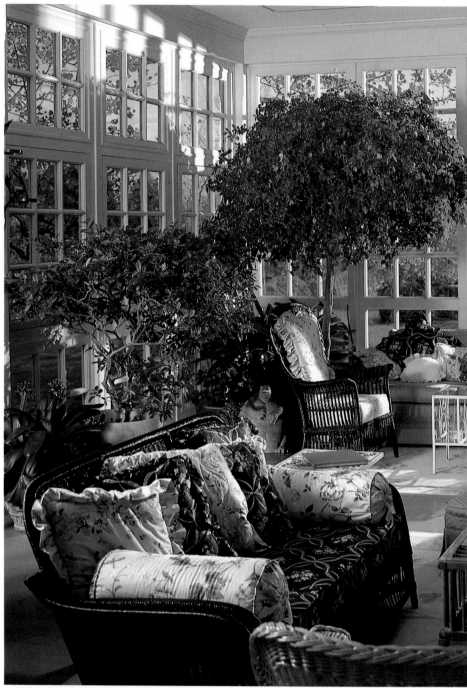

LEFT: The red room is called the fox room because it is dedicated to fox-hunting memorabilia. The pinks belonged to Caroline's grandfather John Stanley Ames, one of the original masters of foxhounds for the Orange County Hunt Club in Virginia. Hunt scenes, foxes, and an English mahogany table complete the room.

ABOVE: In the far corner of the porch room is an eighty-year-old bougainvillea that stays there year-round. American Victorian wicker furniture makes this a most inviting room on a spring day, when the flowering fruit trees outside the window are in glorious bloom.

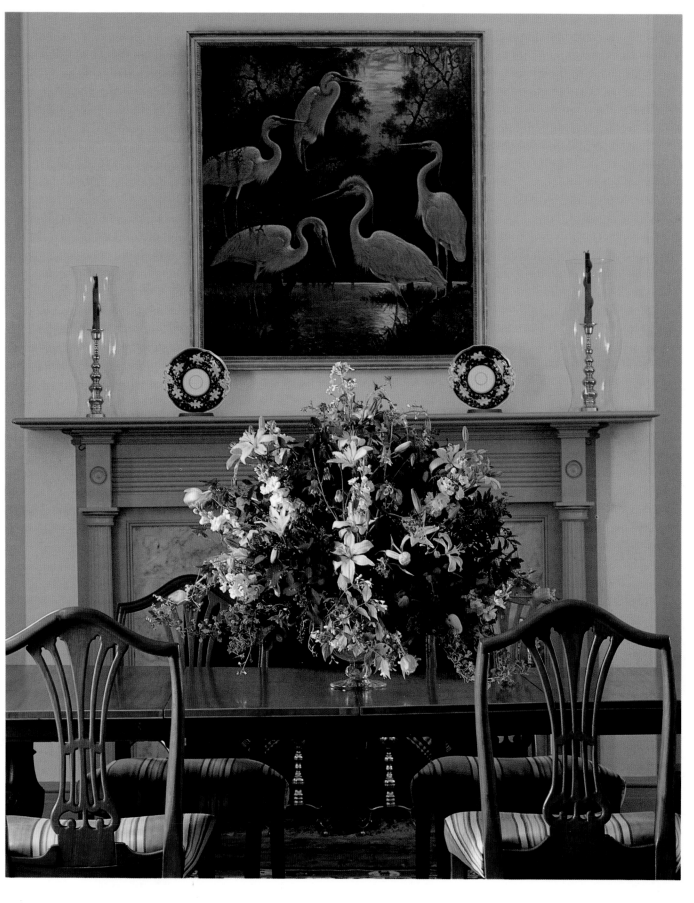

LEFT: Early American chairs and a Hepplewhite fruitwood table, c. 1780, furnish the dining room. *Herons in the Moonlight,* painted by an unnamed student of Audubon, hangs over the mantel, decorated with English Spode plates, c. 1820.

BELOW: A collection of Vieux Paris porcelain, hand-painted about 1820, is displayed in the American pine corner cupboard and on the mantel. A nineteenth-century Chinese rug complements the colors in the rest of the living room.

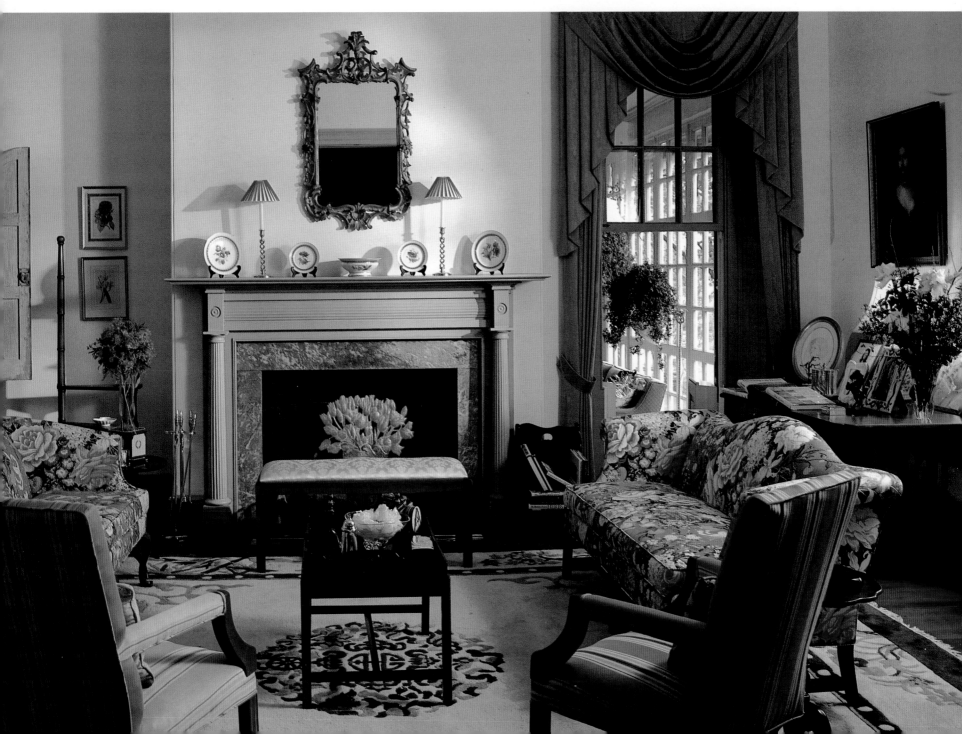

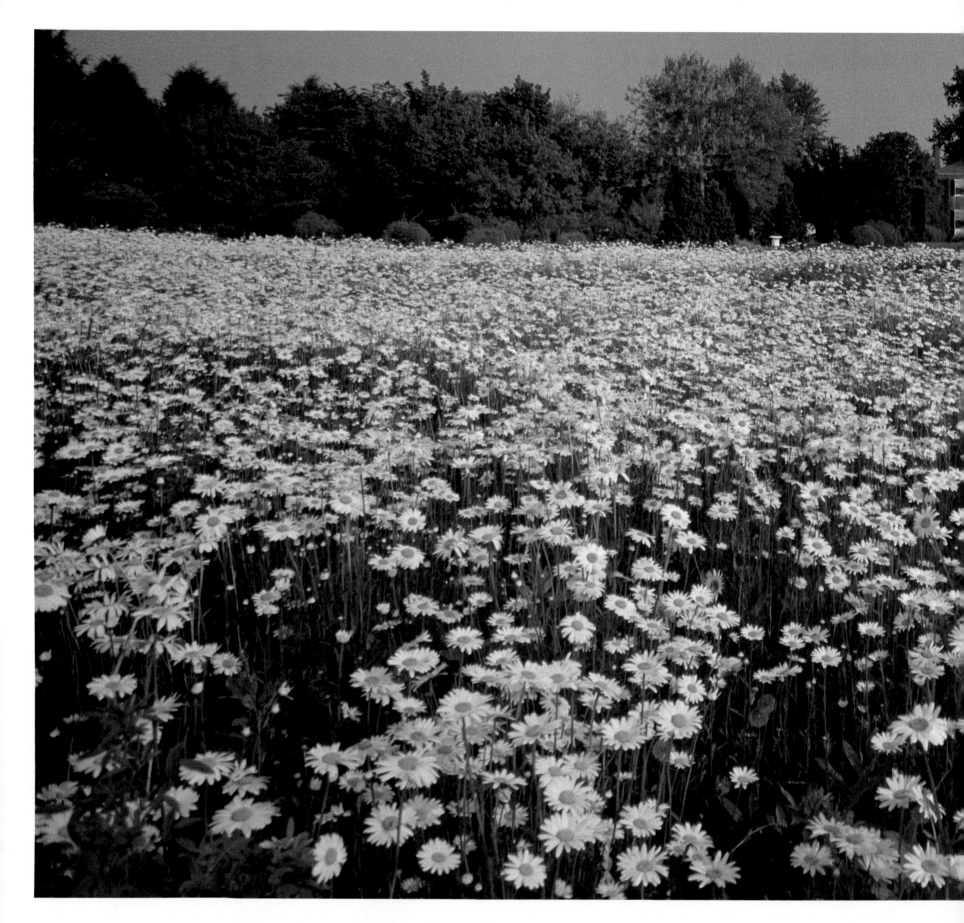

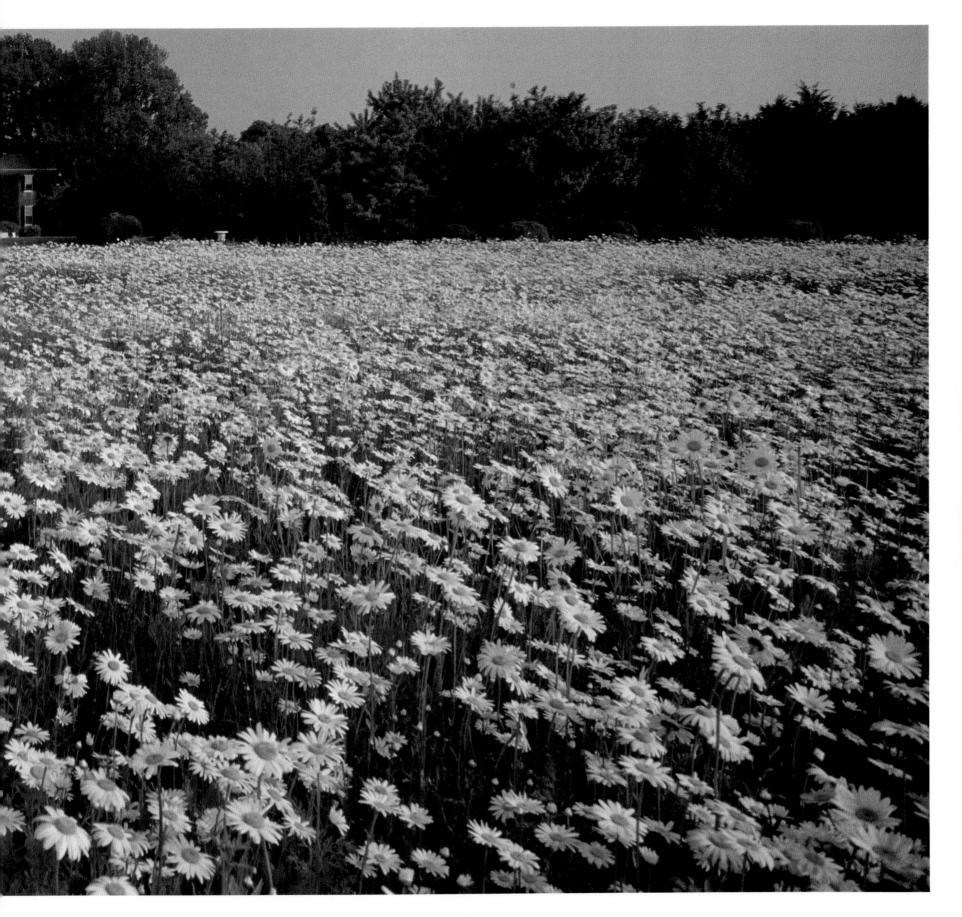

OVERLEAF: The daisies are the first of the wildflowers to bloom in the meadow. They will be followed by riots of yellows, pinks, blues, and oranges as the summer progresses. The meadow stretches all the way from the formal border back to Leeds Creek.

BELOW: A Higan cherry (*Prunus subhirtella* 'Autumnalis'), now in full bloom in April, will bloom again in the fall. Emerging perennial beds on either side of the grass lane make up one of the sections of the garden plan that Caroline laid out with Kathleen Cowgill in the early 1970s.

BELOW: Some of the plantings outside the fence surrounding the pool include late-blooming hosta (*Hosta plantaginea*) and clematis 'Jackmanii', sedum (*Sedum spectabile* 'Autumn Joy'), phlox (*Phlox paniculata* 'Mt. Fuji'), rudbeckia, and daffodils that have already bloomed.

RIGHT: The outer border is planted with trees, flowering shrubs, and perennials for successive bloom from spring through late summer. There are several varieties of spirea, witch hazel (*Hamamelis mollis*), purple-leaved hazelnut (*Corylus maxima purpurea*), crape myrtle (*Lagerstroemia indica*), purple plum (*Prunus cerasifera* 'Thundercloud'). Currently blooming in mid-June is *Hydrangea paniculata* 'Grandiflora', on the left; lacy purple butterfly bush (*Buddleia alternifolia*); spirea (*Spiraea x vanhouttei*) just finishing; oak-leaved hydrangea (*Hydrangea quercifolia*); and pink spirea (*Spiraea x bumalda* 'Anthony Waterer').

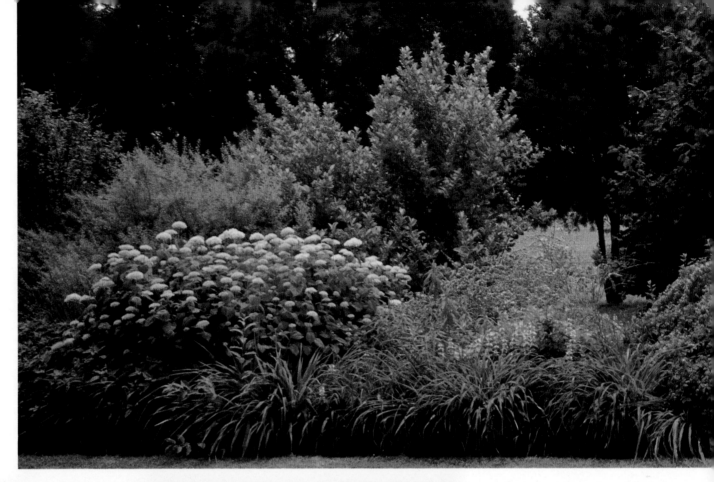

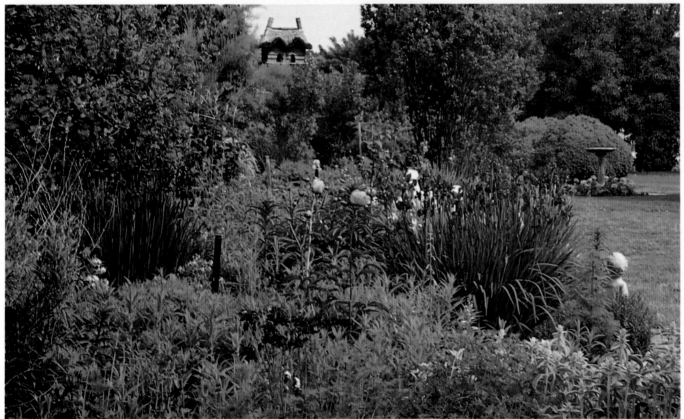

LEFT AND RIGHT: In mid-May the left border is planted with mauve, pink, blue, and gray perennials. Honeysuckle (*Lonicera heckrottii*) backs dark pink valerian (*Centranthus ruber*) next to cranesbill (*Geranium endressii* 'Johnson's Blue') and lamb's ears (*Stachys lanata*). An English thatched dovecote is one of many birdhouses throughout the gardens. The opposite border holds catmint (*Nepeta x faassenii* 'Six Hills Giant'), white bearded iris 'Winter Olympics', blue salvia (*Salvia superba* 'East Friesland'), pink *Geranium sanguineum* var. *striatum*, and purple Siberian iris 'Rose Queen'. As the season progresses into summer, more pinks and yellows will come into these borders.

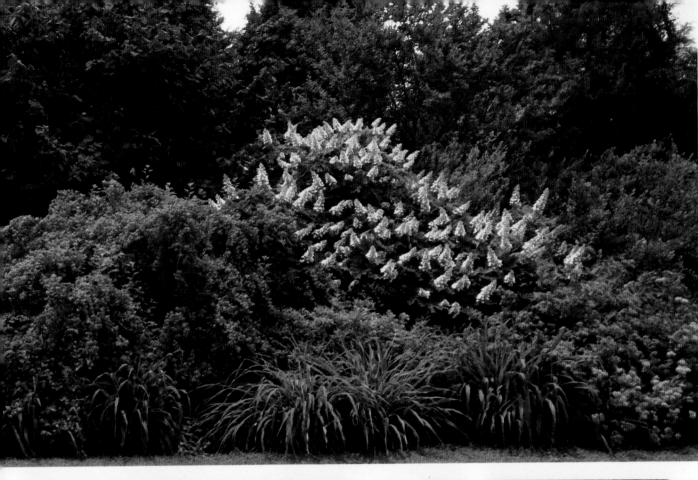

BELOW: In mid-May blue and white columbine (*Aquilegia* hybrids) and iris accent this garden, planted primarily with dwarf evergreens in a wide range of color, from yellow to dark green to blue-gray. Some of the more uncommon trees are a weeping thread-leaved false cyprus (*Chamaecyparis pisifera* 'Filifera Aurea'), and dwarf blue spruce (*Picea pungens*). Later on in the season, tree peonies and poppies add different color accents.

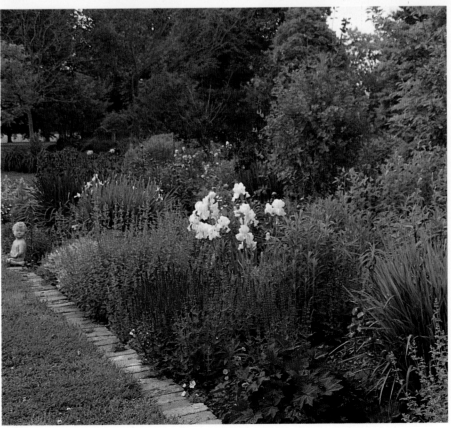

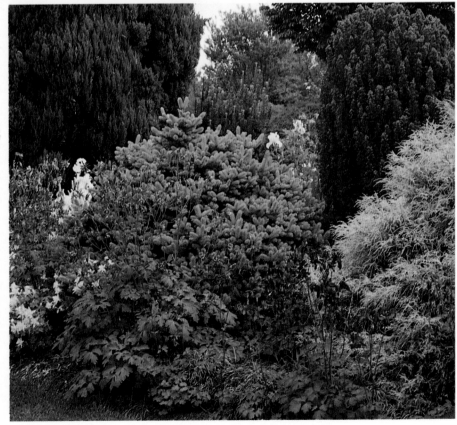

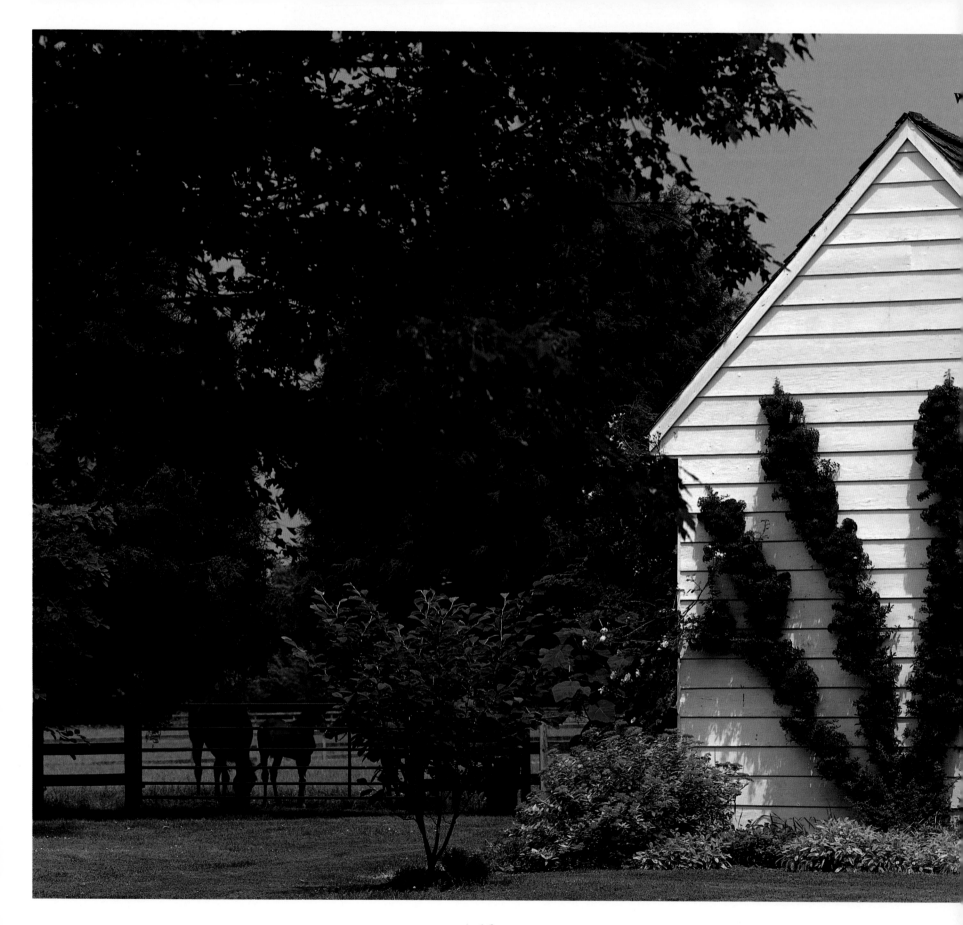

Espaliered pyracantha climbs the smokehouse underplanted with spirea (*Spiraea* x *bumalda* 'Gold Flame') with golden sage (*Salvia aurea*) in the middle. The little tree on the left is a witch hazel (*Hamamelis* x *intermedia* 'Arnold's Promise'). A New Dawn rose climbs up the left side of the smokehouse.

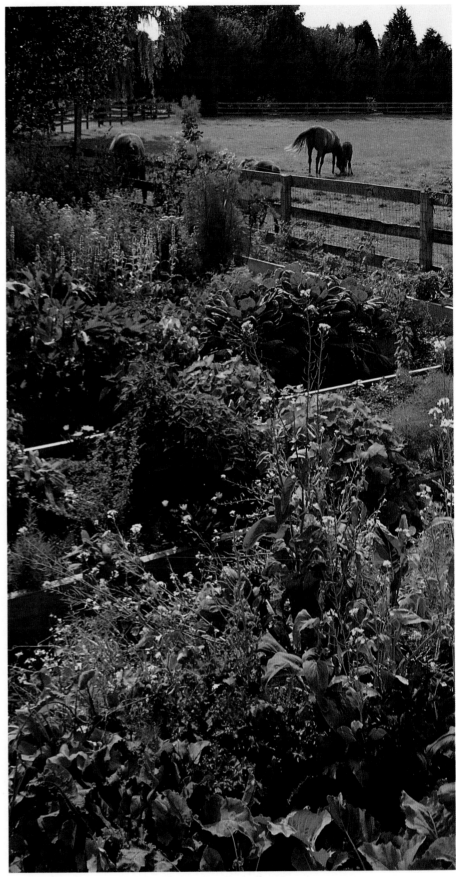

RIGHT: The raised vegetable and cutting garden.

COVE COTTAGE

This country cottage gently nestles among every kind of garden imaginable and is picturesquely sited on a point of land on Le Gates Cove. Marjorie and Roger Judd built this house in 1964, and have added on to it over the years, most recently adding a second-floor master bedroom suite and a cathedral-ceiling living room to emphasize the views of the water and the plantings that surround the house.

When the Judds bought the property, it was pastureland, and the whole area was full of poison ivy, trumpet vine, and poke weed. After clearing all that away to build the house, the first garden they planted was the vegetable garden, followed by flowering fruit trees, and then woodland plantings. The shady banks along the creek are planted with daylilies, hostas, foxglove, columbines, and other woodland plants. Perennial borders have been added along the vegetable garden and around the house. Tiny pocket gardens and a formal herb garden are interlaced with brick pathways and terraces. Roger has done most of the exterior brick work in the terraces and walkways.

Inside and outside seem to flow together. The extension to the living room has increased the sense of being in the gardens with the formal brick-terraced herb garden directly outside, a smaller shade garden on one side, and a brick terrace bordered by perennial beds on the other. The property is thoughtfully and gracefully landscaped to make the most of its site. The most recent addition is the porch room and the pool.

RIGHT BOTTOM: The high ceilings, oiled brick floor, and glass walls make the living room into a room within a garden. Just outside on the left is a small shade garden, partially enclosed with a low brick wall. Beyond the far wall is the more formally arranged herb garden with Le Gates Cove in the distance. Outside on the right is a raised brick terrace edged with perennial borders.

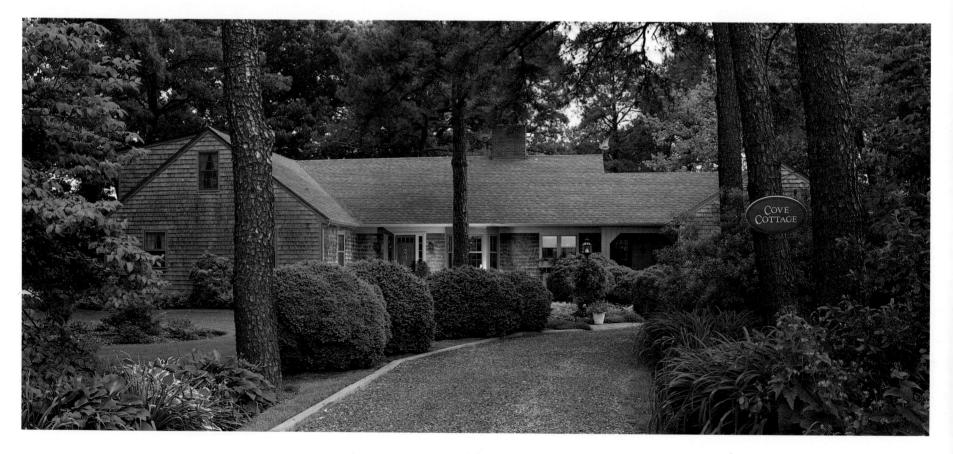

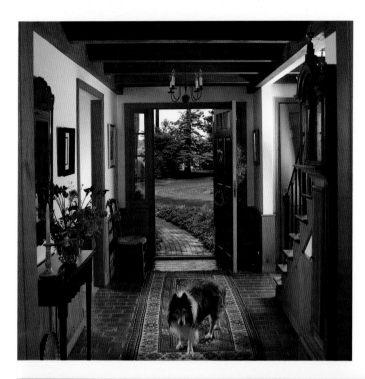

LEFT: The Judds' sheltie, Nicky, greets all the guests in the entry hall. Many pieces of furniture in the house were made by Marjorie's father; among them is the tall case for the clock on the right.

RIGHT: The upper-level sitting area of the large living room. Marjorie's father made the lowboy on the far wall. In front of the windows on the lower level is an Empire settee with stencil design, painted a rare yellow color.

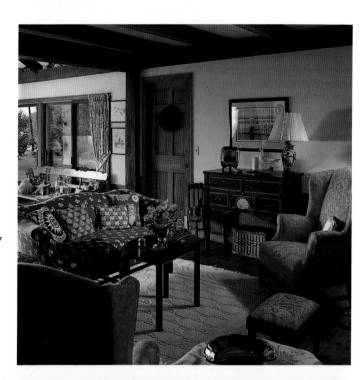

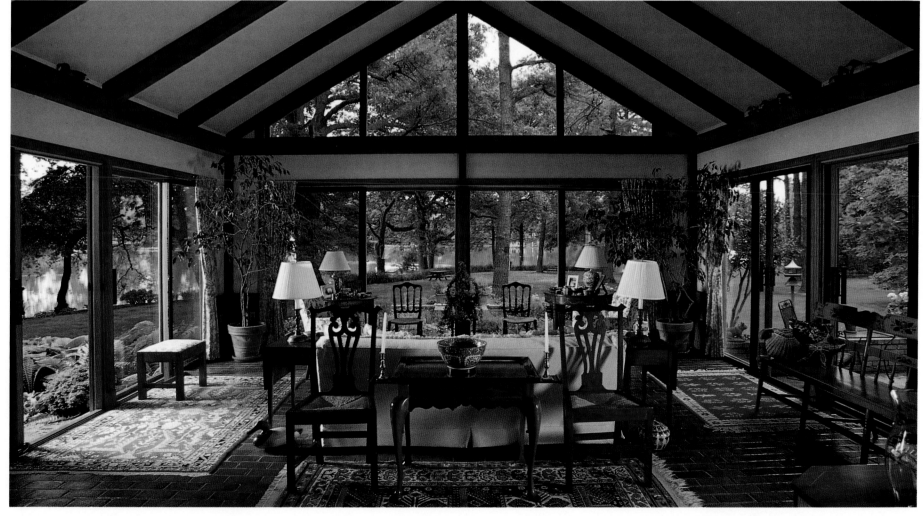

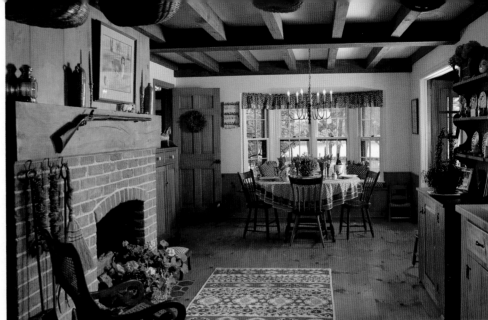

ABOVE: The kitchen with its brick fireplace and wide pine floor boards is an especially warm and cozy room. The bright prints of the Souleiado fabrics on the table make the room cheerful even on a gray rainy day.

LEFT: The intimate dining room has exposed beams in the ceiling as do all the rooms downstairs. The painting on the far wall is by Martha Hudson.

BELOW: The garden room is furnished with wicker furniture and gaily flowered cushions. An antique wooden horse, handmade wren house, and a ship's lantern add finishing touches.

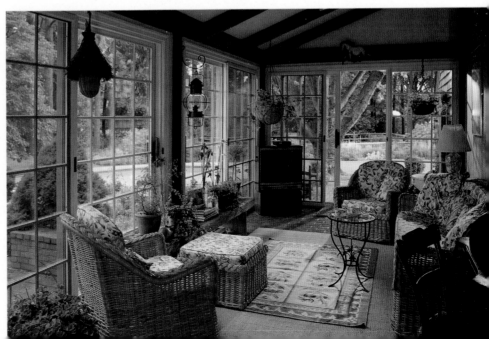

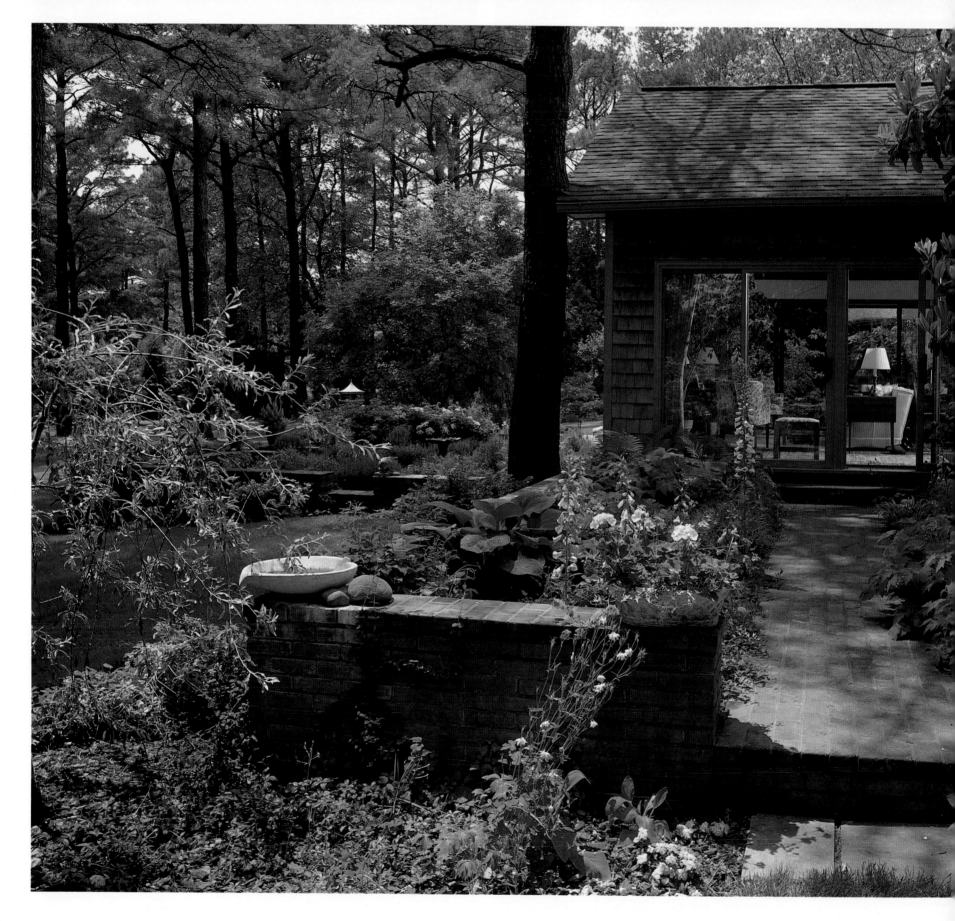

LEFT: This little garden on the side of the house is in the shade most of the day. Outside the low brick wall on the left is a weeping pear (*Pyrus salicifolia* 'Pendula'). Inside the wall the large blue green hosta is *Hosta sieboldiana* 'Elegans.' On the right the green foliage is Japanese anemone (*Anemone tomentosa*), backed by a tall *Magnolia grandiflora.* Tall foxglove and pots of geraniums add color.

RIGHT: The outside border beside the brick walk is planted with liriope (*Liriope muscari* 'Variegata') and lamb's ears (*Stachys byzantina*). The inner border has Dusty Miller, more liriope, snapdragons, and valerian (*Centranthus ruber*). Dwarf Alberta spruce (*Picea glauca* 'Conica') mark the entrance to the terrace. To their right is a *Caryopteris clandonensis,* which will bloom later on in the season.

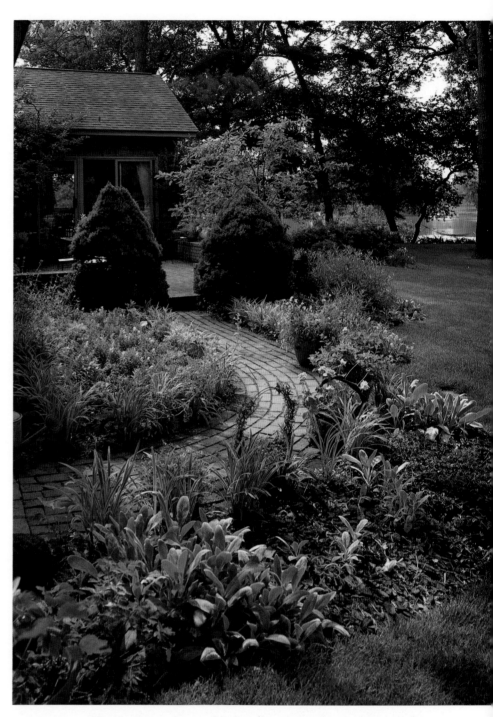

OVERLEAF: The herb garden, edged with germander, is Marjorie's design. The two far squares are centered with topiary rosemary, and surrounded by sage, lavender, thyme, winter hardy rosemary 'Arp,' comfrey, feverfew, rue, pineapple sage, marjoram, horehound, purple fennel, tansy, and lovage, alchemilla, sweet woodruff, and garlic chives.

RIGHT: A long perennial border edges the length of the vegetable garden.

BELOW: The vegetable garden in June. The loosestrife (*Lythrum virgatum*) in the border outside the garden is just beginning to bloom. Hollyhocks (*Althaea rosea* 'Singles') frame the garden at both ends. Way in the distance, the daylilies (*Hemerocallis* hybrids) are beginning to bloom along the banks of the creek.

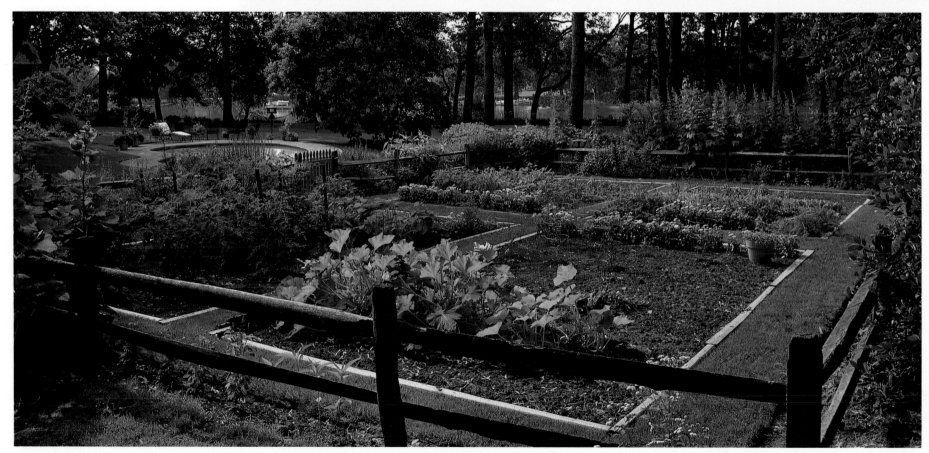

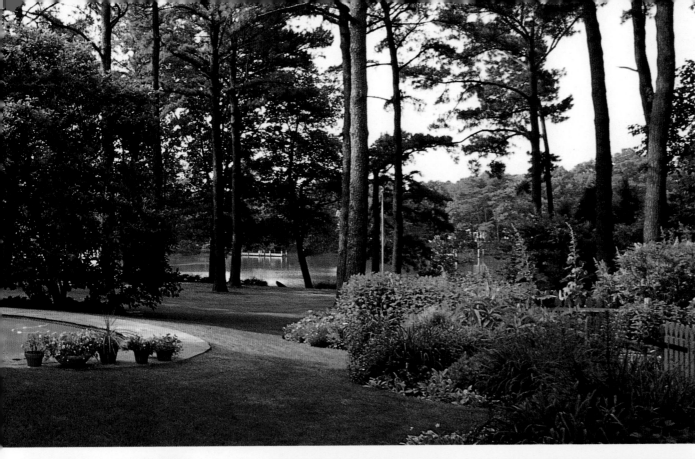

BELOW: The border is planted for continual bloom from early June through fall. In June, coreopsis (*Coreopsis virticillata* 'Moonbeam'), lythrum, and coral bells (*Heuchera sanguinea*) are beginning to bloom, mixed in with *Artemisia ludoviciana* 'Silver King,' and lamb's ears for their foils of gray-green foliage. Tall monarda will bloom in midsummer followed by Japanese anemones in August and September. Sedum (*Sedum spectabile* 'Autumn Joy') will bloom from August till Thanksgiving.

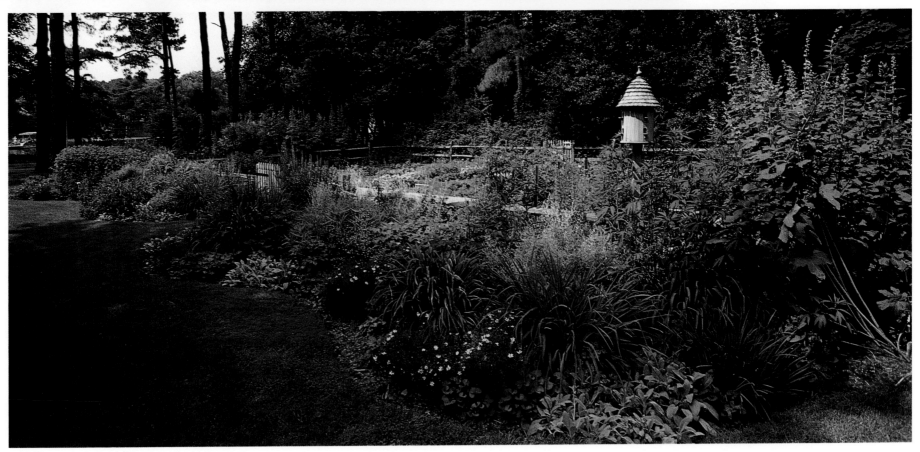

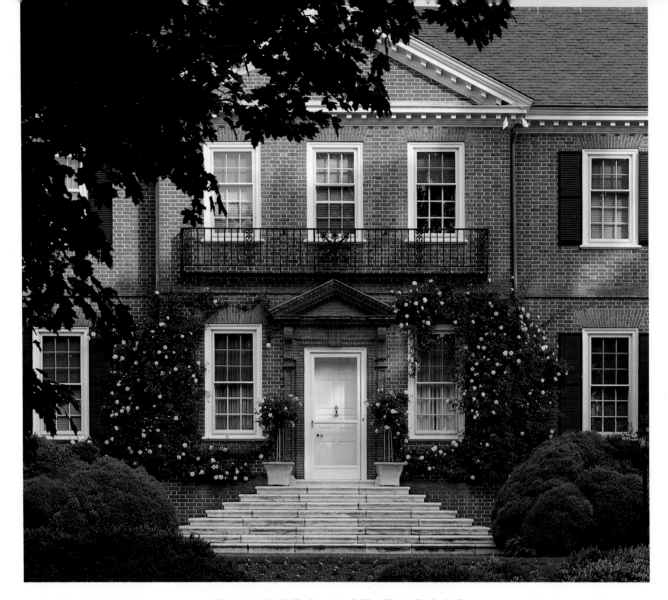

TIMBERLANE FARMS

This redbrick Georgian manor house was built in the 1930s as a weekend shooting retreat. It is said that the builder was terrified of fire and therefore insisted that no wood be used in the construction. The house had never been lived in full-time until the present owners bought it in 1985; consequently there were no gardens or even landscaping of the property. The only thing that existed was some boxwood that had been planted by the previous owners, who had begun restoration.

The present owners have added extensive landscaping, maxi-mizing the views of the river and creek, restored the pool area, added tennis courts, and put in formal plantings in front of the house, terracing, and formal gardens.

The perennial borders were the first to be planted, for color, for as long a season of bloom as possible. From there the gardens have evolved with the addition of flowering crabapples and weeping cherry, evergreens, and pyracantha. A gazebo, an arbor covered in roses, a reflecting pool, and a small fountain add graceful fin-ishing touches to the vast grounds around the formal Georgian structure.

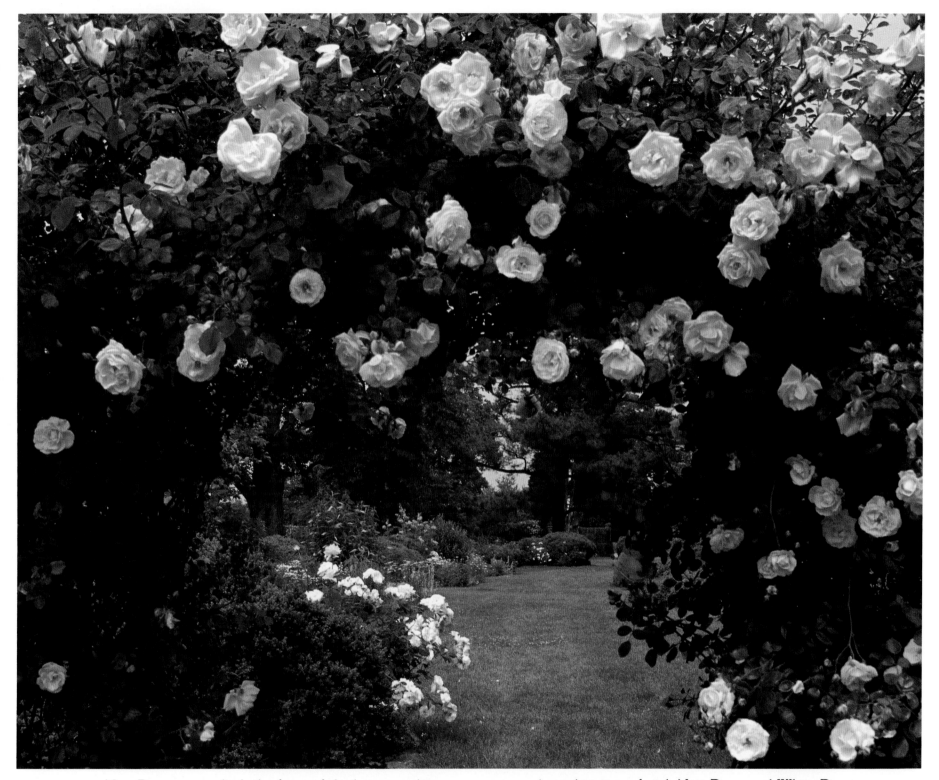

ABOVE LEFT: New Dawn roses climb the front of the house, and tree standard Sun Flare roses in urns flank the formal entrance at the top of marble front stairs.

ABOVE: A combination of pink New Dawn and White Dawn roses intertwine to cover the rose arbor that forms an entrance to the garden behind the house.

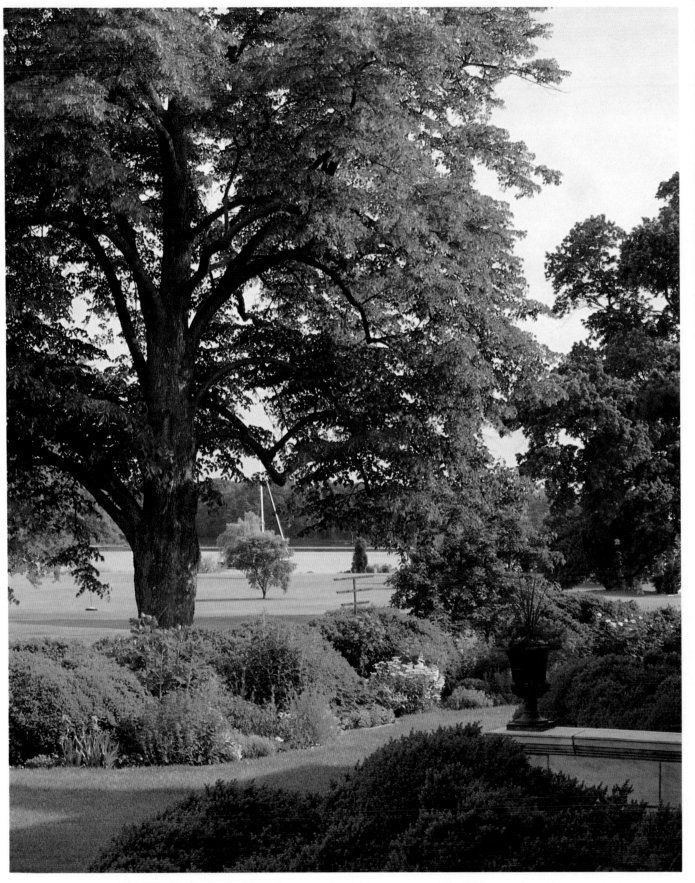

ABOVE: Coral plume poppy (*Macleaya cordata*), which was used as a Victorian screen plant, and a buddleia back the garden of old-fashioned perennials in traditional English garden colors of pinks, purples, and blues with whites and yellows for accents. Valerian (*Centranthus ruber*), yellow primrose (*Oenothera missouriensis*), feverfew (*Chrysanthemum parthenium*), love-in-the-mist (*Nigella damescena*), and yarrow (*Achillea filipendulina*) are blooming in early June.

LEFT: A sweep of the lawn leading out to Leeds Creek is framed by the formal box beside the marble back steps and the graceful perennial border.

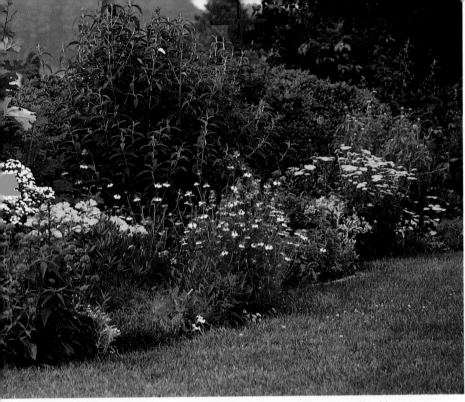

RIGHT: Variegated-leaf red-twig dogwood (*Cornus alba* 'Argenteo-marginata'), coral bells (*Heuchera sanguineum*), catmint (*Nepeta* x *faassenii*), yellow primrose, and pink spirea (*Spiraea* x *bumalda* 'Anthony Waterer') are some of the blossoming perennials and shrubs in this border.

BELOW: Seen here in this small section of the border is lamb's ears (*Stachys lanata*), pink physotegia, and phlox not yet blooming, perennial salvia (*Salvia superba* 'East Friesland'), lady's mantle (*Alchemilla mollis*), and santolina.

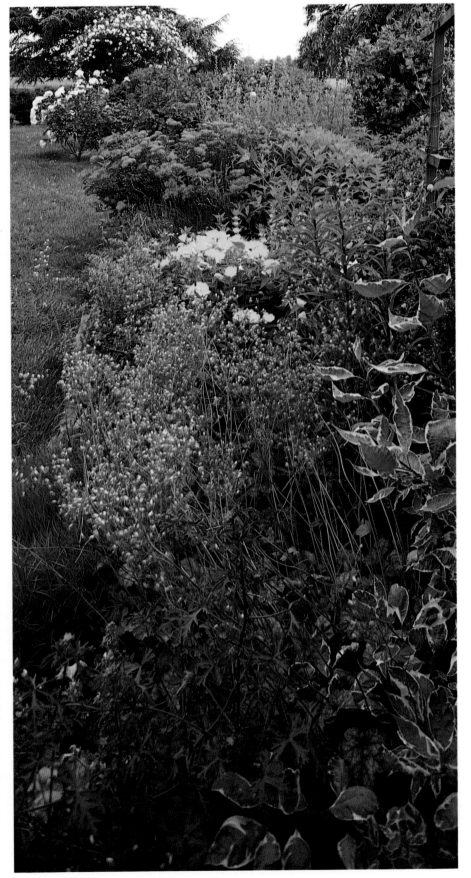

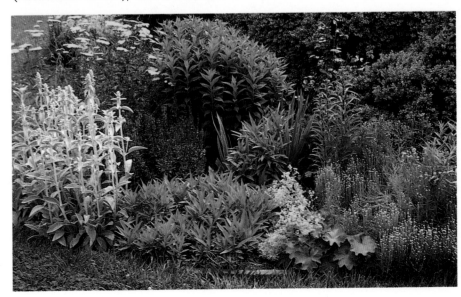

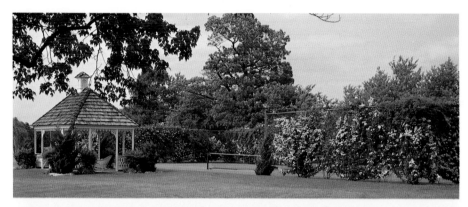

LEFT: Plantings around the gazebo include nandina for its red berries and colorful foliage in the fall. Pyracantha, filled with white blooms in June, covers the fence around the tennis court.

BELOW: The brick-and-stone terraced steps are planted with perennials, herbs, and rock plants in shades of pink, mauve, and gray. Among the rocks are pink cranesbill, coreopsis, santolina, miniature pink spirea, and plumbago.

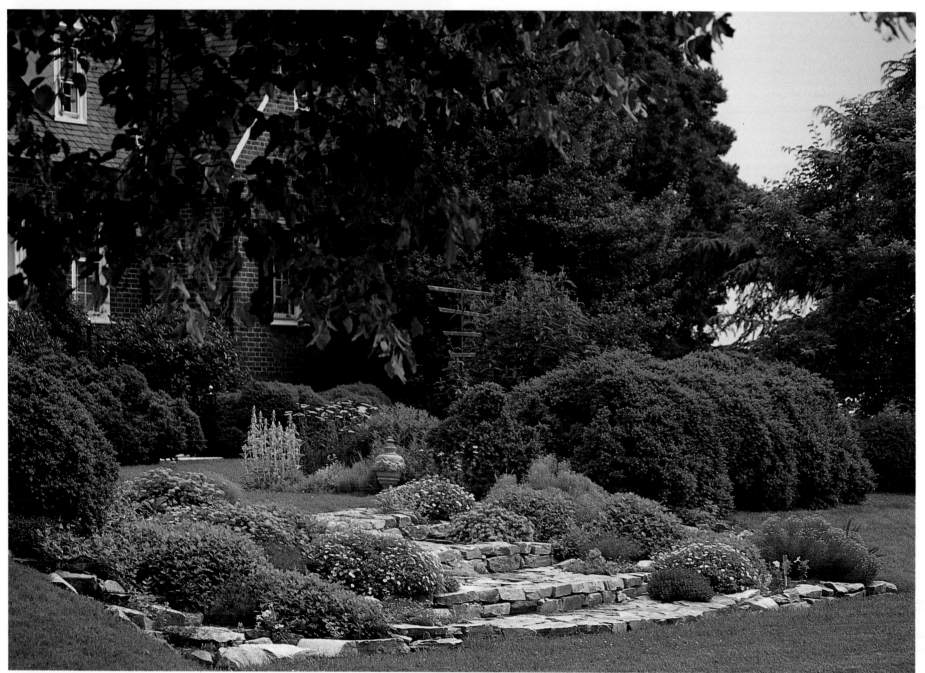

BELOW: The pyracantha, in its October brilliance, is interspersed with
yellow climbing roses.

OVERLEAF: The formal balance of the Georgian structure is enhanced
by the boxwood-enclosed garden on the terrace behind the house,
separating it from the sweeping lawns.

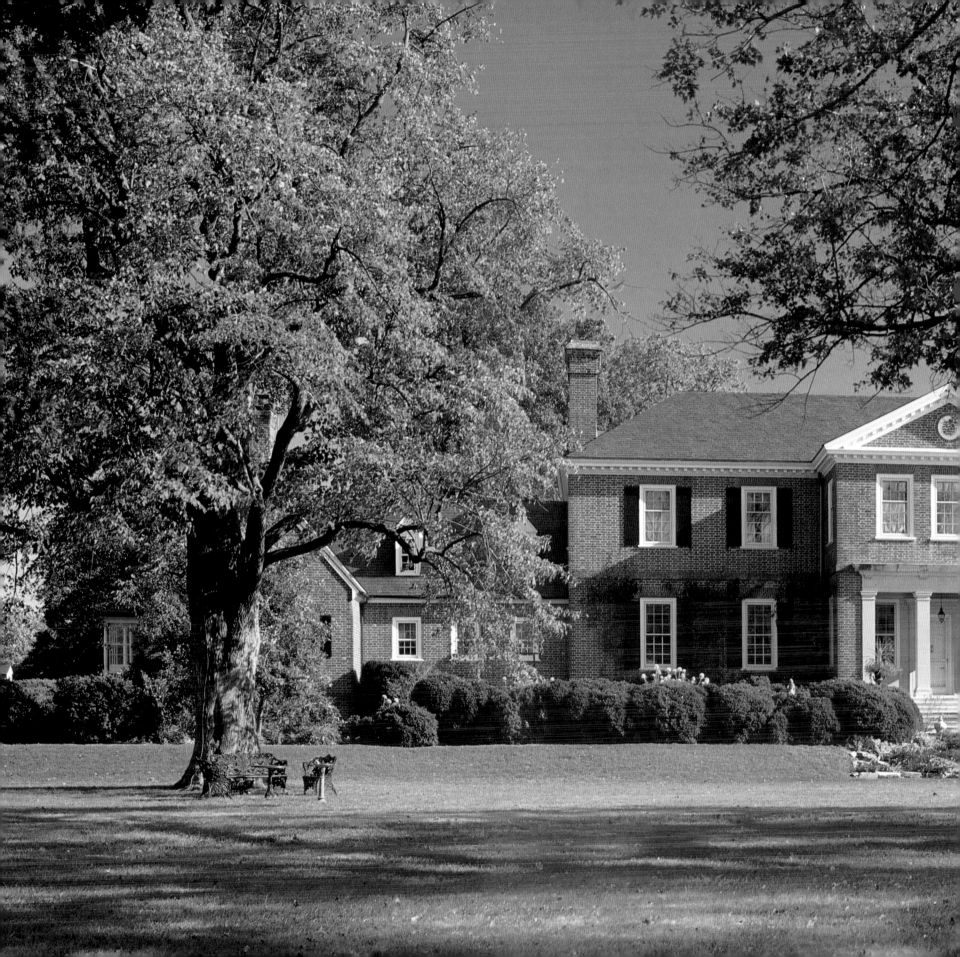

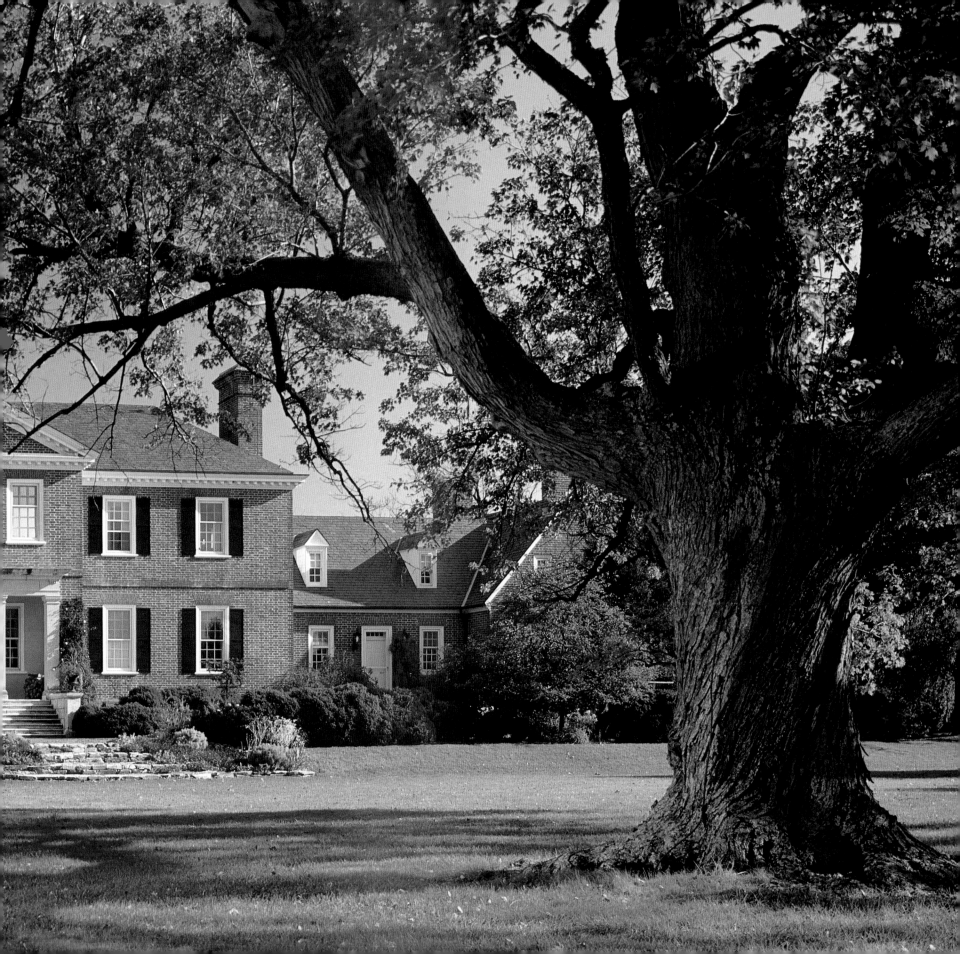

GRAYCEWOOD

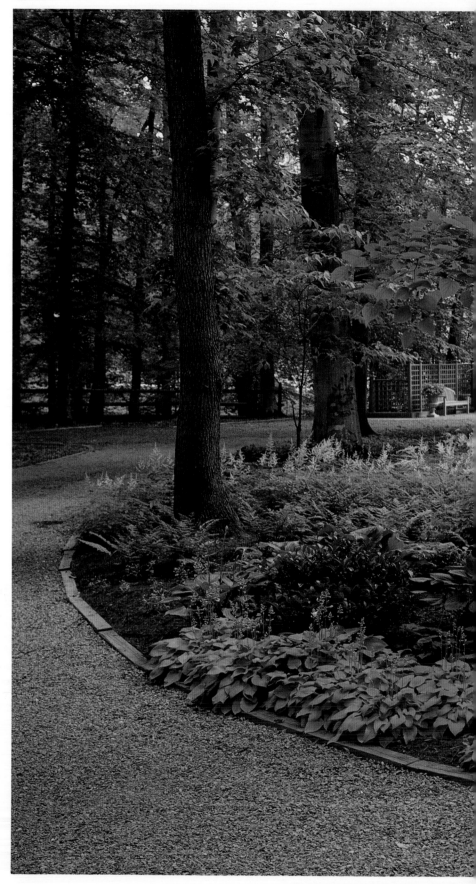

It was the boat house near the head of Ship's Head Creek that first interested Breene and Shery Kerr as they were sailing their boat south for the winter in 1983. Since purchasing the property, the Kerrs have taken the house through several changes. In the first, they added a large screened porch room across the back, converted the breezeway into a keeping room, added five fireplaces and two bathrooms, and finished the third floor. The second phase consisted of converting the double garage into a guest room and bath. In 1991, they completed an addition above the drawing room, enlarging the master bedroom above and expanding the window in the drawing room into a conservatory.

The house now has distinctly different personalities depending on how it is approached—from the water, or down the drive along the woodland garden to the front door. The gardens have evolved through the years into a more formal scene that unfolds just inside the drive. A fenced lawn adjacent to the house makes a transition from the shore side to the waterside, which is more open and inviting to guests who arrive by boat—a not-infrequent occurrence.

Just inside the gate is the woodland garden, planted with shade-loving perennials intermixed with annuals for color. Flowering trees, such as the little redbud (*Cercis canadensis*) in the front of the shade garden and a purple plum (*Prunus cerasifera* 'Thundercloud') to the right of the front door, add color in the spring. In bloom here in late June are frothy pink astilbe (*Astilbe* x *arendsii* 'Rheinland'), white goat's beard (*Aruncus dioicus*) against the large tree trunk toward the back of the garden, and oak-leaved hydrangea (*Hydrangea quercifolia*). To its left is a dwarf andromeda (*Pieris japonica* 'Mountain Fire'). Beside the turn in the path in the middle of the garden is fall-blooming *Begonia grandis* with large green leaves with deep red undersides. Creating a tapestry of green textures in variants of yellow-green to dark emerald shades are toothed wood ferns (*Dryopteris spinulosa*) in the left foreground and Christmas ferns (*Polystichum acrostichoides*) behind, hostas 'Golddrop' and 'Royal Standard', and caladiums 'White Christmas' and 'Kathleen'.

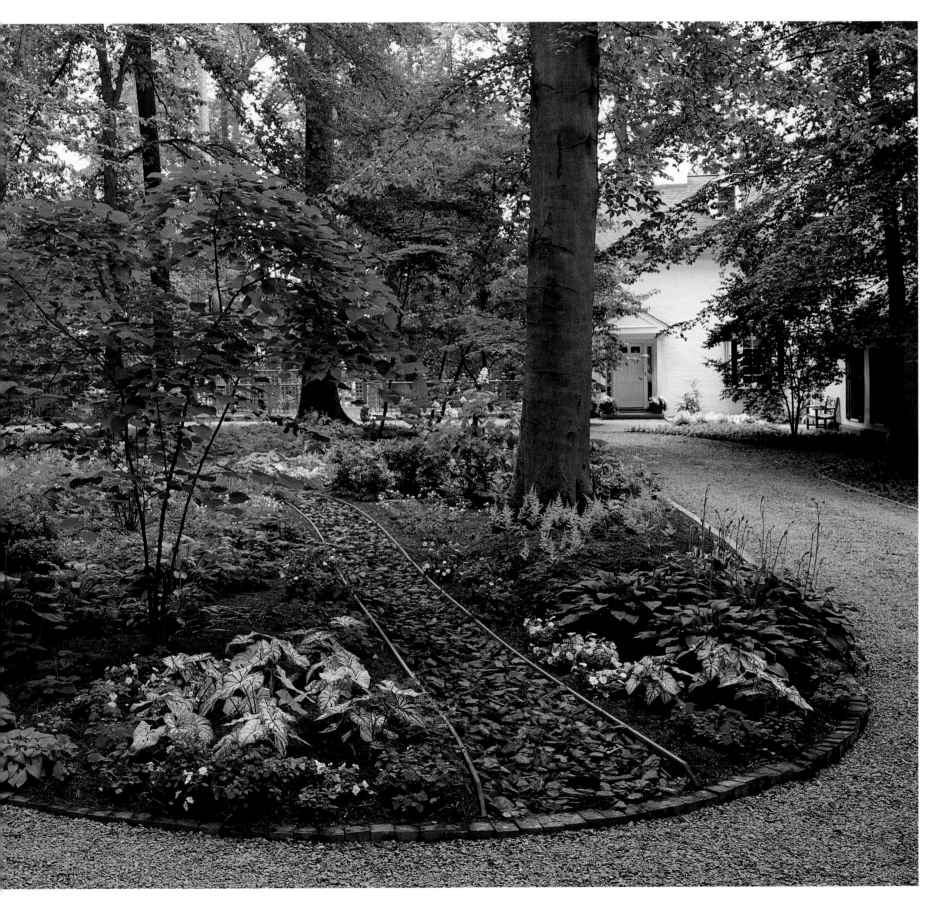

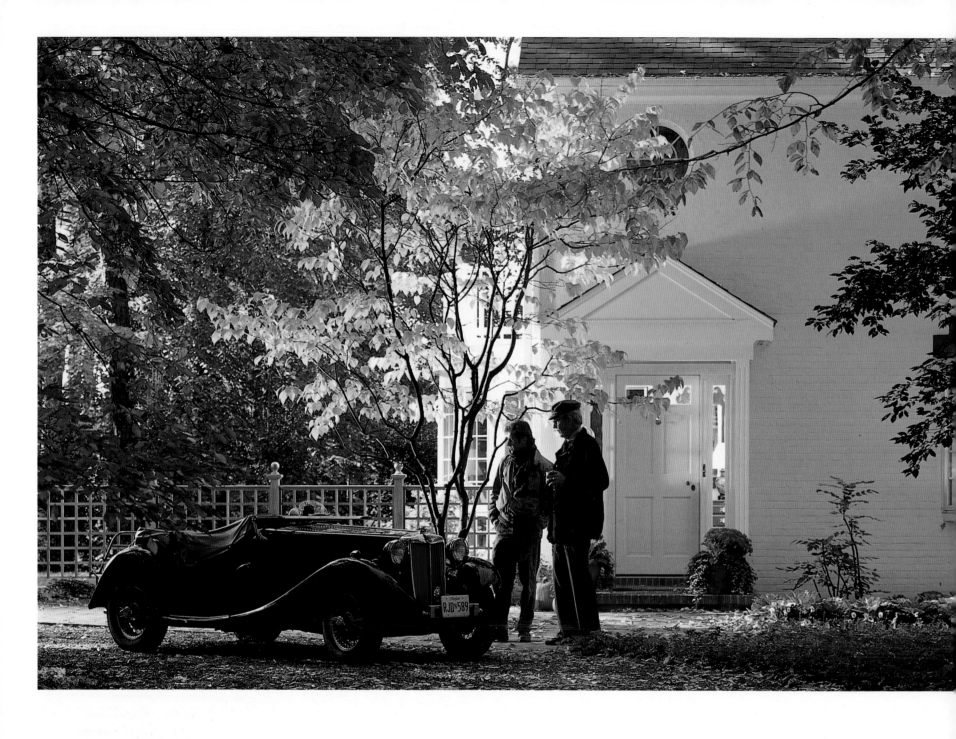

LEFT: Breene's 1952 MG-TD in front of the house. The little garden to the right is now planted with ornamental kale and cabbages, edged with pansies to bloom throughout the winter months. In summer the bed is filled with a carpet of caladium. To the left of the front door is a Japanese lilac (*Syringa reticulata*) with wonderfully scented off-white blossoms in early to mid-June.

RIGHT: One of a pair of Foo dogs that protect the property from evil spirits outside the garden fence. Made of African iroko, the fence was imported ready-made from England and then customized for this garden. The fence was new in the spring, began to weather in the fall, and will in time be a lovely soft gray. Plantings of chrysanthemums, kale, and pansies are repeated in the border in front of the fence, under the conservatory window, and on around the house and the porch behind.

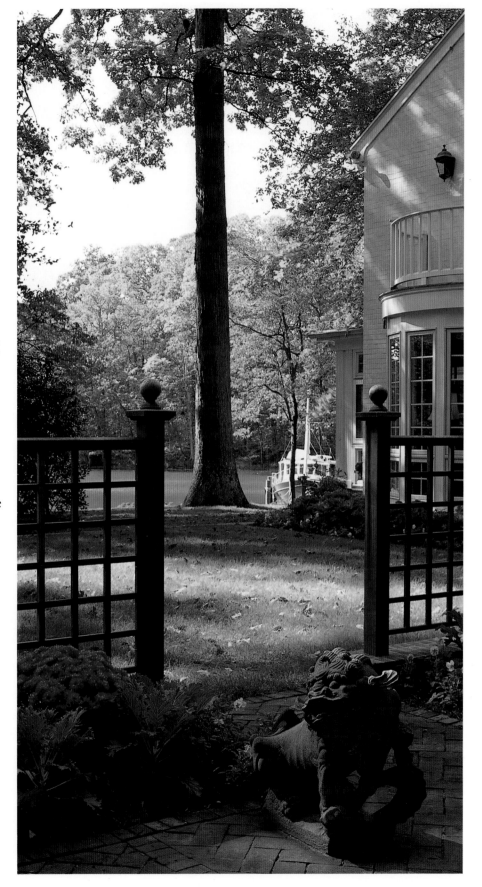

LEFT: The conservatory window faces south and looks into the garden. It is a quiet place to sit and read. Window treatments are only on the top to maximize the outside views.

BELOW: Looking from the conservatory into the drawing room with the library beyond on the left, and the dining room on the right. The cayenne color of the rug was the basis for the lively colors Shery chose for this room and the library, which is done in deeper tones of the color.

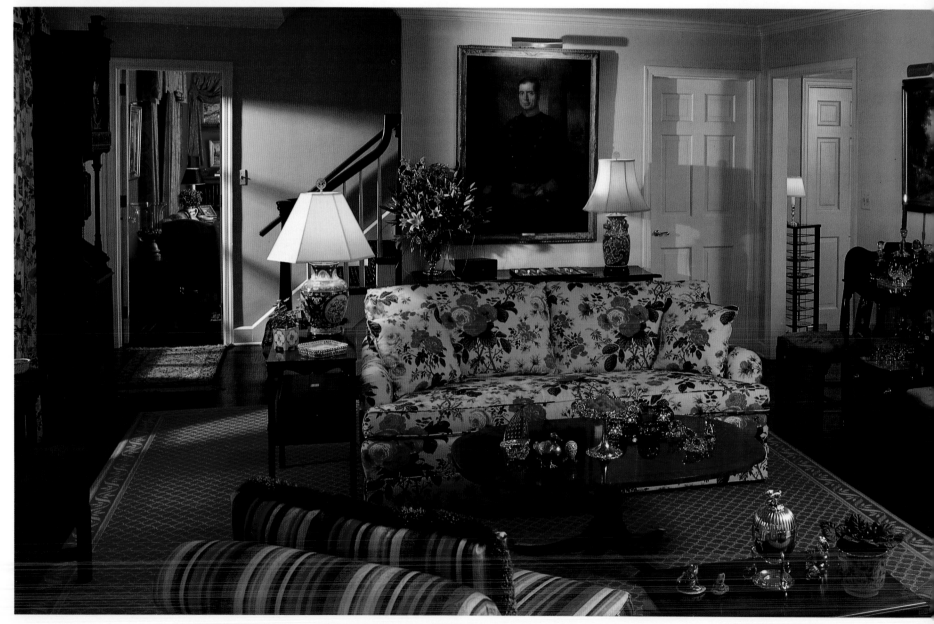

RIGHT: A portrait of Pizarro by an unknown artist, which had belonged to Breene's mother, hangs above a seventeenth-century English chest. Shery often uses rubrum lilies in arrangements for the room, not only for their color but for their scent.

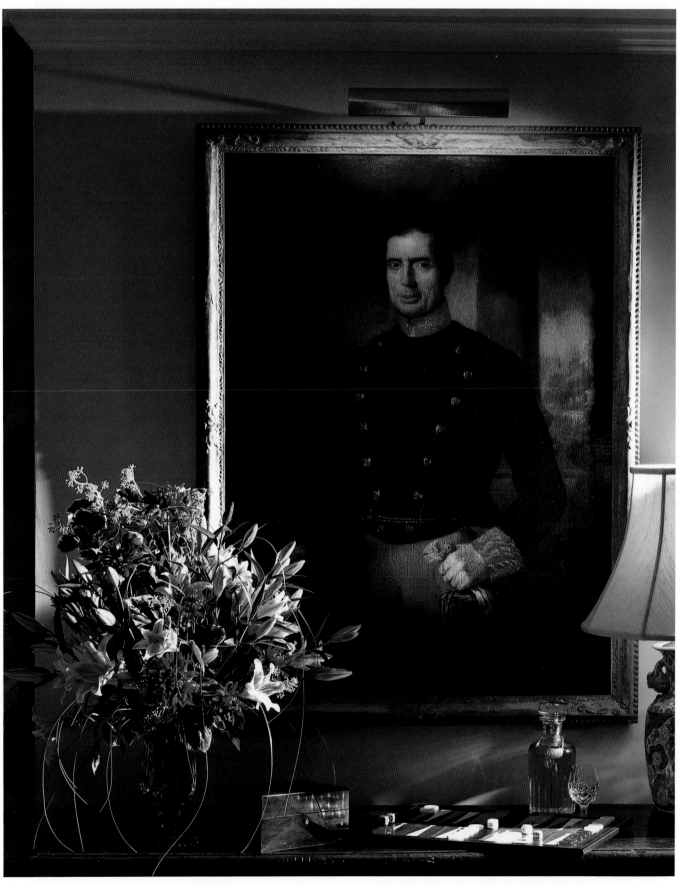

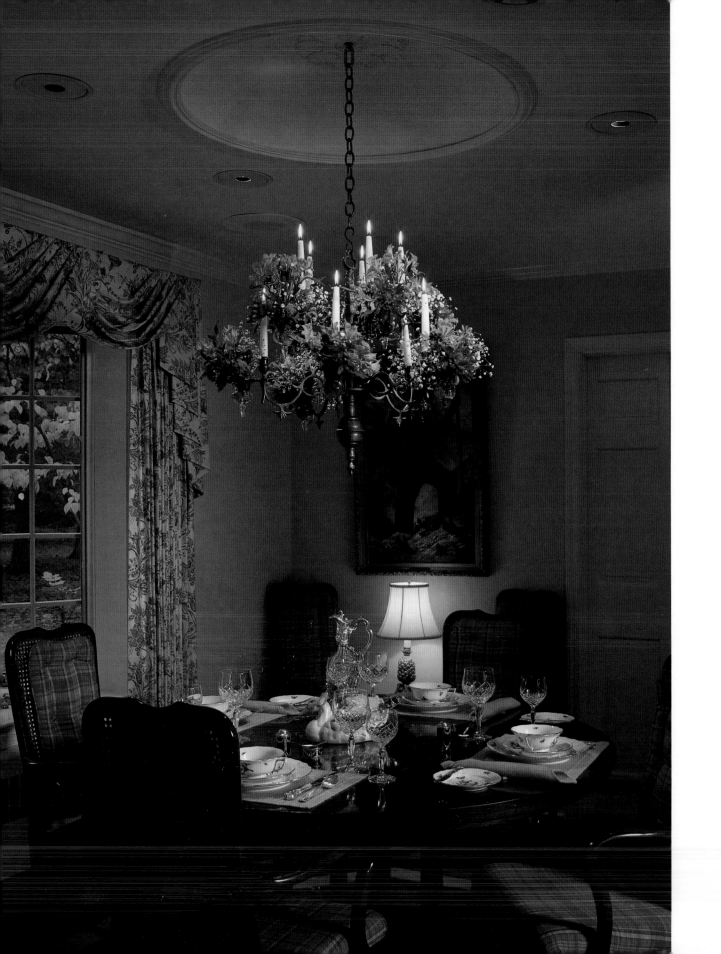

LEFT: The centerpiece of the dining room is the Austrian chandelier, with red, green, and gold crystal flower cups and candles. The formerly flat ceiling was redone with the coving to reflect the candlelight so that no other light would be necessary for the room. The crystal decanter and wine glasses are Austrian.

RIGHT: A few steps down from the kitchen is the keeping room, which was created by enlarging and enclosing the breezeway. The fireplace is one of the five that were added to the house over the course of its renovations. Breene bought the Deluermoz painting of the bull in Mexico City. Dragonflies and other creatures decorate the firescreen, which Breene's mother designed for the family's house in Minnesota.

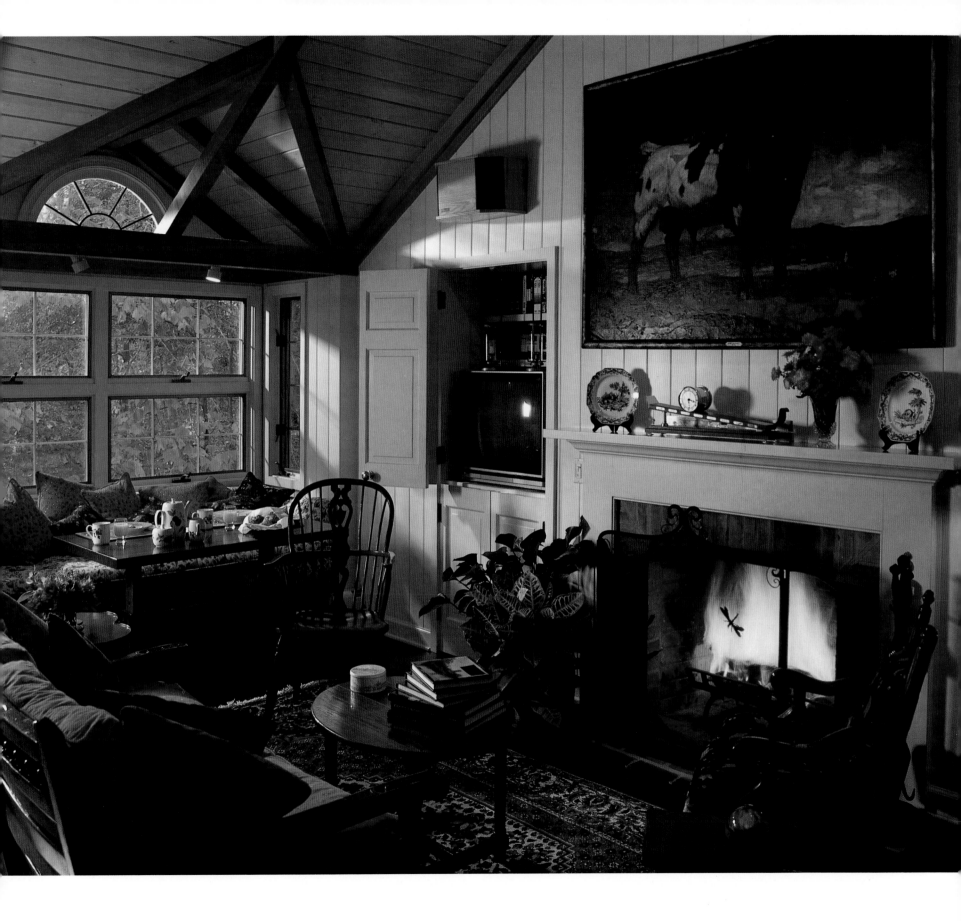

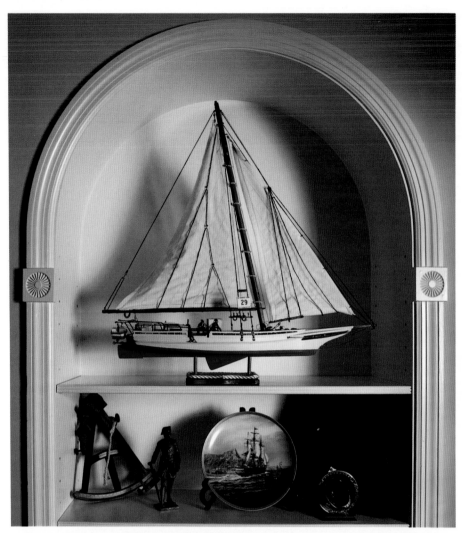

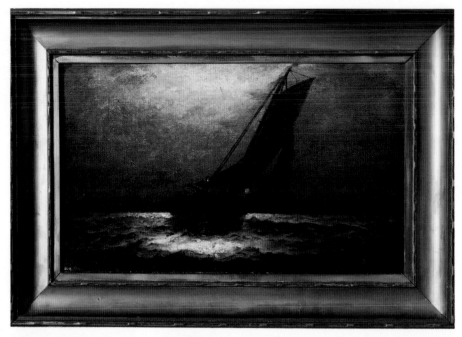

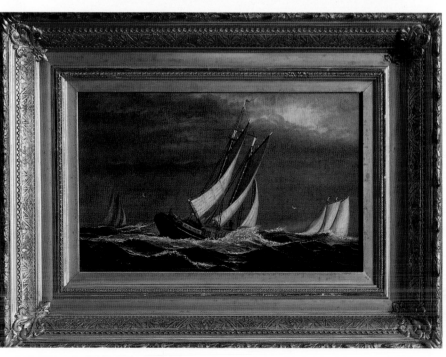

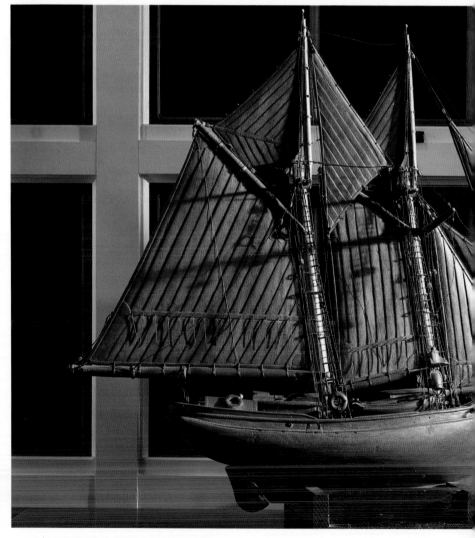

Throughout the house are interesting boat models and ship paintings. FAR LEFT: An Eastern Shore skipjack by Talbot County model-maker Bill Deckert. LEFT: Ship's painting by James Gale Tyler, 1855–1931, a New York artist who painted America's Cup races. BELOW LEFT: An untitled marine painting by an unknown artist. BELOW: An authentic model of a New World schooner that sailed from Maine to Maracaibo was made in the 1920s by a wood carver in Venezuela.

BELOW: The boat house with a Wenawmet Kitten, an eighty-year-old catboat from Cape Cod, and the 39-foot wooden cruiser *Misty,* built some thirty years ago in Boothbay Harbor, Maine.

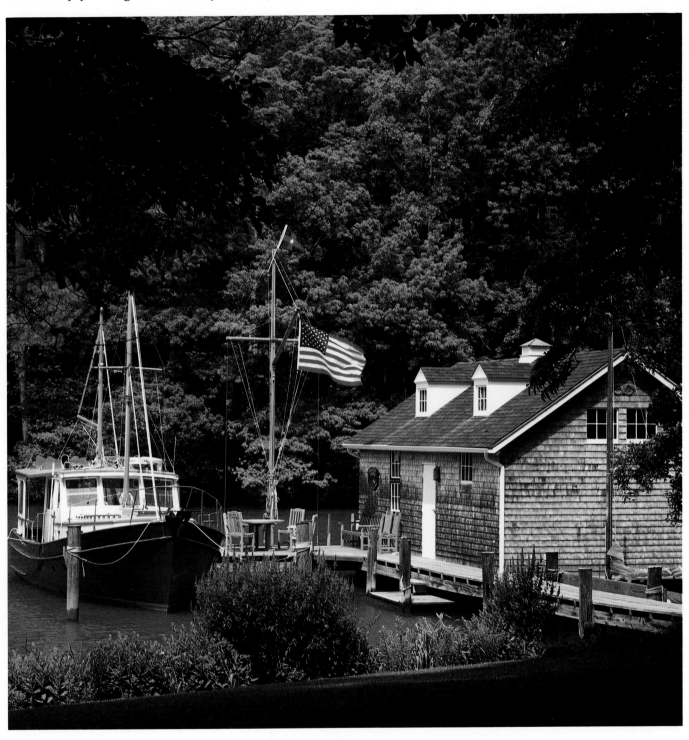

OVERLEAF: The boathouse with a 23-foot 1947 Chris-Craft Express Cruiser inside. The boat has never needed restoration since it has been continuously maintained and used. Coming into port is the Kerrs' dragon, *Grayceful,* a 30-foot Olympic-class sloop.

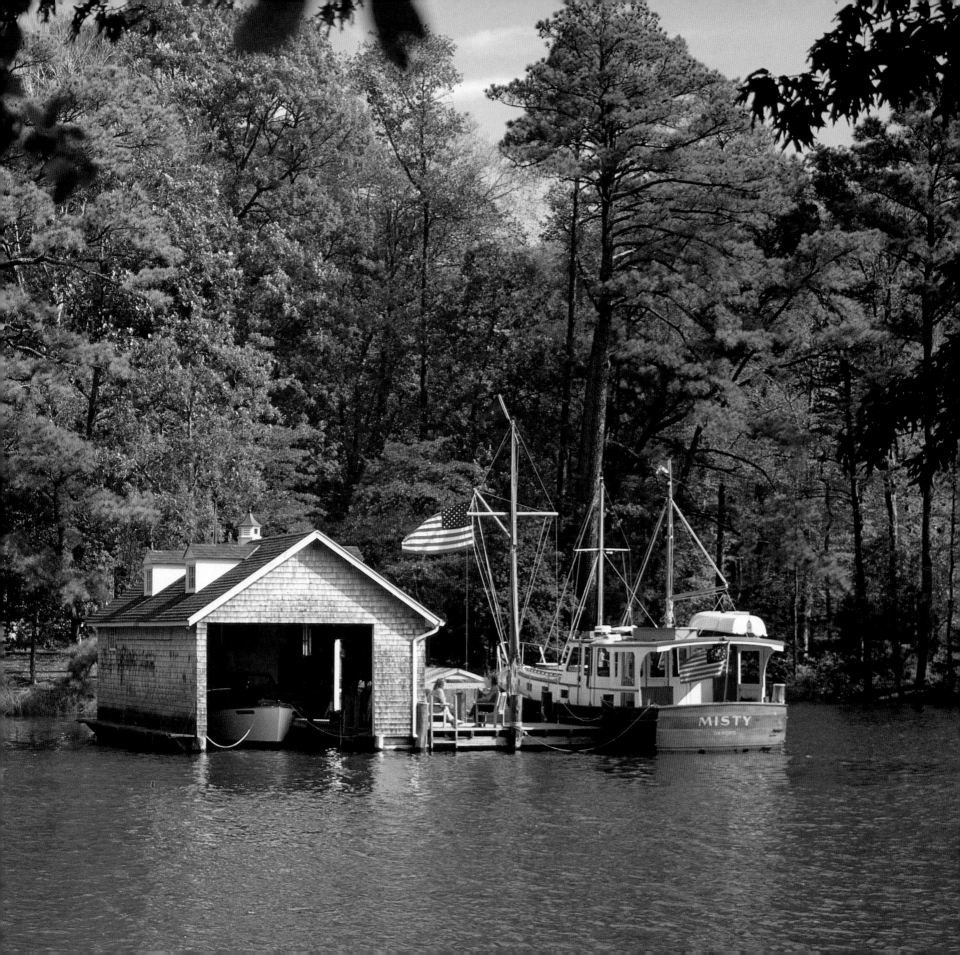

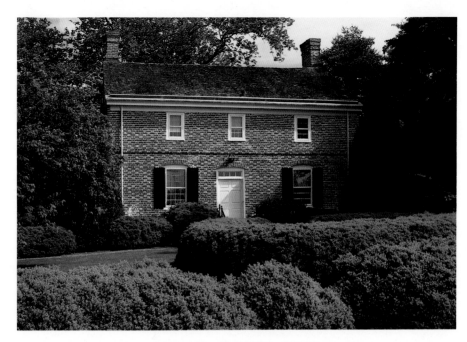

THE REWARD

The Reward owes its name to a 1668 land grant by Lord Baltimore to two surveyors in payment for their services. The property was apparently not developed until 1740, when the existing redbrick farmhouse was built. The current owners have expanded the gardens from the existing boxwood into the gardens and grounds of today. There are now formal gardens, an English-style herb garden, clematis-covered fences, extensive perennial borders, flowering trees and shrubs. Special attention to details such as wooden carvings, unusual birdhouses, Chinese garden seats, fountains, and statuary create a sense of elegance with a touch of whimsy.

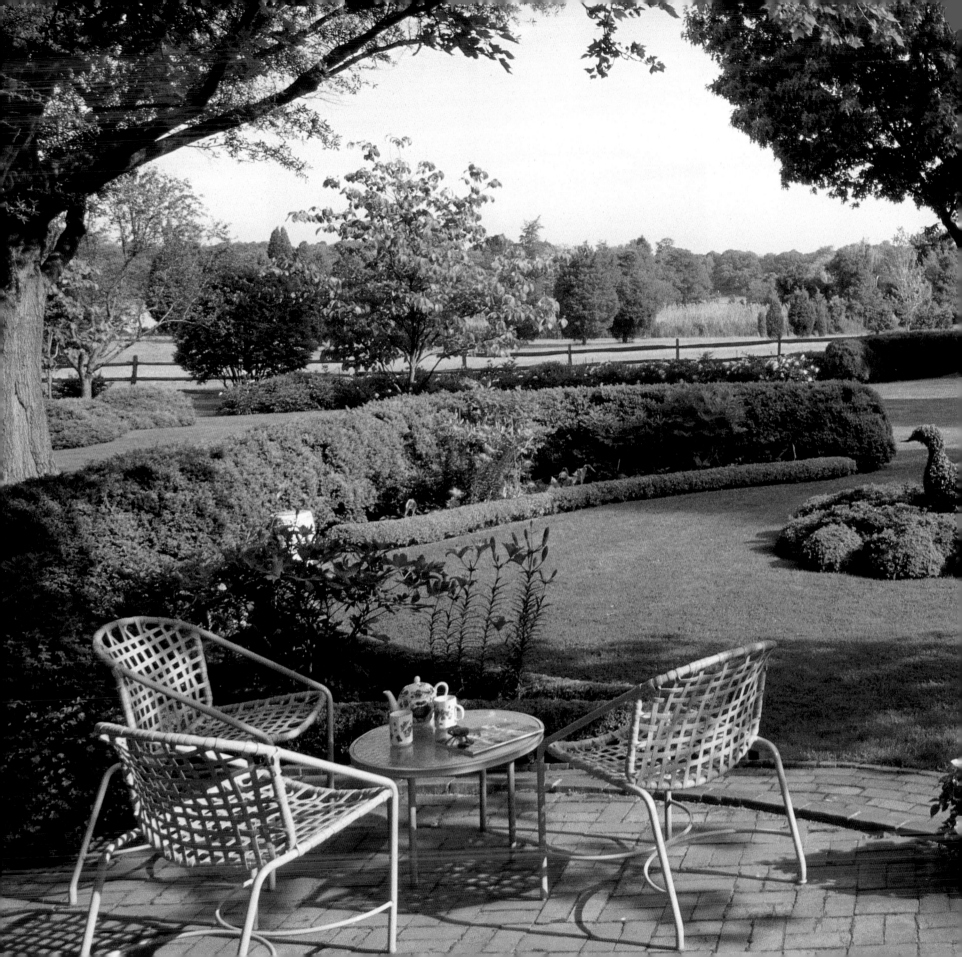

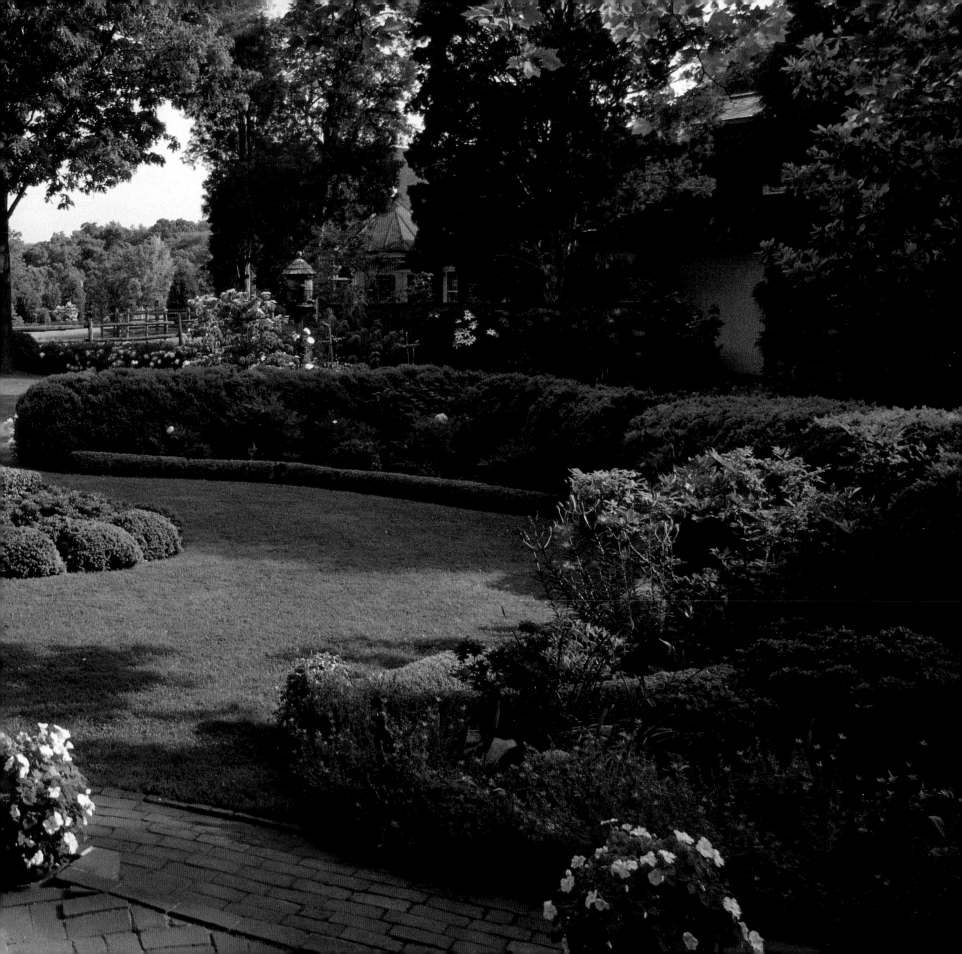

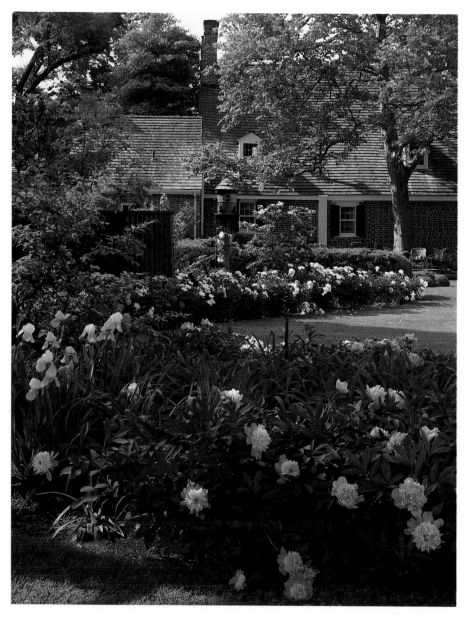

ABOVE: Many varieties of peonies and iris fill this herbaceous border with color in early June. Several varieties of lilies and phlox will follow later in the summer.

OVERLEAF: An ivy-covered topiary goose sits inside mounds of miniature Kingsville box. Curved borders are backed with English box and edged with Korean box with flowering shrubs and perennials planted between for seasonal color. The tree peonies and azaleas are just about finished and the lilies are just beginning. The borders open out toward the gardens and Langford Creek beyond.

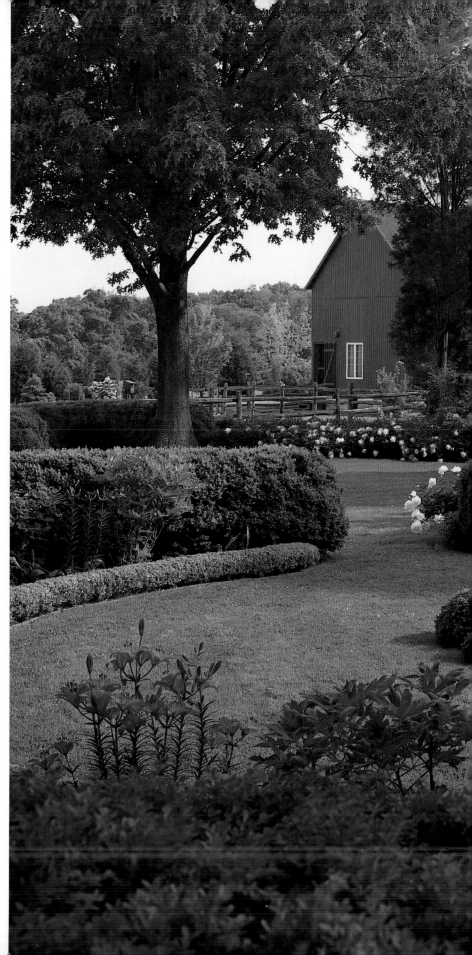

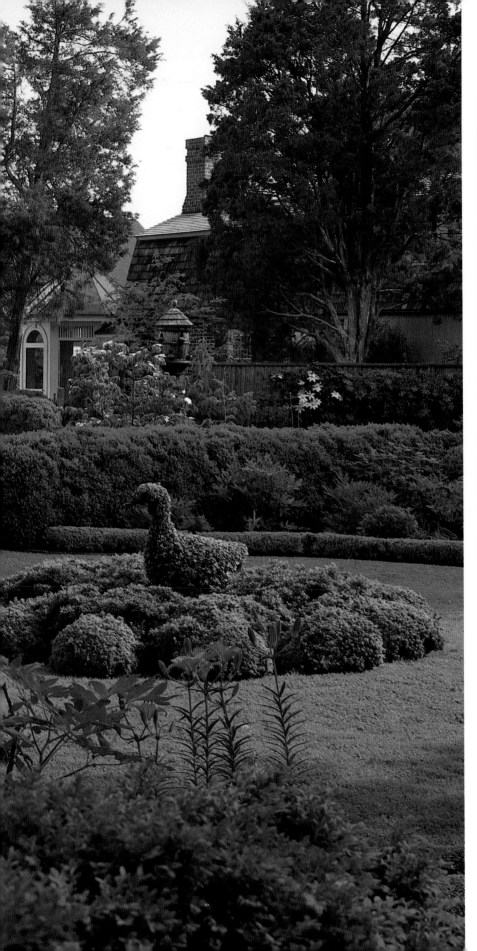

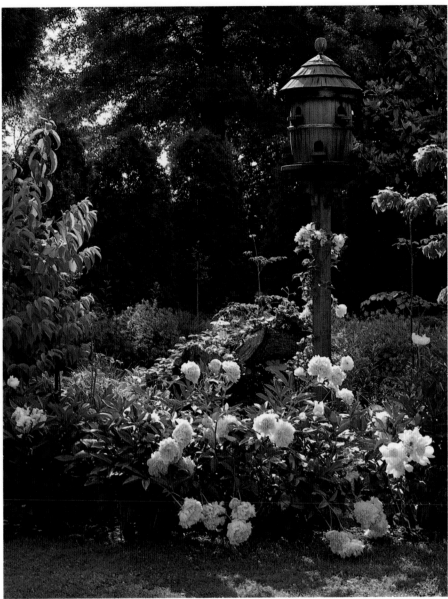

ABOVE: Peonies and blue cranesbill (*Geranium endressii* 'Johnson's Blue') surround an old stump and an English dovecote birdhouse made for the garden. A Japanese dogwood (*Cornus kousa*) is beginning to bloom overhead.

LEFT: Looking from the terrace outside the house toward the barn and the gazebo beyond the topiary, peony borders and a clematis-covered fence add strong color to the scene.

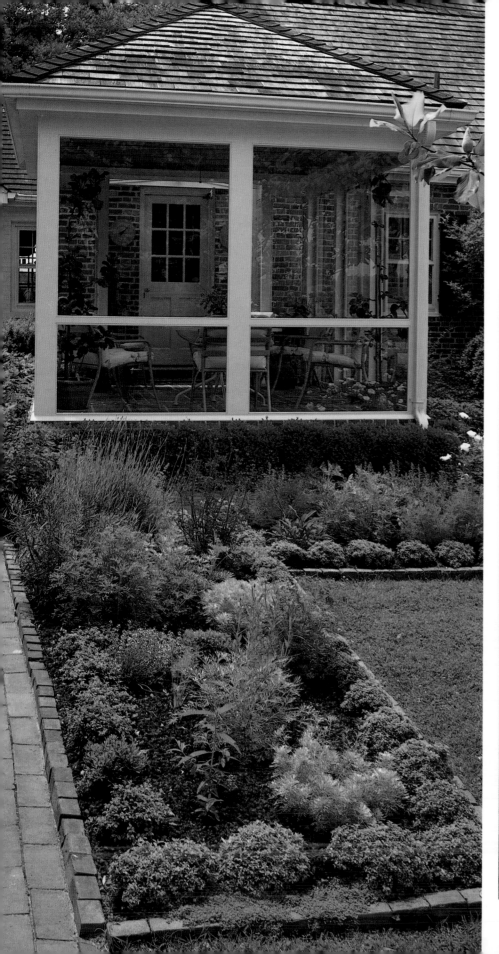

LEFT AND BELOW: The herb garden is a recent addition off the glass-enclosed porch. Kingsville box edges the borders planted with parsley, sage, tarragon, artemisia, and thyme. A *Magnolia virginiana* is planted in the center of the herb border with miniature white roses in one corner and liriope 'Monroe's White' edging one side. From the glass room, perennial beds frame the fence with two varieties of clematis in bloom at the far end.

RIGHT: 'America' roses climb the trellis on the old water tower, which has been converted into a toolshed.

FAR RIGHT: Clematis 'Henryii' climbs the smokehouse behind the trunk of an ancient mulberry tree.

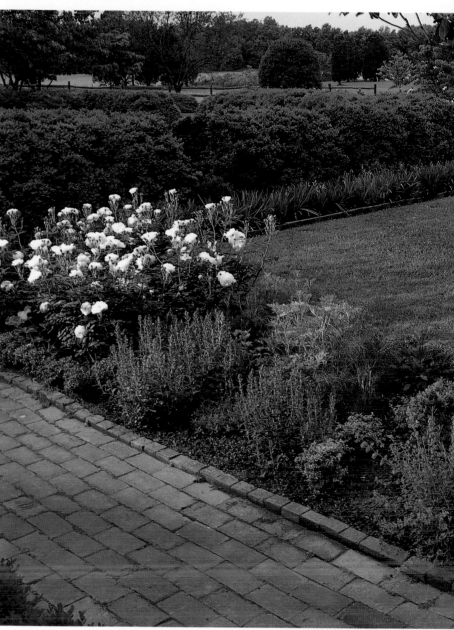

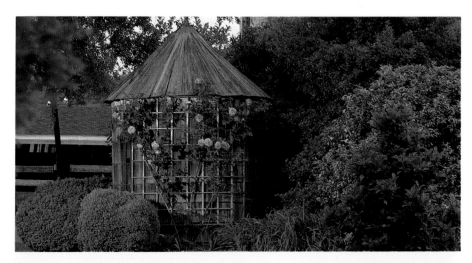

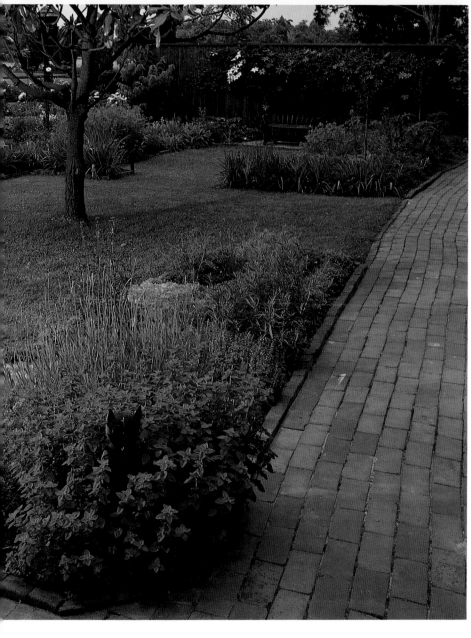

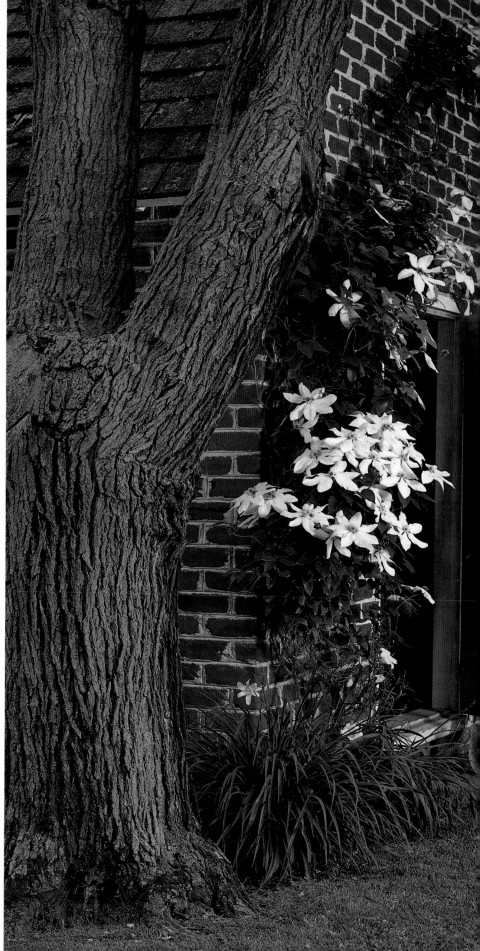

BAYBERRY COVE

T his cedar contemporary house nestles in a grove of loblolly pines at the edge of Broad Creek. The home of Al and Margaret Naeny, it was designed to take full advantage of the ever-changing view of the water. Clerestory windows create patterns and shadows of light that move through the house all day and change as the seasons change and the sun is higher or lower in the sky. Al and Margaret built the house in 1971, on land they bought in 1966, as a weekend and vacation house. Inside, the rooms open on one another in a nontraditional pattern, with the main living room open two storeys to the ceiling and skylights. A loft, used as an office, is open to the rest of the house on three sides.

In 1985 the Naenys added a wing with a master bedroom suite and a generous deck on the upper level and a family room downstairs, making it into a year-round home. Most recently, a glassed-in porch was added to the living room across the front of the house. The pool and its careful landscaping is a recent addition. The property is planted with native trees and shrubs that flower in the spring or change foliage colors or have interesting fruits in the fall.

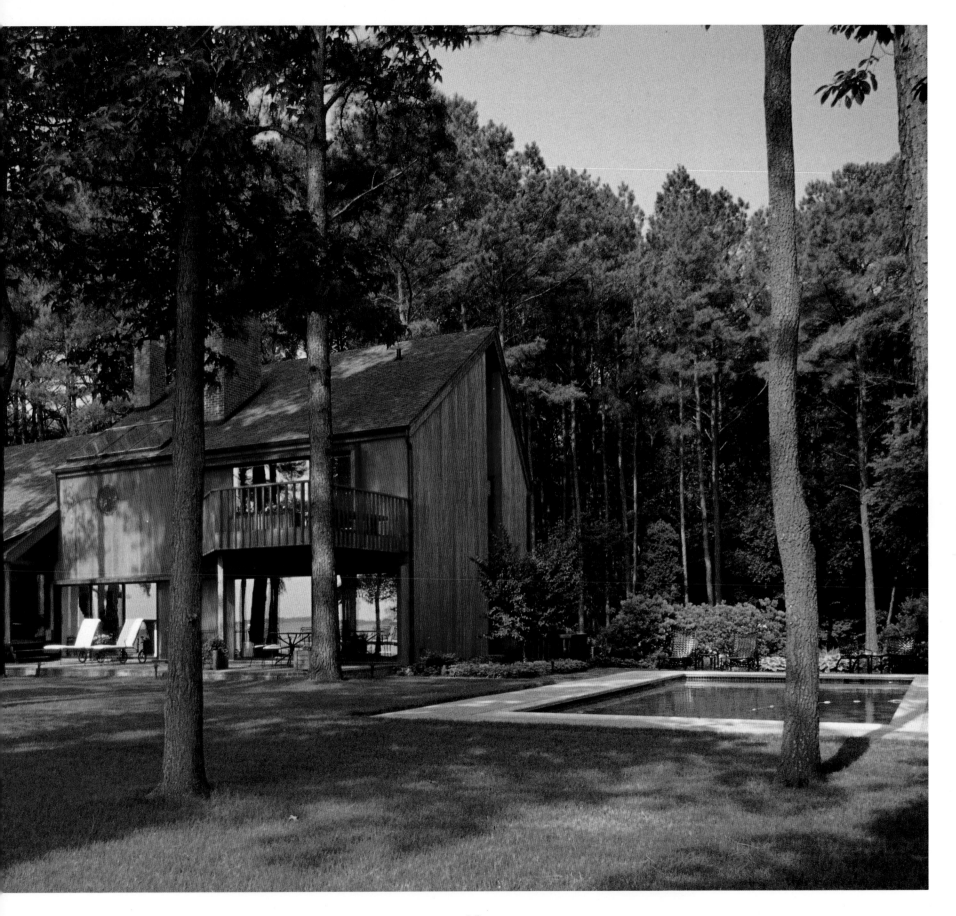

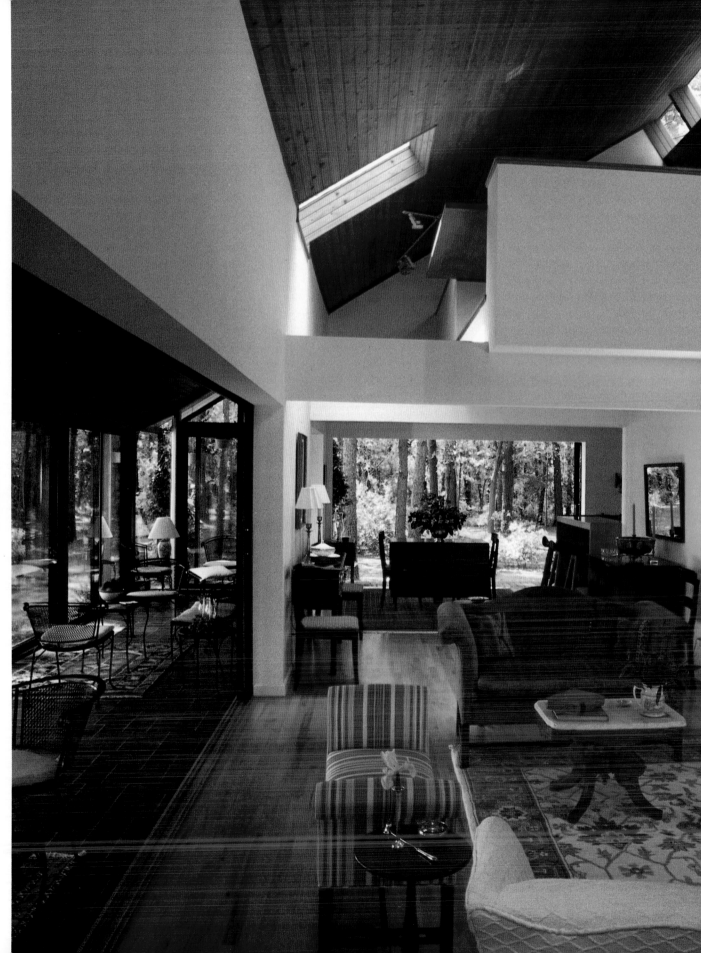

BELOW: The entrance hall as seen from the corner of the master bedroom.

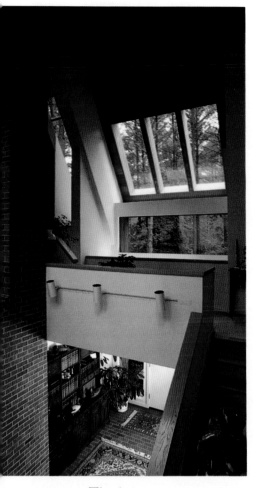

RIGHT: The living room opens into the dining room, with a kitchen to the right. Upstairs, the loft is open to the downstairs on three sides. Stairs at the back of the living room lead to the loft; an open hall on the perimeter of the living room connects it to the master bedroom. The glass-enclosed porch room on the left is the newest addition.

FAR RIGHT: The combination guest room and study are behind the chimney for the master bedroom and study fireplaces.

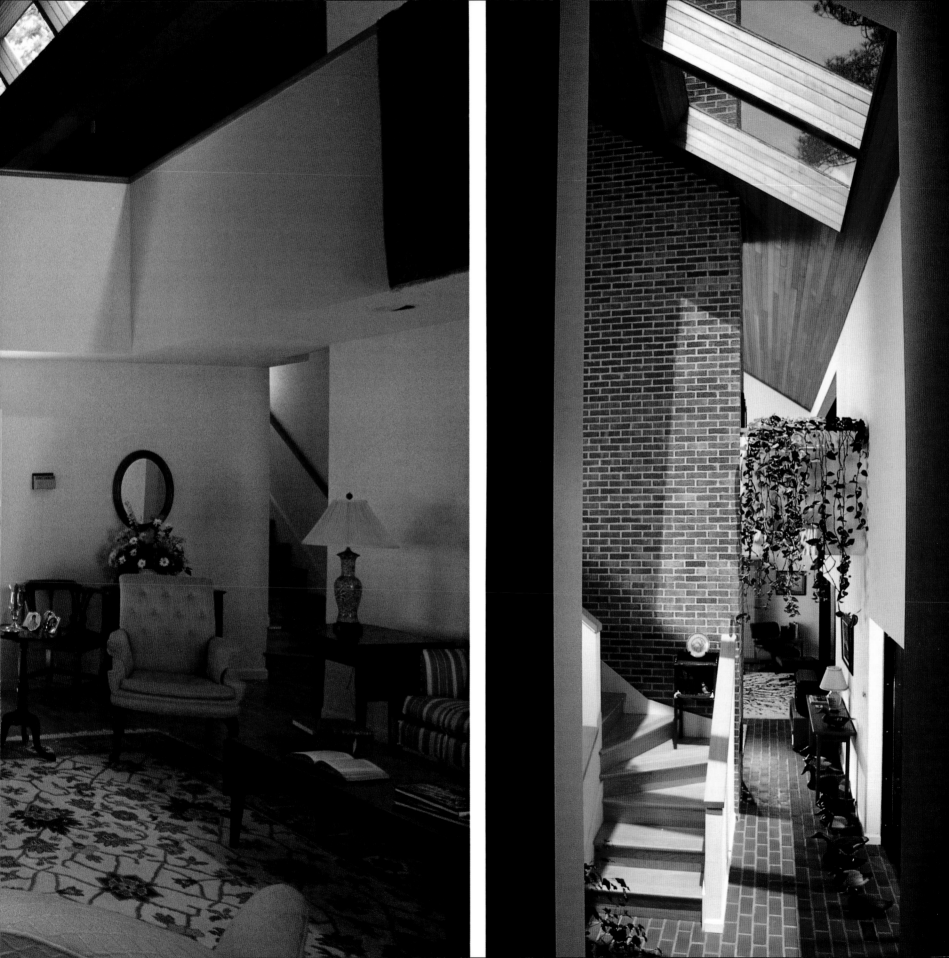

The pool is surrounded by carefully chosen native trees and shrubs. To the left of the walk are dark green inkberry (*Ilex glabra compacta* 'Shamrock') and on either side of the walk bayberry (*Myrica cerifera*). Pachysandra ground cover adds texture beneath azaleas and iris next to a cluster of broad beech ferns (*Thelypteris hexagonoptera*). Two varieties of hostas ('Shade Fanfare' and 'Lancifolia') edge the walk. Next to the house, behind the other plantings, is a cornelian cherry dogwood (*Cornus mas*) that has yellow blossoms in early spring and red fruit in summer.

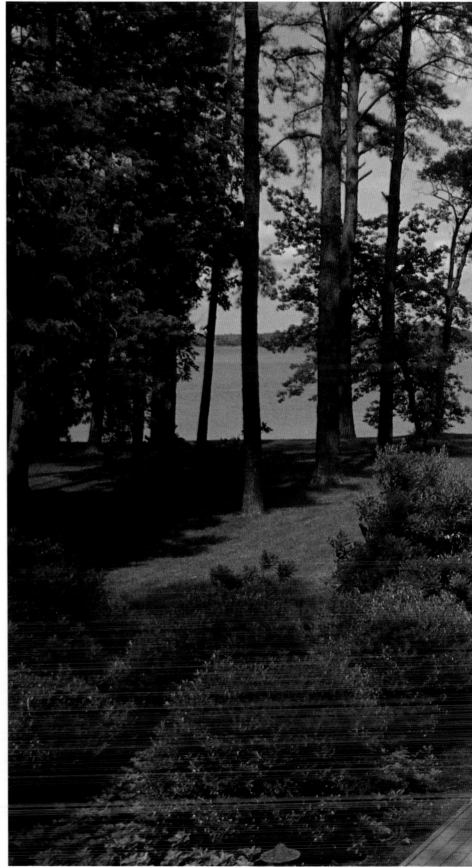

In early June, a grape arbor and fruit trees surround the extensive vegetable garden, filled with many varieties of lettuce. Al has planted the vegetable garden since the late seventies, when he and Margaret used to come down on weekends and holidays, and he has been expanding it ever since.

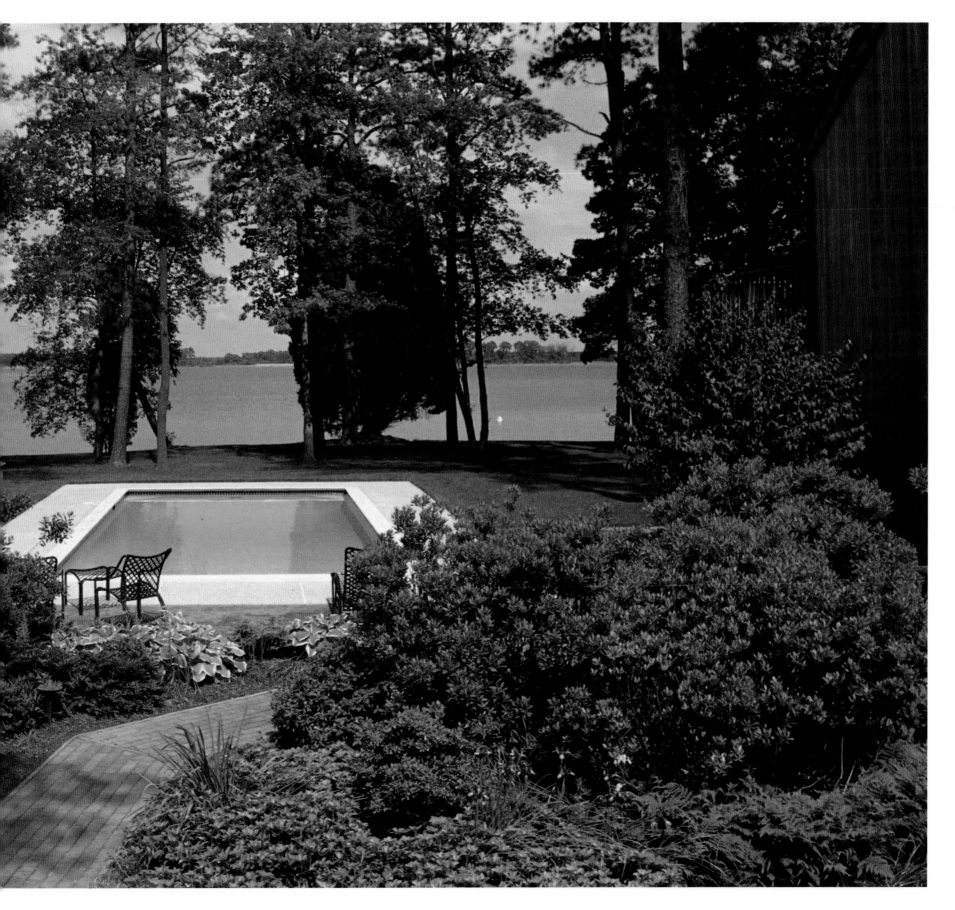

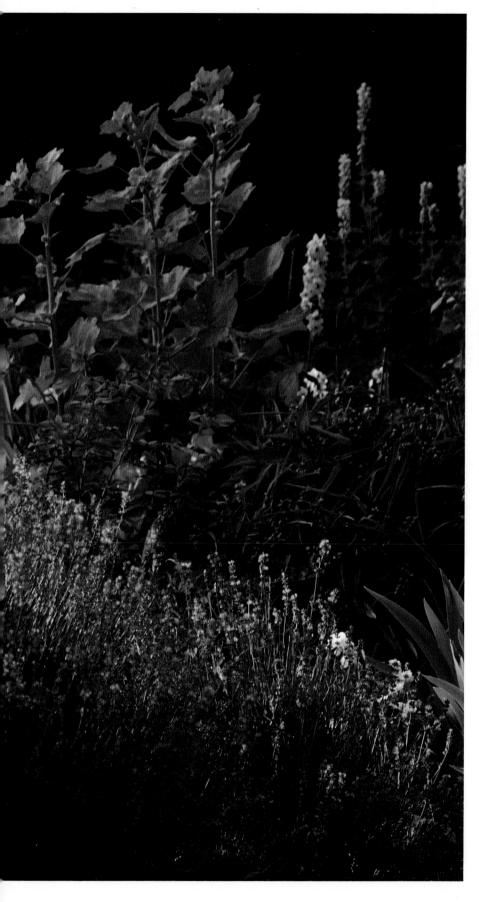

LAND'S END FARM

Bordered by two creeks and the Chester River, Land's End Farm occupies a magnificent site on this point of land. The home of Nancy Jane and Adrian Reed, the house dates back to the late 1700s, but was extensively altered with twentieth-century additions in the 1940s and again in the 1960s when Adrian bought the property to farm it. Nancy Jane breeds and raises Welsh and crossbred horses. The property around the house is carefully landscaped and dotted with colorful gardens all around.

Nancy Jane began the gardens when they cleared an old cattle grazing lot that was filled with poison ivy, honeysuckle, and Virginia creeper. She started with spring bulbs and shade-loving plants around the old gravestones of early settlers which were part of the property. When the pool was put in, she began planting perennial borders around that. Little by little, the borders expanded to include flowering shrubs and trees that add shape and color variation. Now the property has many mature and beautiful deciduous and evergreen trees and several perennial borders; a more formal terrace, surrounded by carefully tended plantings, with a fountain, all backed by a weathered brick wall.

LEFT: Old-fashioned lavender (*Lavandula angustifolia*) edges the rose border. A dark pink hybrid tea adds the perfect backdrop of color and scent. Tall butterfly bush (*Buddleia alternifolia*) next to yellow *Thermopsis caroliniana* and later-blooming asters add complementary colors to the roses. To the right of the roses, hollyhocks are coming, and delphiniums are starting to bloom next to a mass of tradescantia.

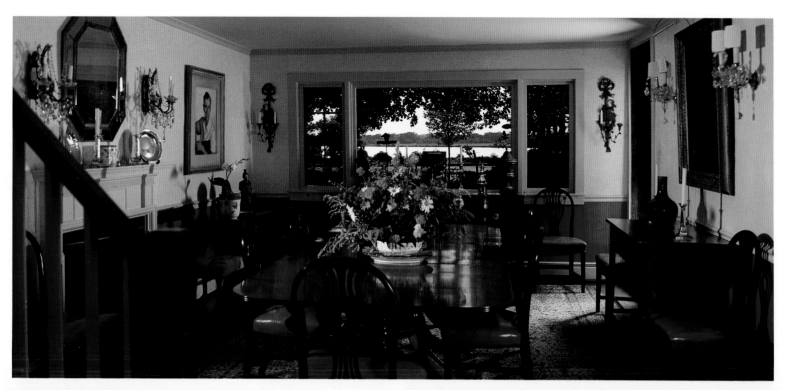

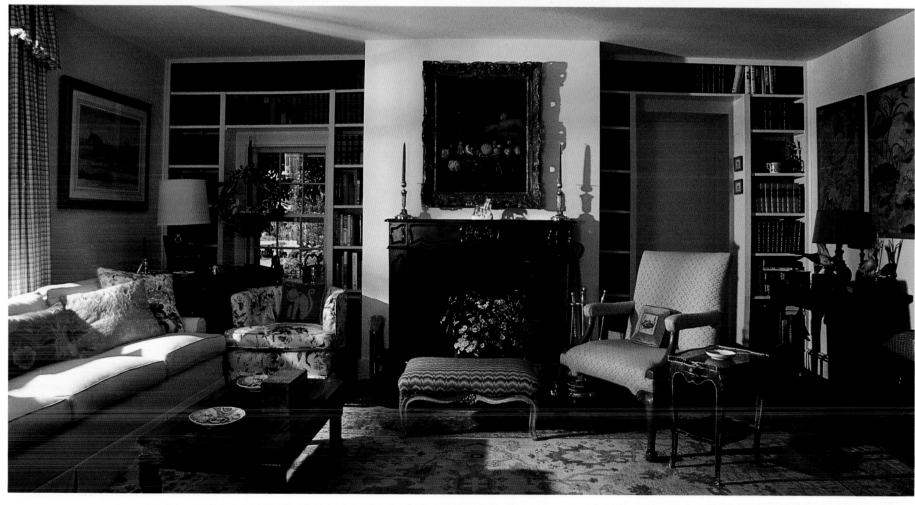

LEFT: Mid-Georgian Hepplewhite chairs surround the English Sheraton table in the dining room. Three pairs of sconces accent the room: a Louis XV crystal pair on the fireplace wall; an English Georgian crystal pair on the opposite wall; and rare Italian gilded carved wood sconces on either side of the window. A portrait of Adrian's father, painted by Boutet de Monvel, hangs to the left.

BELOW LEFT: The library is furnished with a mix of English and French furnishings. The seventeenth-century still life above the fireplace is by Jan Davidsz de Heem. A painted Louis XV footstool is in front of the fireplace, next to a mid-Georgian mahogany open armchair.

RIGHT: The porch across the back of the house has views of the horses, the river, the pool, and the gardens.

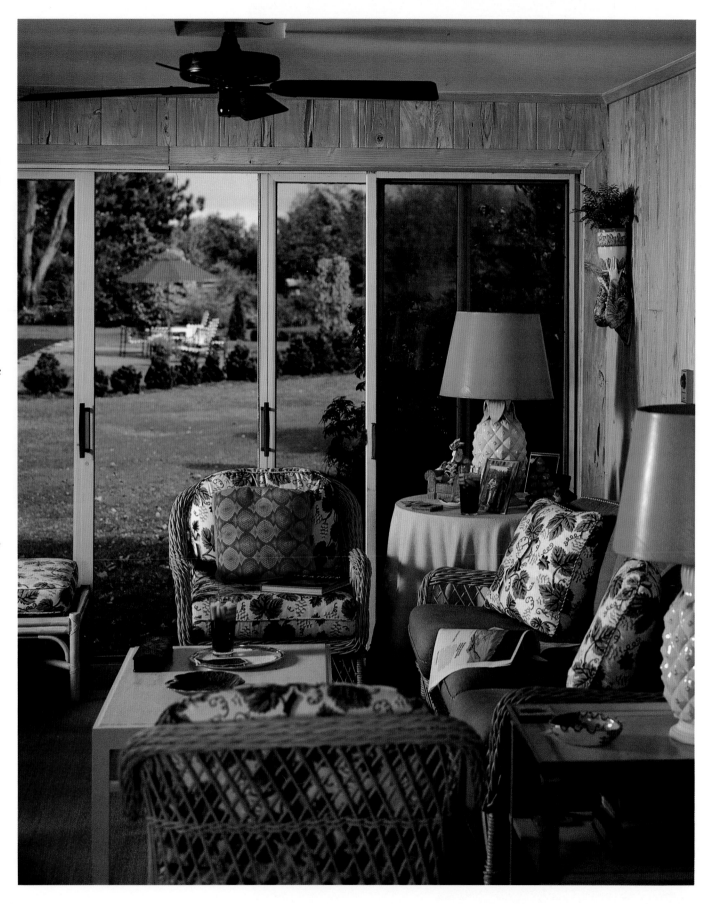

RIGHT: A pair of white wisteria trees underplanted with santolina flank the entrance to the pool. Hinoki cyprus (*Chamaecyparis obtusa* 'Nana') have been planted on either side of the wisteria and will form a solid hedge in a few years. On the far side of the pool a red-leaved tricolor beech (*Fagus sylvatica* 'Purpurea Tricolor' and the yellow-green of the evergreen *Camaecyparis pisifera* 'Filifera Aurea' add colorful variations of foliage against the woods behind.

ABOVE: The low brick wall contains terrace plantings of liriope, spring bulbs, and azaleas.

———————

LEFT: The Reeds' Chesapeake Bay retriever, Fudgsicle, lies outside the porch room. The border along the porch is edged with *Anemone blanda* 'White Splendor'. Climbing hydrangea (*Hydrangea anomala* subsp. *petiolaris*) partially covers the low brick wall that frames the brick-paved terrace on two sides.

———————

RIGHT: Weeping hemlock (*Tsuga candensis pendula*) on the left and blooming privet (*Ligustrum japonicum*) behind outlines the corner of the terrace. In the background the pool is surrounded by perennial borders and all kinds of colorful trees and shrubs.

———————

OVERLEAF: The perennial border adds a soft color break between the pool and the pasture, with the Chester River in the distance.

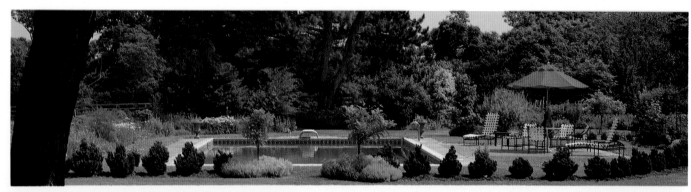

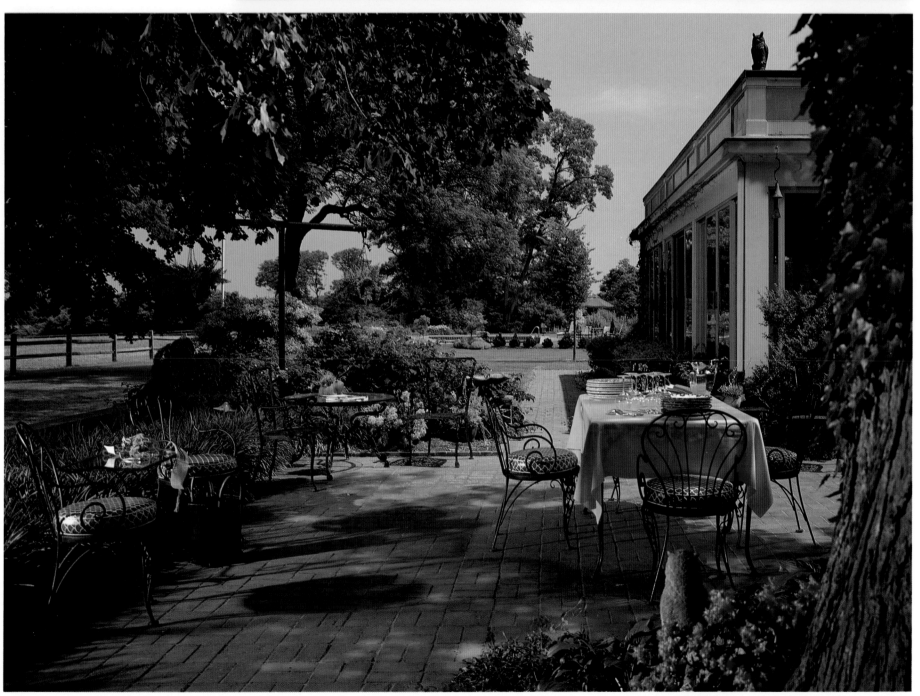

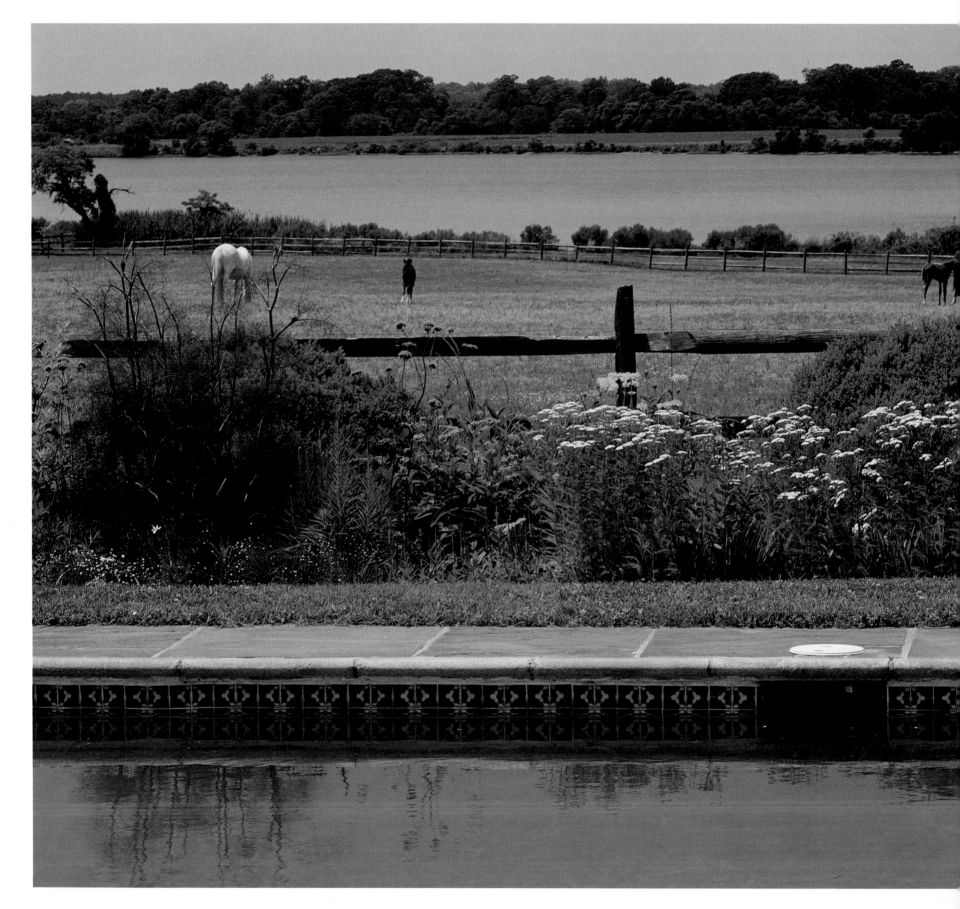

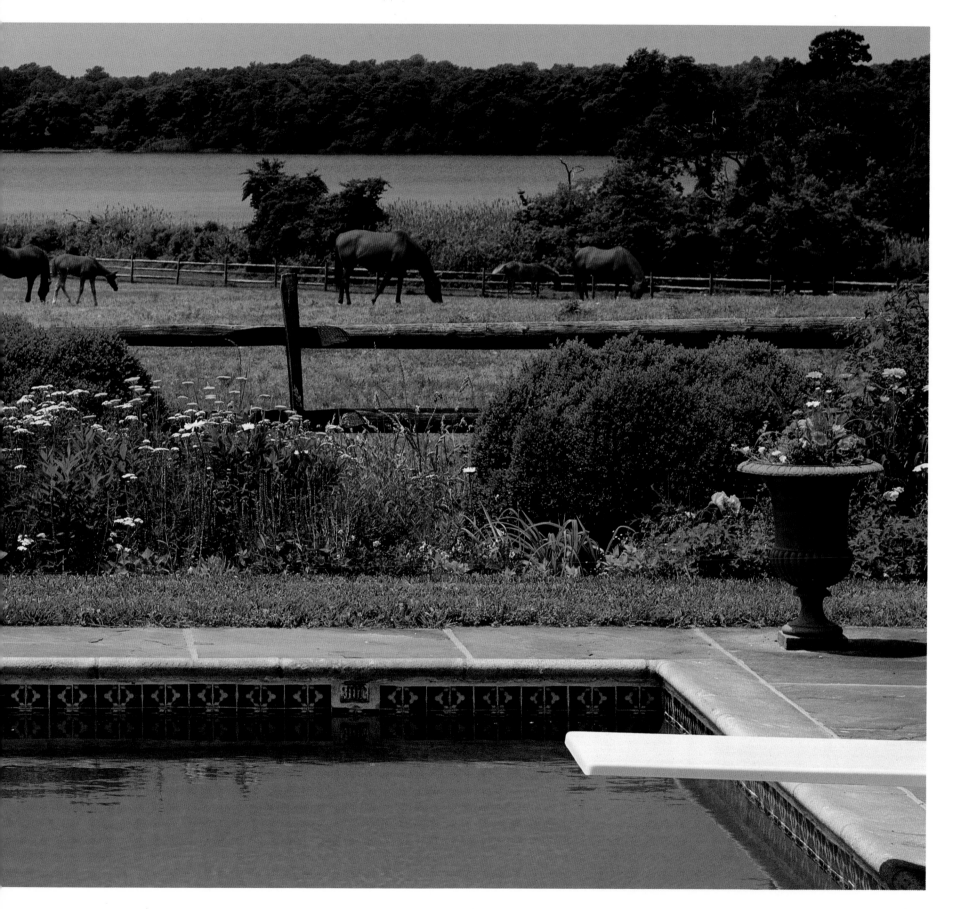

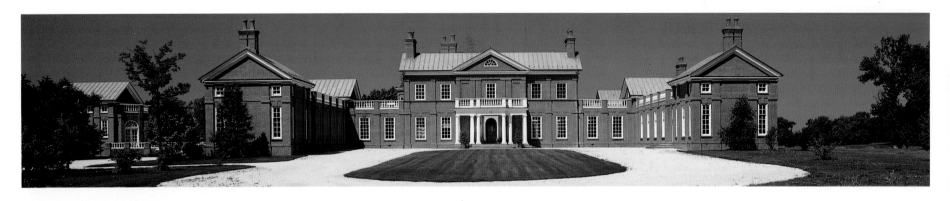

PENDERYN

Built in Regency style, this twentieth-century manor house is the home of Mario and Maureen Boiardi. The plans were drawn up in 1984, the foundation laid in 1985, and the house completed in 1989. The design is a basic H with symmetrical wings. The house was designed to take advantage of water views on three sides. Every detail was carefully researched for accuracy for the period. The Boiardis spent two years looking for the right furnishings for the house. Most of the furnishings except for the upholstered pieces are of the period and primarily English, though a few are French in origin.

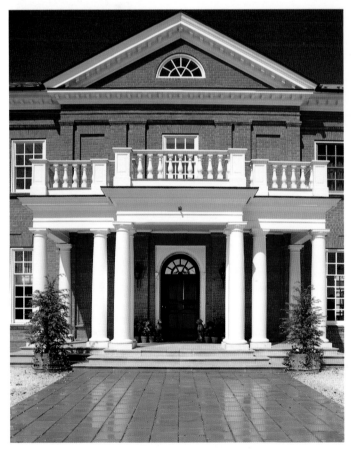

LEFT: The front entrance to Penderyn.

RIGHT: In the front hall, the Italian marble floor is made up of large white squares inset with dark green squares. The overdoor in a broken pediment design holds a fine oriental porcelain vase. The columns on either side of the door have gold leaf Corinthian capitals. Two English mezzotints engraved by James Whessel, c. 1800, hang beside the door.

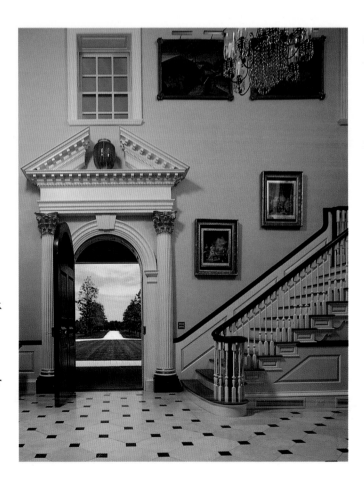

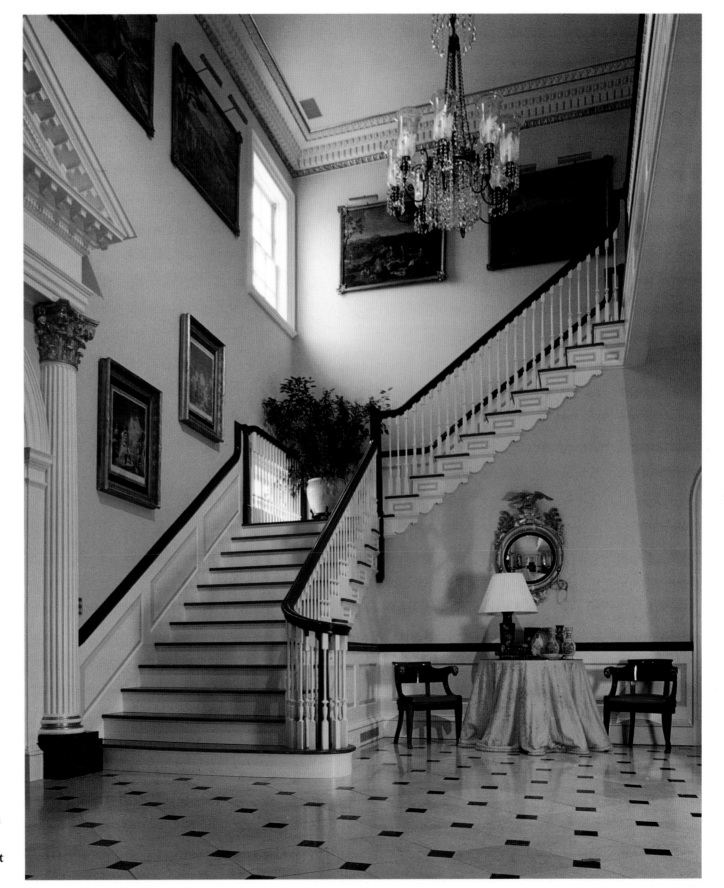

Four French oil paintings, c. 1840, depicting the four seasons hang on the two stair walls beneath the edge of the ceiling cornice. The crystal chandelier with shaped hurricane shades of Anglo-Irish glass is nineteenth century. Above the table is an English round convex mirror with candle holders, c. 1810. The cornice moldings are egg and dart design.

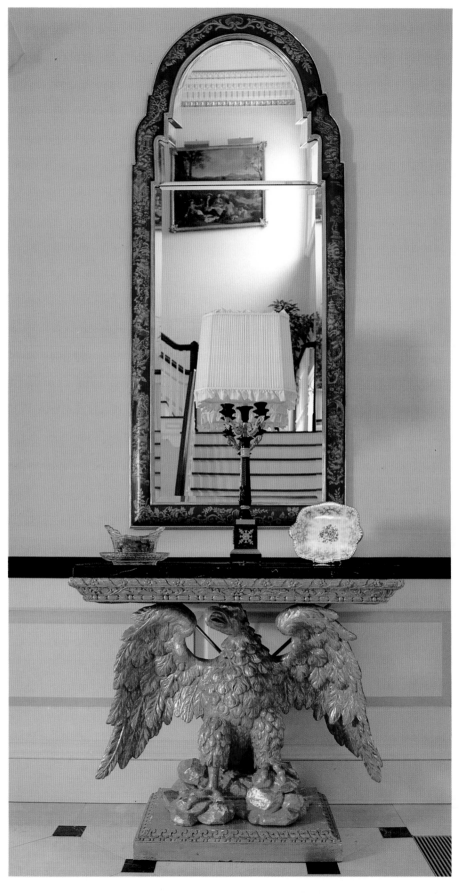

LEFT: The English console table, with a spread-wing eagle base of gesso and gilt carved wood, is one of a pair in the hall made by William Kent, c. 1745. On the table is a French bronze *doré* candelabrum with ormolu mounts, c. 1810, that has been made into a lamp. Behind it hangs an English japanned Queen Anne mirror, also one of a pair; they are copies of mirrors made for Napoleon's nephew, who was to become King of Spain.

RIGHT: A Venetian glass mirror hangs over the fireplace in the library. On the mantel are a pair of Anglo-Irish candelabra, c. 1810. The silk wall coverings were painted in China. The painting on the easel to the right of the fireplace is by Fantin Latour, c. 1860. On the bookcases on either side of the fireplace are a pair of cloisonné enamel on glass Pilgrim vases from the Ch'ien Lung dynasty, c. 1790.

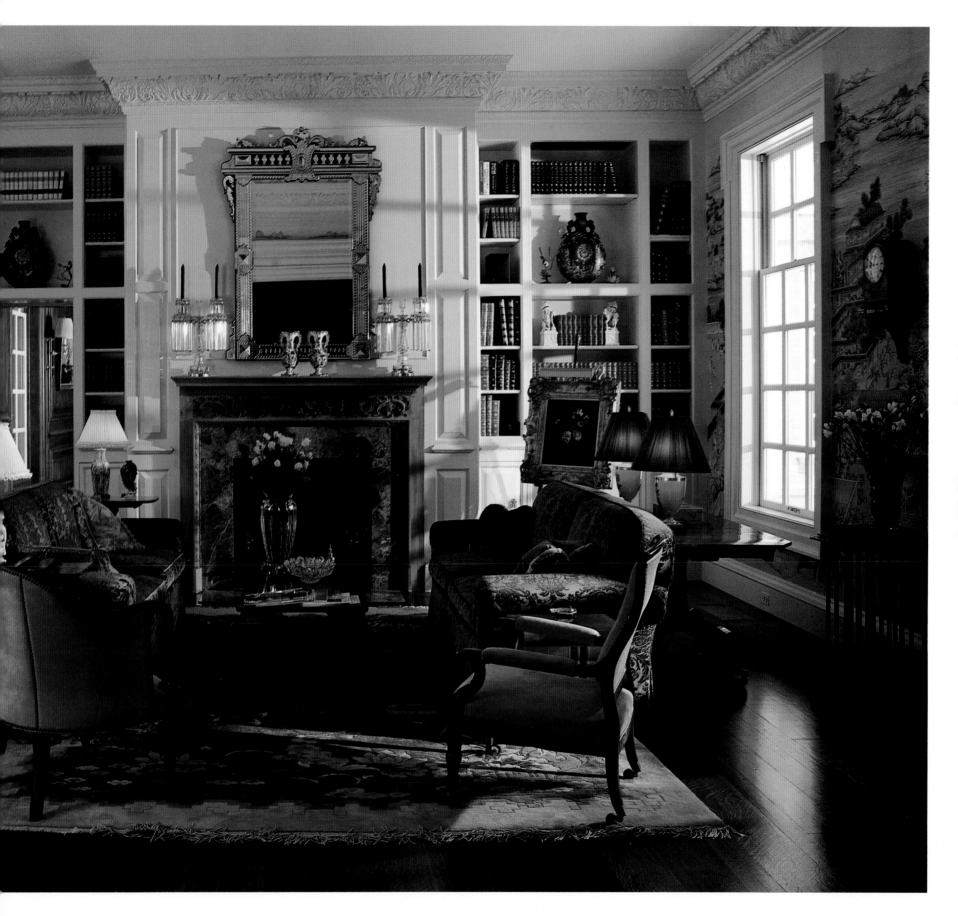

The formal drawing room; on the
right the gallery hall that leads to
the front hall. On the round table
in the center of the room is a
Mandarin punch bowl from the
Ch'ien Lung dynasty, c. 1800.
The rugs are Turkish Oushak, c.
1890. The paintings on the far
wall are from left: *Flowers* by
Bernard Toussaint; to the right is
The Rose by F. C. Frieseke; to its
right is *Girl Reading* by Joseph
Marivsauy. The long gallery that
forms part of the crossbar or the
H of the house is lined with
arched windows that repeat the
arches in the ceiling. Between the
windows are carved pine seated
Imperial warriors, c. 1550. The
large vases at the ends of the
gallery are Imperial Satsuma
tribute urns, c. 1850. Three
eighteenth-century English
chandeliers light the gallery.

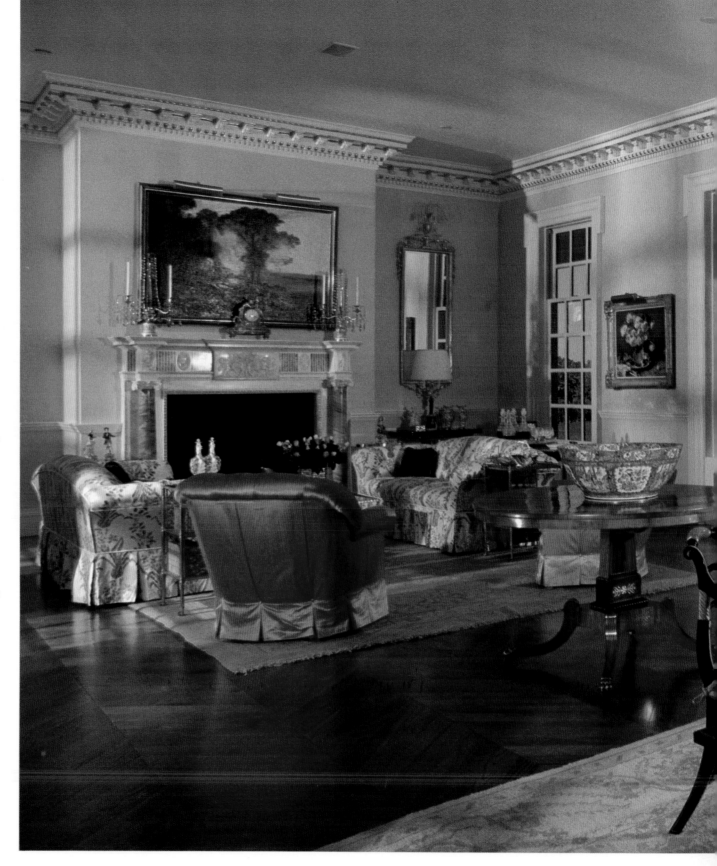

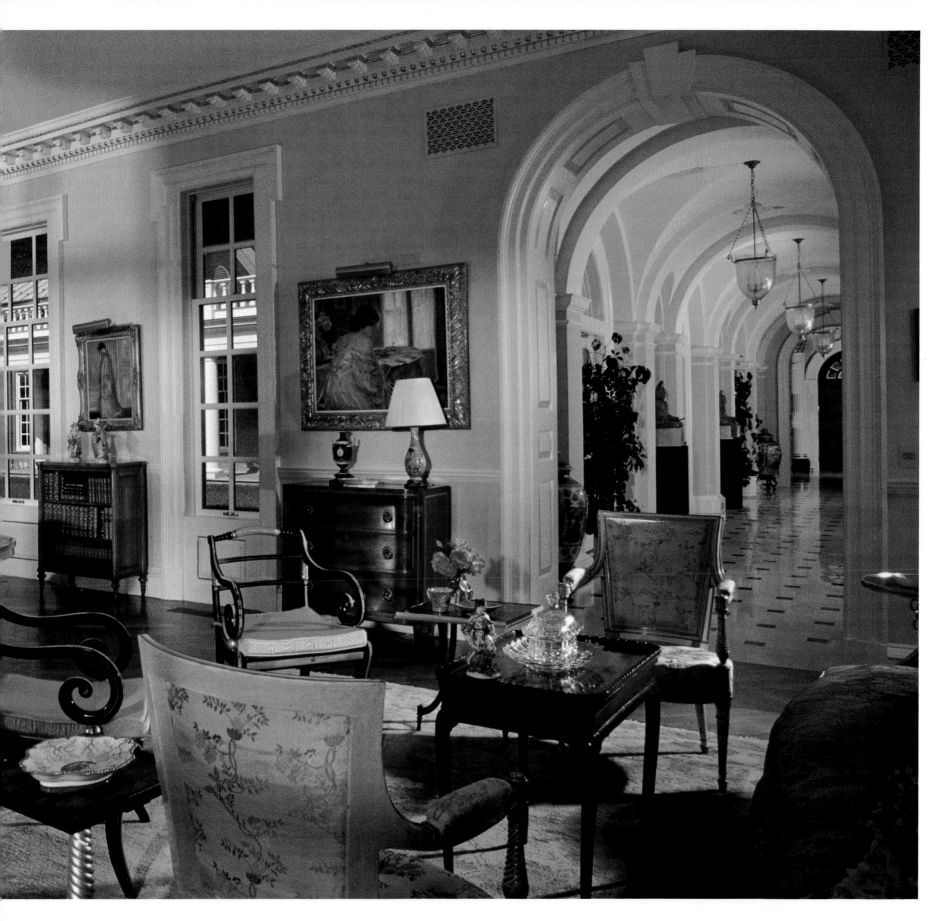

BELOW: Between the doors to the dining room is an Adams mirror,
c. 1790. Flanking it are a pair of reverse paintings on glass that are
Chinese export from the same period. Below the mirror is a Sheraton
sofa with Aubusson pillows. In front are a pair of sabre-leg painted
Empire armchairs, c. 1800.

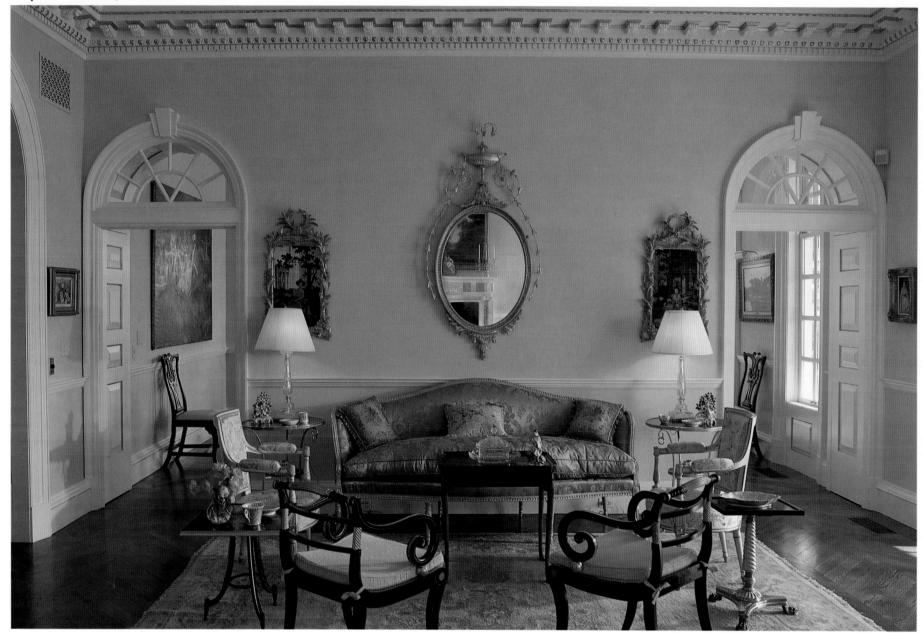

RIGHT: The fireplace is English Sienna marble and white marble,
c. 1770. On the mantel is a French gilt bronze *doré* and gray marble
clock made by Rogue Paris in 1780. The painting is an English
landscape by Alfred East. To the left of the fireplace is a reproduction
eighteenth-century Adams mirror, one of a pair in the room made by
Stephen Cavallo.

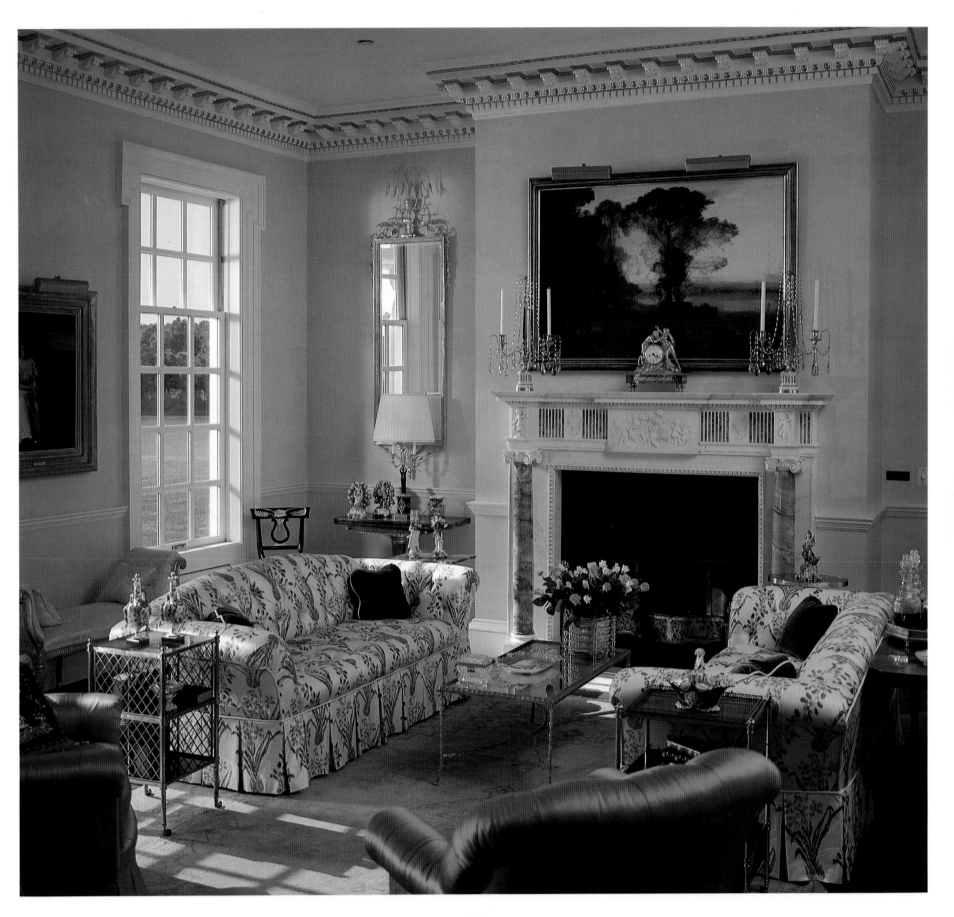

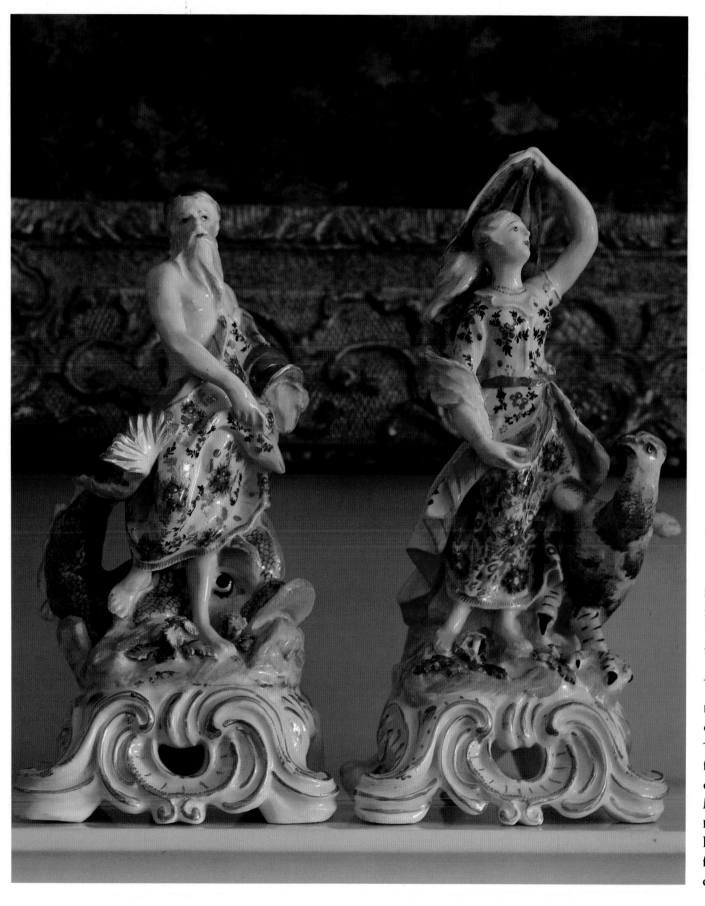

LEFT: Two pieces of a set of four Bow porcelain figurines, c. 1740, representing four elements; these two are air and water.

RIGHT TOP: A pair of English china figures, c. 1790. FAR RIGHT, TOP: English Chelsea porcelain figurine of village parson and couple, c. 1800. RIGHT BOTTOM: Meissen porcelain vases, c. 1820. FAR RIGHT, BOTTOM: German Furstenburg porcelain male and female musicians in chinoiserie dress, c. 1770.

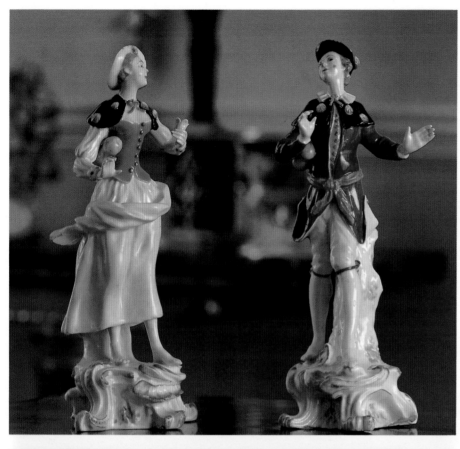

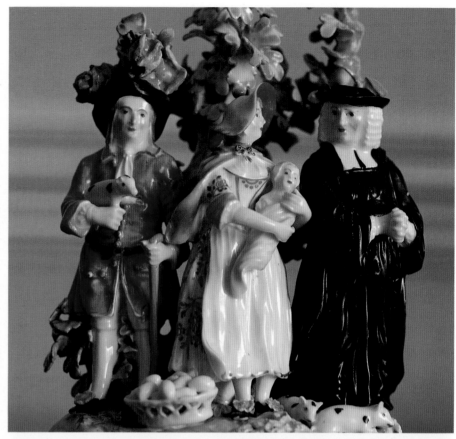

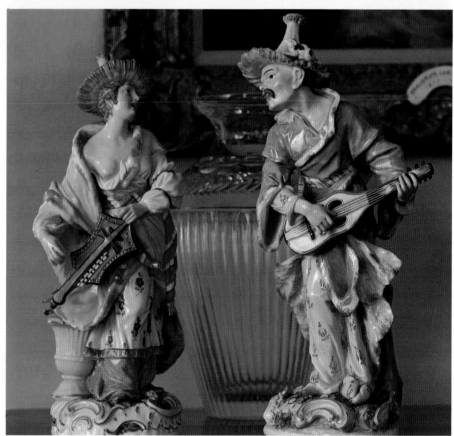

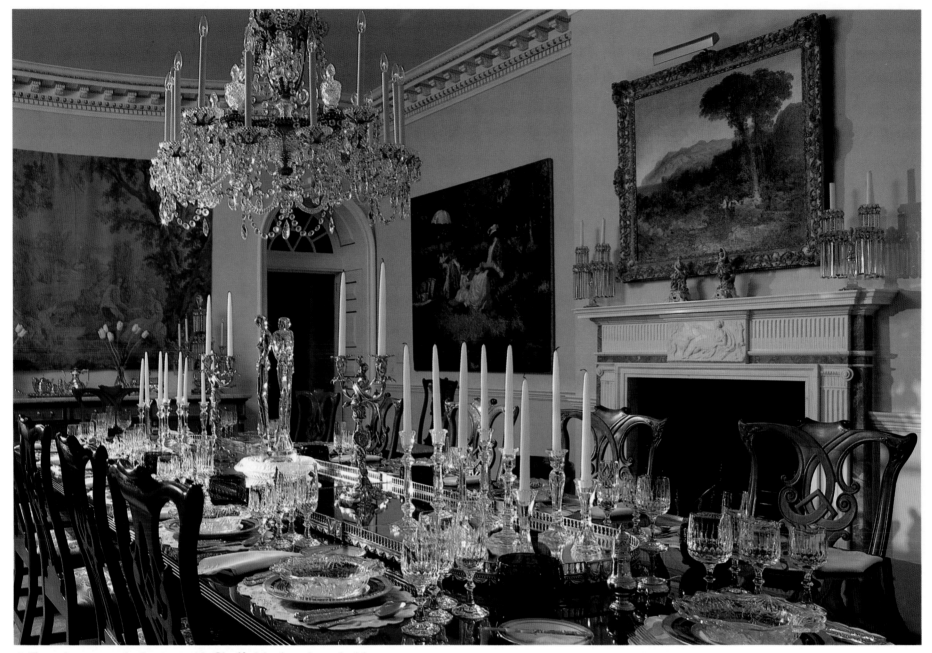

A French mirrored plateau with Sheffield silver base holds a
contemporary Italian Murano figure of the three graces surrounded by
English cast sterling silver candelabra, c. 1764, and antique crystal
candlesticks. American antique crystal soup plates and blue Bristol wine
rinsers, c. 1800, are part of the elegant setting. The dining room table
and chairs in Portuguese Queen Anne style were handmade by Stephen
Cavallo for the room. The English ormolu and crystal chandelier is by
Perry of London, c. 1830. The tapestry at the end of the room is
Aubusson, c. 1870. The painting of the ladies in the garden, to the left
of the fireplace, is an untitled English oil by A. Baslien, c. 1920. The
mantel is English white marble and jasper, c. 1770. The painting above
it is by Thomas Moran.

Looking from the hall through the family living room and dining room to the kitchen. An eighteenth-century iron and brass chandelier hangs over the table.

The fireplace in the family living room is from a sixteenth-century monastery. The height and depth was not quite right for the room and the missing space has been filled in and marbleized by Helen Hobbs. In the foreground is a Sheffield Georgian gallery tray with rare Egyptian feet, c. 1810.

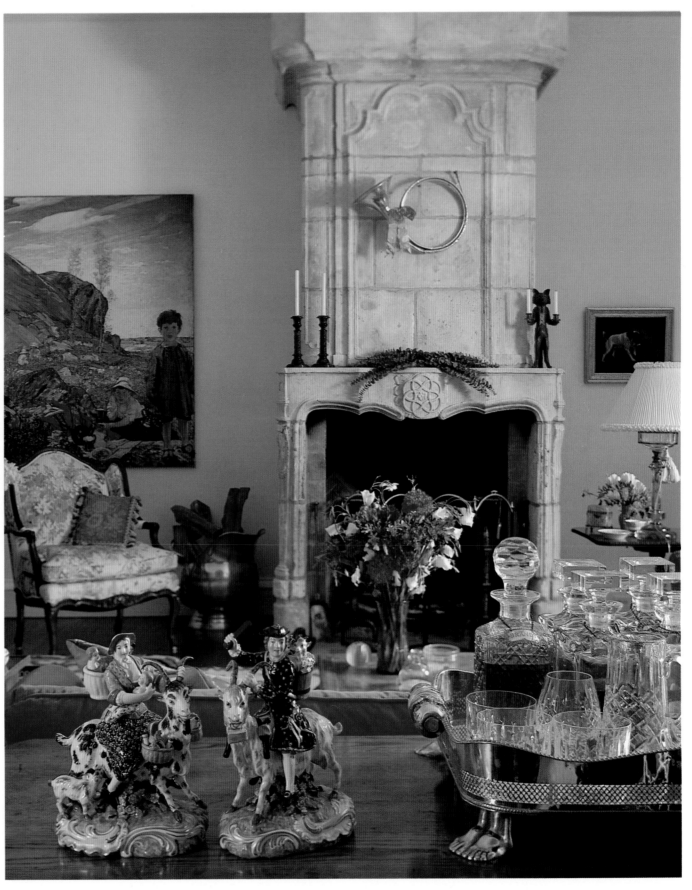

DEERBOURNE

The house and gardens called Deerbourne occupy a point of land on Ship's Head Creek. The terrain is gently rolling and the land undulates along the creek, part wooded and part open. All is surrounded by farmland. Virginia and Kenneth Sappington built the house in 1968 of old brick taken from the foundation of a very old house in Pocomoke City. Much of the interior paneling, floors, and woodwork comes from that same house.

The gardens have evolved through the years. The original plan included the pond, which was enlarged and planted at the time the house was built. More recently it was enlarged again, the slope of its banks made gentler and new plantings added. The formal garden was the first to be laid out with flowering fruit trees, perennial borders, and a green garden of hostas and other shade-loving plants and shrubs. A woodland garden behind the house and along the creek has paths winding through it. In spring it is filled with columbine and honesty, followed by foxglove and azaleas. Then come the irises that bloom in the formal garden, around the pond, and in the borders. Along the sunny banks are daylilies and other flowering plants. This is obviously a garden that has been lovingly planned and carefully thought about year after year.

Tranquility and softness are provided by the shapes and colors of the continually changing seasonal blooms from the very early spring bulbs and flowers into the season of the fruit trees in all manner of pinks and white, along with the delicate plants in the woodland walk. Stronger colors come into play in midsummer with the rudbeckia and lythrum, daylilies, and hibiscus around the pond. Softening everything are ornamental grasses that add texture and gray greens and variegated foliage that act as foils to the strong colors of midsummer. In fall, the look changes again.

ABOVE: In late April a 'Kwanzan' cherry (*Prunus serrulata*) is in full bloom at the edge of the formal border, with white blossoms of peach trees and a red-leafed plum tree behind. Blooming in the border are red tulips and bright yellow 'Basket of Gold' alyssum.

LEFT: In August the pond reflects the grasses (*Pennisetum alopecuroides* and *Miscanthus sinensis*) with their seed heads just starting to show next to rudbeckia and lythrum in its second bloom.

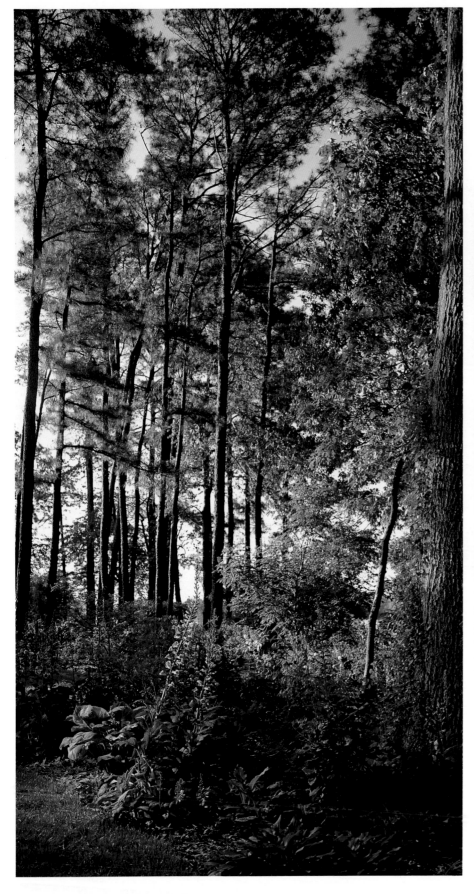

LEFT: In the woodland garden, pink foxglove are blooming in late May. A blossoming horse chestnut (*Aesculus pavia*) is behind them and to the right. White honesty and several varieties of hostas and ferns are planted throughout the garden. Earlier in the spring several colors of columbine (*Aquilegia* hybrids) and sweet rocket have already bloomed.

BELOW: The pool is surrounded by wild cherry trees.

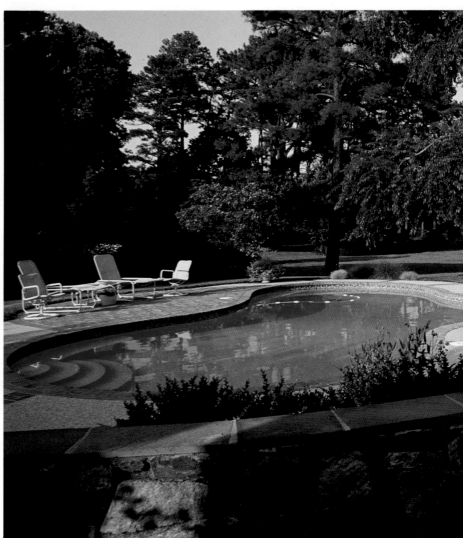

TOP RIGHT: The pond is in its early August vibrant bloom with a cool green backdrop of the woodland garden beyond. Ringing the pond from left is a juniper (*Juniperus horizontalis* 'Andorra'), several varieties of hibiscus (*Hibiscus moscheutos*), lythrum (*Lythrum virgatum* 'Morden's pink'), *Miscanthus sinensis* with late-blooming daylilies (*Hemerocallis* hybrids) in front, and rudbeckia.

RIGHT CENTER: Looking from the pool toward the house in August. The pennisetum is in the foreground with *Rudbeckia nitida* 'Herbstonne.' Pots hold ornamental grass (*Calamagrostis acutiflora* 'Karl Foerster') and gray-leafed *Helichrysum petiolare*. In the background on the left is profusely blooming crape myrtle (*Lagerstroemia indica*).

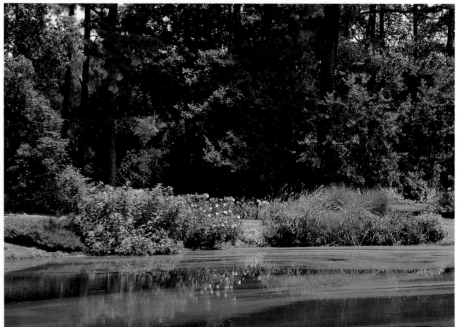

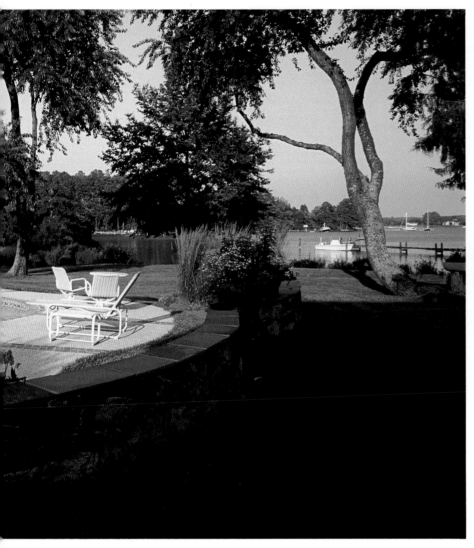

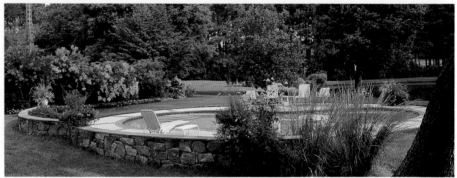

RIGHT: Sedum (*Sedum spectabile* 'Autumn Joy') and Russian sage (*Perovskia atriplicifolia*) are planted at the edge of the pond. A groundcover called *Houttuynia cordata* 'Variegata' is on the left. Beneath the crabapple tree a few daylilies are still blooming on this early August morning. The tall spikes of green are the flags of the yellow irises that bloomed earlier in the summer.

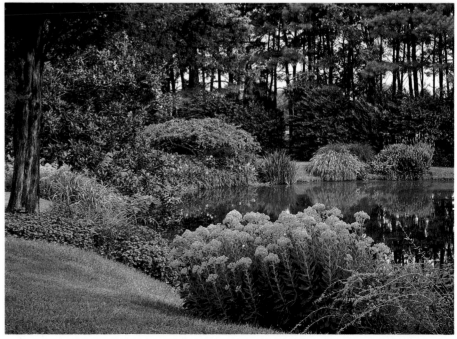

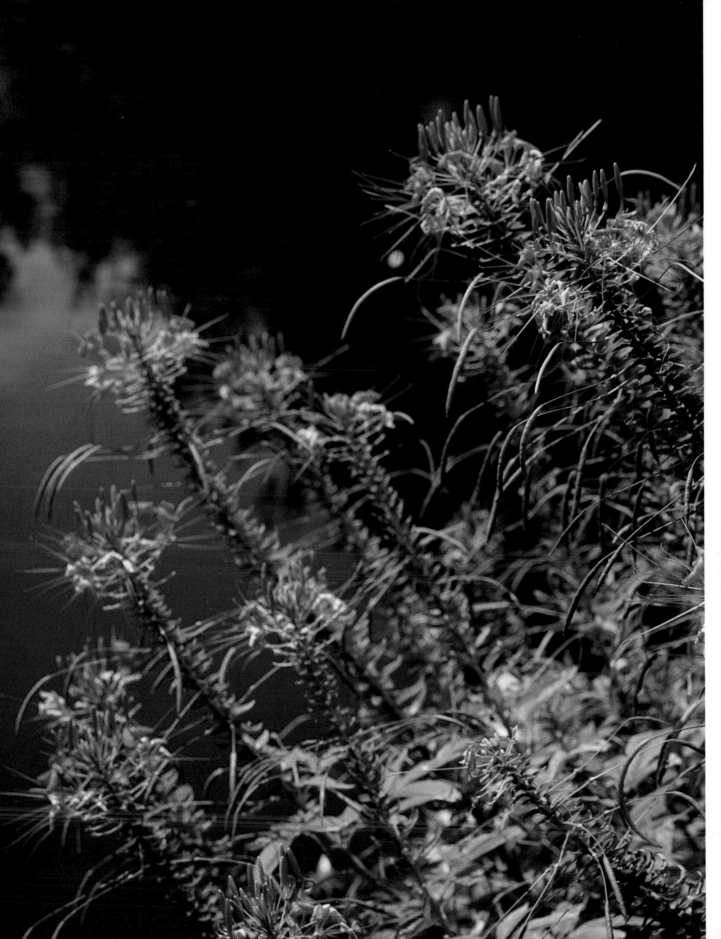

LEFT: Cleome in full bloom in August.

RIGHT: Honey locust blooms in early spring next to Ship's Head Creek.

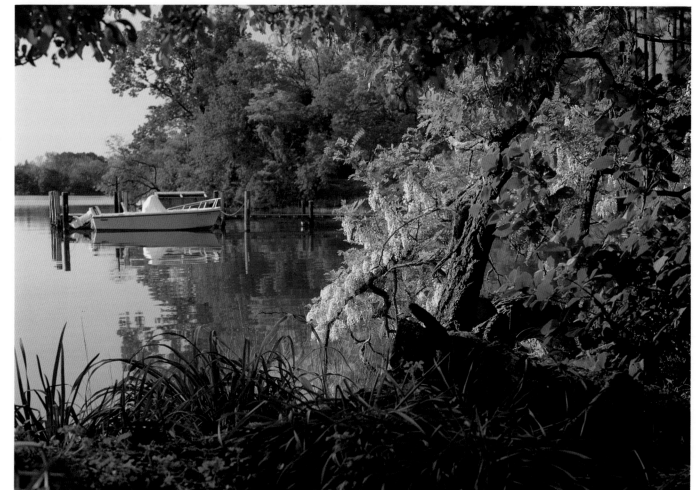

BELOW: Hundreds of daylilies of many colors have been naturalized along the bank, planted to bloom from the end of June through July. A full sweep of the landscape can be seen from the northwest corner of the grounds. The woodland garden is intermingled with the trees on the right, and the pool is tucked behind a protective low stone wall and tall ornamental grasses on the left.

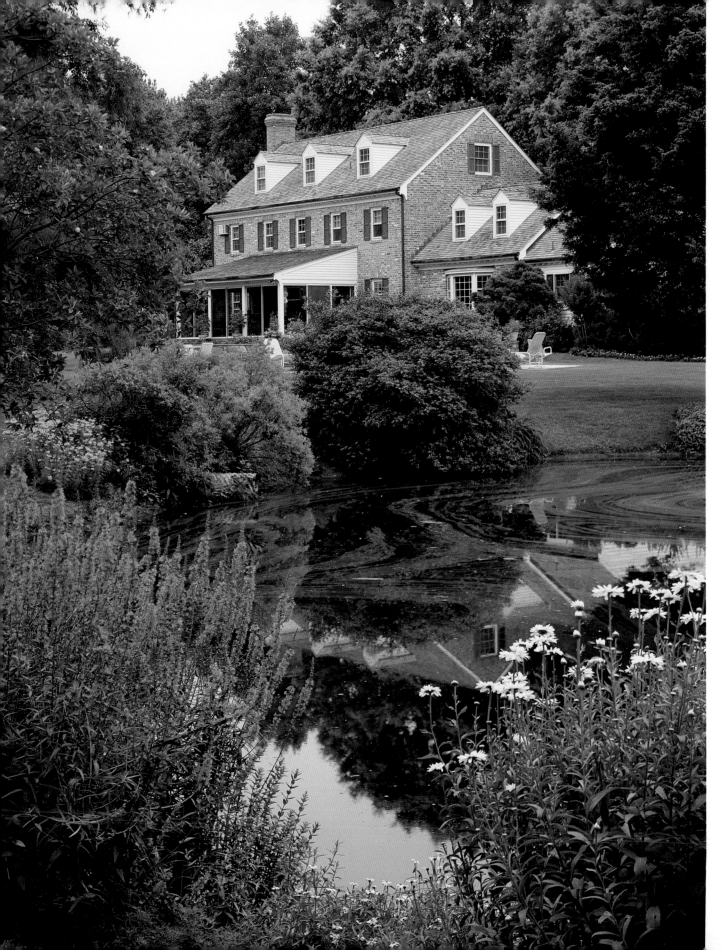

LEFT: Lythrum, little white zinnias, and tall Shasta daisies (*Chrysanthemum* x *superbum*) frame the pond in the foreground. On the far side of the pond under the sweet bay magnolia is bright yellow coreopsis (*Coreopsis verticillata* 'Zagreb'), next to *Clethra alnifolia* and *Osmanthus heterophyllus* 'Rotundifolius.'

BELOW: Daylilies (*Hemerocallis* hybrids) are just beginning to bloom under the large oak trees.

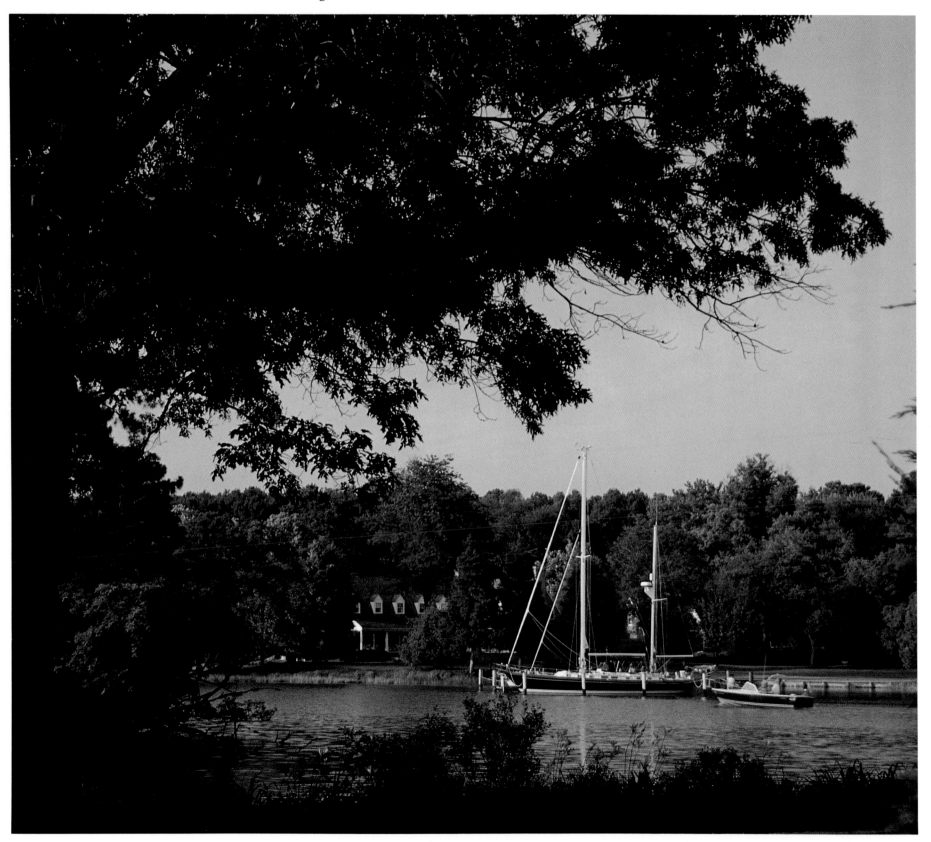

HOUSE ON SHIP'S POINT

Light and shadow are the keynotes of Muriel G. Blumenthal's home on the shores of Trippe Creek. Dramatic in its simplicity, the house has high cathedral ceilings with tall and, at times, pencil-thin windows. Built in the early 1970s, it is furnished with colorful fabrics, tapestries, and interesting sculptures, paintings, and ceramics. It is a most comfortable and livable house, with both expansive views and tantalizing glimpses of the water, depending on the shape and location of the windows.

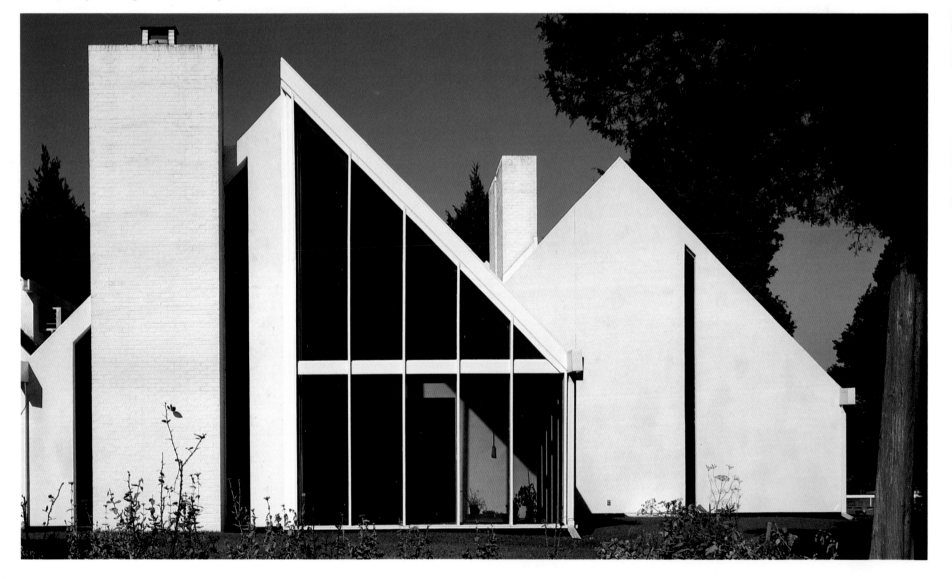

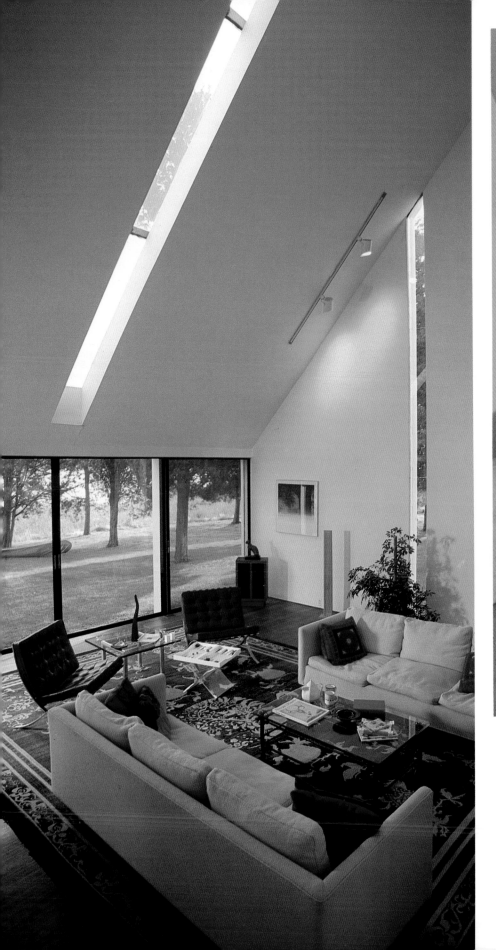
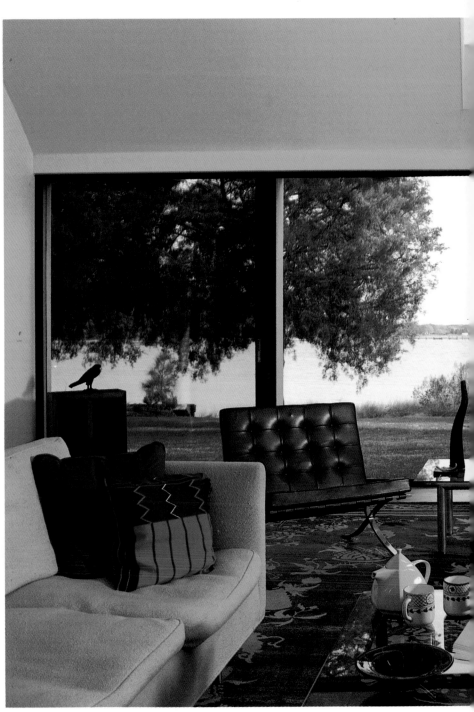

The living room has sliding glass doors that open on the garden with Trippe Creek in the distance. Elongated windows and skylights accent the high ceilings and add brightness even on an overcast day. At the same time, the limited amount of exposed glass aids in keeping the house cool in the hot summers of the Eastern Shore. The large tapestry on the wall is by Rufino Tamayo.

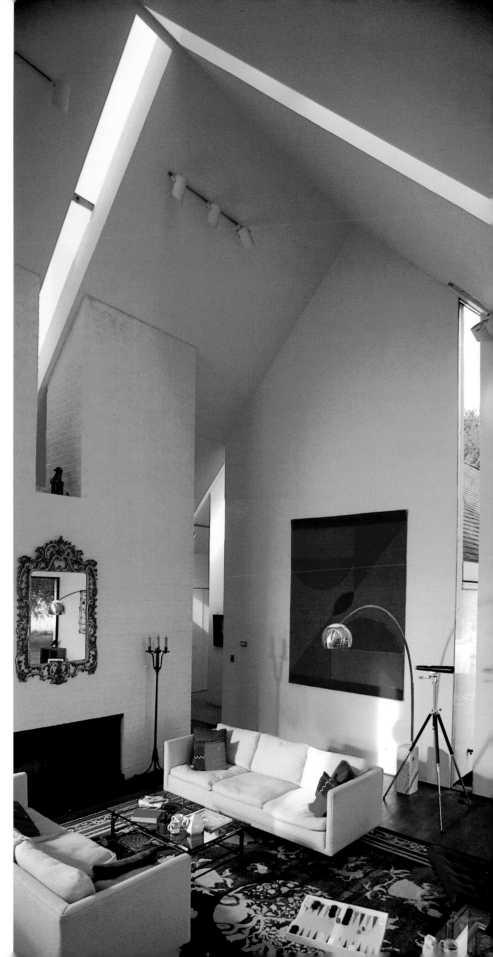

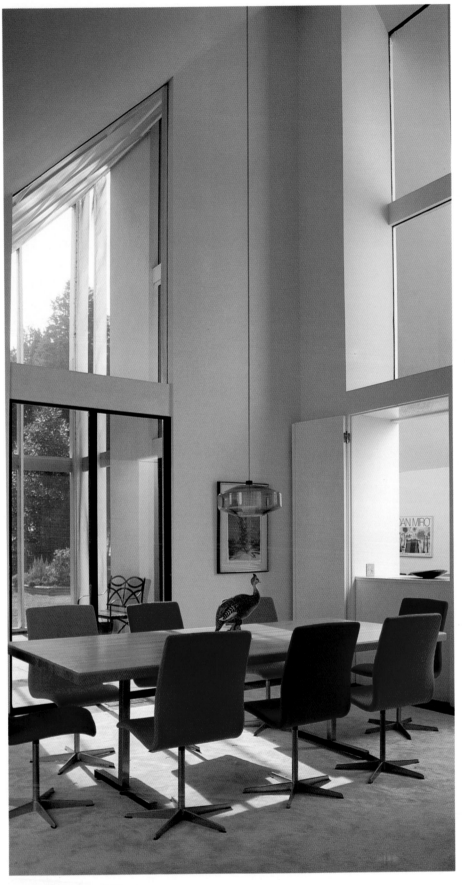

BELOW AND RIGHT: The commodious kitchen has not only generous work space but a cozy breakfast area with a fireplace. *Delphinium*, painted by Jane Eakin, perfectly accents the tall chimney. The kitchen opens onto the screened porch on the left.

LEFT: The dining room opens onto a screened porch for delightful spring and fall breezes. On the right is a large pass-through to the kitchen.

FAR RIGHT: An oil painting of the Dordogne by Julian Taylor that Muriel bought in Paris tops the architectural detail at the end of a long hallway.

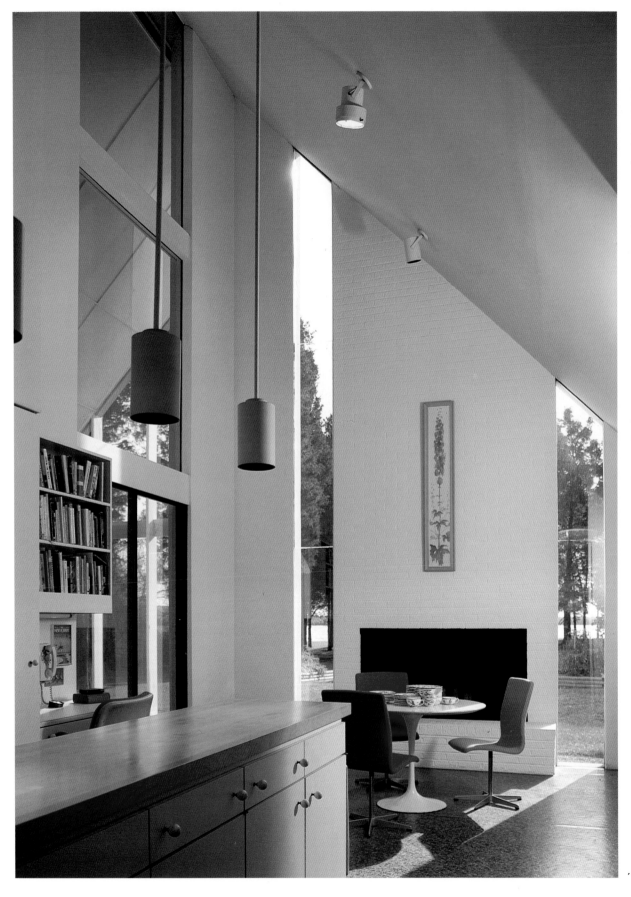

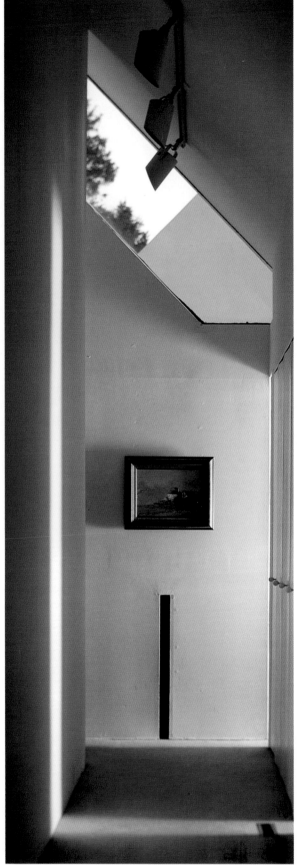

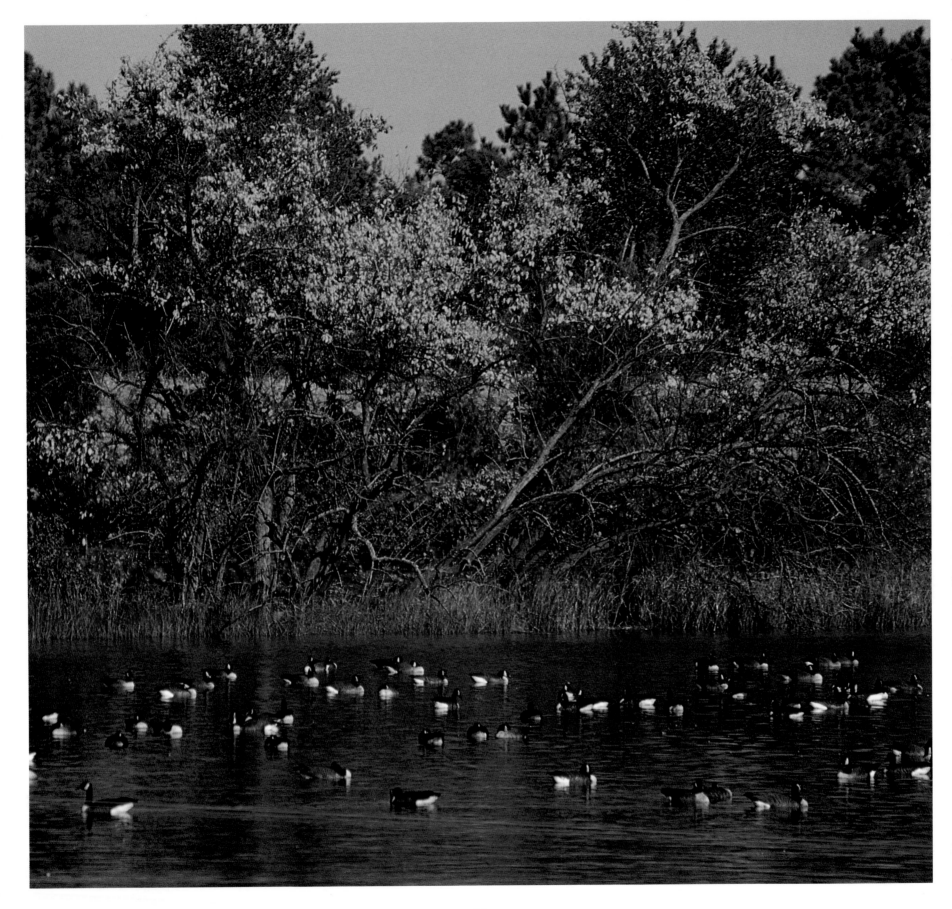

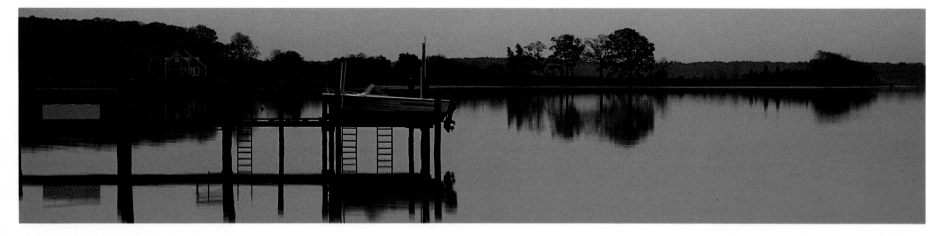

BEVERLY

Built in 1853–1857 by a family named Harper, and reportedly named after a family farm in England, Beverly was a plantation of some 1500 acres and at one time had a small boatyard. Today on San Domingo Creek the white frame farmhouse still has a typical ell-shaped floor plan with a large parlor opening to the left off the front hall and a library and dining room to the right. The configuration of those three rooms has remained unchanged throughout the life of the house. A previous owner streamlined the original lacy Victorian porch that ran the full width of the living room and filled in the ell on the front. A widow's walk was removed when the house was expanded.

Peggy and Jim Calvert bought Beverly and moved to the Eastern Shore from Connecticut in 1986. They refurbished the old house, replastered the walls, added flues and insulation to the chimneys, and shored up the kitchen wing. They also added a garage, workshop, and upstairs studio to the kitchen wing, and repaired the twin pink marble fireplaces in the dining room and library.

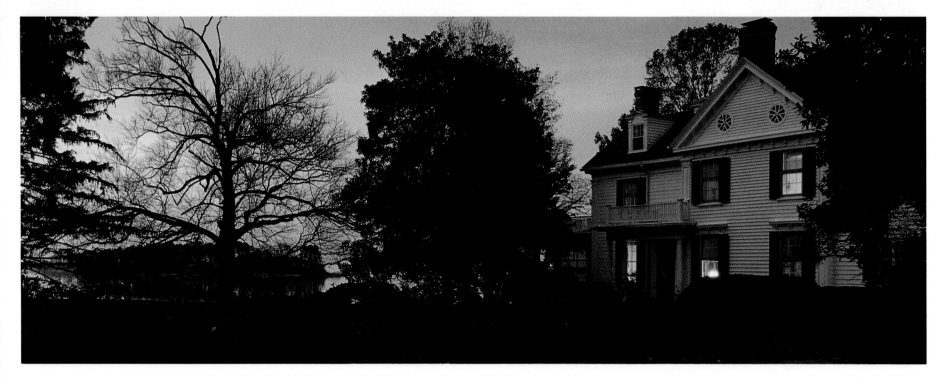

BELOW: The front hall has the same high ceilings that are found throughout the house. It opens onto the covered front porch, through the grand double door with sidelights and a wide fanlight. Beyond the drive is a boxwood-enclosed formal rose garden.

RIGHT: The living room has elaborate moldings and an overmantel with a painting inset in it that was in the house when the Calverts bought it. The living room is painted a gray beige to set off the elaborately carved chimney breast detailing and the handsome carved ceiling moldings, which were probably added after the house was built. On the left of the fireplace is a painting by Charles Reid; on the right, one by S. Caison. The French doors that flank the fireplace open onto a porch that runs around this side and the entire back of the house and overlooks San Domingo Creek.

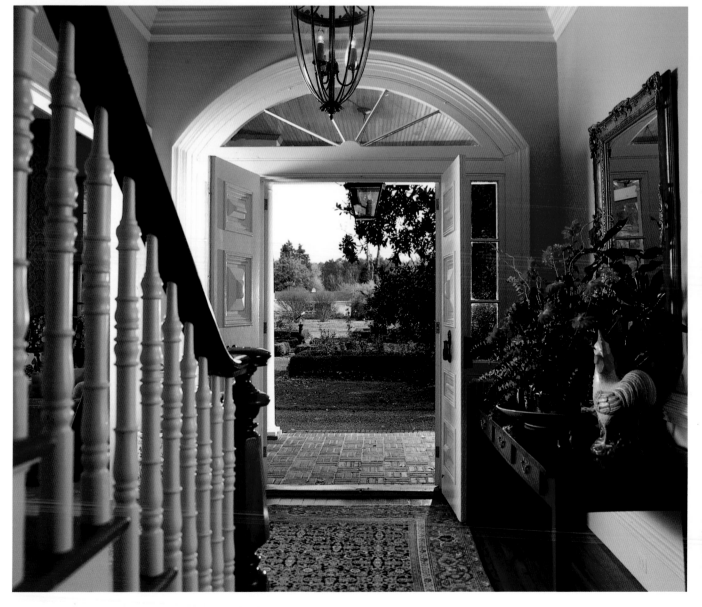

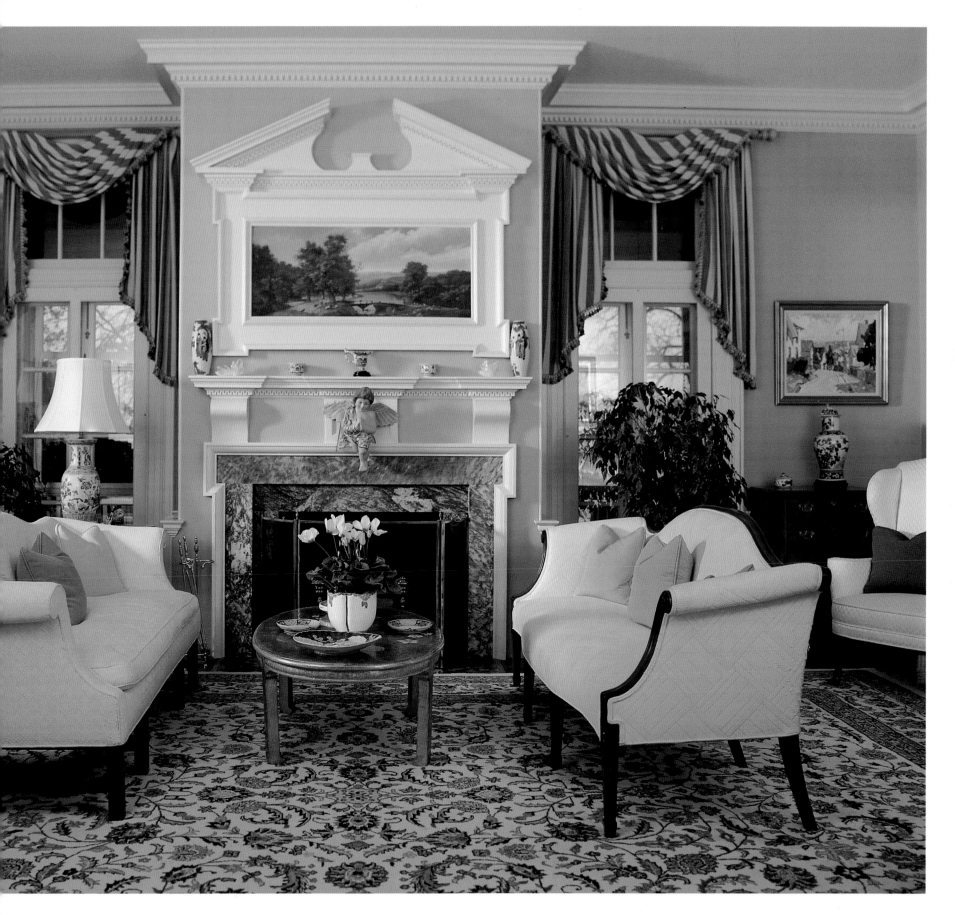

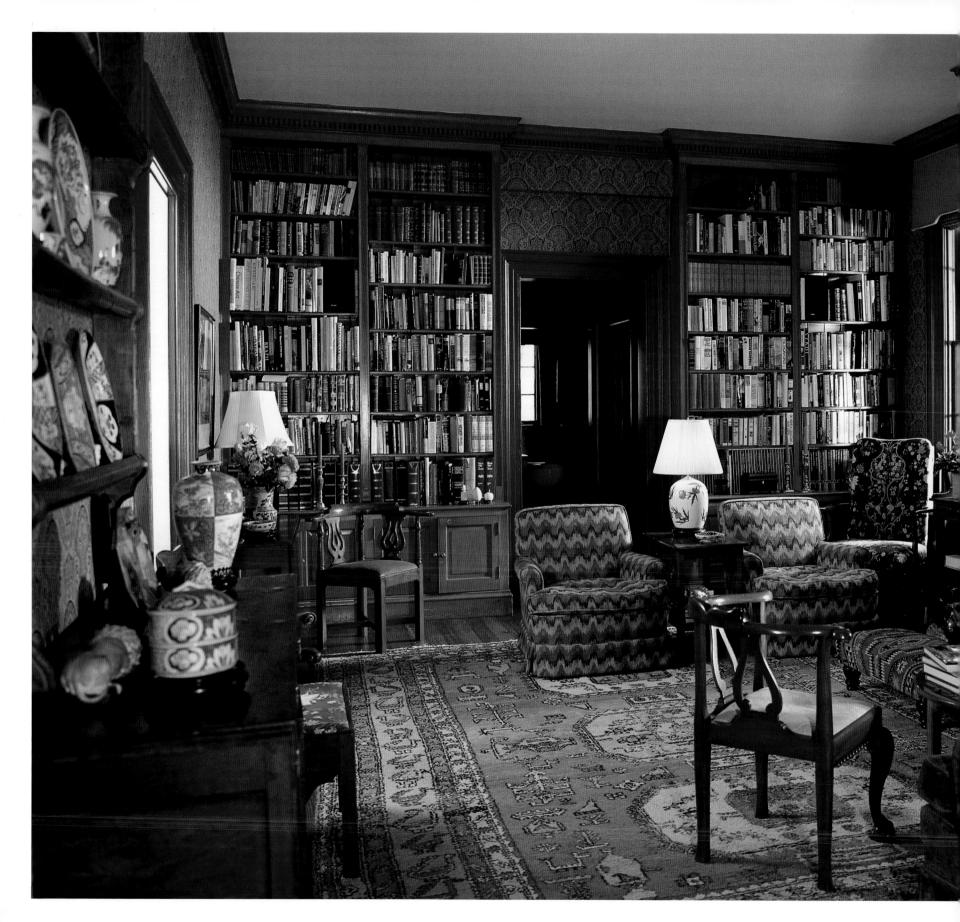

LEFT: The library is decorated with colors and fabrics to highlight the rich wood tones of the library shelves and the pink marble mantel, which was in pieces when the Calverts bought the house.

RIGHT: Roses from the garden add a delicate fragrance to this and other rooms throughout the house.

RIGHT BOTTOM: Painted wood ducks, made in Vietnam, a brass and copper pitcher, and a Cape Cod lighter on the hearth.

OVERLEAF: The dining room table set for a sunset dinner. The French doors on either side of the fireplace open onto the wraparound porch at the back of the house. Hand-painted rose porcelain plates accent the mantel.

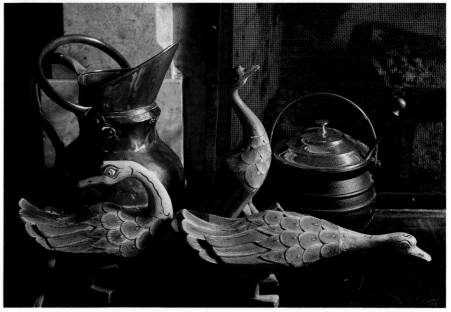

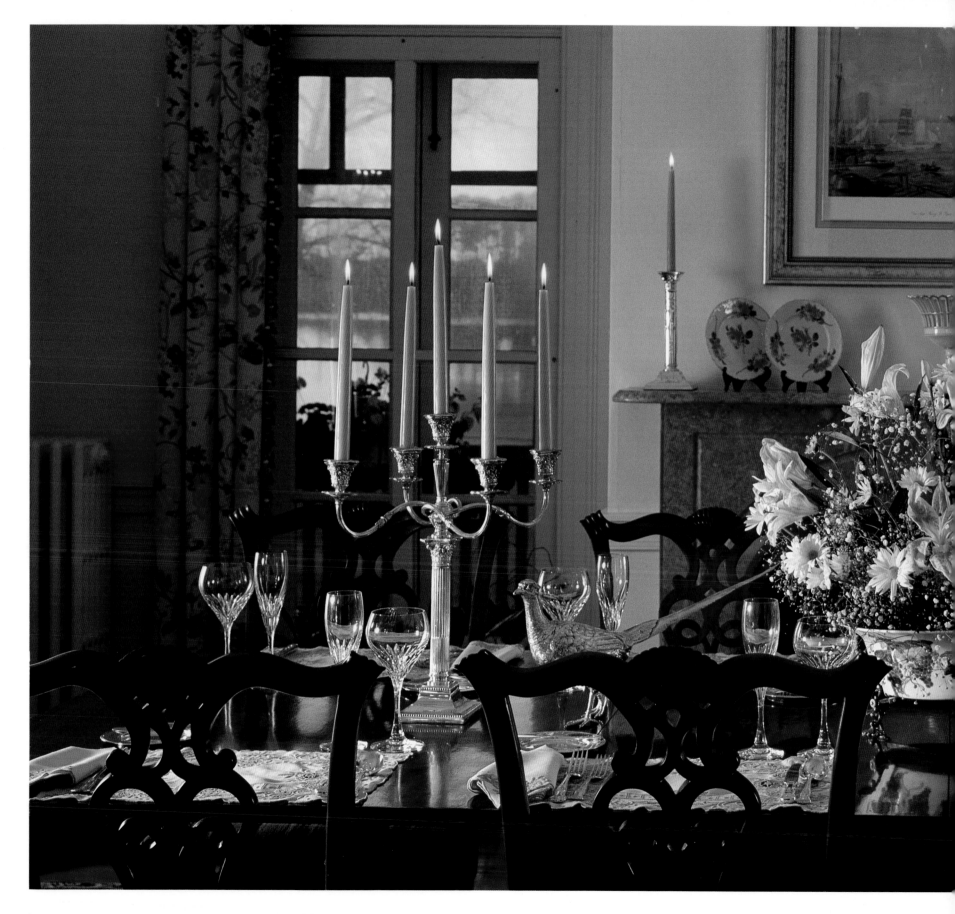

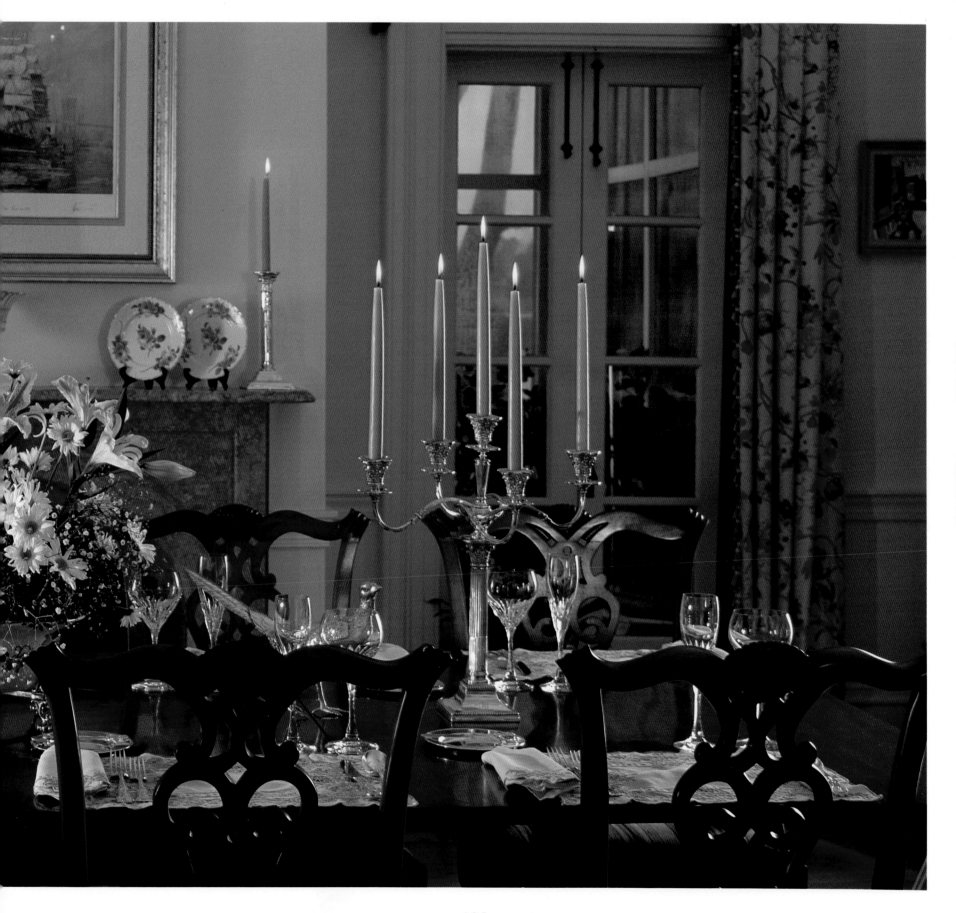

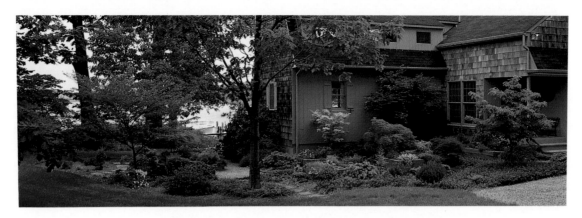

ON LANGFORD CREEK

When Marnie and Bill Flook bought this property in 1967, the house had been converted from a boat house into a small weekend cottage. In 1980, the Flooks added a large addition, more than doubling the size, and began the garden. They built a series of plant boxes and filled them with innumerable varieties of dwarf conifers and rhododendrons, Japanese maples, wildflowers, and rock garden plants. Marnie became interested in rock gardening twenty-five years ago and has studied it extensively ever since. The property on Langford Creek now has exquisite and colorful varieties of both unusual and well-known species of bulbs, perennials, berries, conifers, flowering trees and shrubs, ornamental grasses, and wildflowers.

BELOW LEFT: In the foreground to the right of the plant box is an andromeda *Pieris* x 'Brouwer's Beauty'). Outside the corner of the plant box is *Sedum middendorfianum*. In the box are red *Penstemon pinifolius* and pink cranesbill (*Geranium sanguineum* var. *striatum*).

BELOW RIGHT: A bright green maple (*Acer japonicum* 'Aureum') stands out against the side of the house, with a red-leafed maple in the corner. In the plant box is a Japanese maple (*Acer palmatum dissectum* 'Viridis') and a red-leafed maple. Directly in front of the box is a dark pink dwarf mountain laurel (*Kalmia latifolia*); in front of it are two dwarf rhododendrons: light pink *Rhododendron* 'Kozan', and the darker pink *Rhododendron chinsayi*. The boxes are surrounded by dwarf forms of cryptomeria.

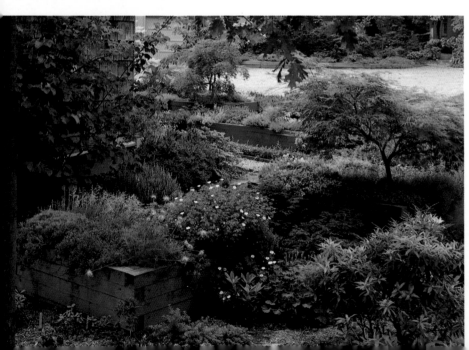

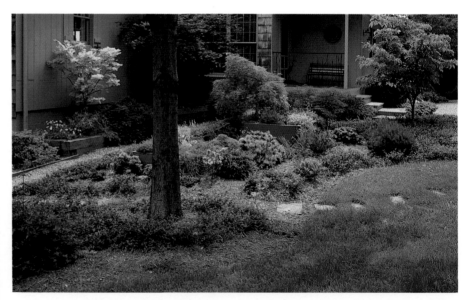

Weeping hemlock (*Tsuga canadensis* 'Cole's Prostrate').

Cranesbill (*Geranium sanguineum* var. *striatum*).

Lithodora diffusa 'Heavenly Blue'.

Penstemon pinifolius.

Sedum middendorfianum.

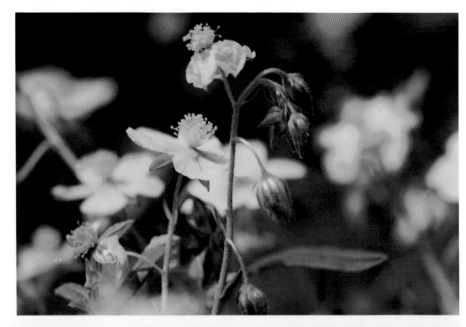

Helianthemum nummularium 'Amy Baring'.

One of many dwarf species of columbine (*Aquilegia* hybrids).

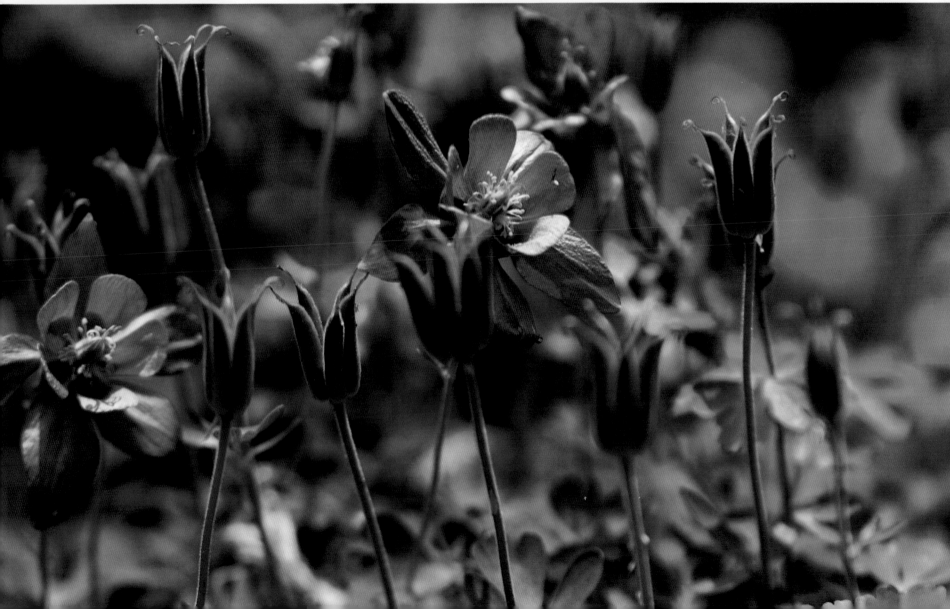

THE GRASSES

On the water's edge at Caulk Cove is this interesting garden and newly renovated house owned by Jan and Tom Alspach. The garden is about shapes and textures and subtle colorations. Native species of trees, shrubs, and grasses have been used to create protected spaces in the grounds and around the house. Even though the property is on the water and there are houses nearby, the careful landscaping ensures a sense of privacy.

Because of the extensive use of ornamental grasses and evergreen plants and shrubs, there is pattern and color as well as form even in the winter months. In early spring and throughout the summer season, soft plantings of naturalized daffodils and daylilies offer gentle bursts of color. Jan has incorporated many of the native plants that most people tear out, such as honeysuckle and trumpet vine, but is careful to keep them in check so they are accents of color and scent and not invasive weeds. Magnolias, hollies, and honey locusts are some of the native trees incorporated into her plan. Perennials with annuals mixed in round out the plantings for a full range of three long seasons of bloom. Jan designs landscapes and gardens professionally, as well as makes garden sculptures; and her own garden reflects both her professional and personal preferences.

Jan and Tom bought the house in 1987. At that time it was a simple cottage, which they completely redesigned and opened up by gutting the original house and then putting it back together. Out of three small bedrooms, they made a studio and a large bedroom downstairs that opens into an angular hall. They raised the ceiling from 8 to 14 feet in the living room. A year and a half later they decided to enlarge the house further with a two-story addition that included a combination living–dining room and a large screened porch on the ground floor and a master bedroom suite upstairs, all opening on the water.

LEFT: Tall plumed grass (*Miscanthus sinensis gracillimus*) is backed by a Franklin tree (*Franklinia alatamaha*), a descendant of a native species found in 1770 in Georgia and not seen in the wild since 1790. They are next to a hedgerow of English laurel (*Prunus laurocerasus*). Big trees shade the property down toward the water with an old white oak on the bank, a sycamore maple and a native dogwood in its fall red foliage in front of it, and a honey locust (*Gleditsia tricanthos* 'Halka') on the right.

LEFT: Eastern redbuds (*Cercis canadensis*) have their yellow fall foliage. Beneath them is a variegated shrub *Osmanthus heterophyllus* 'Variegatus' next to a clump of yellow zinnias and nasturtiums still blooming in late October in this protected sunny spot. Doublefile viburnum (*Viburnum plicatum* 'Mariesii') has its purple fall foliage next to a clump of *miscanthus*, cherry laurel (*Prunus laurocerasus* 'Otto Luyken') hedgerow, and a purple smokebush (*Cotinus coggygria*).

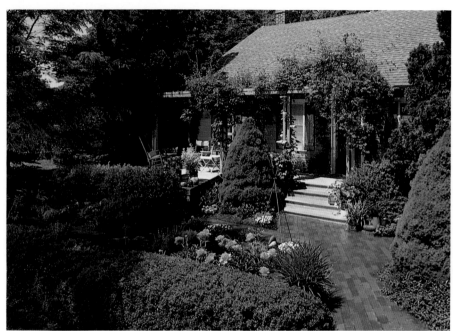

ABOVE: A somewhat formal garden is planted in front of the house with a brick walk leading to the deck and front door. A Japanese holly (*Ilex crenata* 'Hoogendorn') hedge defines the outside of the garden. Along the deck is a dwarf holly (*Ilex cornuta* 'Burfordii Nana'). A pergola over the front door has three vines growing on it for almost continuous bloom. Goldflame honeysuckle (*Lonicera* x *heckrottii*) is blooming profusely in late May. Not yet blooming is a native trumpet vine (*Campsis radicans*) next to a hardy kiwi (*Actinidia arguta*) that will have a tiny white flower followed by a dwarf variety of fruit by fall. Climbing up the post is a lavender clematis 'Ramona.' The pink peony in full bloom in the corner is 'Ave Maria.' Beside the walk is the ornamental grass *Spodiopogon sibericus* 'Silver Spike,' which will grow into a major form with prominent seed heads by mid- to late summer.

RIGHT: The tall shrubs in front of the deck are dwarf Alberta spruce (*Picea glauca* 'Conica'). Purple allium 'aflatunense' add a bit of color to this corner of the garden. Next to the allium is a low variegated Japanese sedge (*Carex hachijoensis* 'Evergold'). A dwarf mugo pine (*Pinus mugo* 'Compacta') adds another texture and shape to the border. The white peonies on the right are a single Japanese variety called 'Gold Standard.' In pots on the deck are variegated Tatarian dogwood (*Cornus alba* 'Variegata') and pink azaleas (*Rhododendron* 'Rosebud'). In the border in the background, purple Siberian irises are peeking through. The tripod will be covered in midsummer with hyacinth bean (*Dolichos lab-lab*).

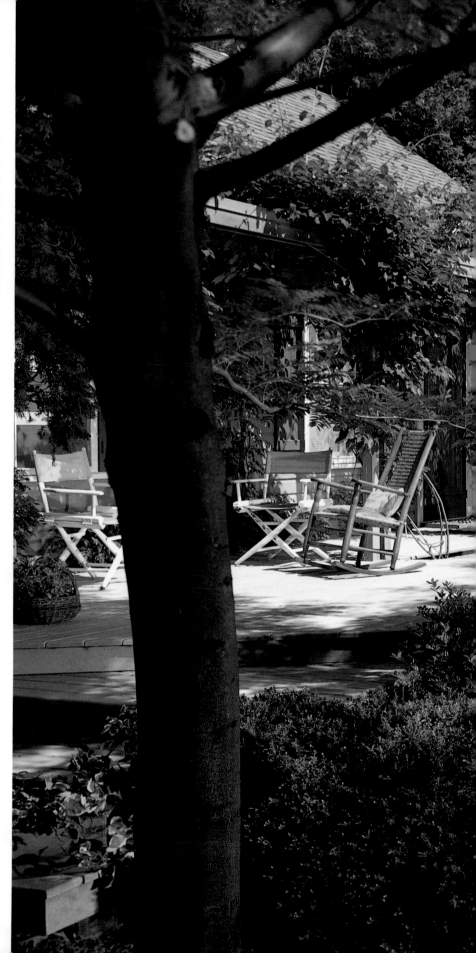

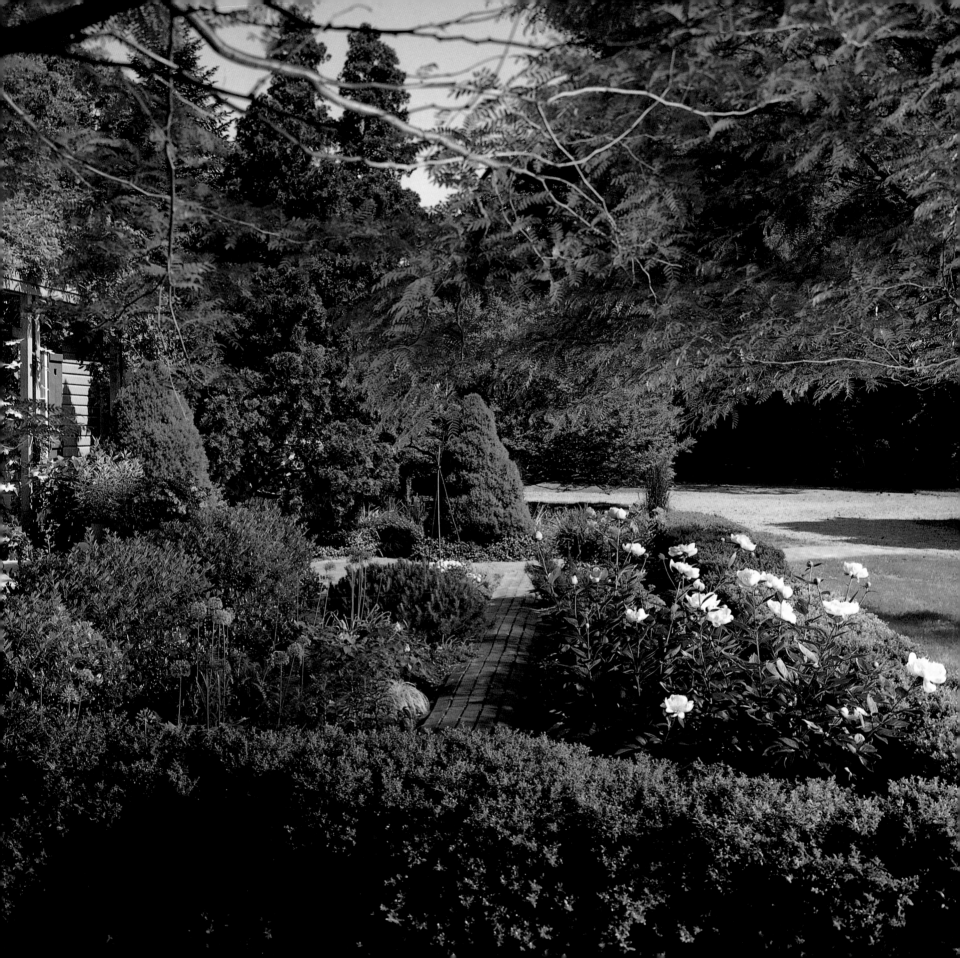

LEFT: At the drive, a sweet bay or swamp magnolia (*Magnolia virginiana*) takes center stage with barberries and cotoneasters mixed with daylilies and ornamental grasses for varieties of color and textures. *Berberis* 'Crimson pygmy' is underplanted with rockspray cotoneaster (*Cotoneaster horizontalis*) on the left. Japanese holly (*Ilex crenata* 'Rotundifolia') frames the area next to the brick gatepost. Three upright junipers (*Juniperus chinensis* 'Spartan') add height and dark green color. Ornamental maidengrass (*Miscanthus sinensis* 'Gracillimus'), daylilies that will bloom from June till August, and cranberry cotoneaster (*Cotoneaster apiculatus*) complete the border.

LEFT: This border in spring has variations of foliage and textures in *Sedum purpureum* 'Vera Jameson' and the tall reed grass (*Calamagrostis acutiflora* 'Karl Foerster'). Garden rhubarb is the large-leafed plant in the center. Just beginning to bloom are *Centurea montana*.

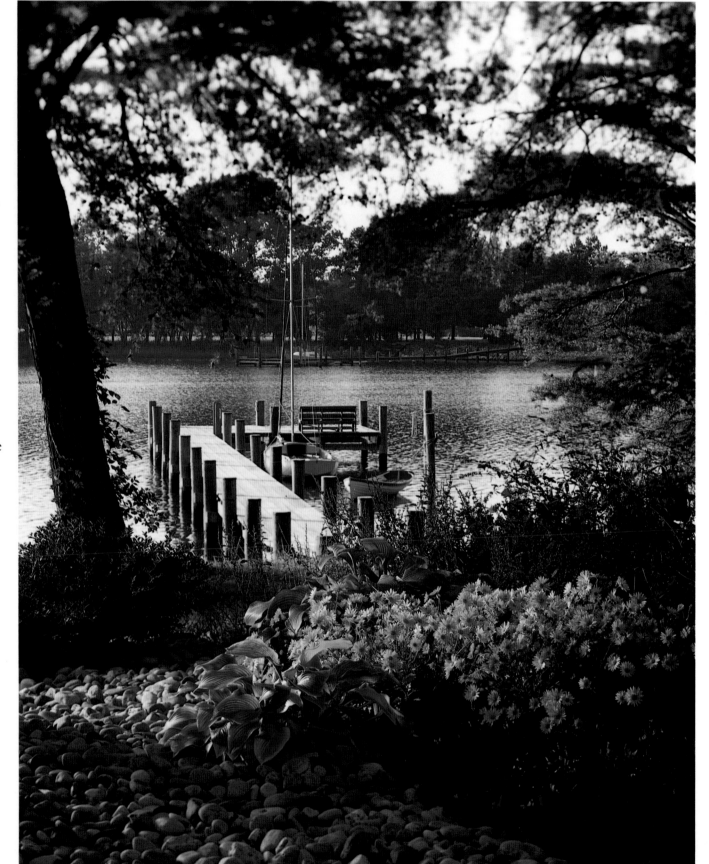

RIGHT: Stones at the edge of the border create a patterned frame for fall-blooming *Chrysanthemum* 'Sheffield Hillside', ornamental kale, and hostas 'Krossa Regal'.

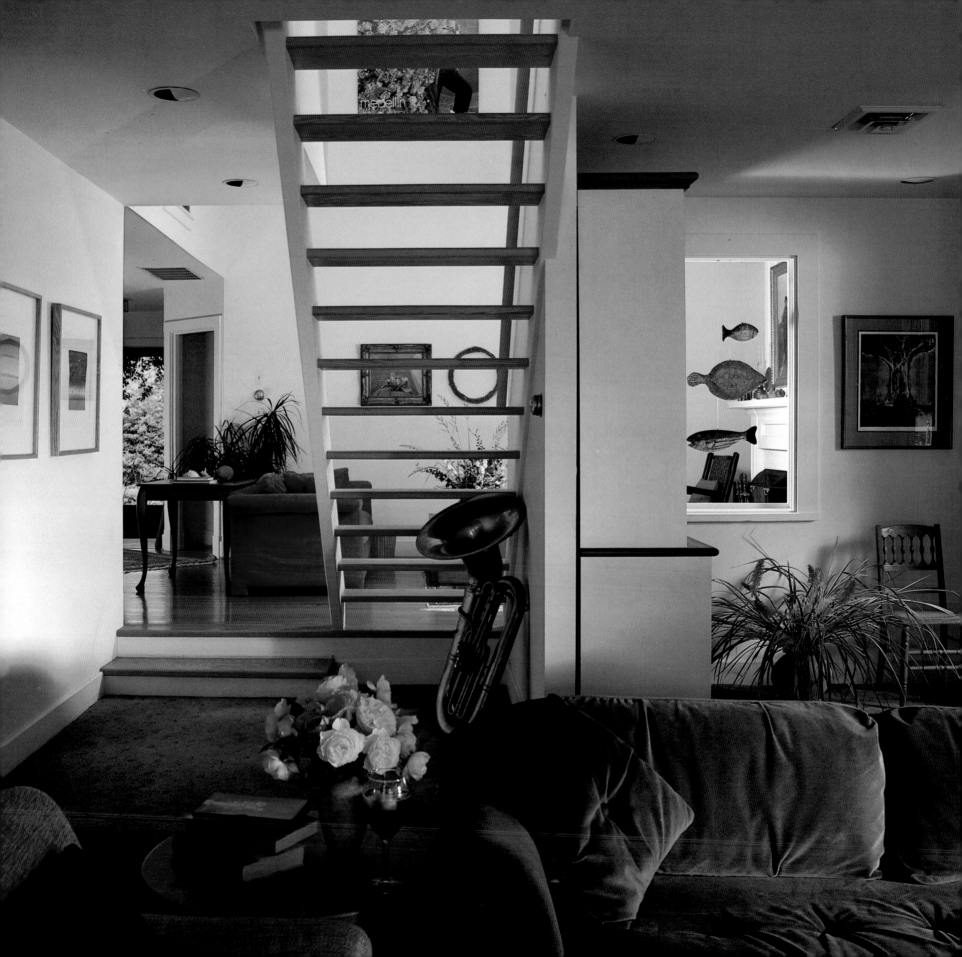

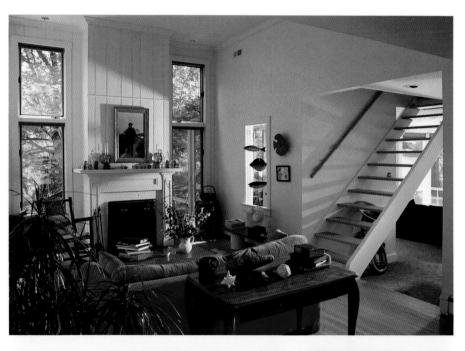

LEFT: Looking through the new addition to the old, the two living rooms are open to one another through the stairs and arch and window on the right. The hanging carved and painted wooden fish were done by local Maryland artist Randy Hofman.

BELOW: Variegated miscanthus in a porcelain vase made by Jan artfully fills a niche in the hall.

TOP RIGHT: The whole room was originally knotty pine paneling; the fireplace wall was spackled and painted. The oil over the mantel is by British artist Walter Dendy Sadler, 1880, titled *On the Way to Fish*. The Italian alabaster sculpture on the bench is *Opus Three* by Daras Kirsh. The ceramic pieces on the table in the foreground were made by Jan.

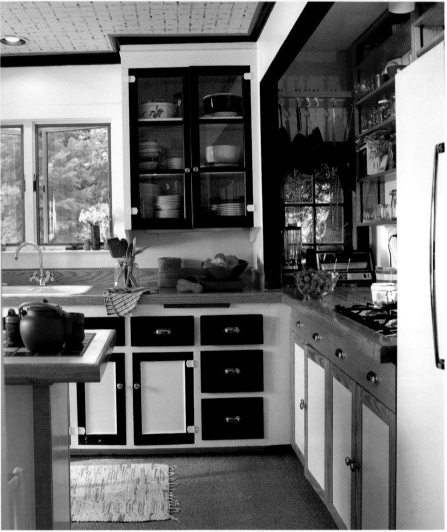

RIGHT: The kitchen.

The screened porch is a perfect place to enjoy the sun setting over Caulk Cove.

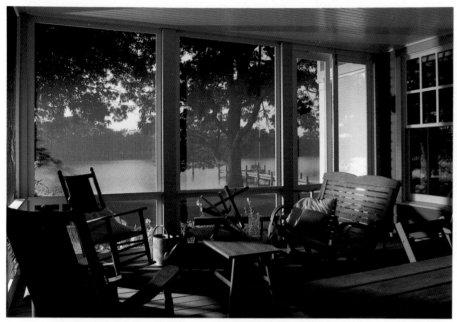

A long mixed border runs beside the whole length of the house on the water side. Currently in fall bloom is the annual Mexican bush sage (*Salvia leucantha*). Beyond the brick wall is a border edged with stones to form a pattern around the plantings. Set among the stones are clumps of little Japanese sedge (*Carex hachijoensis* 'Evergold') and dark green holly (*Ilex crenata* 'Hoogendorn') behind. Tall Japanese silver grass (*Miscanthus sinensis* 'Variegatus') tolerates the shade of the *Zelkova serrata* 'Green Vase' tree in the center of the bed. The purple-flowered shrub to the right of the *miscanthus* is a *Buddleia davidii* 'Nanho Blue' still blooming in October. Behind it is a dwarf *Fothergilla gardenii,* which turns a brilliant combination of red, yellow, and orange in the late fall; it has small white bottle brush blooms in April.

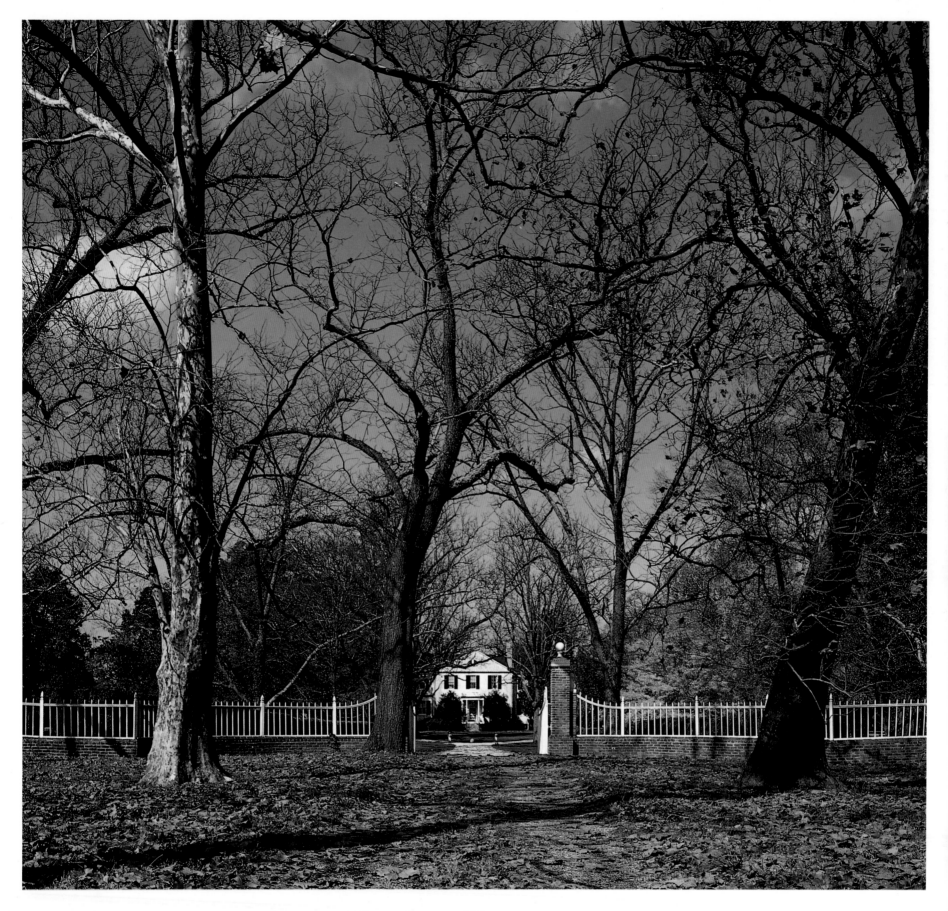

WYE HEIGHTS

At the end of a mile and a half of wooded drive, past a grazing herd of fallow deer, and then a herd of black Welsh mountain sheep, is the formal entrance gate to Wye Heights. Built in the early 1800s for a member of the Lloyd family, one of the founding families of the Eastern Shore, the house sits commandingly on the Wye River. As was typical of the time, it was built with a grand entrance on the river, since houses were often approached from the water. With more than six hundred miles of shoreline in Talbot County alone, the rivers and creeks were frequently a more convenient and shorter means of travel.

The house was built as a plantation manor with rooms and ceiling heights on a grand scale. Additions were made over the years, and it is again today a grand manor house. The home of Thomas and Anne Wyman, it has been beautifully decorated and filled with period antiques and hunt paintings and memorabilia. The Wymans enjoy entertaining and use every part of the huge house. The vast property is farmed, a tradition of the Eastern Shore, though with different crops and animals from those of the early days of the plantation. Tom Wyman brought fallow deer to create a deer park and imported the first herd of Welsh Mountain sheep to raise for their wool and meat.

The grand walled gardens have been restored and comprise acres of formal brick-enclosed gardens. Originally laid out in the late nineteenth century, by the time Tom bought the property, the gardens had fallen into a state of overgrown tangles and general disrepair.

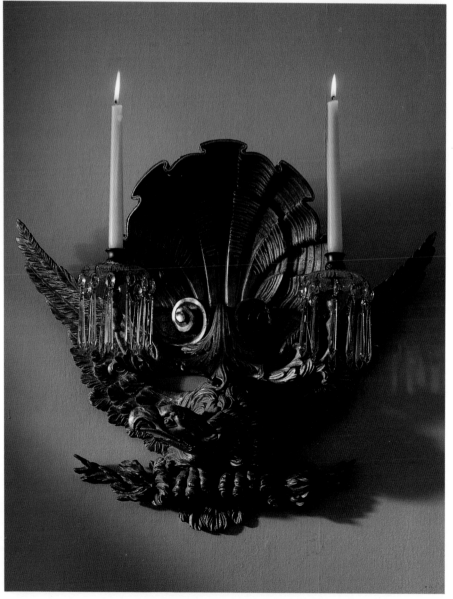

LEFT: Only in the fall or winter can the house be seen through the trees from down the drive.

TOP RIGHT: Looking from the front door through the porch across the green lawn down the tree-lined allée of the formal entrance drive.

RIGHT: An eighteenth-century wooden gilt and gesso wall sconce is one of a pair that grace the entrance hall.

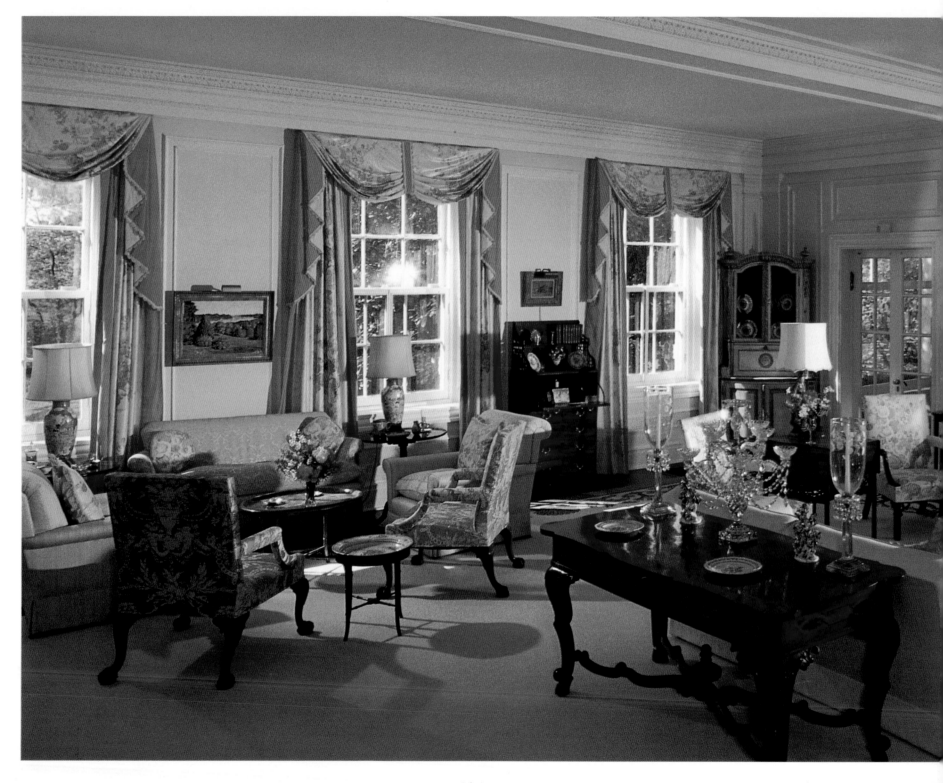

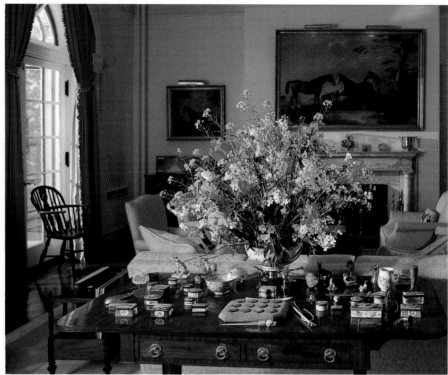

ABOVE: An arrangement of spring flowers from the garden accents the colors in the room. A sofa table in the foreground holds a collection of Billston-Battersea boxes, enamel-work hunting coat buttons, and export bowls. The large painting above the original Empire marble mantel is by John Ferneley, Sr. To the left is a smaller eighteenth-century painting of a horse and rider by Francis Stringer.

LEFT: Once two rooms, the large yellow living room is filled with sunny colors. Mid-Georgian green armchairs with cabriole legs form part of one conversational grouping. An eighteenth-century crystal epergne and a pair of hurricane lamps with etched shades are arranged on the mahogany sofa table.

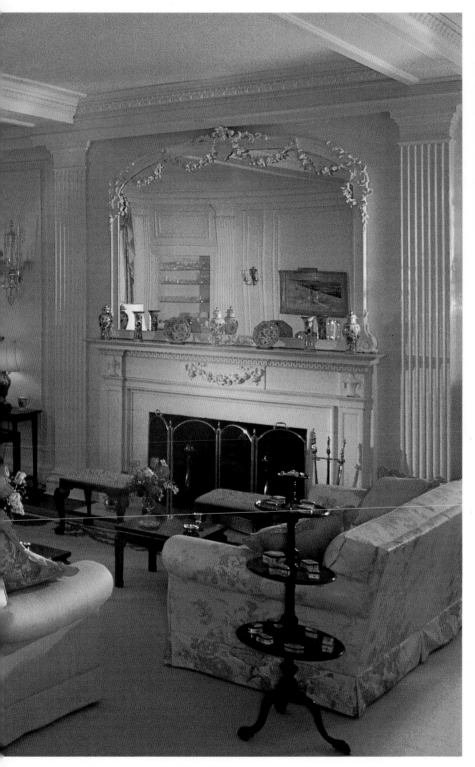

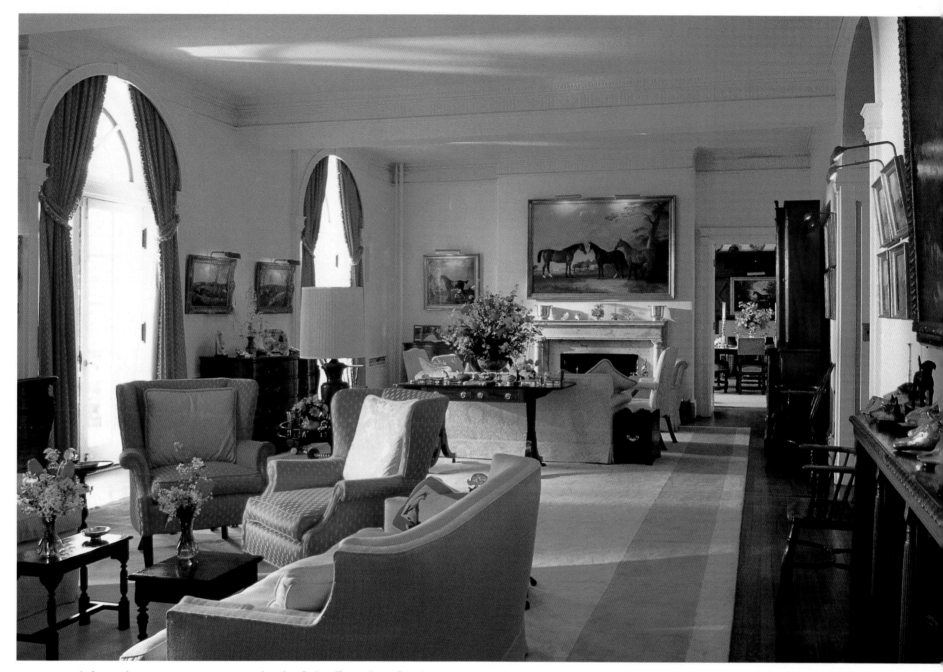

ABOVE: A large hunt scene painting, also by John Ferneley, Sr., hangs on the near wall of the living room above a collection of eighteenth-century stirrup cups and silver hunting horns and a contemporary bronze sculpture by Skeaping. The doorway at the end of the room leads to the dining room.

RIGHT: A 1767 English silver epergne with hanging sweetmeat baskets holds an arrangement of tulips, narcissus, and lilacs, all from the garden. It is the centerpiece on the table set with Georgian reeded candelabra, silver servers, and a pair of silver pheasants. The painting on the far wall is by Thomas Gooch, 1781.

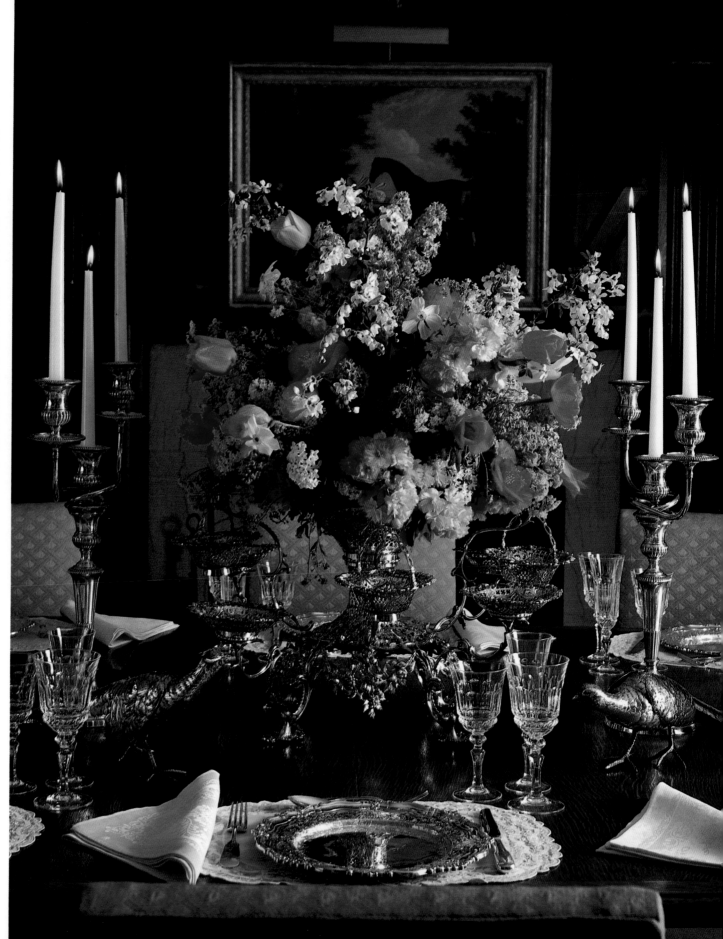

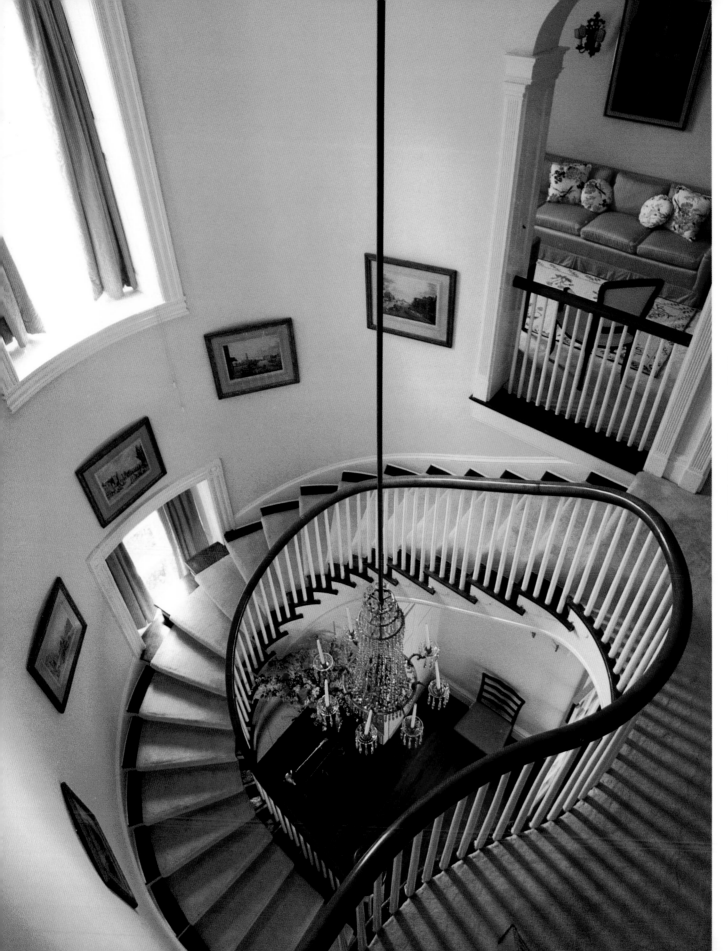

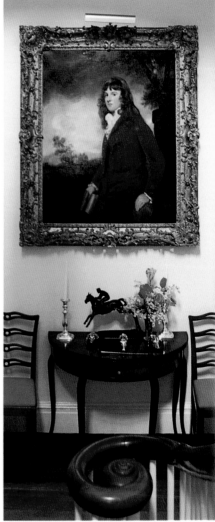

ABOVE: The painting at the foot of the grand staircase is by Sir Joshua Reynolds.

LEFT: The graceful curved stairwell encircles a nineteenth-century crystal chandelier. A group of Thomas Rowlandson lithographs line the stair wall.

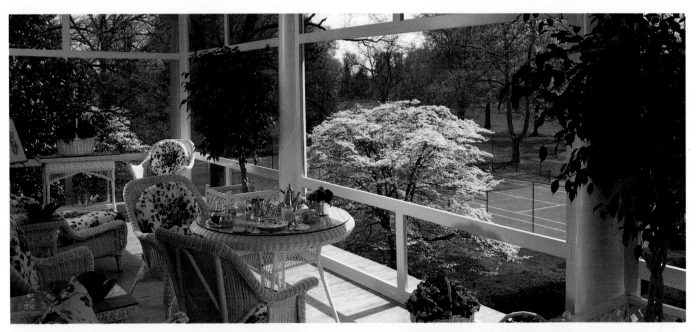

BELOW: Warm and cheerful colors enliven the master bedroom suite. The four horse portraits are of Anne's hunters and were painted by Eve Prime; the contemporary painting above the fireplace is by C. Neal. Spanish Riding School figurines adorn the mantel.

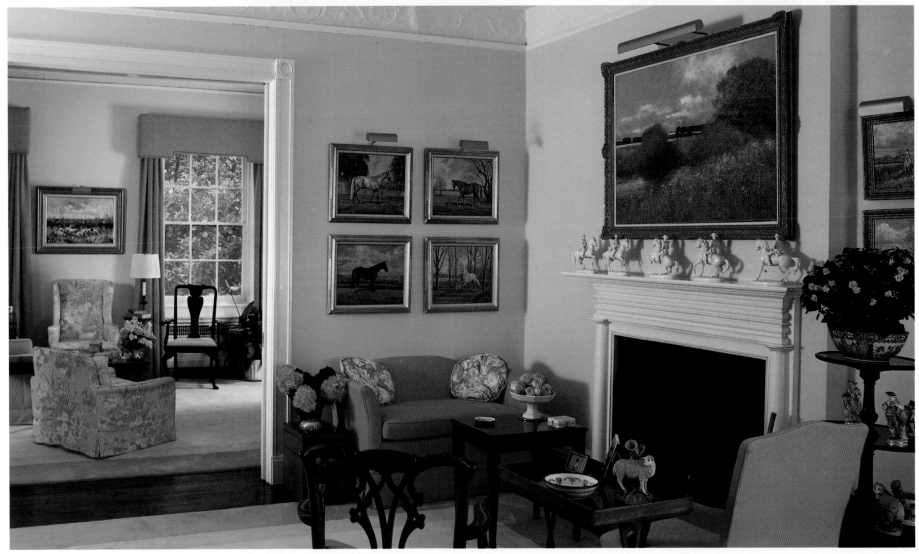

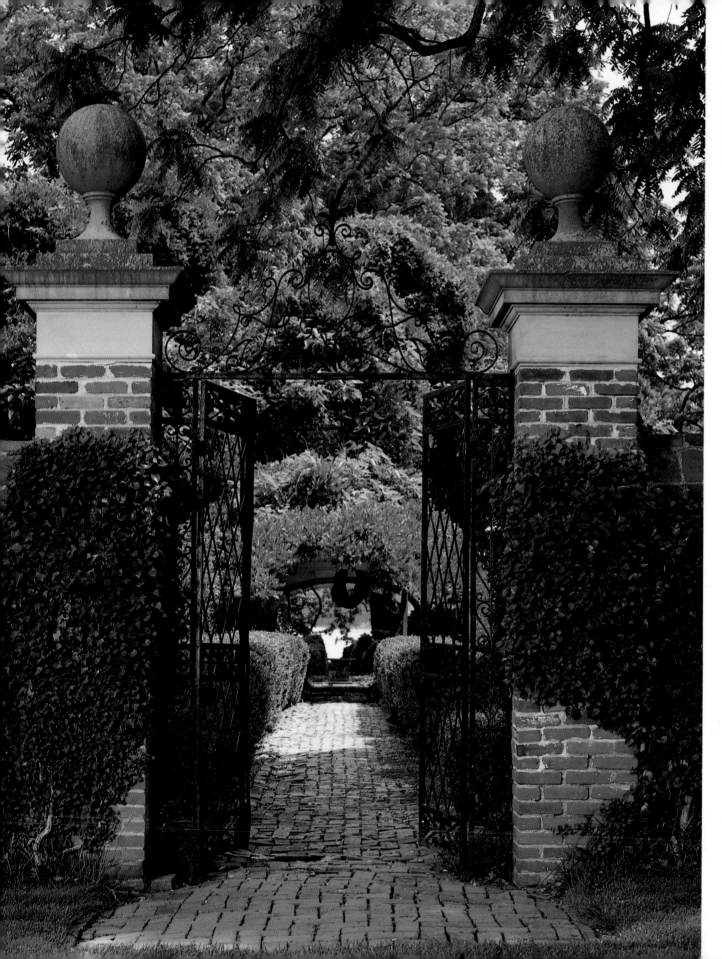

LEFT: Entrance gates to the gardens with an ancient wisteria over the arbor inside. Acres of brick-walled gardens that were put in around the turn of the century have been restored, replanted, and brought to life.

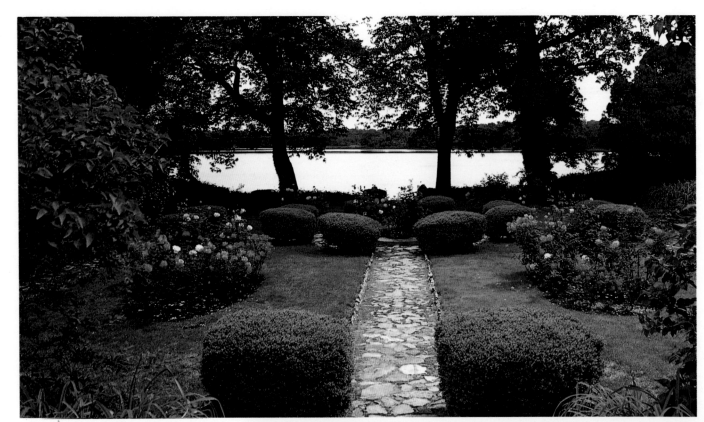

ABOVE: Carefully trimmed box accent the formal rose garden planted in geometrically shaped beds. The Wye River is in the distance.

RIGHT: This brick and white wood arbor is smothered in roses throughout the summer months. Once more than three hundred yards long, it reached all the way to the riverbank. From this vantage point, beyond the arbor are the brick paths that lead through the gardens. Beyond each of the white gates is a different garden plot that changes with the seasons.

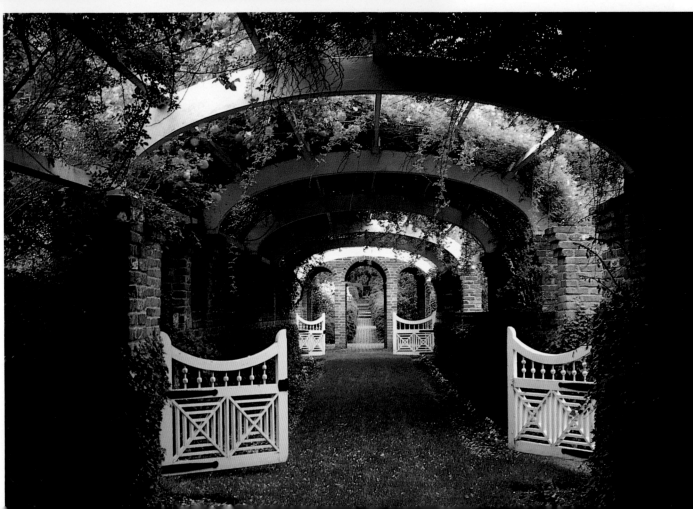

LEFT: A contemporary Welsh sculpture, carved from French limestone, was made for the Wymans.

RIGHT: Inside the gazebo that was recently made for this garden, the table is set for tea with a delicately fragrant bouquet made up of a sampling of the roses that bloom in the garden in June.

BELOW LEFT AND RIGHT: In May this garden, enclosed by a low white picket fence, abounds with color in dozens of varieties of tulips interspersed with narcissus and underplanted with alyssum in yellows, blues, and whites. Later on in the season, the center beds will be filled with roses, lilies, and other colorful perennials for cutting. The lilacs and flowering crabs and cherries are beginning to bloom in the background.

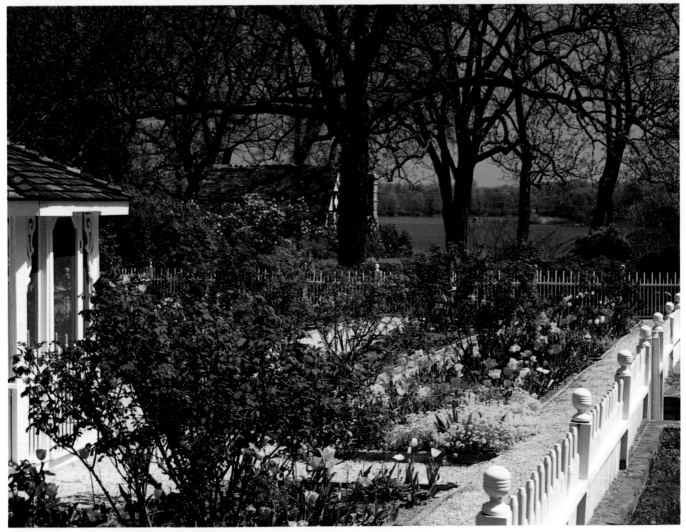

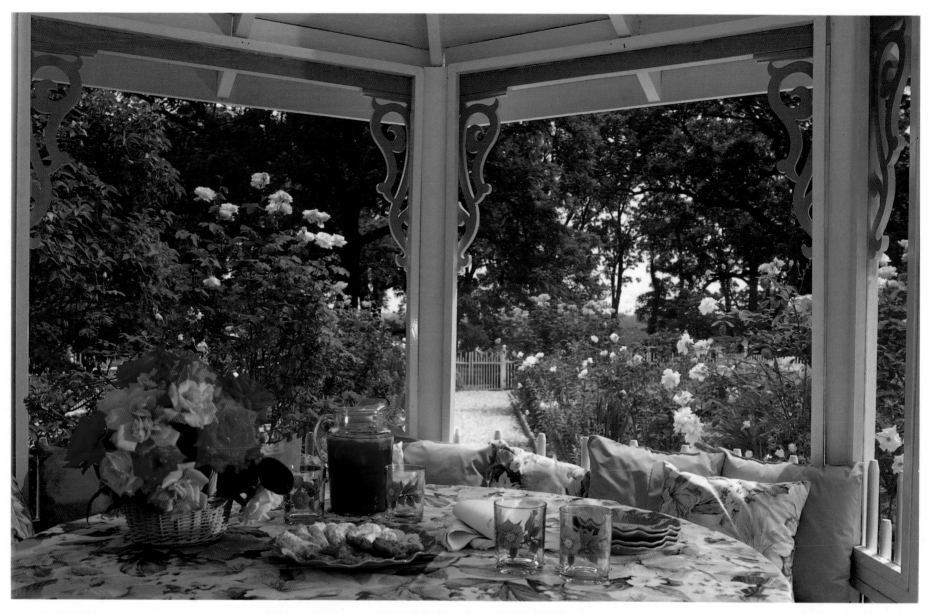

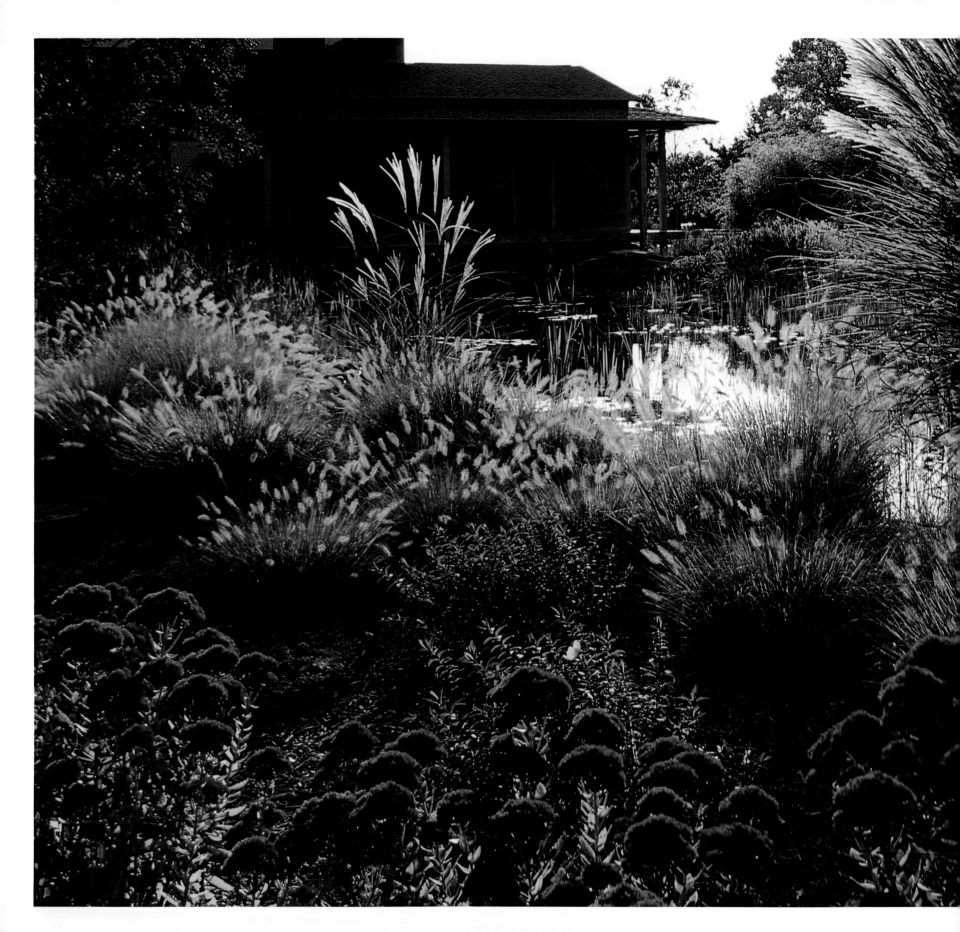

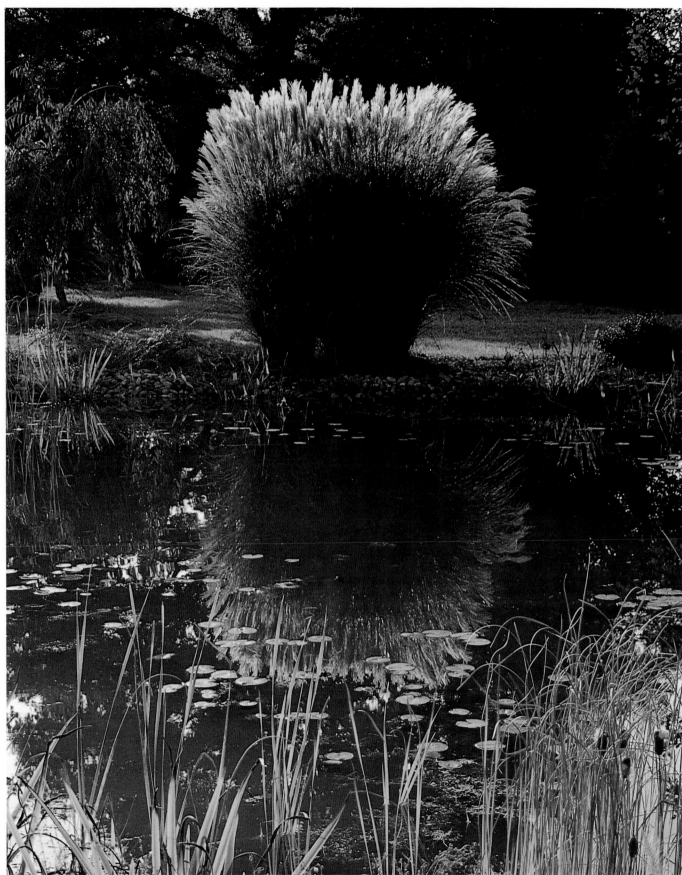

ASAGAO

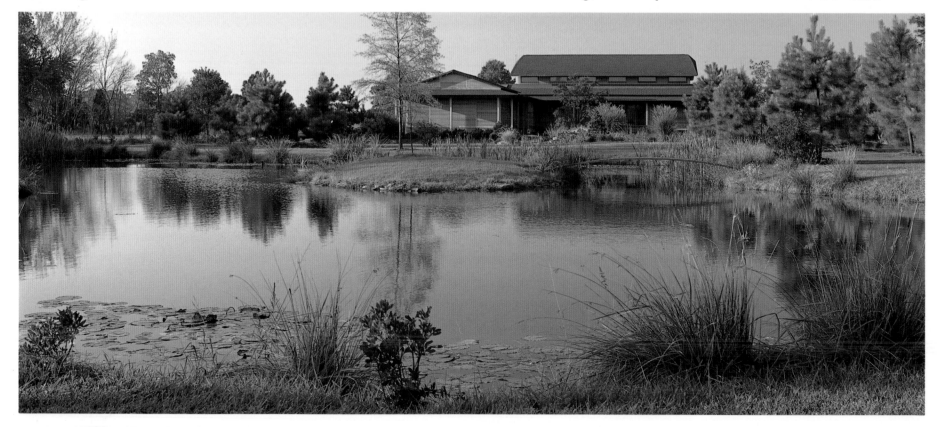

The owners of Asagao wanted the feeling of the serenity and tranquility of a Japanese-style house that framed water views of the river and ponds but was adapted to a Western style of living. The owner and his American architect traveled to Japan, where they met with Japanese architects to discuss and critique their plans to merge Japanese and Western elements. Built in 1990, Asagao has many traditional Japanese features such as its asymmetrical layout, deep overhangs, verandas (called *engawas*) that wrap around the house, and a classic Japanese entrance, which represents the transition from outdoors to the inside. Once inside the entrance, steps up to a hall invite the visitor to choose a direction, and at the end of the hall is another choice of direction. Not only are water views—or garden or stone patterns—framed at floor level or other unexpected (to a Western eye) locations, but the sound of water is emphasized with chains for downspouts so that when it rains, the water is heard and seen. Fountains are at play in the water gardens outside. Massive sliding panels open at the touch of a finger onto the *engawa* to join the interior to the outdoors. Light and the shadows it creates were also taken into account in the design of the house. As in Japanese-style gardens, the paths are not straight, so the traveler will be drawn to look down and see what is there—sometimes a pattern of stones or plantings, for texture or color.

OVERLEAF LEFT: In the fall sedum 'Autumn Joy' and ornamental grasses with mature seed heads accent the tranquility of the pond. OVERLEAF RIGHT: The fall afternoon light sets ornamental grass plumes aglow at water's edge.

BELOW: The largest of five ponds frames the front of the house.

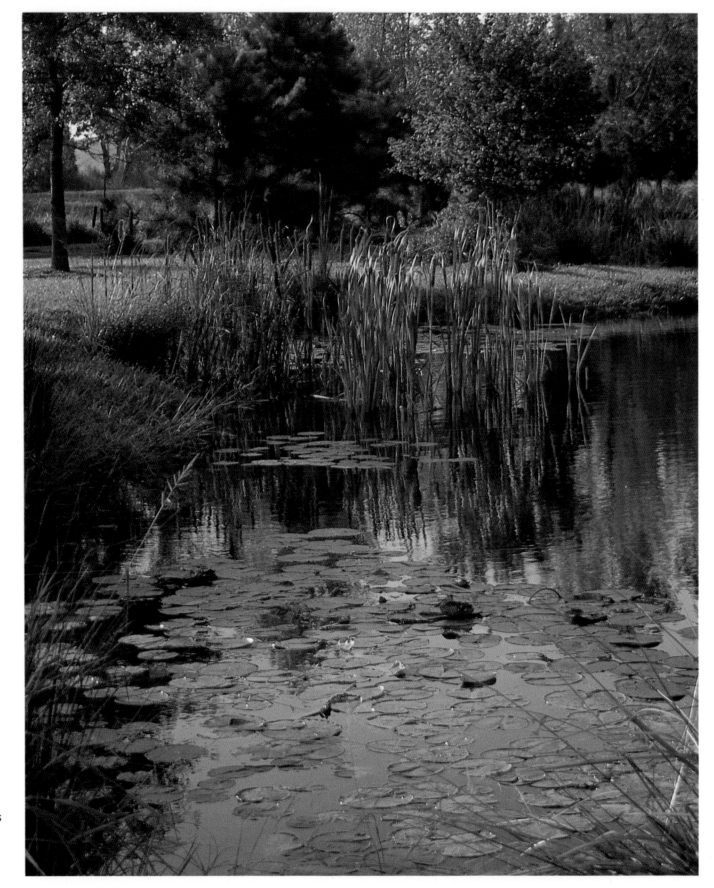

RIGHT: In summer the lily pads
and lotus flowers bloom in the
pond. Now, in October, the pads
add interest and break the
reflection of the grasses and
cattails.

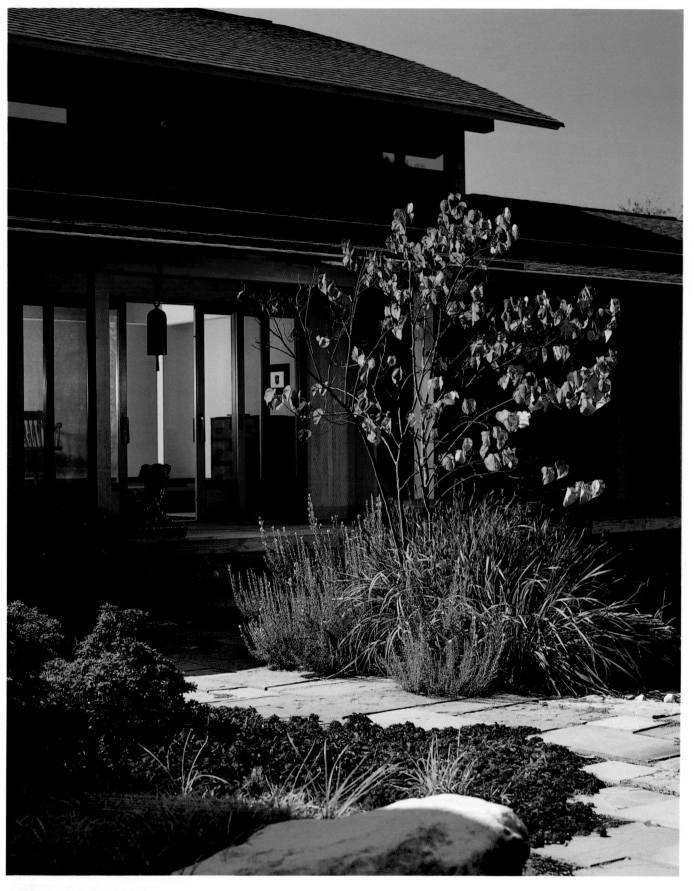

LEFT: A flagstone walk, set in an irregular pattern, leads to the front entrance. Rosemary and irises with their seed pods left on surround a redbud (*Cercis canadensis*) tree as part of the plantings.

ABOVE: The house is set on piers supported on stones at the water level so that the ponds and water gardens can flow beneath the verandas.

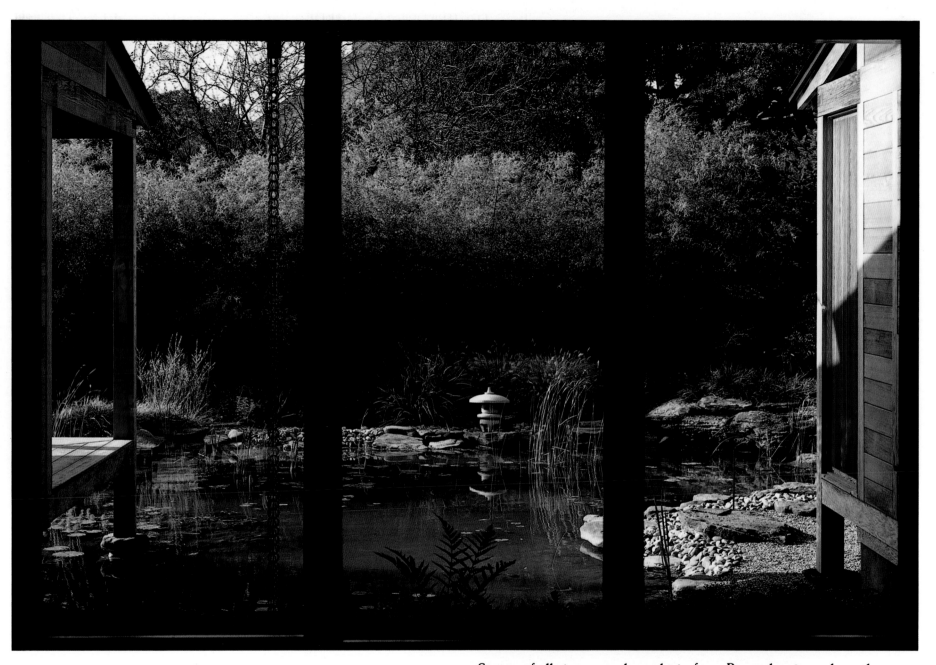

Stones of all sizes were brought in from Pennsylvania—where the owner hand-selected the large ones—to form patterns and accents in the landscaping of the property. At the corner of the overhang is one of several chains, used as downspouts to highlight the sound of water when it rains.

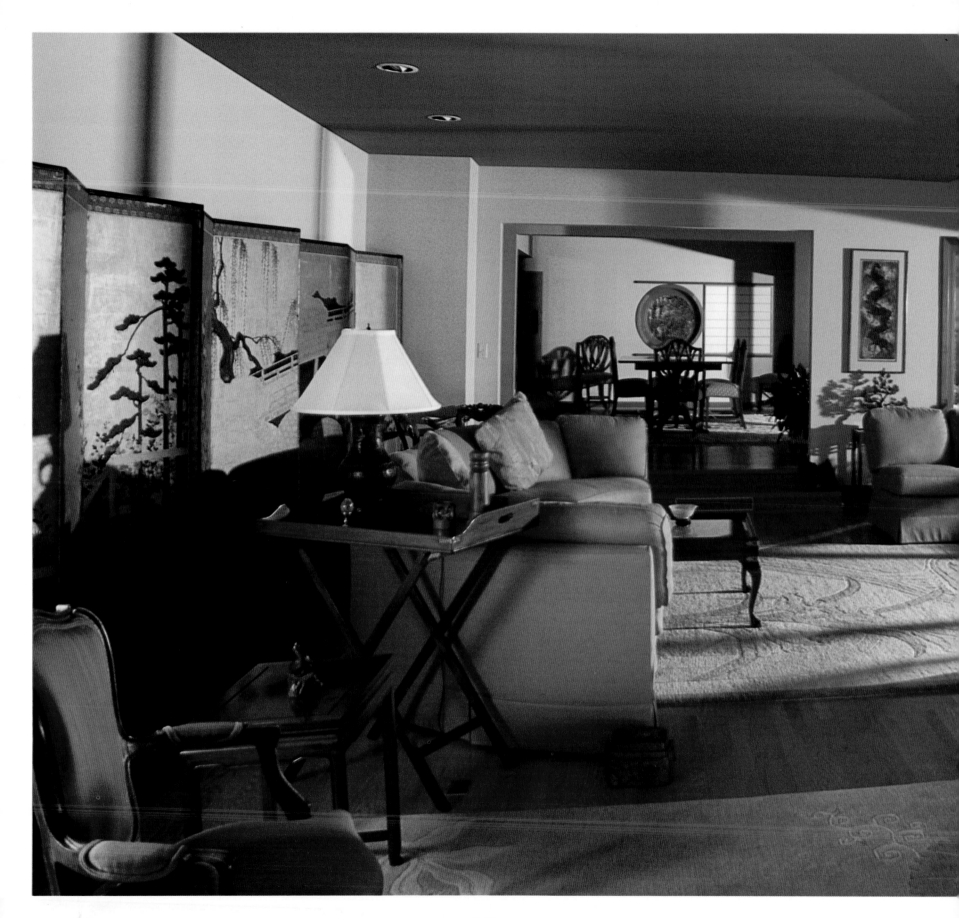

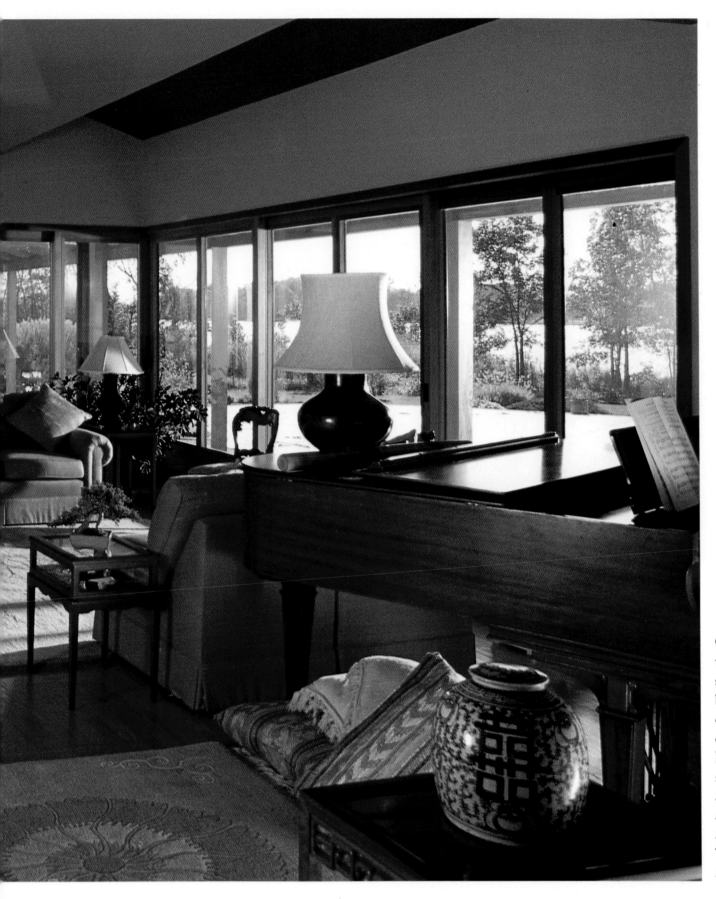

One length of the living room, which is furnished in Western style, has sliding panels that fold back onto each other so that the entire wall can be removed to open up the area to the outside. Deep overhangs on the verandas shield the inside from high sun and gentle rains. Tibetan rugs and a late-nineteenth-century screen add Asian touches to the room. The dining room is a few steps up at the far end of the room.

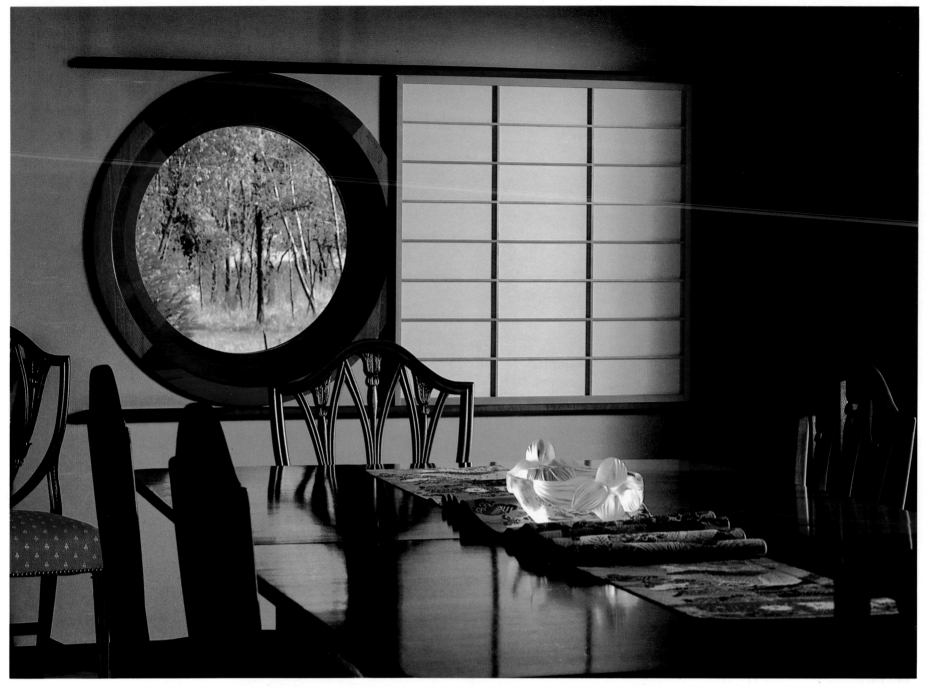

An obi and a crystal bowl decorate the dining room table in front of a round window, with a view of another piece of garden, marsh, and river in the distance. A sliding shoji screen can cover the window, allowing soft light in or out.

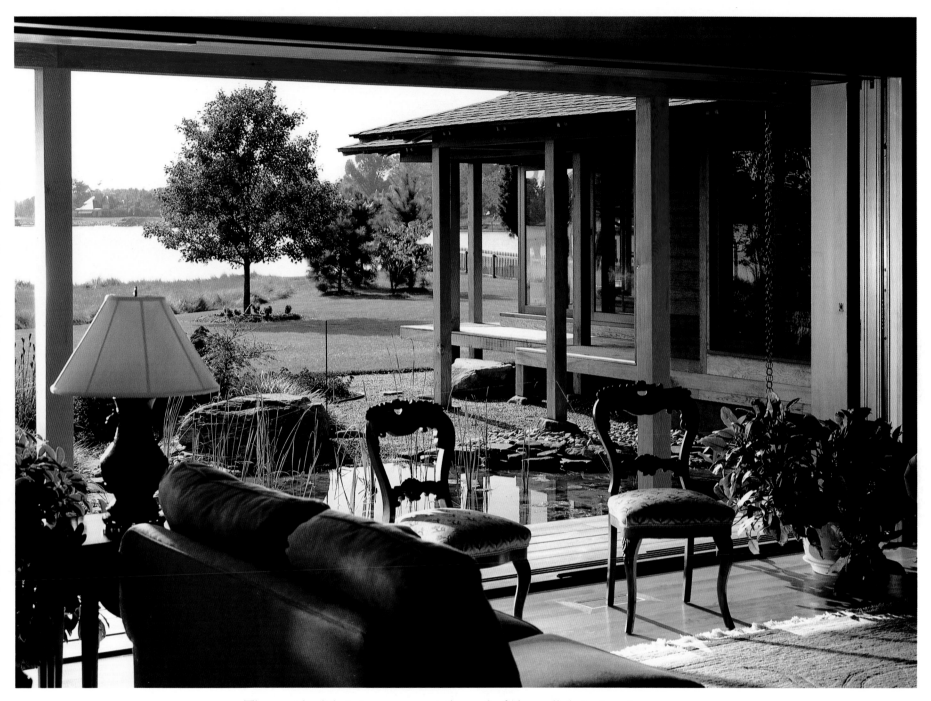

The panels slide into a recess at the end of the wall, bringing the
outdoors into the room. The master bedroom suite is across the pond.

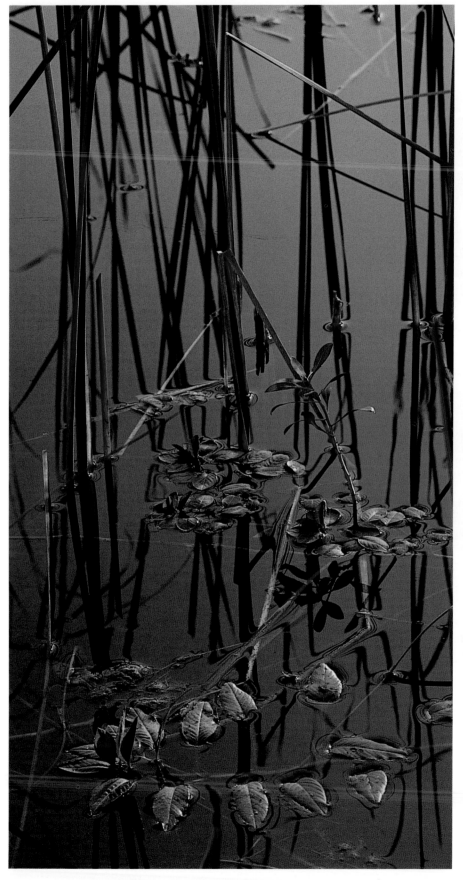
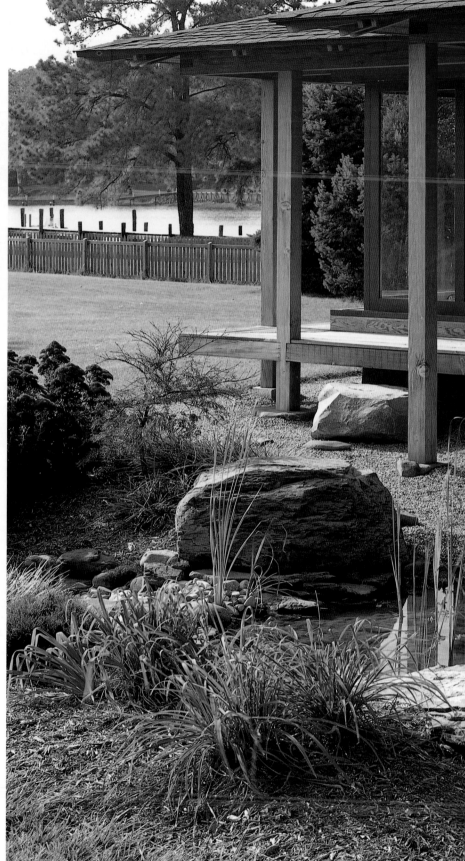

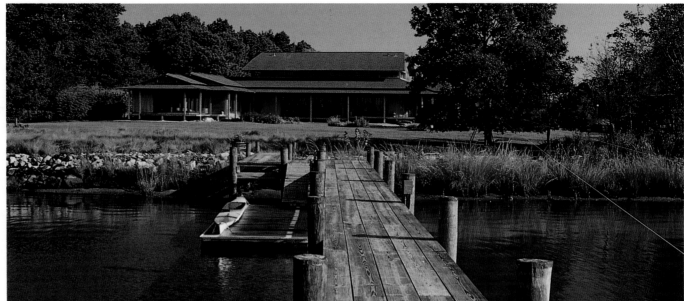

FAR LEFT: Water reflections.

———————

LEFT: Small stones, large rocks, and boulders have been individually placed for garden interest.

———————

ABOVE: The house as it appears from the end of the dock. The marsh grasses at river's edge are mowed only once a year to encourage their growth and the thick, wind-swept patterns they create.

———————

RIGHT: The broad palette of woods used in the house includes cyprus, mahogany, cedar, and cherry.

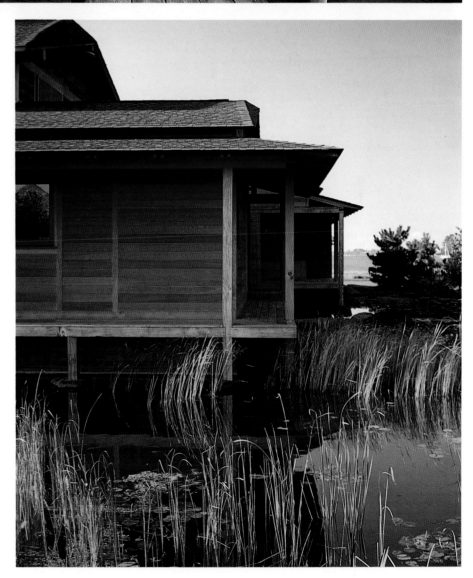

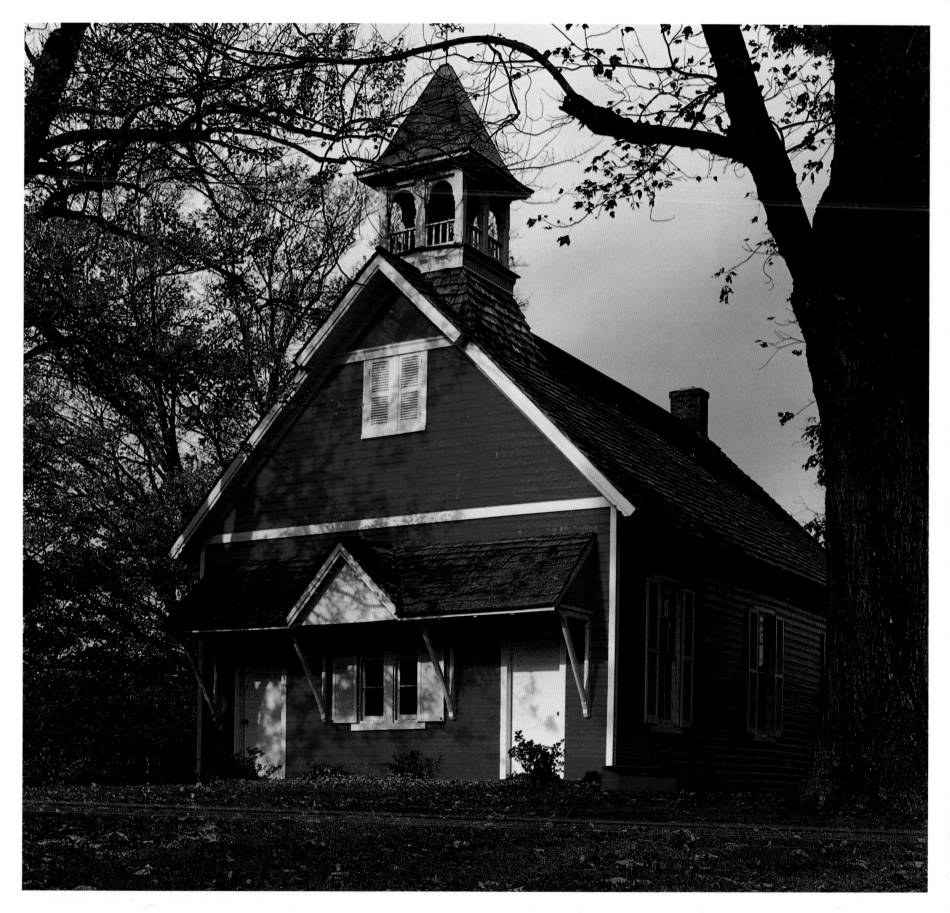

HAWKSWORTH
FARMS

T his nineteenth-century white clapboard farmhouse with elaborate trim has been added on to through the years, most recently after the current owner bought the house in 1976. A porch was added upstairs and a long living room with lots of windows was added to take advantage of the water views. The kitchen and dining room were also rejuvenated. Furnished with antiques and an extensive collection of late-nineteenth and early-twentiety-century European Art Nouveau posters, the house is surrounded by lovely gardens and graceful trees.

RIGHT: **An English Georgian six-sided lantern lights the entry hall inside the front door of the house. A nineteenth-century Chinese umbrella stand holds a collection of canes and walking sticks.**

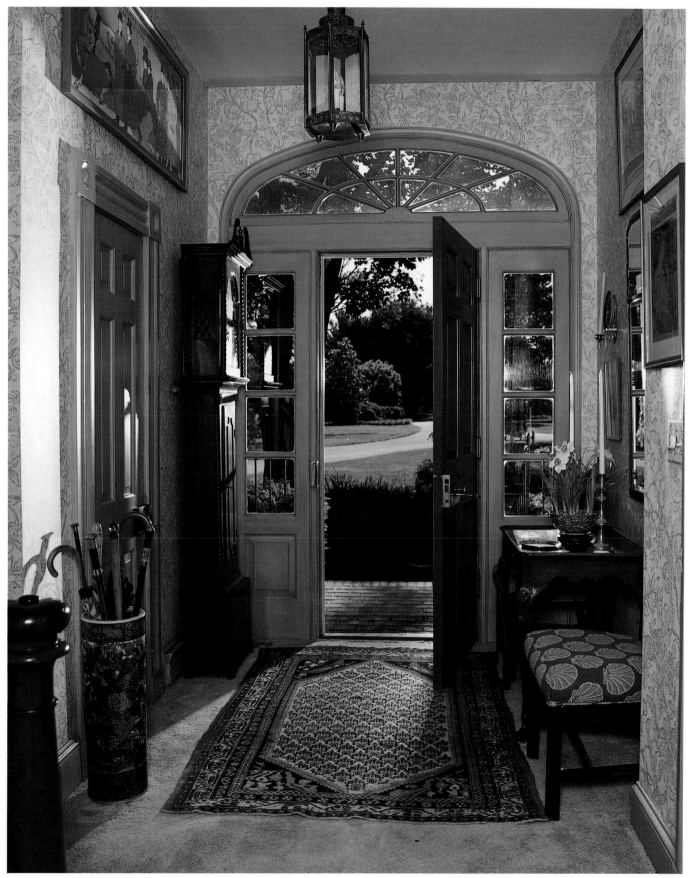

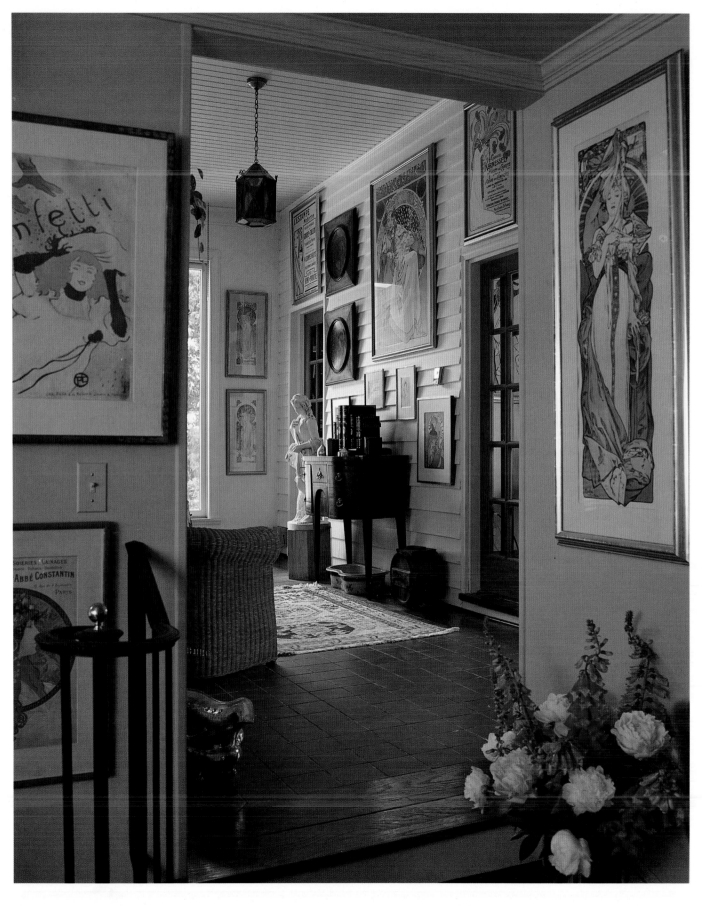

LEFT: The former porch has been enclosed and turned into a little sitting room. The walls are covered with part of the owner's collection of Mucha posters.

RIGHT: Colorful fabrics and a rich red Oriental rug are used to highlight more of the owner's collection of Mucha, Lautrec, Bonnard, and Vuillard in the parlor.

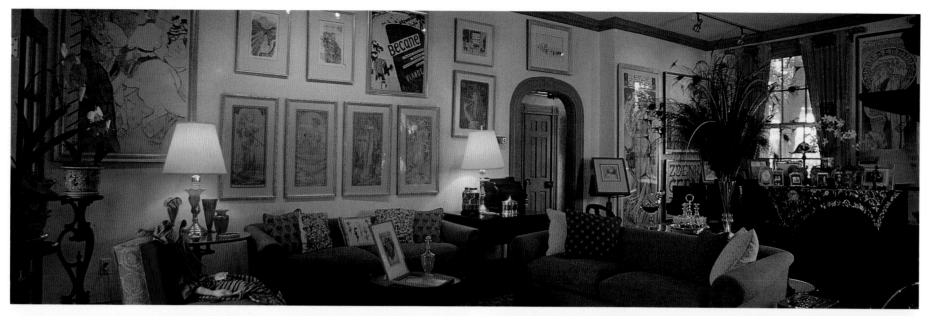

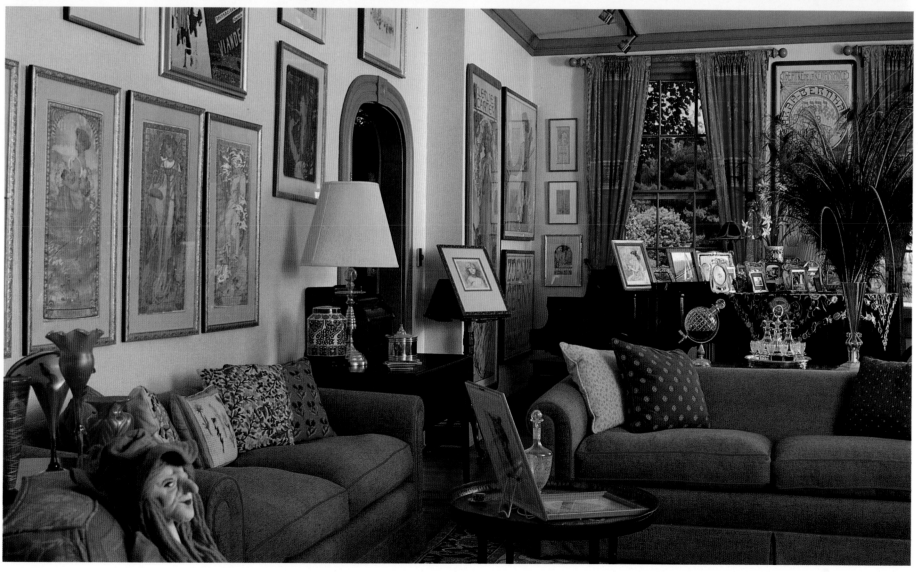

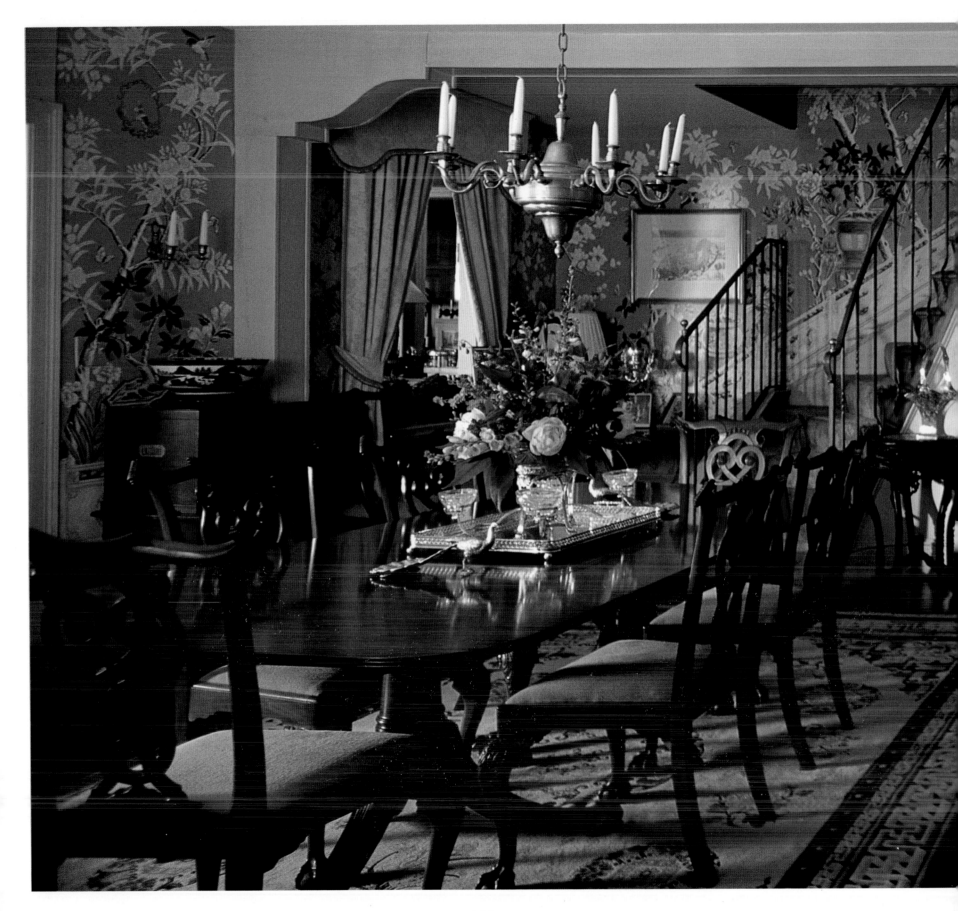

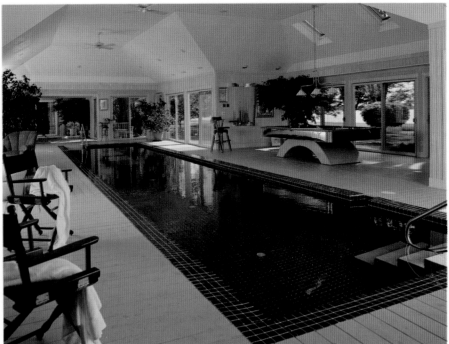

ABOVE: The most recent addition to the house is the pool room just off the living room, with large glass windows and sliding doors for wonderful views of the water and grounds.

LEFT: A double pedestal mahogany Duncan Phyfe dining room table is encircled by Chippendale chairs with ball and claw feet. In its center is a silver plateau holding a silver and crystal epergne filled with flowers from the garden. Chinese hand-painted wallpaper exported for the room enhances the Canton punch bowl on the sideboard on the far side of the room and the rare yellow Ming food jars on the marble-topped table in the foreground. At the back of the room on the left is the "new" living room. Through the door on the right, the parlor and entry hall on the other side can be seen.

In spring, red and yellow tulips are in full bloom in the raised brick
walled beds and around the hedge-enclosed borders of this garden with
its geometric patterns of flower beds. Some of the tulip beds are
underplanted with blue forget-me-nots. A 'Kwanzan' cherry is just
about to burst into full bloom on the right.

Cutting beds hold peonies of every possible shade and bearded irises
ranging from the palest lavenders and yellows to the deepest purples
and bronzes with many combinations of colors in between.

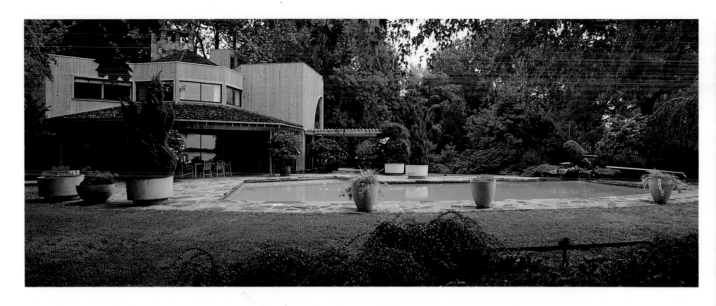

The pool is backed by tall evergreens, planted to display a panoply of greens and a Japanese rock garden and waterfall behind the diving board. Large tubs of gardenias line the terrace outside the pool house and scent the air with a heavenly fragrance after a winter in the greenhouse. Inside, the pool house, with extra guest rooms upstairs, is comfortably furnished around its stone fireplace.

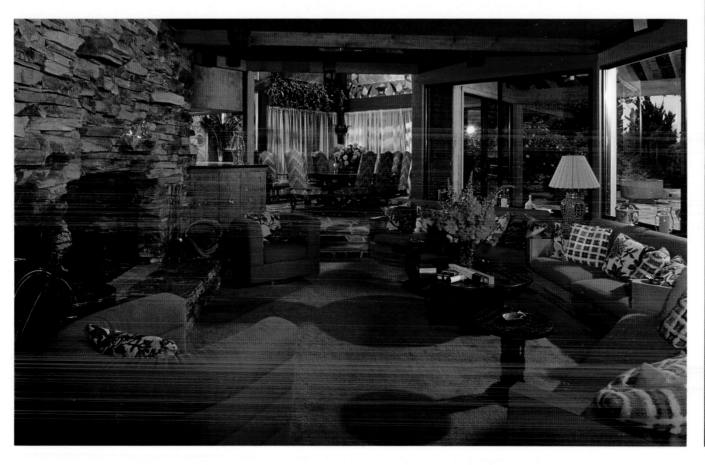

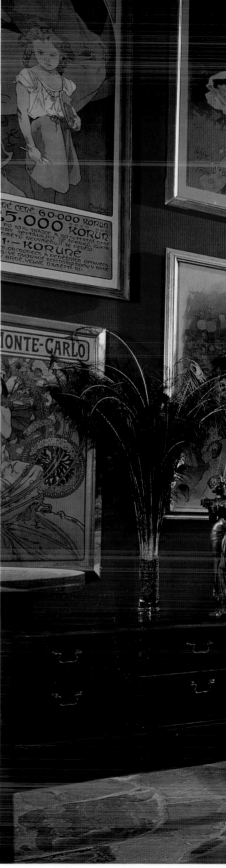

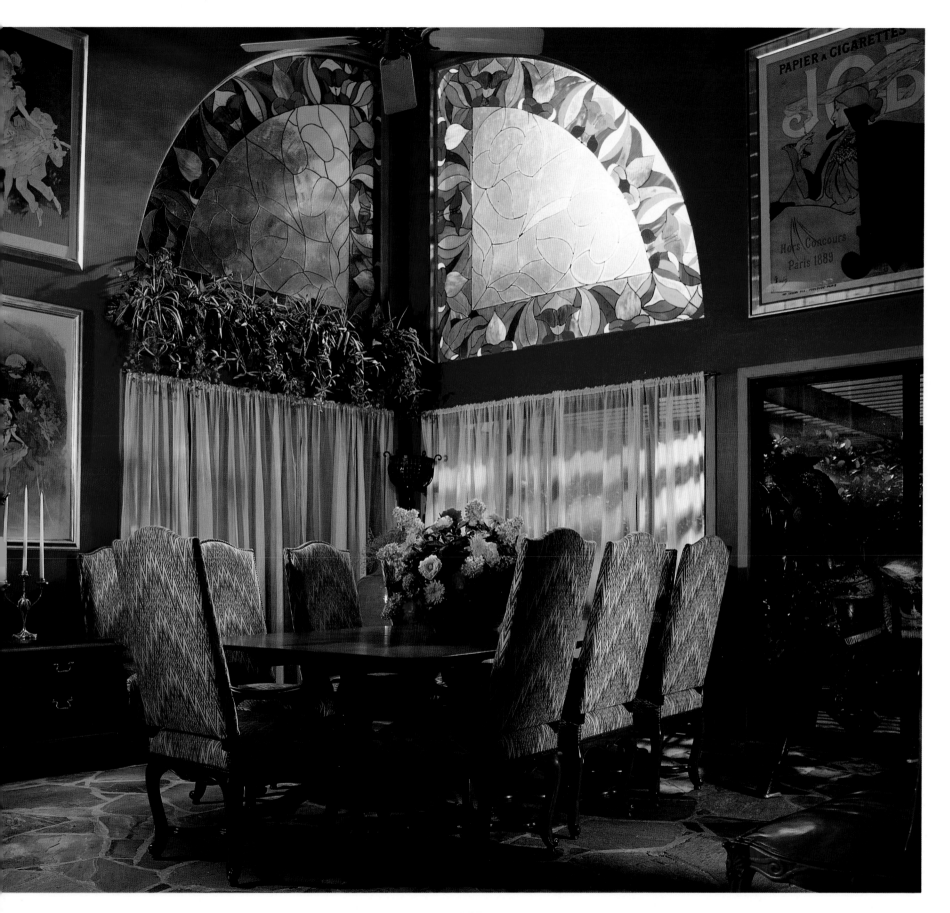

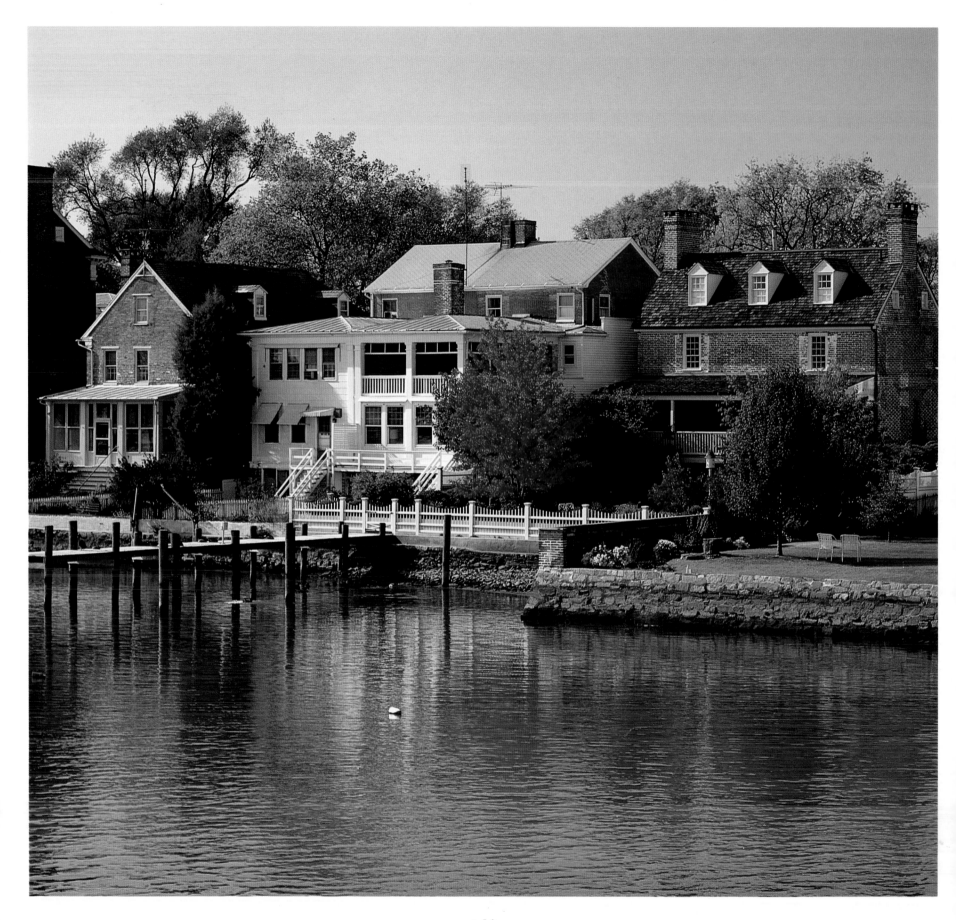

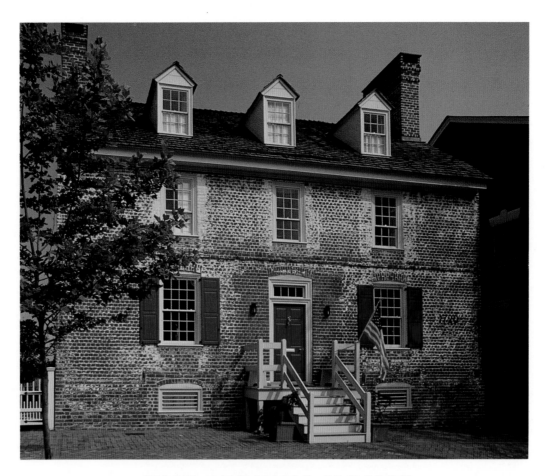

THE PERKINS HOUSE

In historic Chestertown on the high banks of the Chester River is this red brick townhouse, c. 1740, owned by Jane and George Dean. Four years of restoration, which included replacing rotten beams and two chimneys that collapsed during the process, were tortuous, but the Deans persevered, and in 1989, the house was finally completed.

The house is made up of four floors with two rooms on each floor. The top floor is devoted to two guest rooms and a bath; the third floor has the master bedroom suite; the second floor—on the street level in front—has the living room and library. A series of outside steps leads from the street to the garden, now terraced and bulkheaded. The bottom floor, which opens onto the garden, has a dining room and an ultra-modern kitchen. The lowest level was excavated during restoration to restore the original cooking fireplace and to create a new kitchen. In the process of excavation, it was discovered there was no existing foundation, which necessitated putting one in under the existing house. A garden room that extends beyond the dining room and kitchen can be enclosed with glass panels to make a winter sun room. When the panels are removed in warm weather, it becomes a delightful cool porch, opening out into the garden and on to the Chester River.

The Deans started from scratch with the little town garden between the house and the river. They brought in everything, including the trees. Now three years old, the garden is an established in-town garden with something in bloom from the flowering crabapples in spring until late in the fall, when the little maple at the water's edge turns bright red.

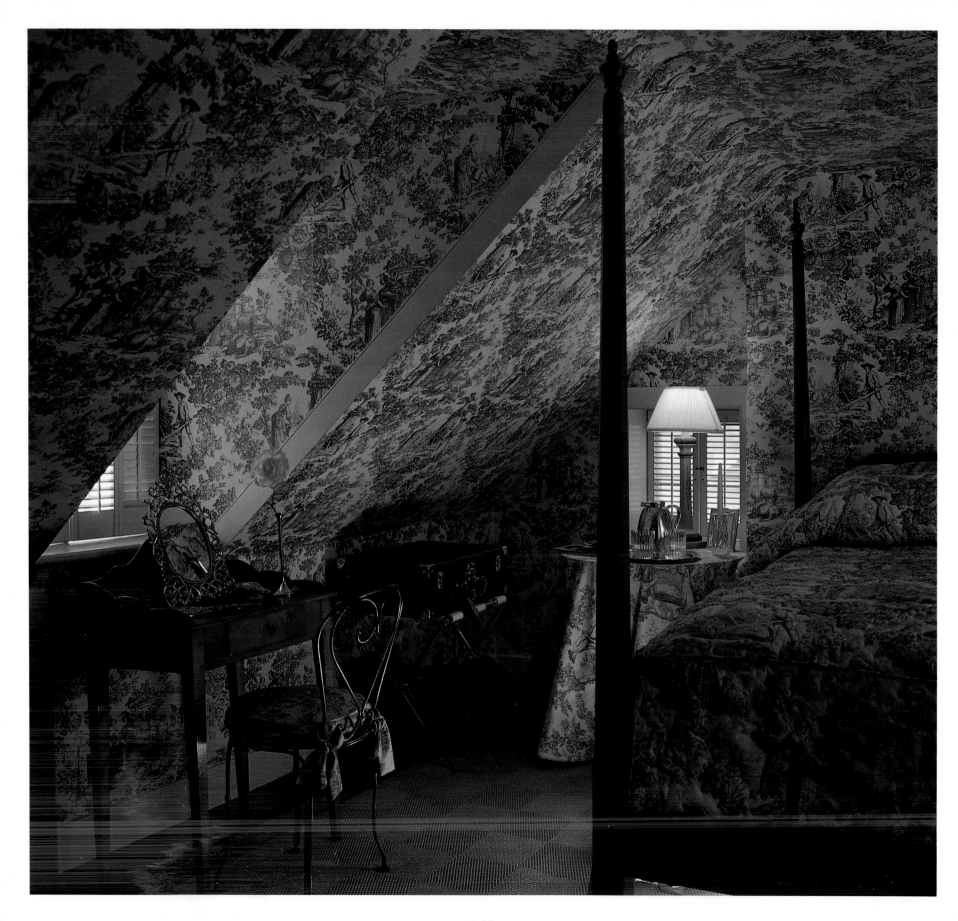

LEFT: One of the top floor guest rooms. The view from the dormer window four floors above the river is quite grand. The hand-blocked wallpaper was made for the room.

——————————

RIGHT: The master bedroom is furnished with English country pieces.

——————————

BELOW: The library on the street level is paneled with wood salvaged from the original house, saved during restoration, and stained. The early nineteenth-century portrait over the mantel is of George Rootes Clayton, one of the founders of Montgomery, Alabama, and an ancestor of George's. The wing chair was made by Frank Rhodes, a Chestertown cabinetmaker, who has made much of the furniture in the house.

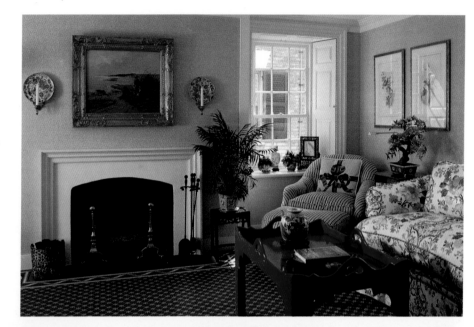

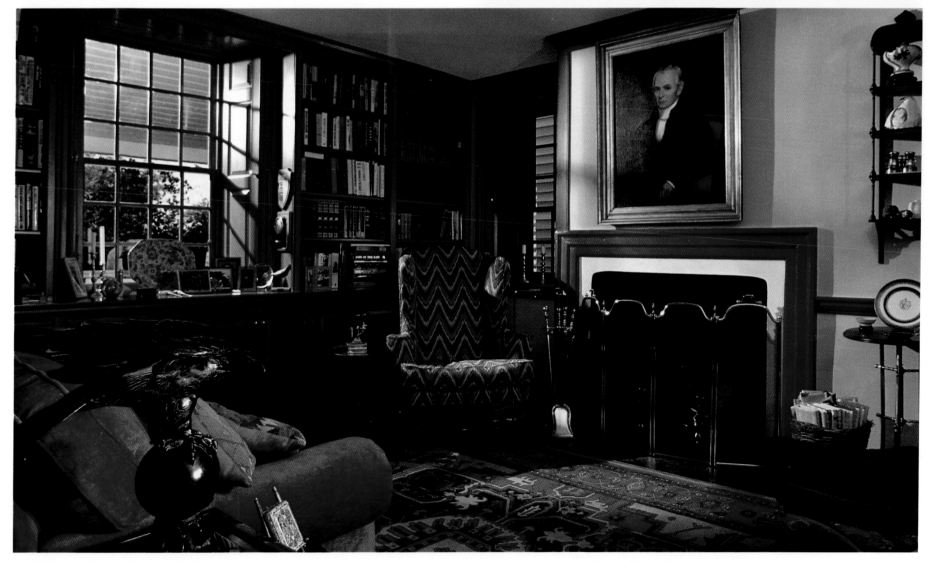

The dining room on the ground floor features a mural that extends around the room and continues onto a paneled screen. It was painted by Sue Tessem, a professor at Washington College in Chestertown, and depicts the view from the dining room through the porch to the garden and the Chester River. The fireplace retains its original arch. The oval glass table and Brunschwig et Fils chairs accentuate the contemporary feeling of the room. The ultra-modern kitchen adjoins the dining room.

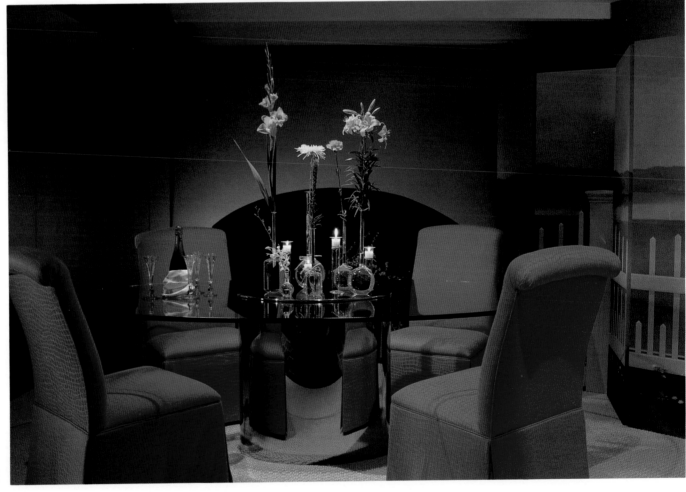

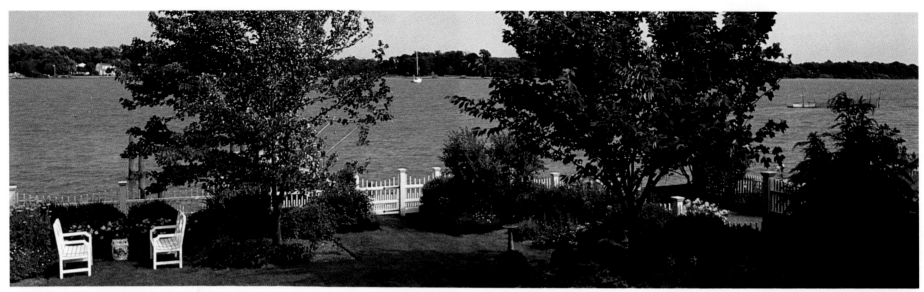

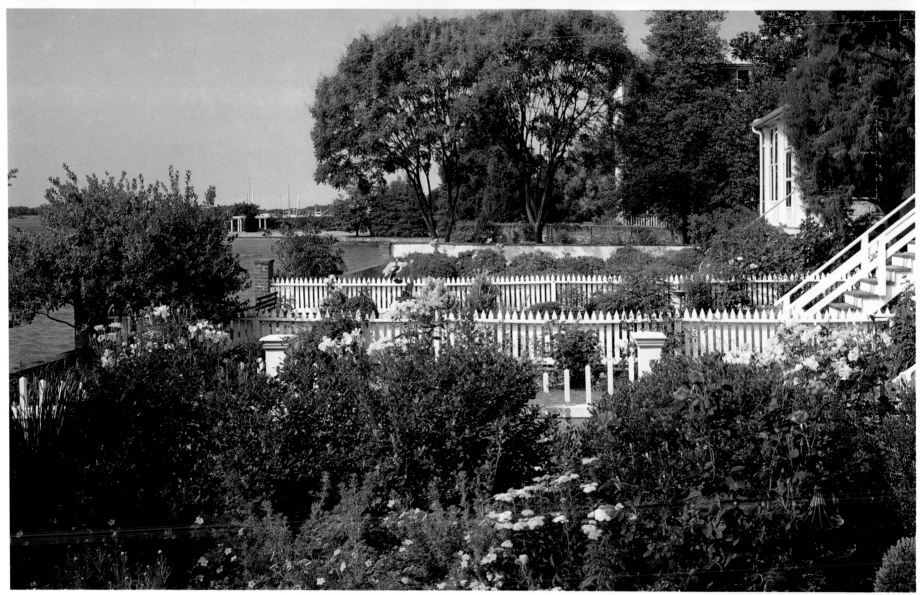

LEFT: The garden as seen from the second-floor deck.

BELOW LEFT: Cottage gardens row upon row behind the townhouses along the river.

ABOVE: From the gate at the street, June roses frame the entrance to the garden and are repeated around the perimeter. Symmetrically laid out, the garden features perennials to provide continuous bloom through the seasons, intermixed with annuals for color, and edged with box and holly. Several varieties of flowering fruit trees add early spring color.

RIGHT: The garden room has Charleston shutters at each end. In winter glass panels completely enclose it for a cozy sun room.

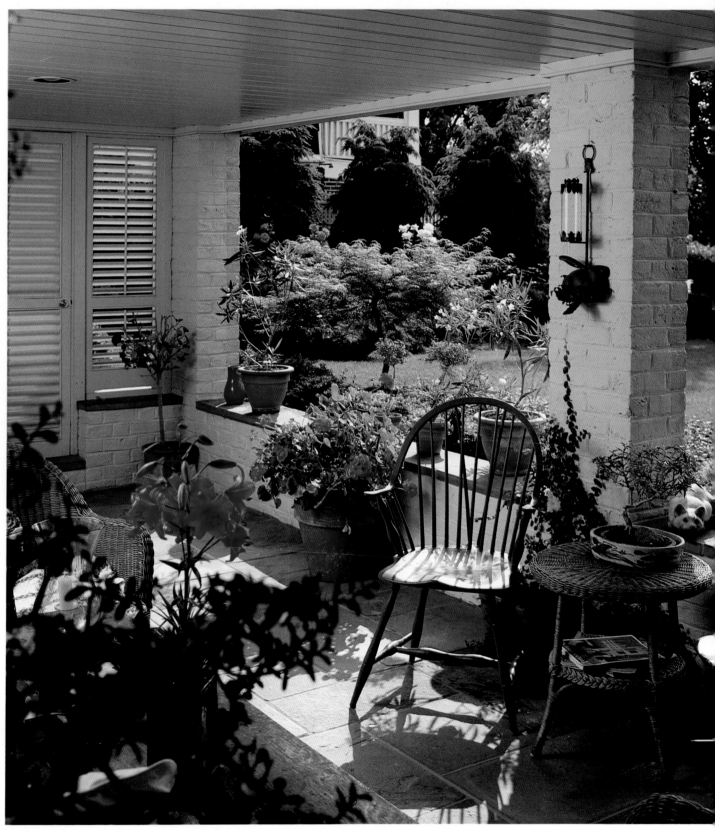

TOP RIGHT: The house as seen from the water's edge. The original house is to the right of the patio. The center part is the new dining room which was created by enclosing the breezeway that led from the house to the garage. The new kitchen-family room and extra bedroom and bath upstairs were made from the former garage on the left.

LEFT: The front entrance.

RIGHT: A combination of grasses in varying stages of full maturity create a lovely soft screen around the swimming pool. From left are tall *Miscanthus sinensis* 'Autumn Light' with a dwarf *Miscanthus sinensis yaku-jima* in front. *Calamagrostis acutiflora* 'Karl Foerster' adds a columnar inflorescence in fall, though it peaks in mid-summer. To the right of the calamagrostis is *Pennisetum alopecuroides* 'Weserbergland', daylilies 'Stella d'Oro' still blooming, and *Sedum spectabile* 'Autumn Joy'.

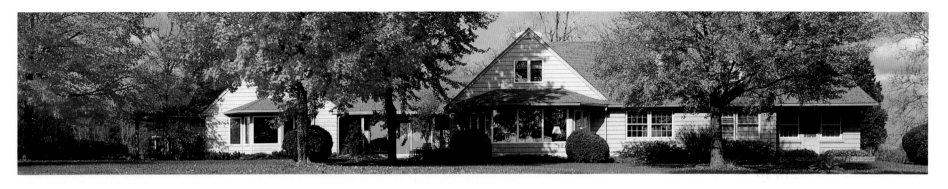

PLAIN DEALING FARM

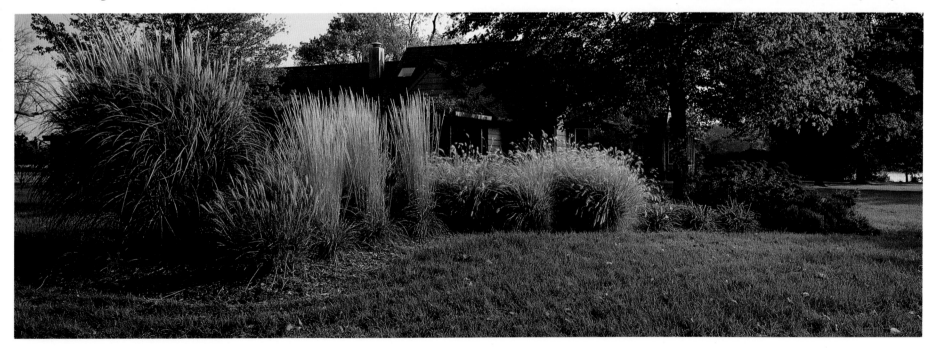

This farm at the head of Plain Dealing Creek dates to one of the earliest Eastern Shore land grants, from Queen Anne. The family of Samuel Chamberlaine purchased the land and built the first house on this site in 1735. Gravestones of Samuel Chamberlaine's wife, Henrietta Maria, and son Thomas were found on the property down by the water. The original house was enlarged and Victorianized in the 1860s and was destroyed by fire around World War I. The creek takes its name from the farm that runs along its shore. The Chamberlaines were Quakers, and they traded with the Indians on this site; hence the name— Plain Dealing Farm.

Colin Ferenbach bought the property in 1970 because he liked to come down from New York to sail and to shoot. The existing house on the property was a simple one-and-a-half-story cottage. A few years ago, when Colin and Vicki were planning to add a pool and terrace, an architect friend, visiting one weekend, serendipitously suggested what—if they let their imaginations run— they could do by making some very serious changes to enlarge the house's interior, and take every advantage of the site and its water views. They thought about it and decided it was a good plan.

The determining factor in the new addition and in decorating the entire house was its contrast to New York, in large part because of its light and space. Vicki very much wanted to maximize that feeling. It is a second home, one to which owners and guests alike come to relax, so it has been kept simple to minimize upkeep.

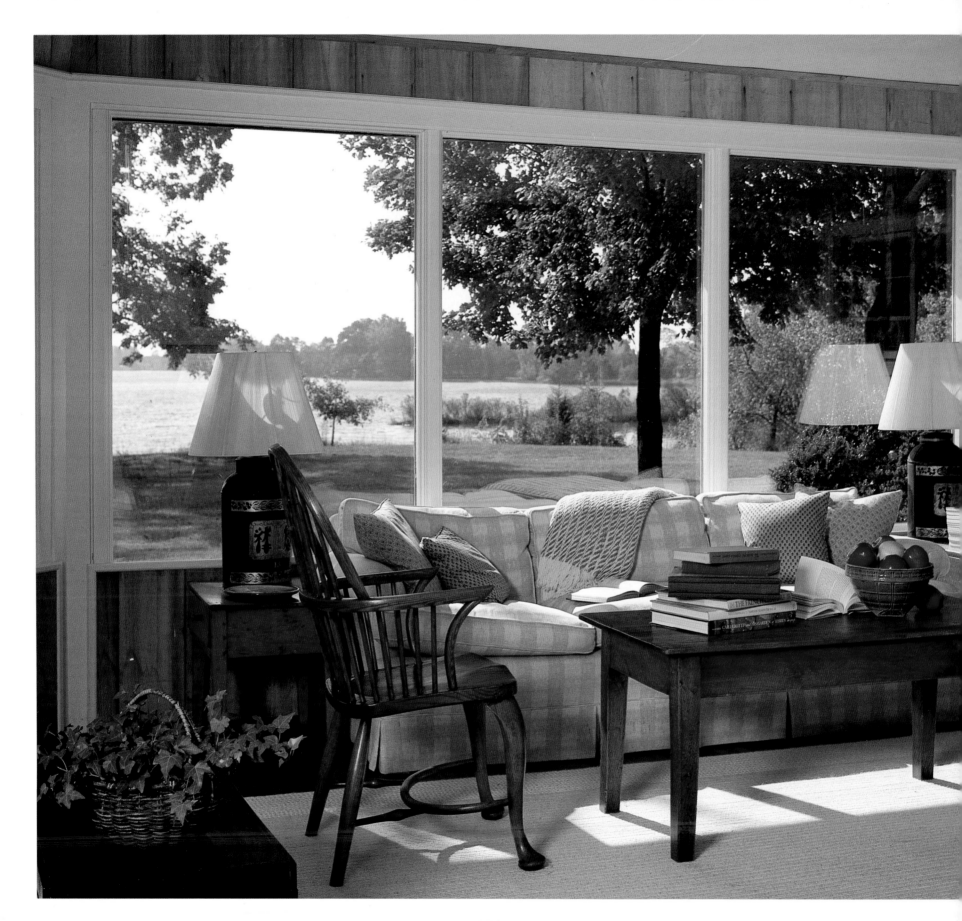

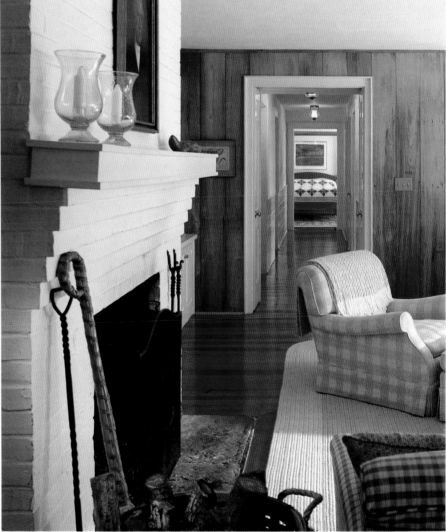

The original part of the house has retained much of the same arrangement of living spaces. Behind the brick fireplace and chimney is a stairway to the second-floor bedrooms. A long hallway off the living room leads to the master bedroom at the end, with other bedrooms and bathrooms along the way. The living room is comfortably but simply furnished, keeping in mind that even though this is a second home, it is a "real" house.

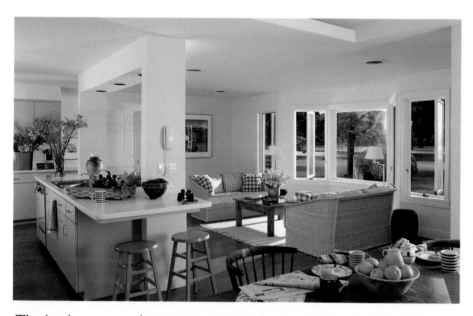

The kitchen is a multipurpose room with a sitting area between the work space and the windows overlooking the creek and an eating area between the work space and the doors leading to the pergola-covered terrace and pool. The placement of windows and doors together with the high ceilings maximize the light; it is always bright even on a cloudy day. The view from the work space out over the creek is a dramatic change from the former kitchen, which was in the back of the house and had no view at all. The kitchen is a room where everyone gathers, and not just at mealtime, which makes entertaining lots of fun.

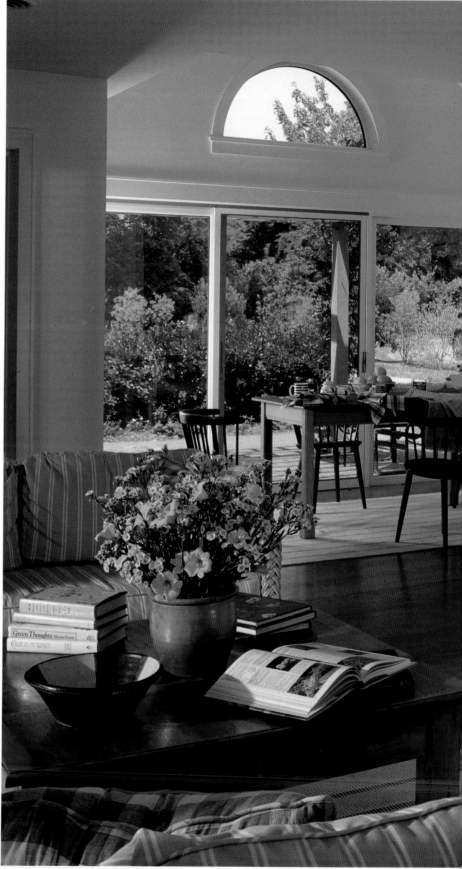

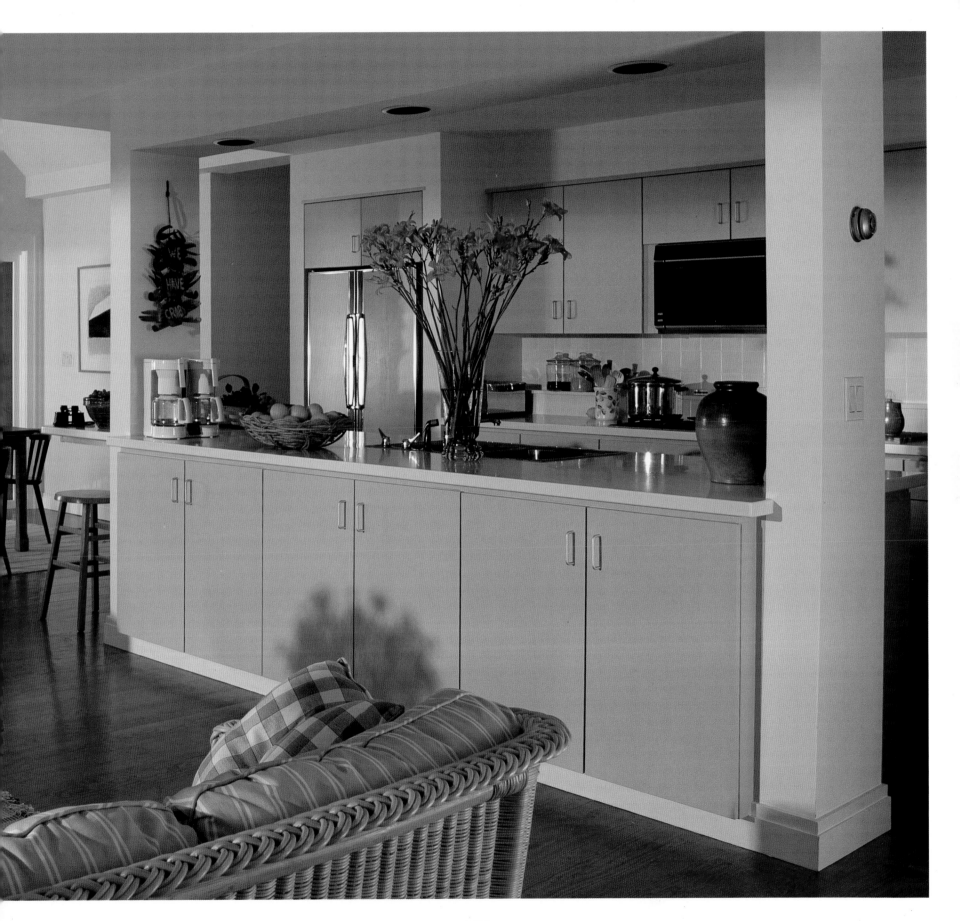

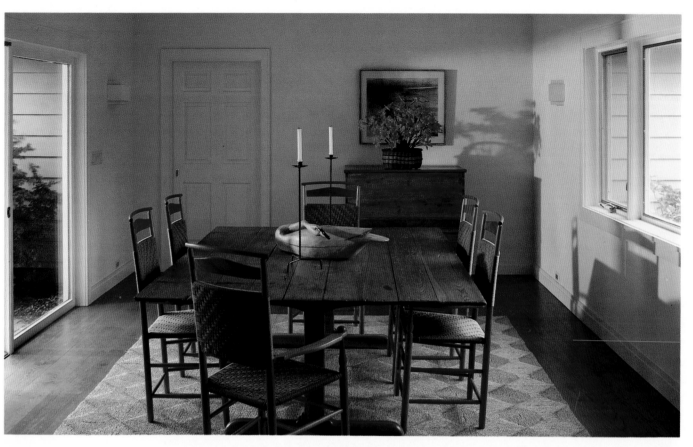

LEFT: The dining room, created from the breezeway, is ideally situated, not only because of its placement between the main part of the house and the new kitchen wing, but because of its openness. It has a spectacular view of the water and the windows on both sides let in the cool evening breezes. The table is made from an old barn door; table and chairs were made for the Ferenbachs by Ian Ingersoll.

BELOW LEFT: The guest room above the kitchen is a favorite room because of its view and its distance from the rest of the house.

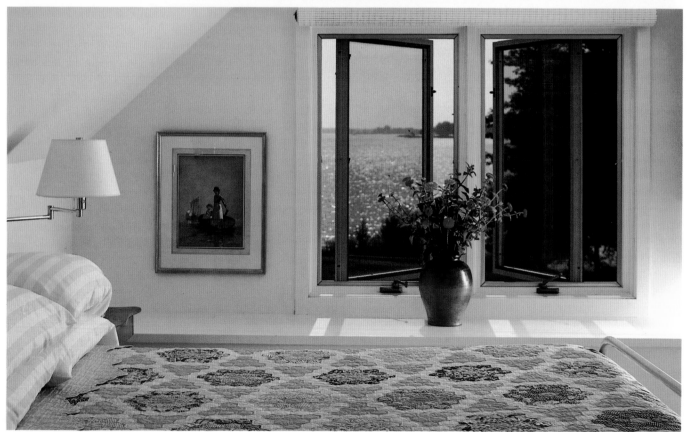

RIGHT: A honeysuckle-covered pergola shields the brick terrace from too bright sun in summer and forms a delightful canopy in the fall beside the house. Between the terrace and the pool is a hedge of *Euonymus kiautschovicus* 'Manhattan' underplanted with ageratum and lantana still blooming in November.

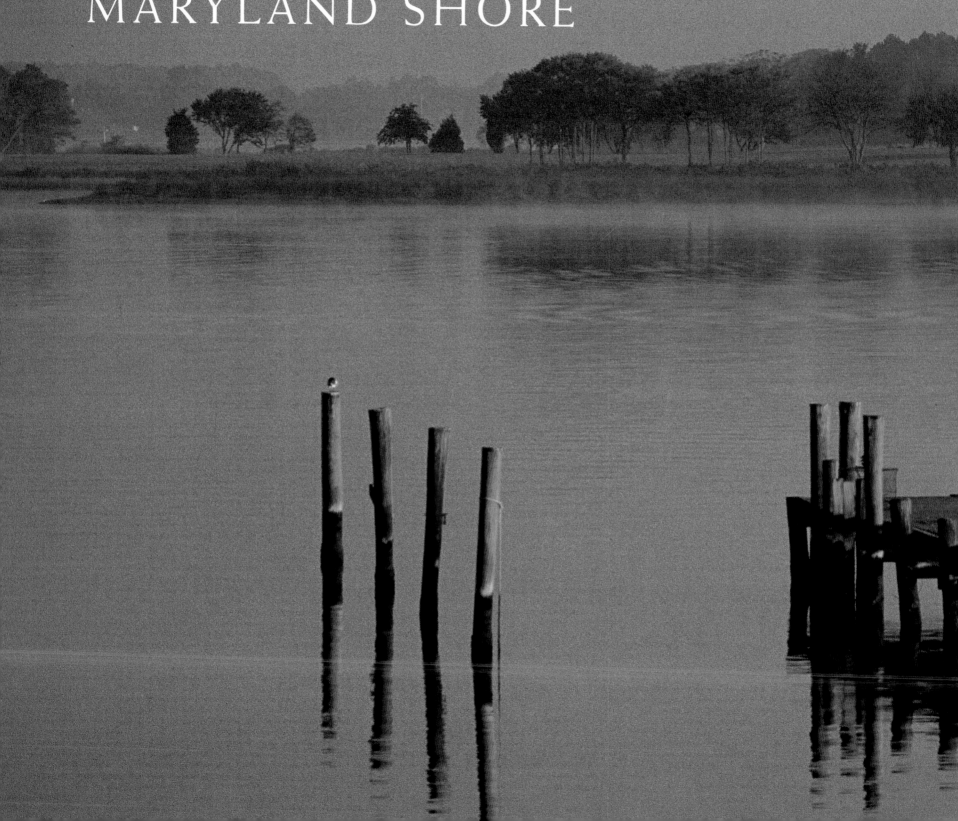

THE LOWER
MARYLAND SHORE

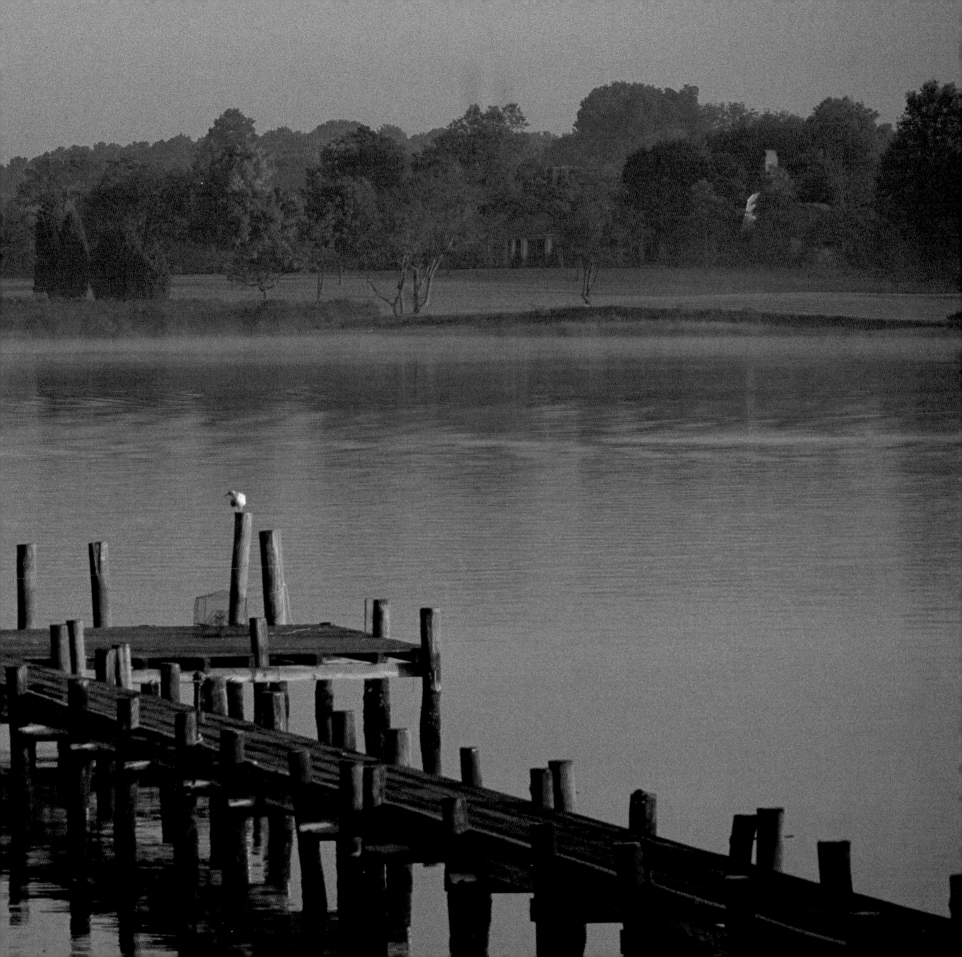

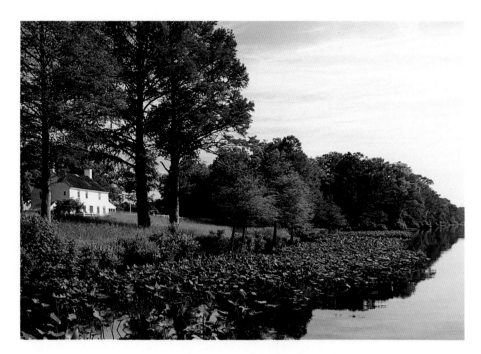

CELLAR HOUSE

ocated on the banks of the Pocomoke River, this small plantation house dates to the early 1730s. Typically oriented toward the water, the house was built on a former Indian building site. During restoration of the house, an Indian burial bundle was found in the cellar.

The Pocomoke, a deep river for this part of the Eastern Shore, is the southernmost of the nineteen navigable rivers there. The town of Snow Hill, upriver from Cellar House, was an early shipbuilding site, with local woods, especially the swamp cyprus that is native to the area, used for the ships.

Cellar House goes back to a land grant from Lord Baltimore in 1666. The original house is said to have been built by a French sea captain for his bride. Whoever the builder was, he added uncommon refinements for the area, such as the full paneling in the great room and great room chamber, elaborate cornices, and chair rails throughout.

Many mysterious and romantic tales are connected to this part of the shore and to this house in particular. Due to the isolation of the site, the deep navigable waters and the many twists and turns of the river, the site would have been ideal for pirates, like much of the Eastern Shore. To lend further credence to the tales, a tunnel under the house runs from a trapdoor under the stairs out to the swamp. Continental troops occupied the house during the Revolution. Always a plantation, its crops changed through the years from tobacco to corn and other grains.

During its history, Cellar House has stood empty several times. By the mid-twentieth century the house was dilapidated and in serious need of repairs. In the mid-sixties, John Graham, an architect from Salisbury, acquired the property and began a major restoration, securing the house against the elements and redefining the spaces. In the seventies, Martha and Jack made more changes for their large family and restored the rooms closer to their original functions. In 1987, they reworked the kitchen, enclosed the screen porch, and changed the rooms further and added more period furniture to the house.

LEFT: **A contemporary sculpture by Larry Morris occupies this site on the riverbank adjacent to the house.**

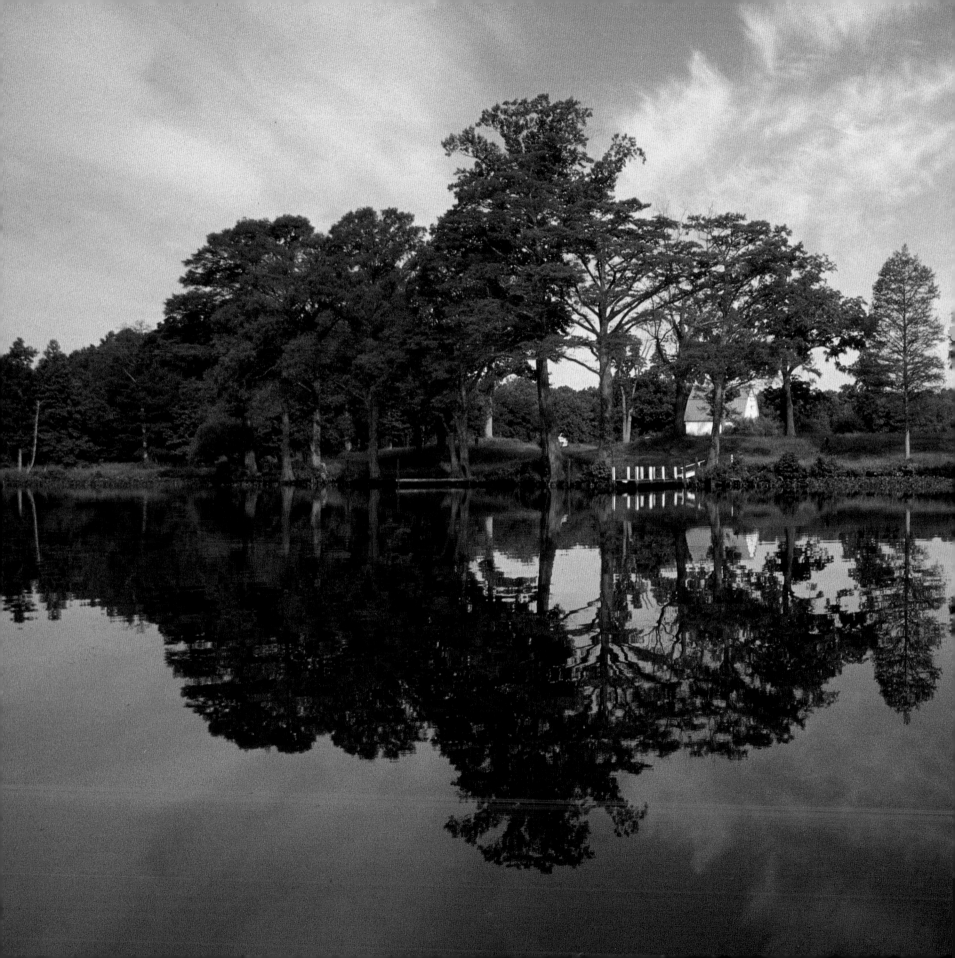

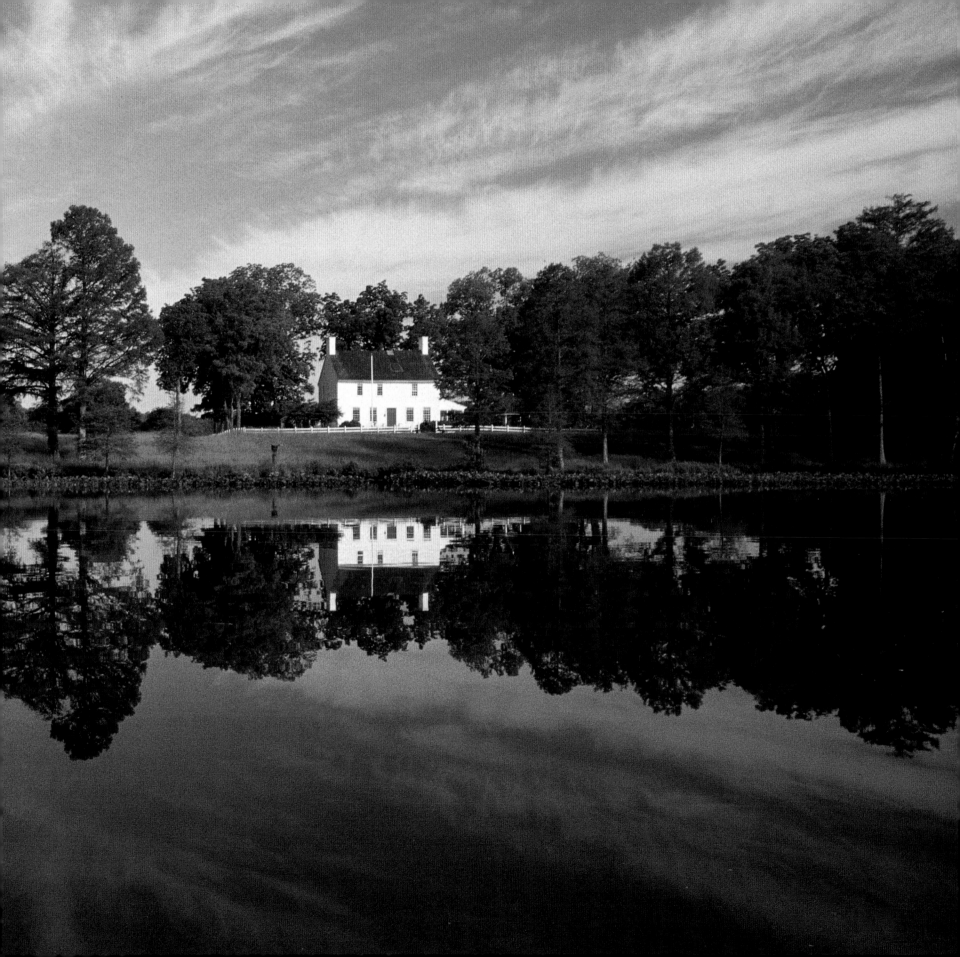

OVERLEAF: Cellar House sits on a high bank overlooking the Pocomoke River. One of the property's barns is on the left.

LEFT: Detail of the door on the riverside entrance. This door and its hardware, like many doors in the house, as well as many of the windows and their muntins and some of the glass, is original.

ABOVE: A 1939 Pierce Arrow, one of Jack Graham's antique cars, sits in the drive. The asymmetrical arrangement of the door and windows was created for function rather than form. The house is frame with two brick ends as is typical of the region and the period. The two chimney stacks service five inside fireplaces.

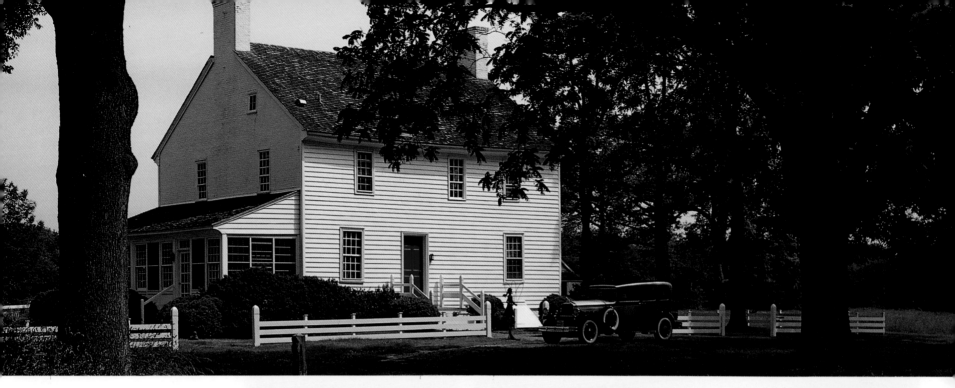

RIGHT: The south end of the house shows an interesting arrangement of windows around the double chimney that comes together on the second floor. The smaller windows are in closets beside one of the fireplaces on the first floor and on either side of the fireplace on the second-floor main bedroom. In the attic are three windows, two on either side of the chimney and the third at the very top next to the chimney. The Grahams call it a "lie-on-your-stomach" window because from that position on an attic beam, a full view of the river and around the bend is possible.

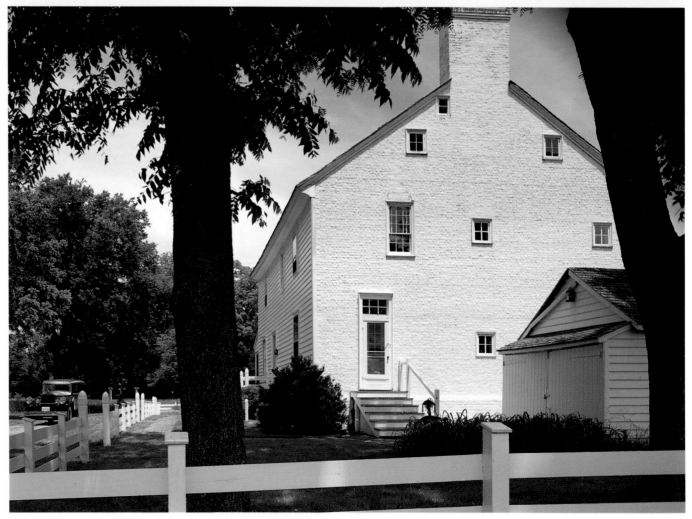

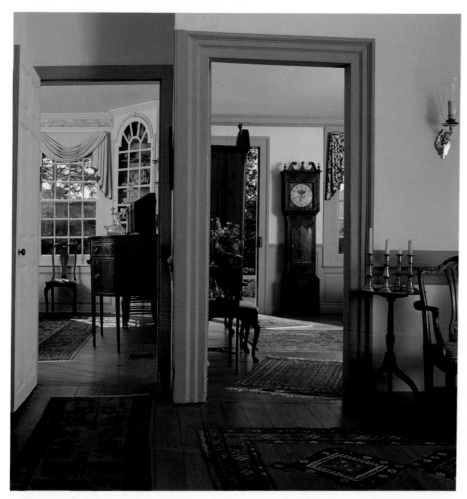

LEFT: Looking from the front door into the dining room on the left and the great room on the right.

BELOW LEFT: A screened porch has been closed in for a sunny year-round room. Some of Jack's collection of antique toys decorate the shelf above the windows.

BELOW: The hall is a true central hall with all the rooms, both downstairs and upstairs, opening off it. The black walnut staircase goes up the outside wall, then turns and goes up along the inside wall, then down the upstairs hall where it turns again and goes to the attic. The spider-legged walnut candle stand, c. 1800, holds a collection of nineteenth-century candlesticks. The room at the end, beyond the stairs, was called the "planter's room."

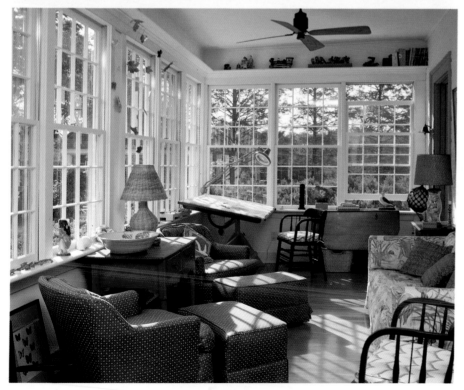

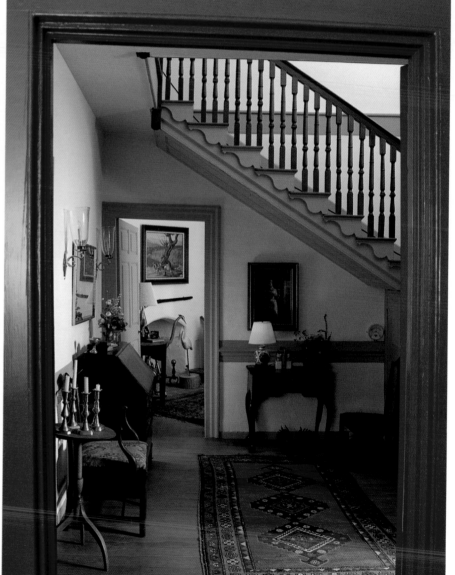

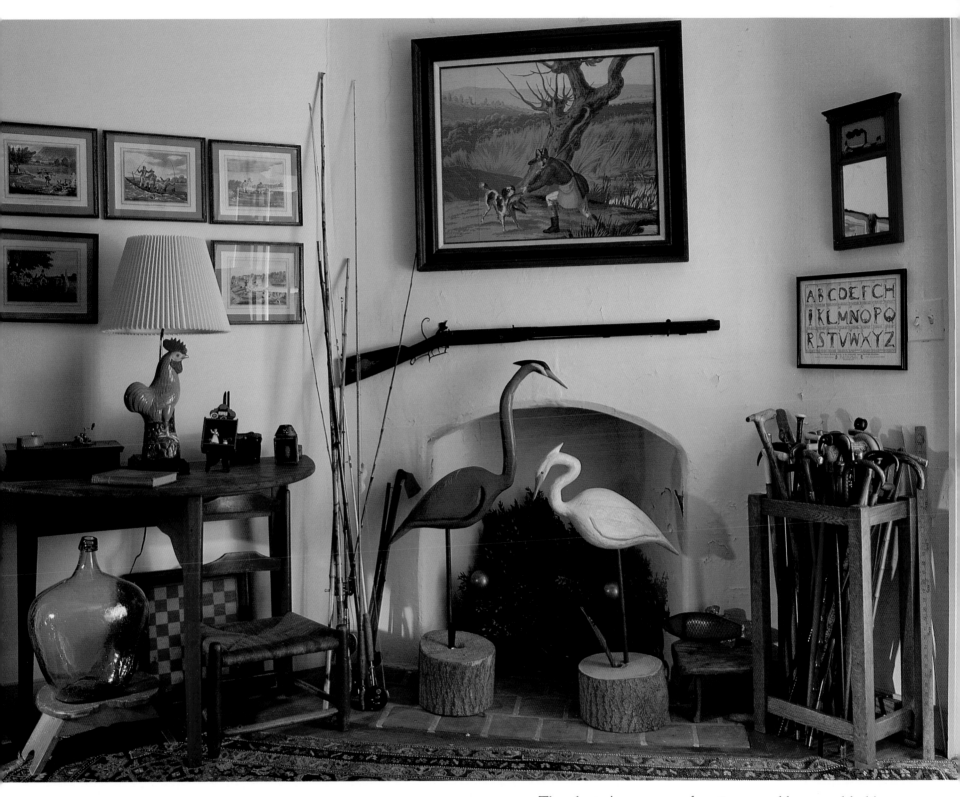

ABOVE: The planter's room now functions as a library and holds some of the Grahams' collections of nineteenth-century fly rods and bamboo poles, eighteenth-century walking sticks, and two cranes by Rick Fish, a contemporary carver from Chincoteague. The table is a primitive Eastern Shore demilune.

FAR LEFT: Sunlight in the dining room plays on a row of nineteenth-century Empire chairs with rush seats.

LEFT: The built-in corner cupboard in the dining room is original to the house. Queen Anne in style, it has been painted in two shades of the same color to exaggerate its dimensions.

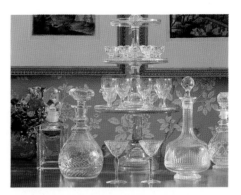

RIGHT: An assortment of crystal decanters and a stacking glass etagere sit in front of a pair of colored etchings depicting King George sending the Hamilton expedition to Italy to record ancient artifacts.

BELOW: The dining room with its original fireplace and mantel has been furnished with two tables to afford intimate dinner conversations. On the table in the foreground is a whimsical Victorian cranberry glass etagere filled with honeysuckle. In the right foreground can be seen part of the eighteenth-century New York Hepplewhite sideboard.

OVERLEAF: The great room has its original paneling on the fireplace wall. The doors open into windowed closets on either side of the chimney. An eighteenth-century tilt-top, birdcage piecrust table is in front of the fireplace; above it hangs a portrait of Levi Cathell, an ancestor of Martha's.

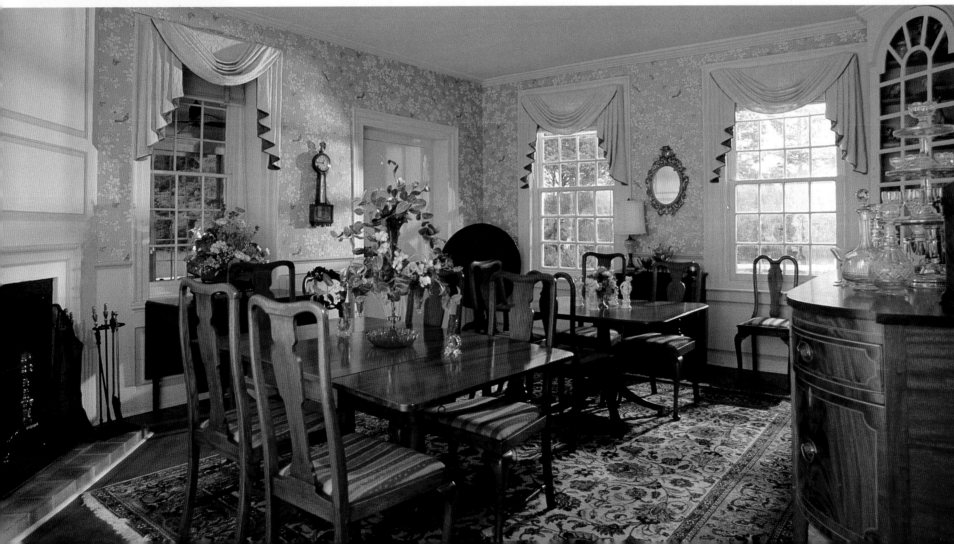

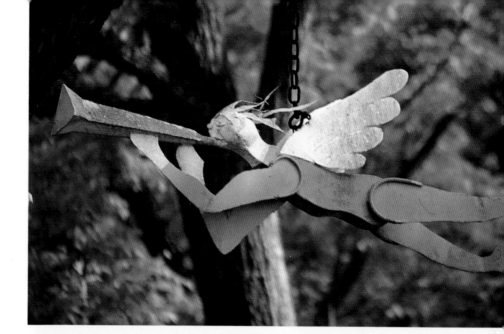

The Grahams have been collecting contemporary American welded iron and steel sculpture for the past ten years. Martha bought their first piece at a local art show from Henry Heller and the collection has grown from there. The angel Gabriel, the frogs, the pelican, the owl, and *Diana and the Hunt* are by Henry Heller; the eagle and the Indian with bow are by Bennet Siegel; the pillars are by Jack Graham.

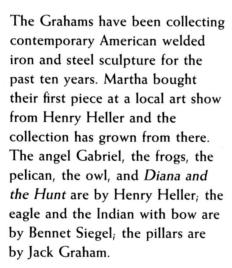

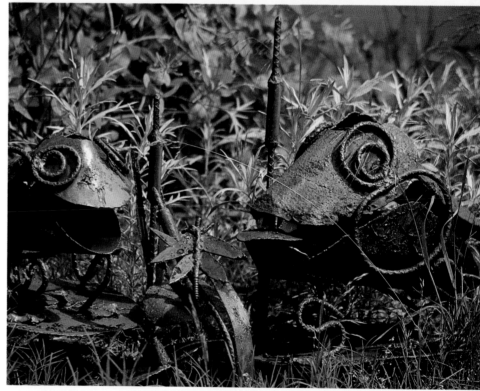

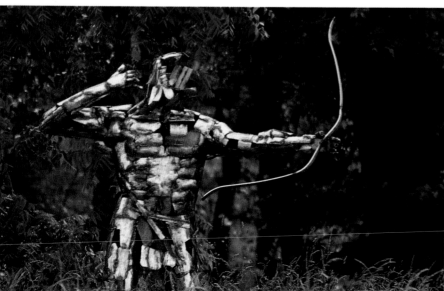

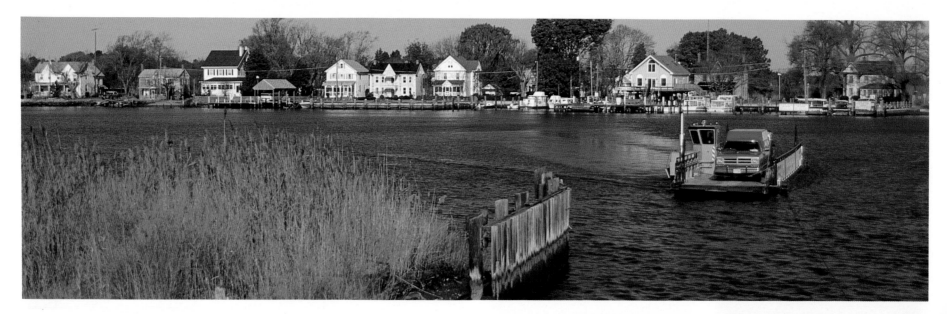

WHITEHAVEN

The village on the banks of the Wicomico River is part of a 1663 land grant called Noble Quarter—later divided into two unequal parts, Ignoble Quarter and Might Have Had More. Whitehaven was one of six towns designated as official ports of entry by the Colonial Assembly in the mid-seventeenth century. Its ferry, a log canoe in the early days, is today a motorized three-car affair and has been in operation for over three centuries. A thriving community through World War I, Whitehaven was home to early settlers, generations of watermen, and wooden ship builders.

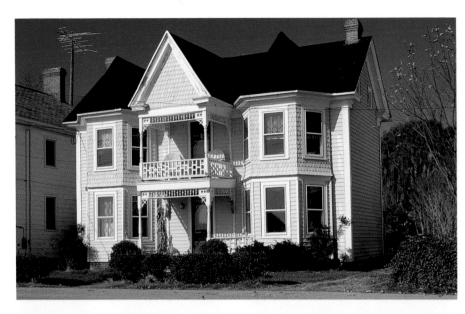

SCENIC ROUTE

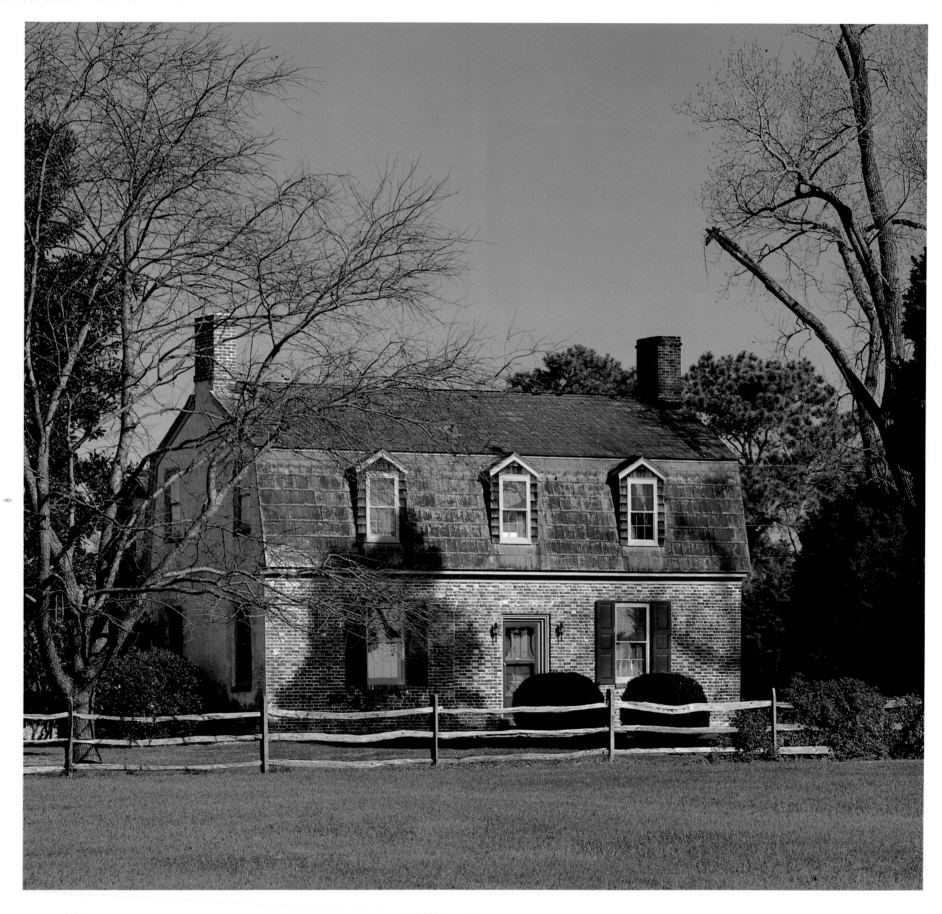

BOLTON

A brick, gambrel-roofed house called Bolton was built facing the Wicomico River between 1730 and 1745 for John Shiles, who purchased it and its plantation. By 1798, the second and third parts of the house had been added. There was an earlier manor house on the property, built around 1660, but no record exists of what happened to it. The earliest part of the present house was, typically, two rooms upstairs and two down with two chimneys on the outside walls so that each room had a fireplace. The inside details of the house are twentieth century—the interiors were destroyed by fire in 1948 when layers of varnish were being burned off the walls.

The house has passed through many owners, among them the owner of the Whitehaven Shipbuilding Company, which during World War I built towing barges and had one of the largest payrolls in the county. During the Civil War, Federal troops were bivouacked in the house, and their commander fell in love with a girl from across the river at Mt. Vernon. He returned after the war to marry her and settle here on land that was part of Bolton.

The house is now owned by Pat and Gene Russell, who have lived in Whitehaven since 1976 and at Bolton since 1986. They have cleared the grounds, put in a pond, extensively landscaped the property, and added the gardens.

LEFT: Bolton is set back from the river's edge in a grove of poplar trees. BELOW: From the side, the two white frame later additions are apparent.

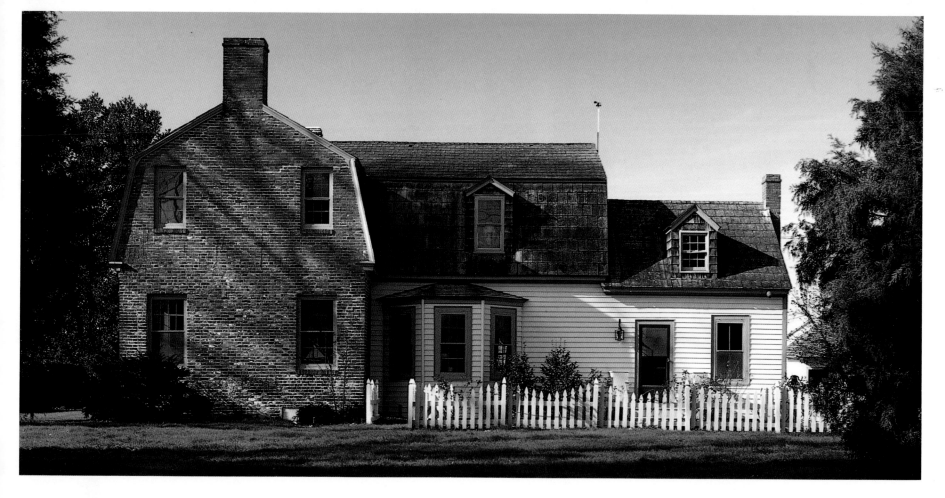

LEFT: A Chinese cachepot, silver candlesticks, and Waterford crystal decorate the table top in the dining room.

BELOW LEFT: Silver mint-julep cups and a pitcher, dating from 1891, from Gene's family and Rose Medallion plates are arranged on the sideboard in the dining room.

RIGHT: Pat and Gene are collectors of Eastern Shore furniture, pieces of which are the focus of the dining room. The table is made of red walnut, which grew only on the Eastern Shore of Virginia and was completely depleted by the end of the eighteenth century. It is known as "red" walnut because the mineral content of the soil gave black walnut a reddish hue. A collection of hand-watercolored lily botanical prints hang above a Federal-style sideboard made by the Salisbury cabinetmakers Teubner and Hopkins in the early 1900s.

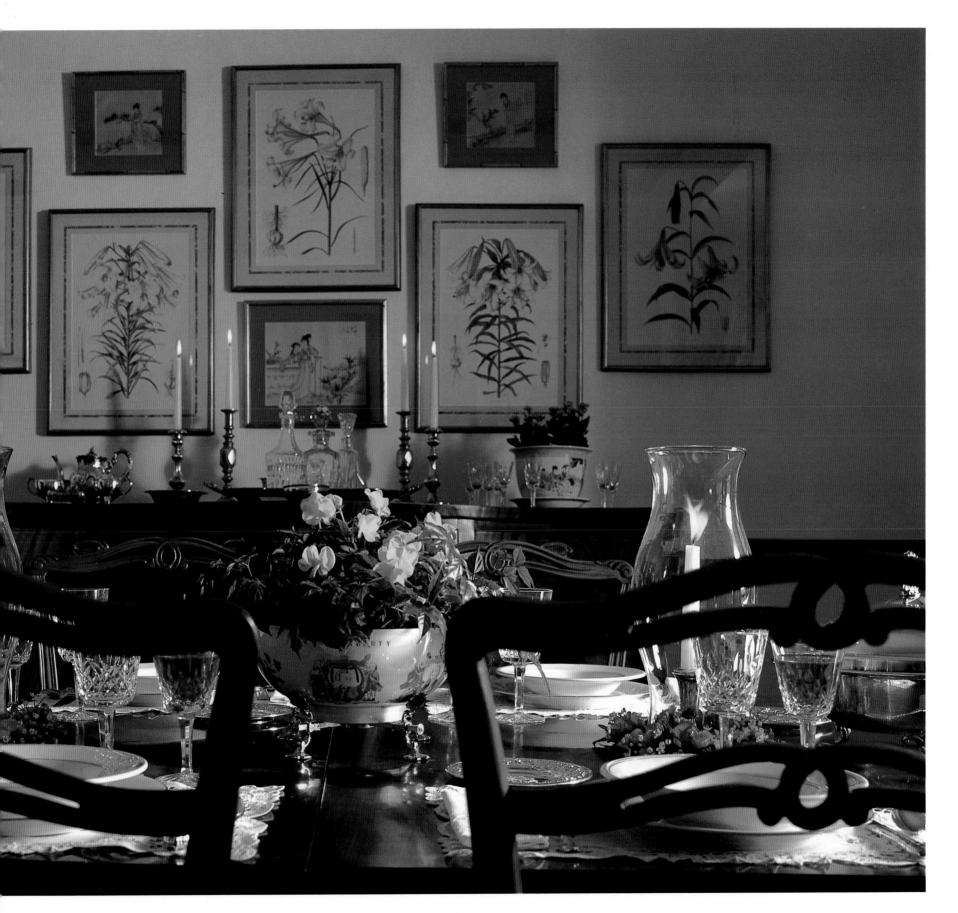

BELOW: The Russells call this the "river room" since it features collections of paintings and models that reflect life on the river here in Whitehaven. The model ship in the window on the left is an antique working model, and the one in the right window is a skipjack made by a local model-maker from Deal Island. The mural on the chimney breast was painted in eighteenth-century style by Megan Cathell Graham. The paintings to the right of the window are of the *Amy Mister*, a skipjack that was abandoned in the marsh a few hundred feet from the house.

RIGHT: A Thai chess set Gene bought when he was stationed in Vietnam is strategically placed beside the window that looks out to the peaceful Wicomico River. It sits on a Hepplewhite Pembroke table, c. 1790, that is a Tidewater Virginia piece.

FAR RIGHT: An arrangement of French Queen Anne chairs and a round tilt-top table sit in front of the fireplace in the formal parlor.

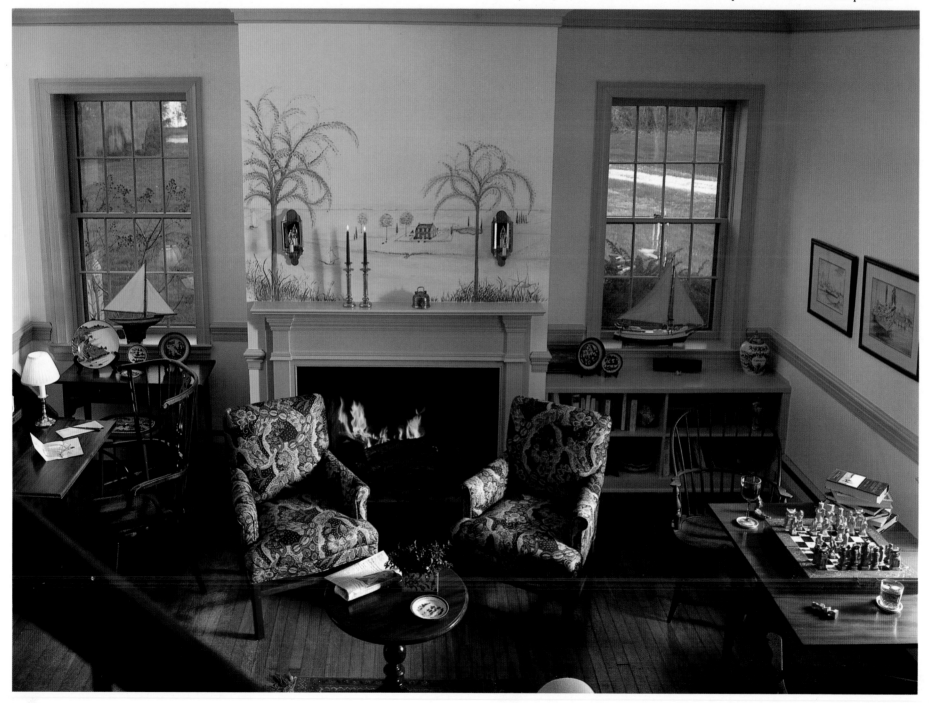

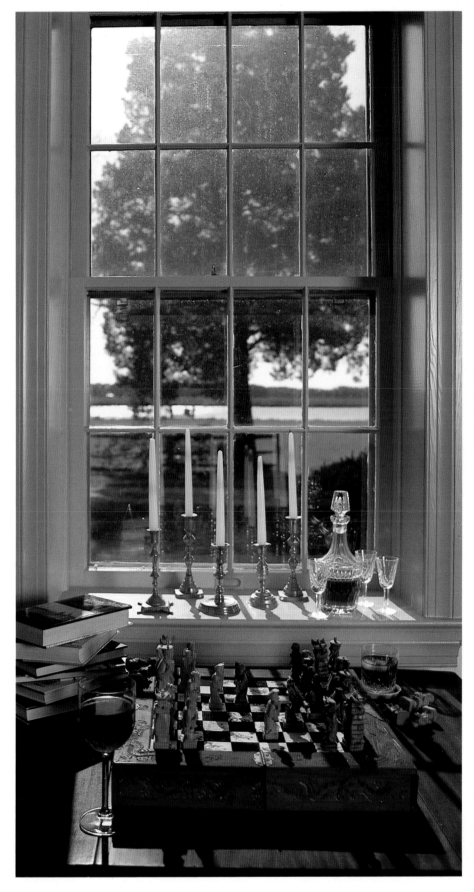
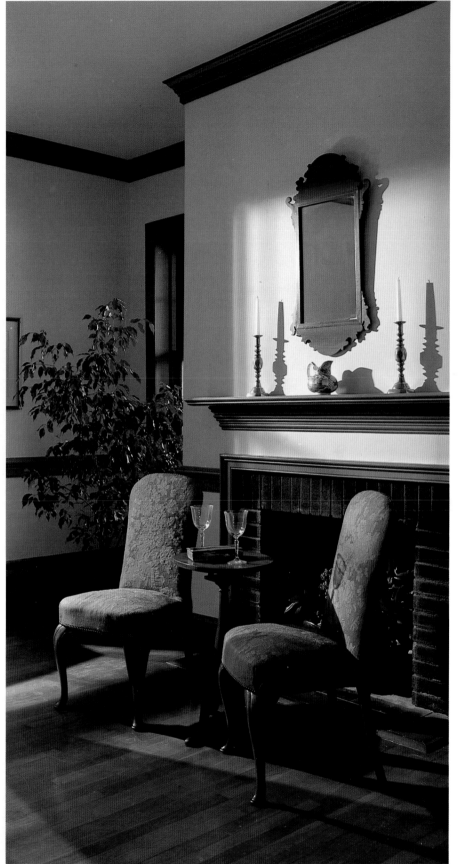

THE PHILLIPS HOUSE

In 1740 or 1750, about the time this little eighteenth-century town house was built, Snow Hill served as a port for shipping agricultural products. The highest navigable point on the Pocomoke River, it became the county seat when Worcester County separated from Somerset County in 1765. Later on it became an important shipbuilding center. This Georgian house was probably built for a plantation owner and his family to use when they came to town. The church across the street was built in 1740, although the parish was established in the 1600s. During the 1800s the house was Victorianized and was later restored to its eighteenth-century style by subsequent owners.

Dick Phillips bought the house in 1973 and has furnished it with period pieces in the formal downstairs rooms. An early-twentieth-century addition that forms an ell with the original house has been redone as a contemporary wing for twentieth-century enjoyment. It has a large windowed bay overlooking the private formal garden laid out in an eighteenth-century manner with boxwood in geometric patterns. A vegetable and cutting garden behind a gate is separate from the formally planted area.

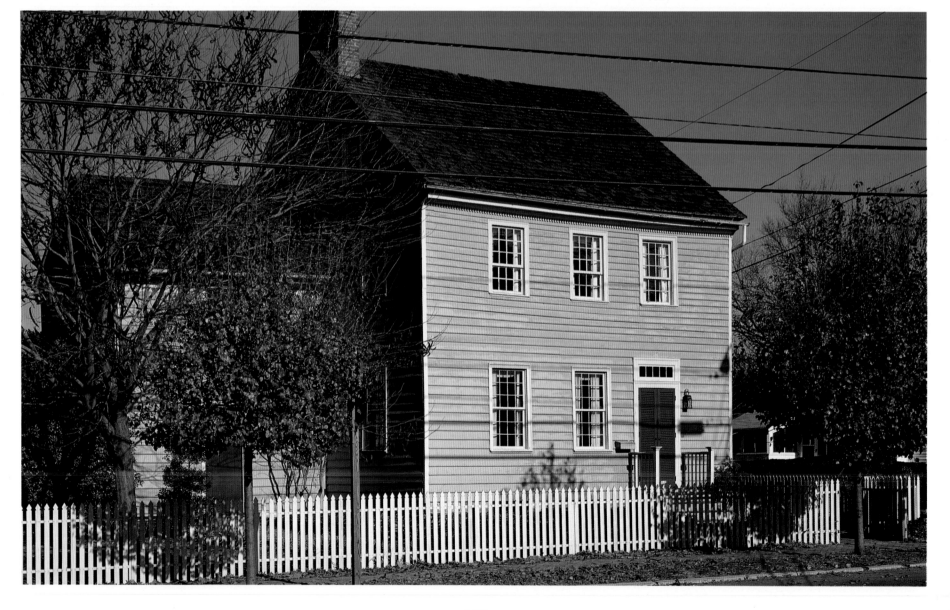

The front door opens into a side hall with the living room and dining room opening off to the left. The stairway, which is part of a Federal-period renovation of the house, leads up to two more floors. The door at the end of the hall is original to the house and now opens into the contemporary garden room. All the woodwork is original. The clock is an English late-eighteenth-century oak eight-day grandfather clock. The small corner cupboard at the back of the hall came from a house in Wicomico County and may have been a built-in cupboard. Its age is not known.

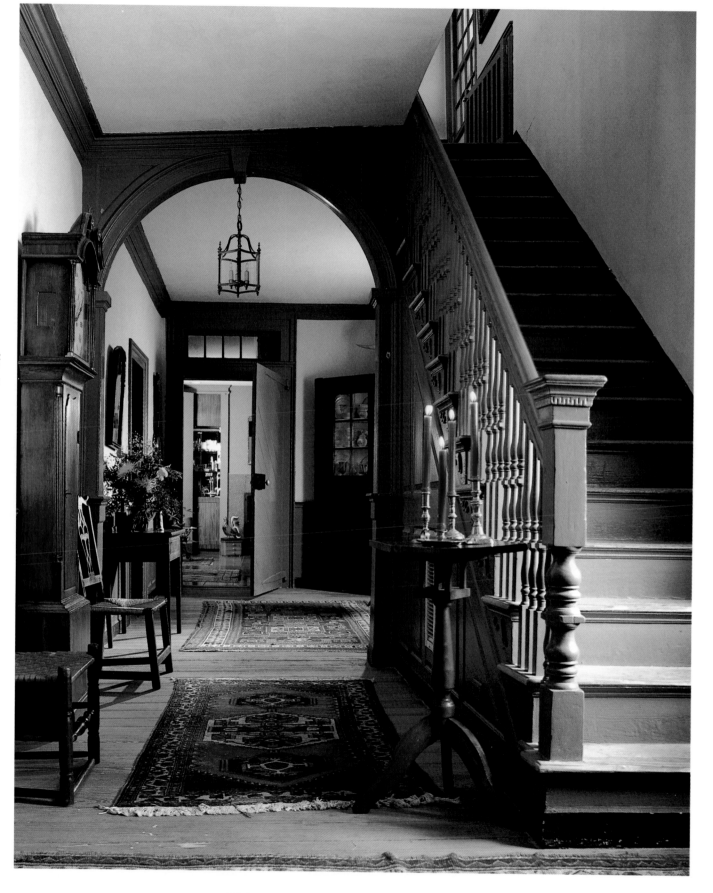

LEFT: Hanging above the little American writing desk is a 1754 Colonial grant from Governor-General Sharpe to one of Dick's mother's ancestors granting him properties from Lord Baltimore. The governor-general's seal is still intact. Beneath the desk is Dick's grandfather's early-nineteenth-century letter press.

RIGHT: The living room has especially detailed paneling on the chimney breast, which is original to the room. When Dick bought the house, the fireplace had been filled in and an elaborate Federal mantel was on the chimney breast. Dick had the fireplace restored, and when they took down the mantel, they found the original arch and black shadow under the bolection molding. This molding was copied from an upstairs fireplace that had never been altered. An early-eighteenth-century English chest on frame in the corner of the room holds a collection of Eastern Shore birds made by local carvers. The cellaret beside it comes from the Eastern Shore of Virginia. Country Chippendale chairs are pulled up to a late-seventeenth-century English oak gateleg tea table with pad feet.

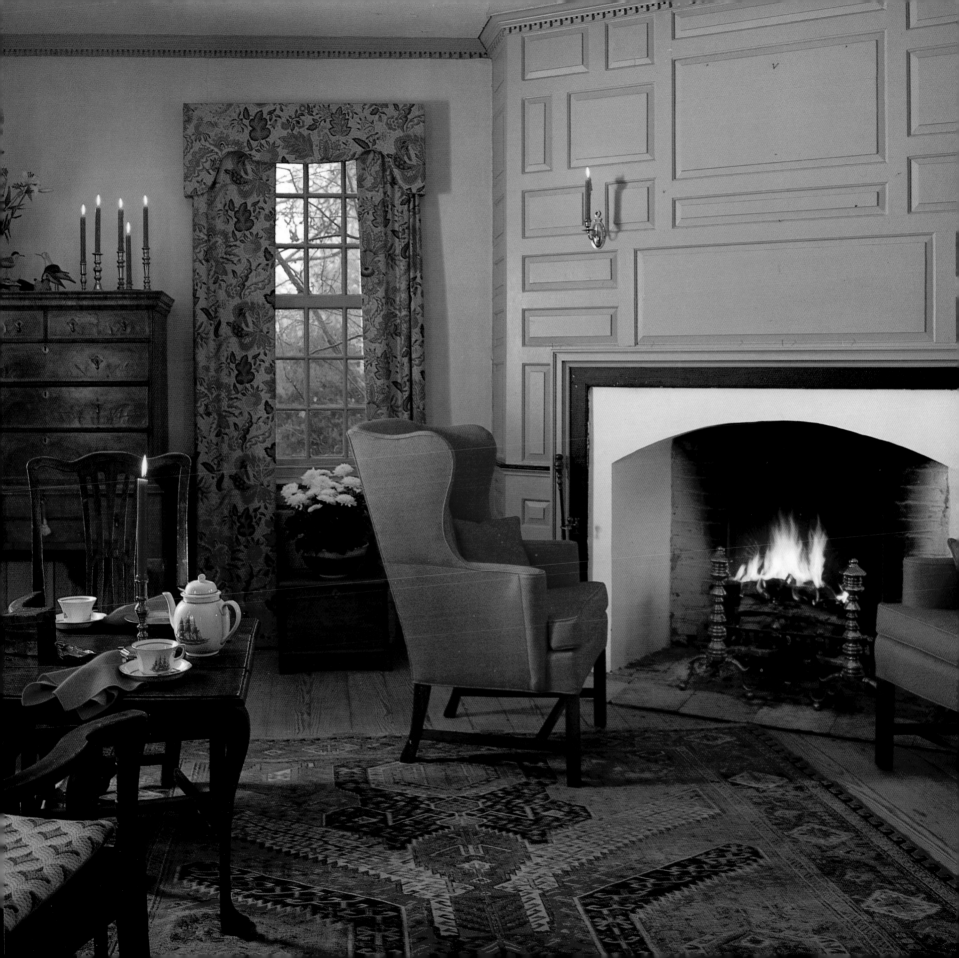

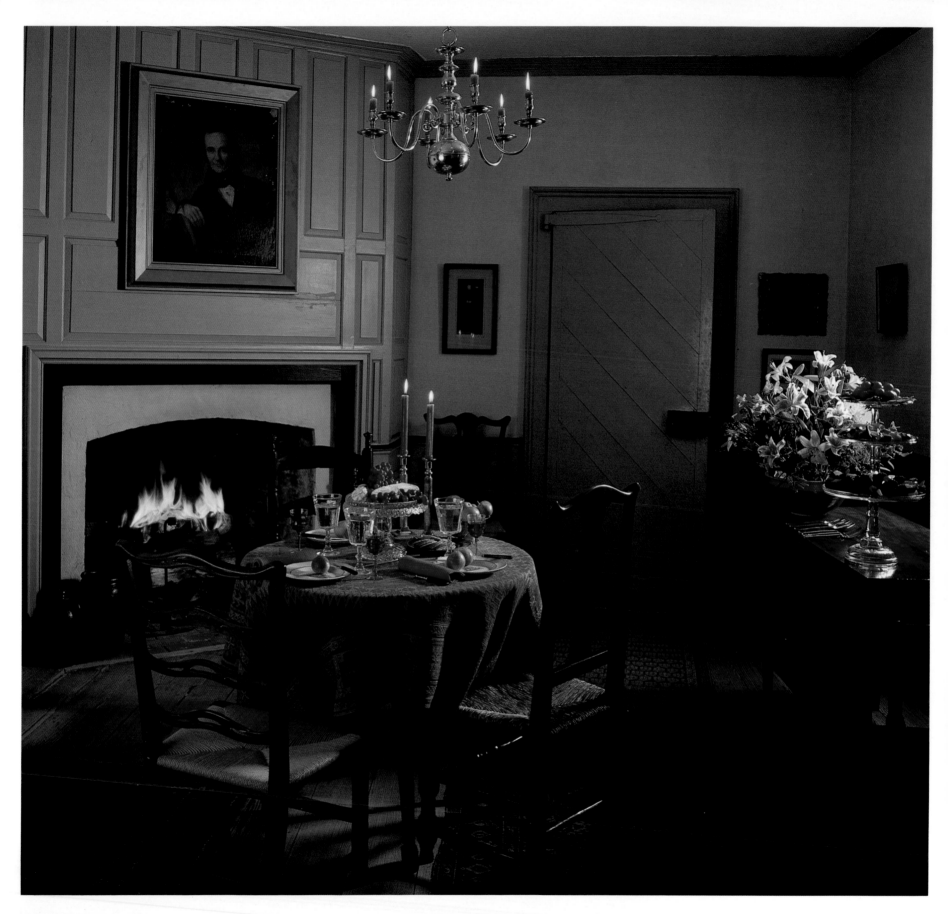

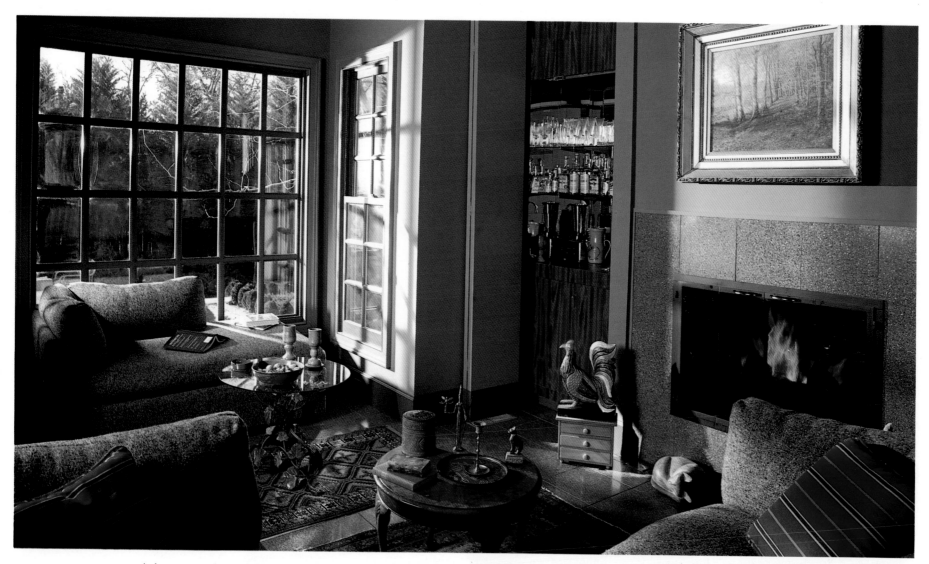

ABOVE AND RIGHT: A large windowed bay overlooks the garden and gets lots of afternoon light in this cozy contemporary room with all the amenities of the twentieth century. Above the fireplace is a landscape painted by Scandinavian Impressionist Jens Djelbo.

LEFT: The dining room, too, has original paneling on the chimney breast, although somewhat less elaborate than in the living room. A late-eighteenth-century gaming table is set for a fruit and cheese course and surrounded by a mixed group of mid- to late-eighteenth-century American country Queen Anne chairs. The mahogany Hepplewhite drop-leaf table is an Eastern Shore piece from Snow Hill. The chandelier is an electrified reproduction piece adapted back to candles.

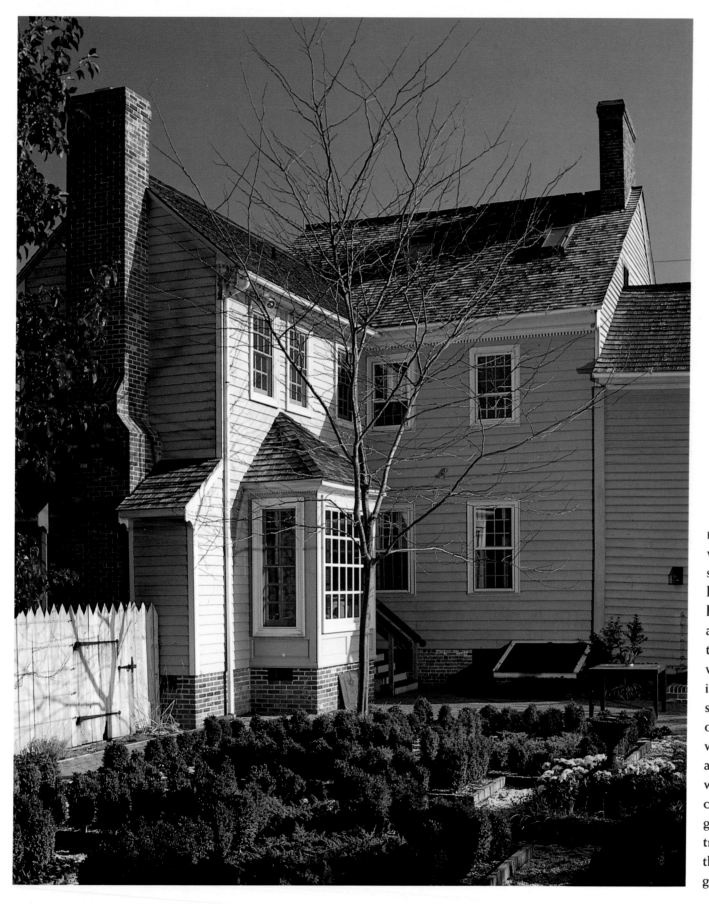

LEFT: The back of the house with the twentieth-century L-shaped room with windowed bay on the left. The oldest part of the house is on the right.

RIGHT: The parterres are planted with juniper in the centers and surrounded by English boxwood. In the right rear corner, the Bradford pear is surrounded by artemisia. The outer perimeter of the formal garden is box, edged with ajuga. In the center is a cast-iron, nineteenth-century urn, surrounded in the fall with a mass of bright yellow mums. Behind the white picket fence is the vegetable and cutting garden, now planted with ornamental cabbage, its beds covered with straw. The whole garden is enclosed by carefully trimmed tall Leland cyprus trees that completely shield this in-town garden from the outside world.

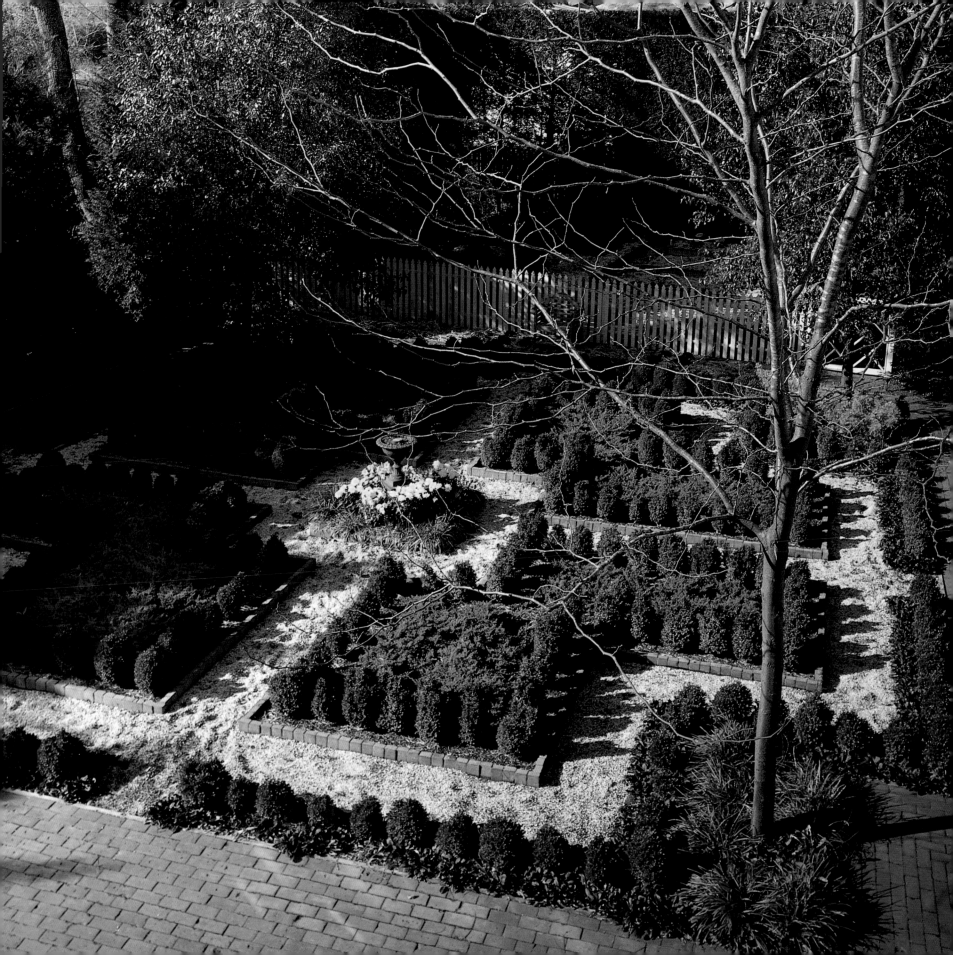

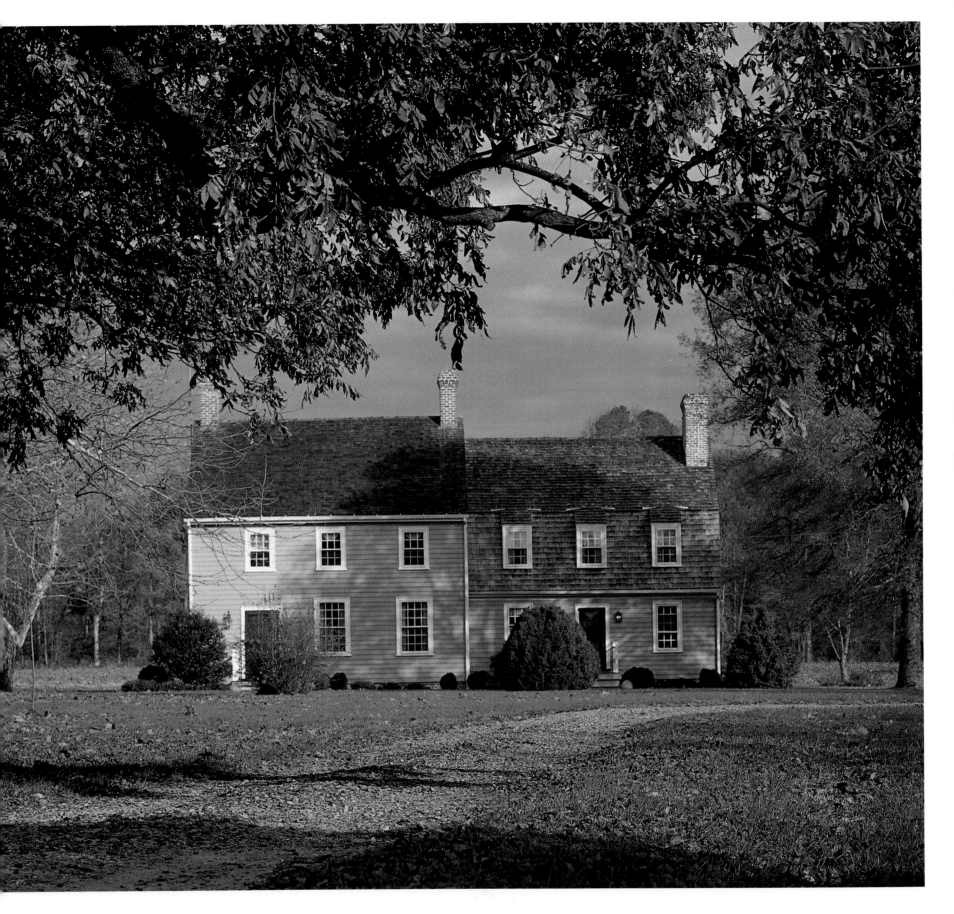

HARRINGTON

Harrington was built about 1750 for Thomas Holbrook, who was one of the signers of the Maryland Declaration of Independence. A relatively wealthy man for his time, he owned a tobacco plantation of more than a thousand acres. The house was laid out in a basic four-room plan with a side hall and a plantation office with its own separate entrance at the end of the hall, a living room, or great room, and a dining room.

When John and Regina Haffner bought the house in 1985, it had been carefully restored by a previous owner, who had stripped it down to the timbers, insulated it, and then carefully restored it.

The woodwork in the old part of the house is original and the paint colors were researched for authenticity. A later addition to the house was pulled down by the owner who did the restoration, and a new addition was added after a plan of a similar house near Chestertown. The previous owners collected old building materials from all over the Eastern Shore, including structural parts of beams and floorboards as well as eighteenth-century glass for the windows. The Haffners have decorated the house, keeping to the original paint colors and adding wallpaper and furnishings that they like for their colors or patterns. They have planted acres of trees on the property, which was formerly farmland.

OVERLEAF: Harrington as seen from the end of the lane.

BELOW: The old 1750 house is on the left. The addition that was replaced in 1970 is on the right. The end of the addition has a new chimney made of old brick.

RIGHT: The hall with its side staircase to the second floor. At the end of the hall is a room with a separate outside door that was used originally as the plantation office and is now a library—game room. On the floor of the hall is a contemporary Afghan war rug, so-called because although made in a traditional style, it has machine guns, tanks, and bombers incorporated into its design. Through the door on the right is the living room, and beyond it, the dining room.

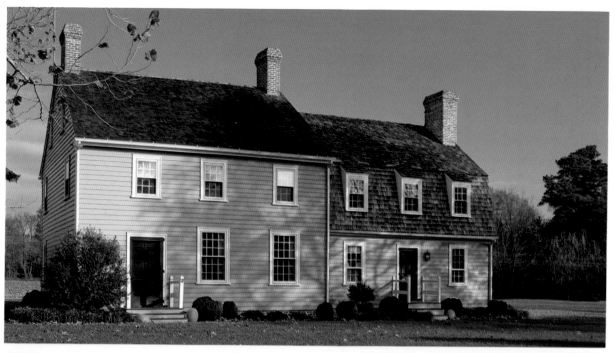

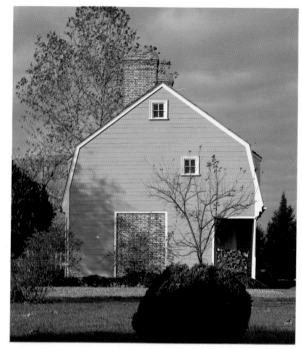

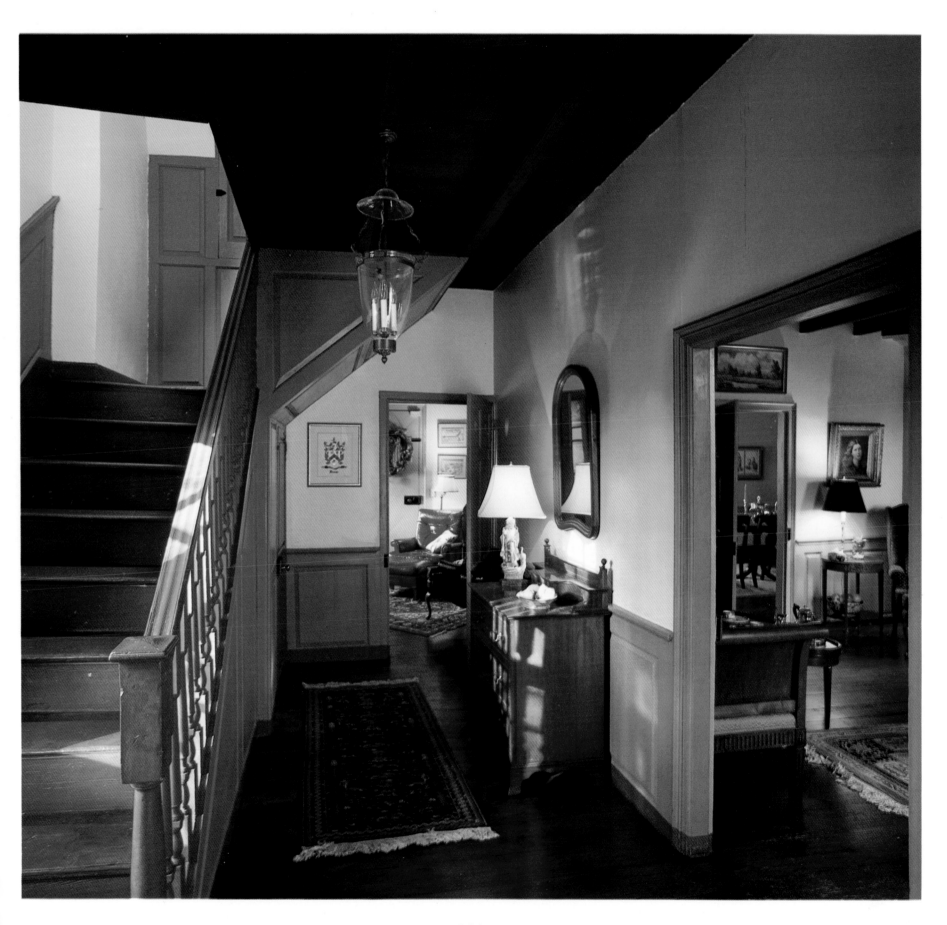

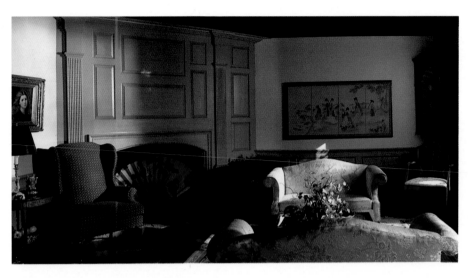

Three views of the living room, with its original paneling. The painting above the door to the dining room is by local artist John Losonczy; the one of the little girl was painted by Louis duBois, Regina's great-great-grandfather, in the second half of the nineteenth century. Some of Regina's collection of nineteenth-century Japanese porcelain is in the hanging corner cupboard—a Thousand Faces melon jar and plate and a signed Fukagawa flying cranes plate.

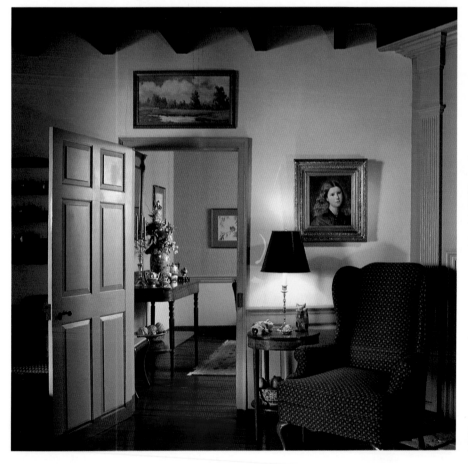

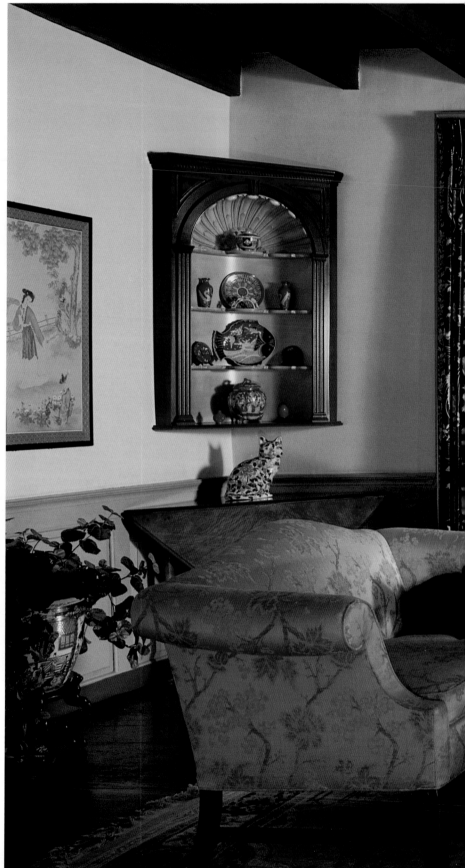

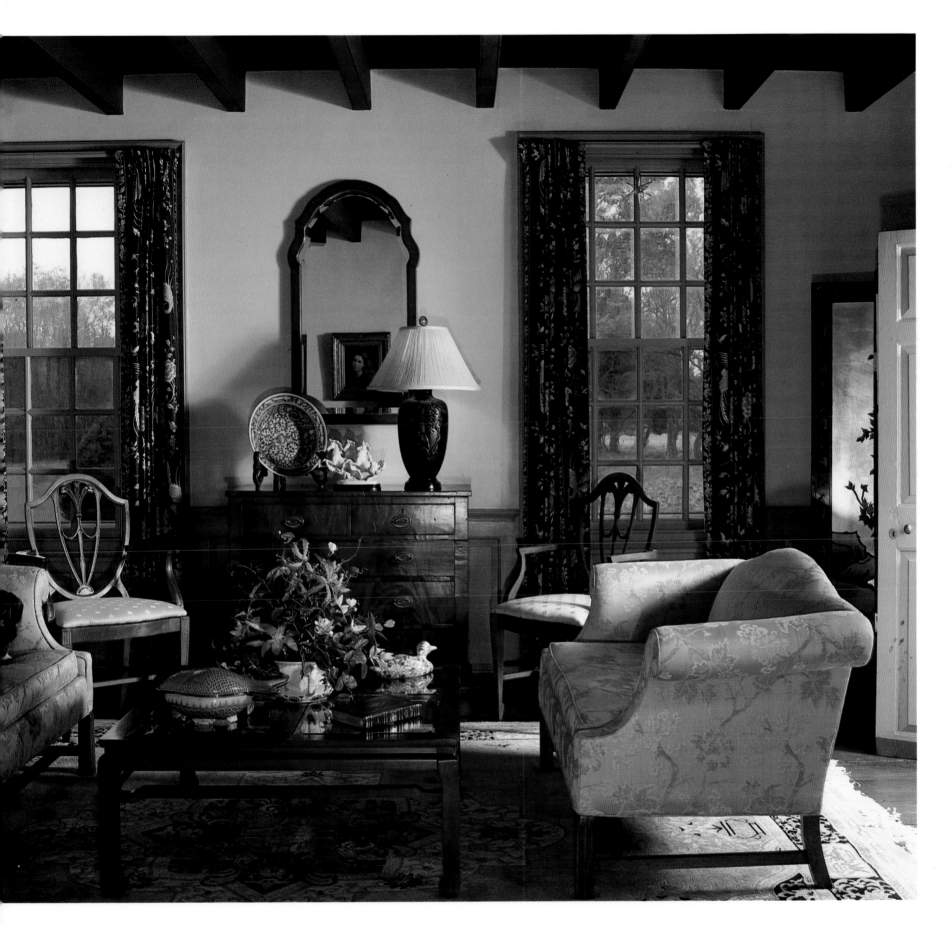

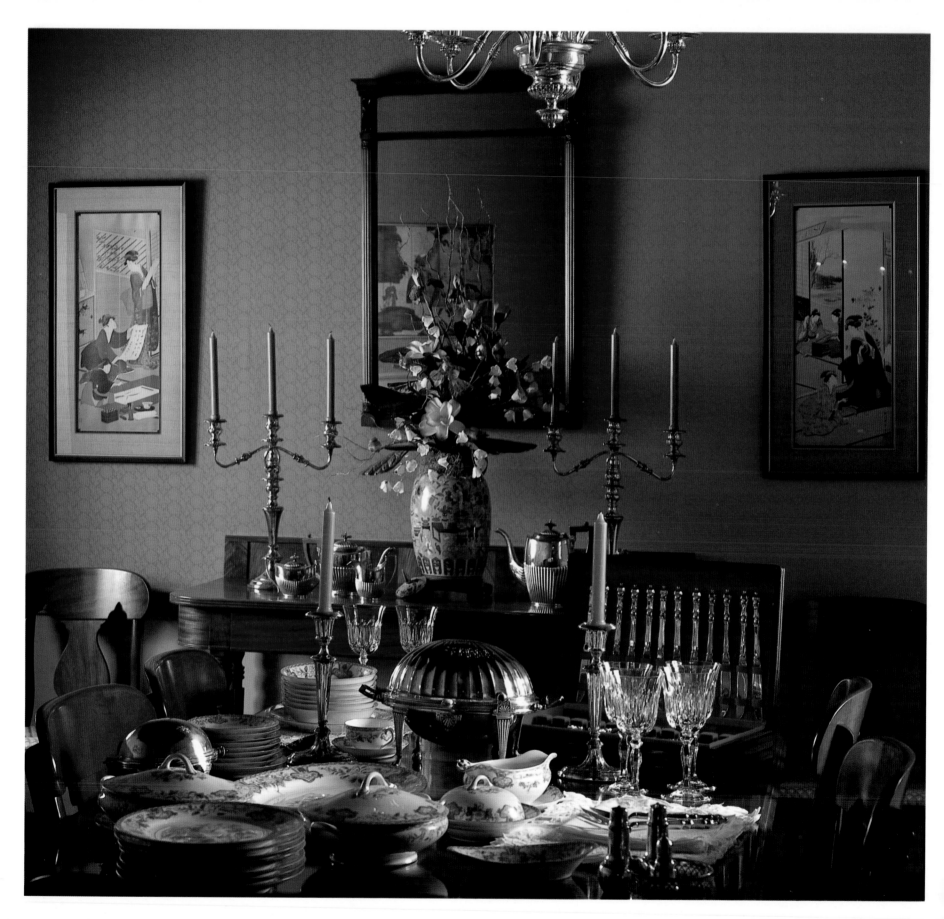

LEFT: A 1920s silver-plate chandelier hangs over the table, which is in the process of being set for an elegant dinner party.

RIGHT: One of the upstairs guest rooms in the new wing.

RIGHT: A turn at the top of the stairs in the old house leads to a series of bedrooms on the left and to the master bedroom on the right.

LEFT AND BELOW: An exact replica of an eighteenth-century fireplace, constructed of old bricks, warms this room in the new part of the house. Above it is a copy of *Dandy Dinmonts* by John Ems, a British Victorian animal painter, which was copied by Regina's sister, Lauren Bell Porter. A collection of animal figures and prints are gathered on one wall.

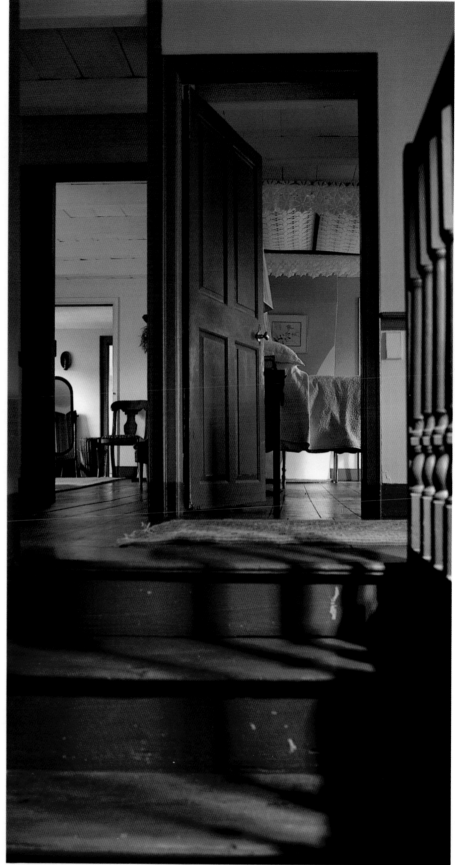

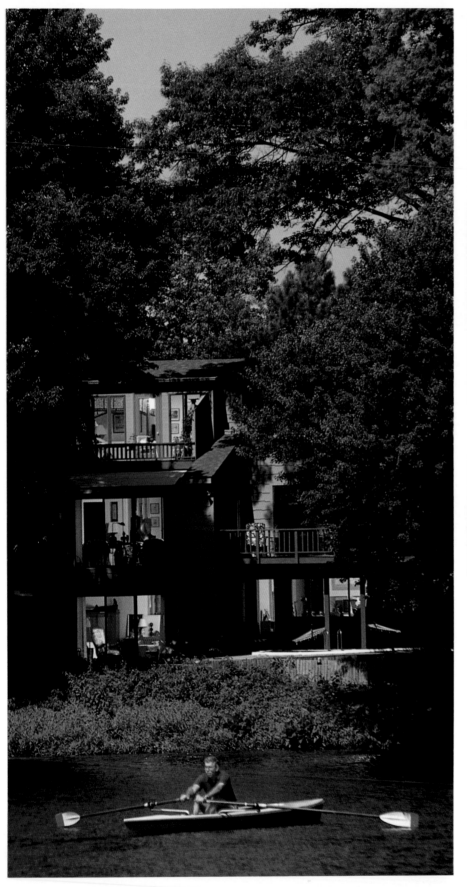

FROG POND STUDIOS

Lake Tony Tank is a fresh water lake with bass and pike, crappie and turtles, right in the middle of a commercial district of Salisbury. This multilevel shingled dwelling was built in the early eighties as a combination house and dog grooming and boarding kennel. Martha and Jack Graham found it to be an ideal location—business district with a rural feeling—for a combination home and studio. Martha, a designer, and Jack, an architect, redesigned the house into two separate studios and a wonderfully comfortable home with spaces to hold their many collections. Martha and Jack are avid collectors of everything from antiques to painted bathtub feet. If it has a design appeal of line or color or texture; if it has historical or social import; or if it is simply interesting, it's likely to be in one of their collections.

Built into a hillside, the house has five levels. On the lake side it is as open as possible to the views of woods and water.

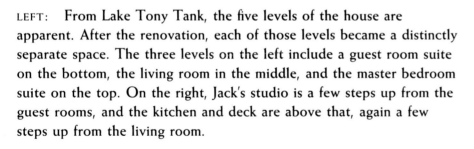

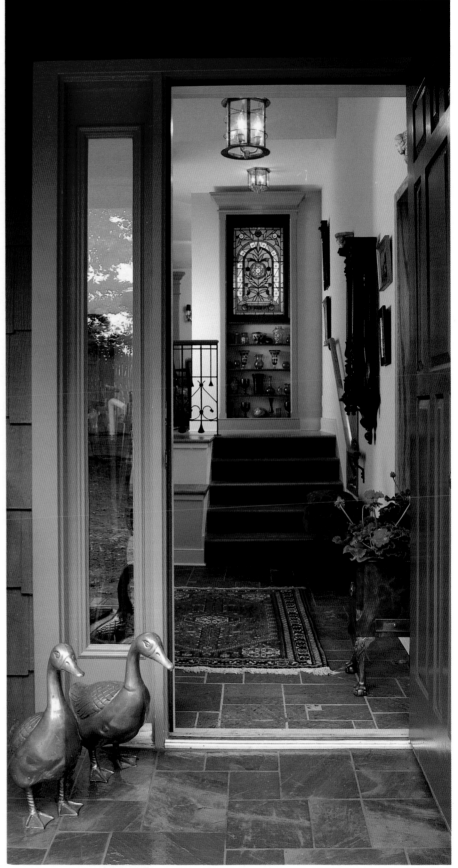

LEFT: From Lake Tony Tank, the five levels of the house are apparent. After the renovation, each of those levels became a distinctly separate space. The three levels on the left include a guest room suite on the bottom, the living room in the middle, and the master bedroom suite on the top. On the right, Jack's studio is a few steps up from the guest rooms, and the kitchen and deck are above that, again a few steps up from the living room.

ABOVE: From the "front," the house appears to be a one-story ranch. Martha wanted a humorous reminder of the house and studio's former use as a kennel, so she designed *Spot* for the entrance to greet clients and guests.

RIGHT: The stained glass window at the top of the entryway belonged to Jack's father and came from Philadelphia. It was the focal point around which the entry was designed. The nineteenth-century wrought iron rail was a gate and is also from Philadelphia.

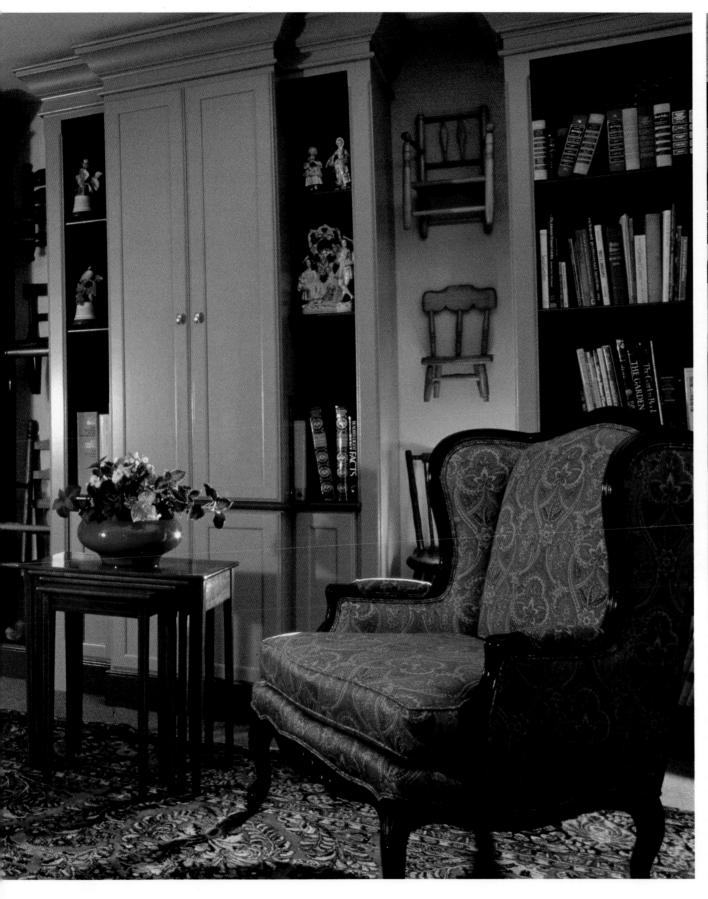

Dining room and library are combined into this large space. Free-standing bookcases are columns that both hold and frame collections. A Victorian mantel, imported English tiles, and an English fire bench make a contemporary wood stove seem like a traditional fireplace. ABOVE: A few of Martha's collection of eighteenth-, nineteenth-, and early-twentieth-century children's chairs.

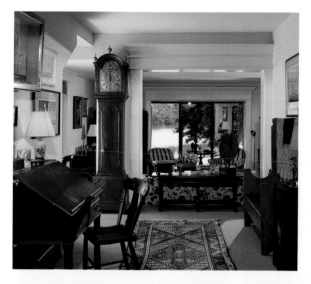

LEFT: The gallery was formerly a completely enclosed small room that now connects the library–dining room with the living room, which is a few steps down. One of the primary design decisions in renovating the house was to open up as many rooms as possible to the outside views, especially the lake. On the left wall is a Pennsylvania schoolmaster's desk. The clock is an eighteenth-century English tall case clock. On the right is an early-nineteenth-century hutch table from the Eastern Shore.

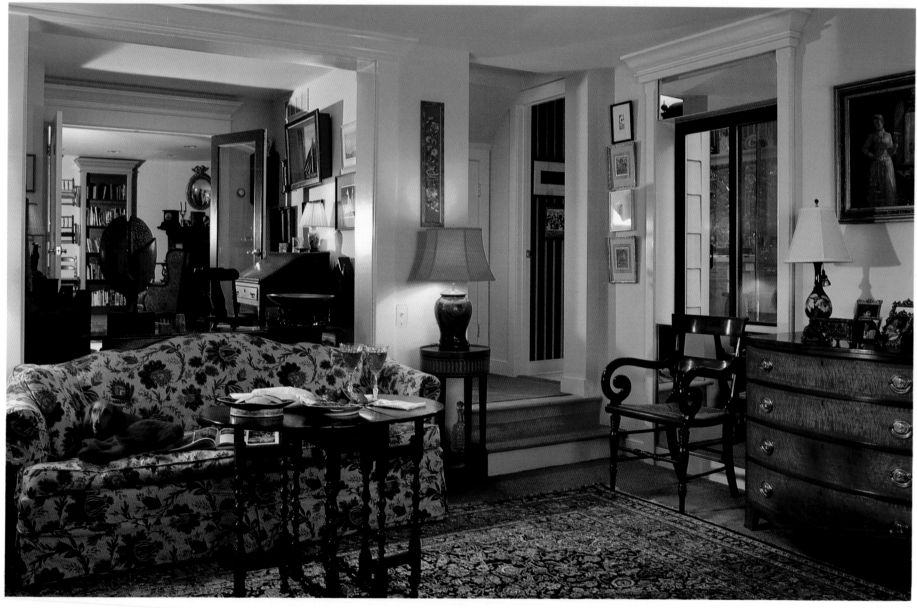

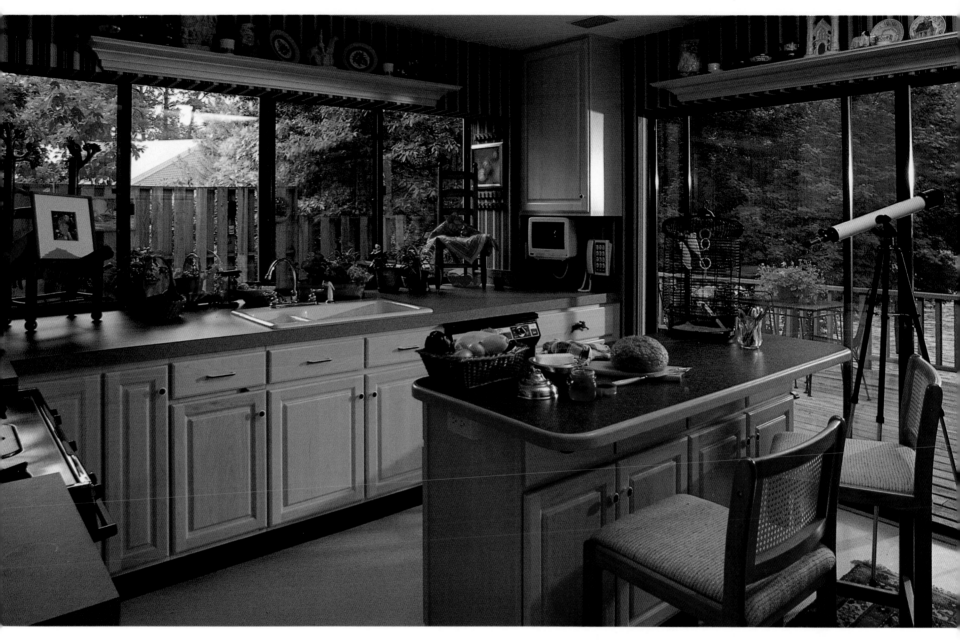

LEFT: Lucy, the Grahams' dachshund, is cuddled up on the sofa. On the right wall is a bow front mahogany chest with oval brasses, c. 1790. The wooden sculpture behind the sofa was bought at an auction at the Maritime Museum in St. Michael's. On the other side of the open glass doors at the end of the gallery is the library–dining room. The door up the steps to the right leads to the kitchen.

ABOVE: The kitchen is another room opened up to views and designed to hold collections. Martha firmly believes that every room should have objects that you like to look at that are unrelated to the function of the room. The moldings over the windows behind the sink and over the deck doors become shelves for English lusterware and Staffordshire figurines. A contemporary chair is on the counter at the right. The windows behind the sink look out on a contemporary sculpture garden, which was formerly a dog run, paved in cement.

The master bath and dressing room combination were created out of former attic space. The window was enlarged and skylights added.

The master bedroom is at the very top of the house. The room was expanded by the addition of a bay window with storage drawers under the window seats. The deck offers complete privacy from all the other rooms as well as from any other house. Lucy and Honeybuns are settling in for a nap.

THE VIRGINIA SHORE

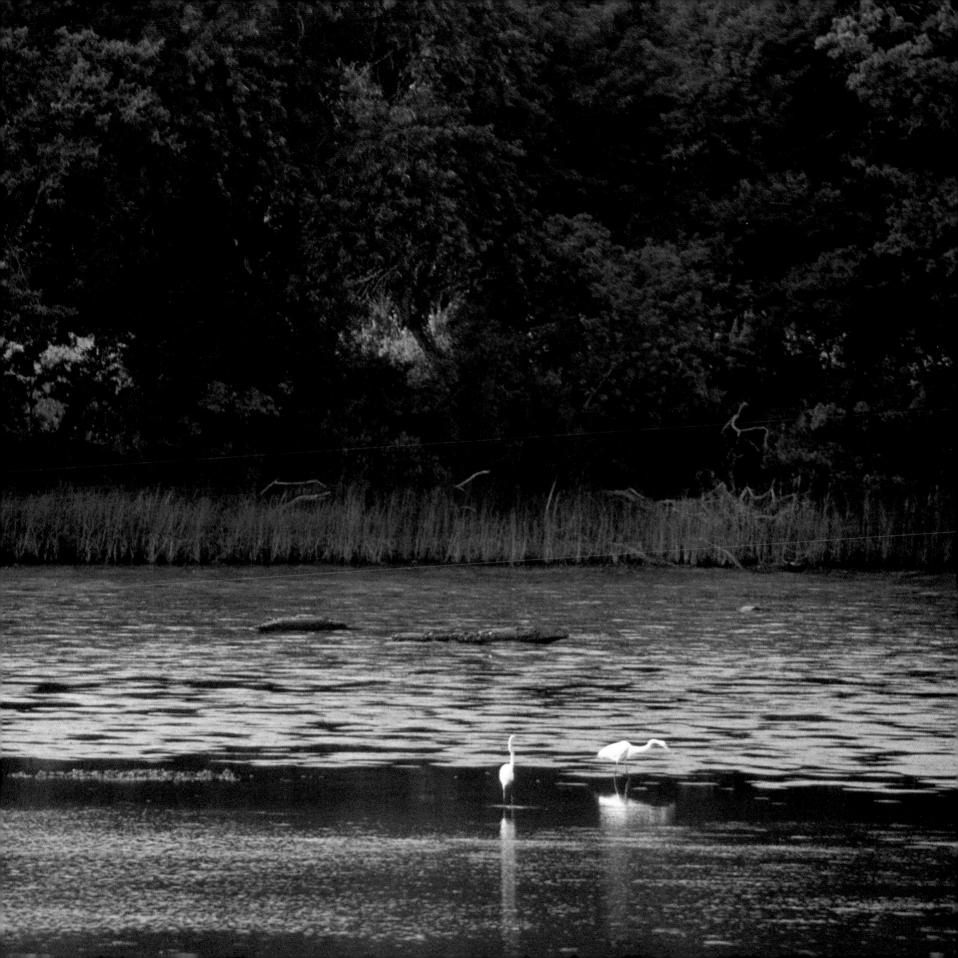

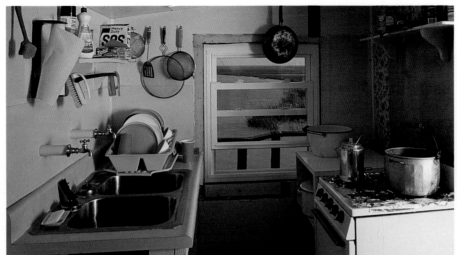

THE MARSHES

Nearly half of Virginia's Eastern Shore is made up of salt marshes and barrier islands that protect this thin strip of land from the sometimes vicious storms that sweep in from the Atlantic Ocean. A life-saving station, its raison d'etre rendered obsolete by modern technology, is crumbling into the sand, and skeletal remains of shipwrecks dot the beaches of the many islands.

Miles and miles of salt marsh cordgrass, green in summer and amber in fall and winter, wave above the water. Rich in organic matter, the cordgrass marshes are the refuge of numerous species of crustaceans, mollusks, and fish that provide an abundant food supply for native and nesting shore birds. Channels through the marshes are passable only in shallow draft boats and usually only at high tide. The Nature Conservancy maintains small huts on stilts high above the marshes, which provide shelter for birdwatchers, fishermen, or hunters who might become stranded due to sudden storms or low tides.

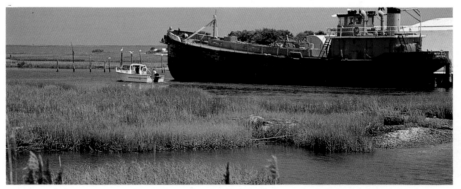

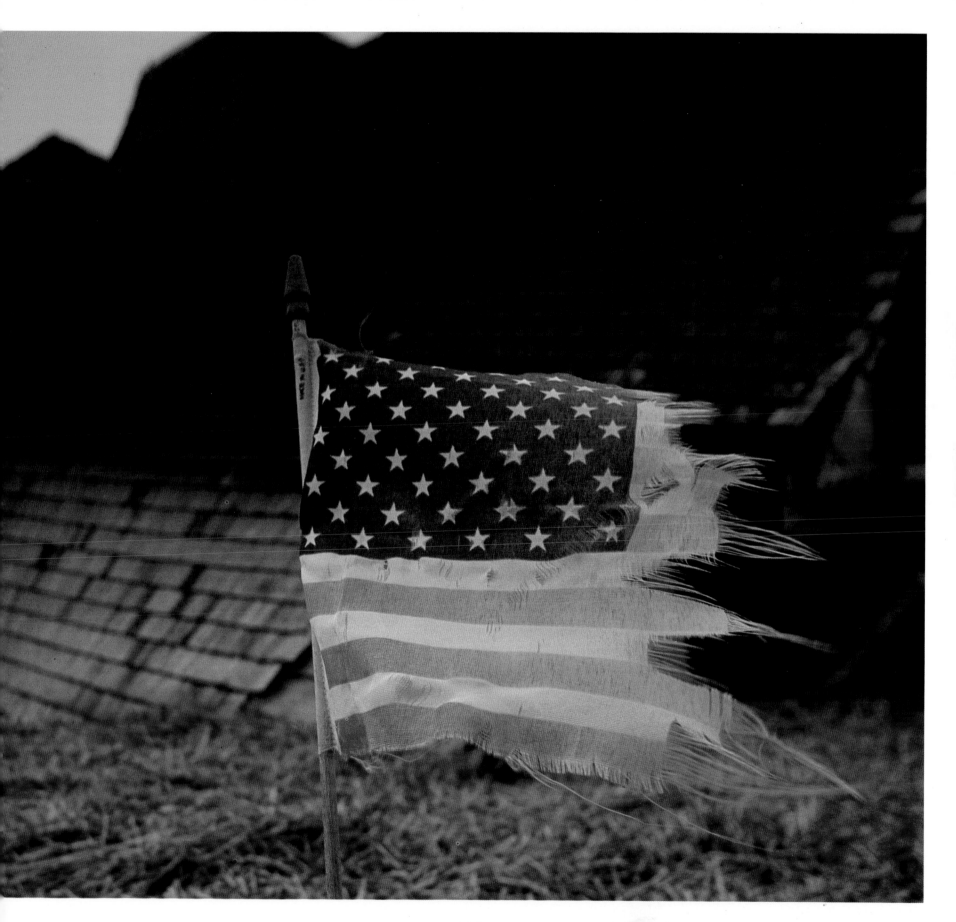

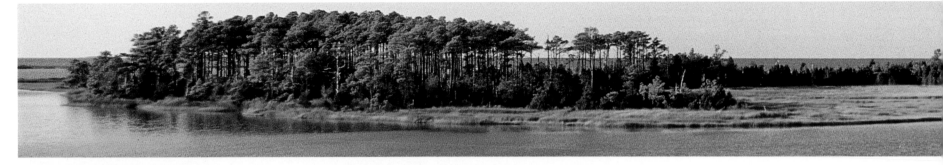

OUTER MOST HOUSE

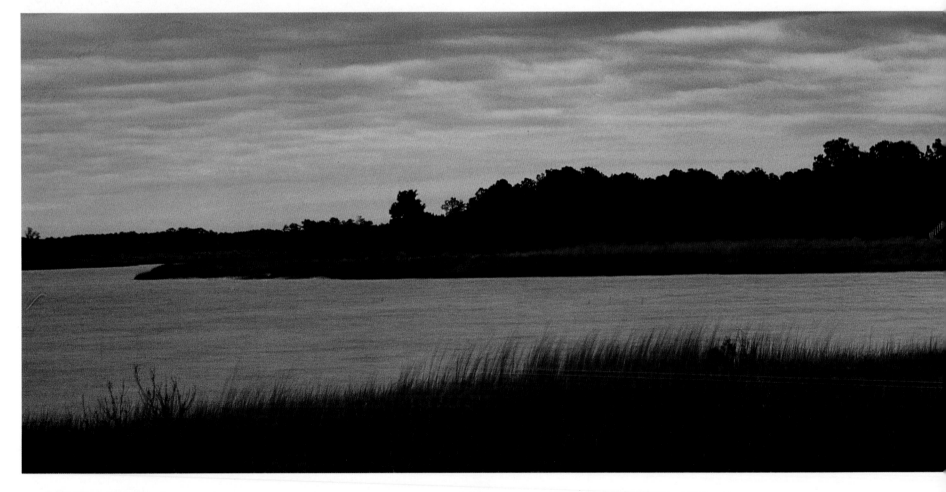

Deep in the marshes of the Virginia Eastern Shore, this red-roofed shingled house is the home of Sonda and Beman Dawes. Built in 1984, the house was designed to take advantage of the magnificence of the marsh from every vantage point. It was built on stilts for the obvious reasons that the land is low and the height would maximize the views and breezes, but also because the bugs are fewer at heights above eight feet.

ABOVE: The late afternoon sun sets the marshes aglow. BELOW: Dawn creates a palette of ever-changing colors over the marshes. RIGHT: In the late afternoon, the sun lights up the house on its shore side. FAR RIGHT: In the downstairs entryway, a gaily painted sculpture, *A Dog Who Eats Ice Cream* by local artist Philip Ward, greets visitors.

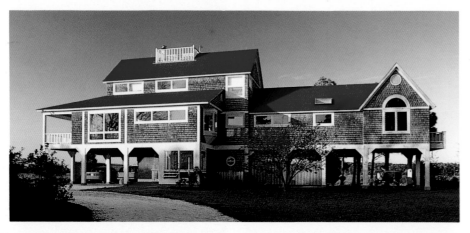

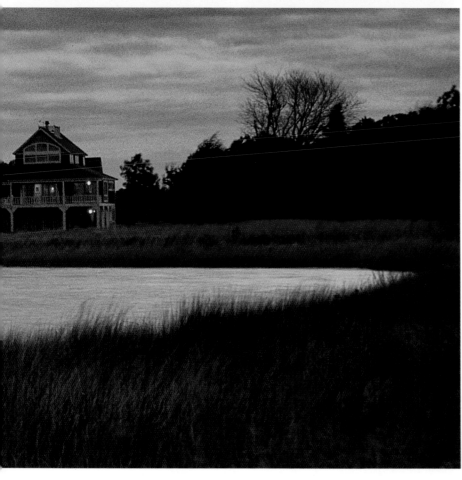

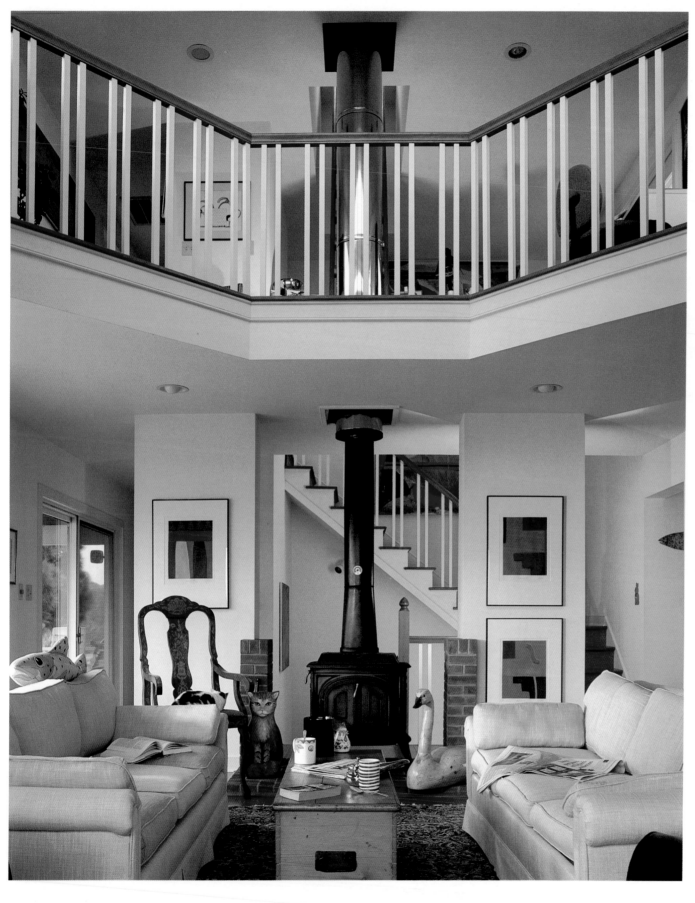

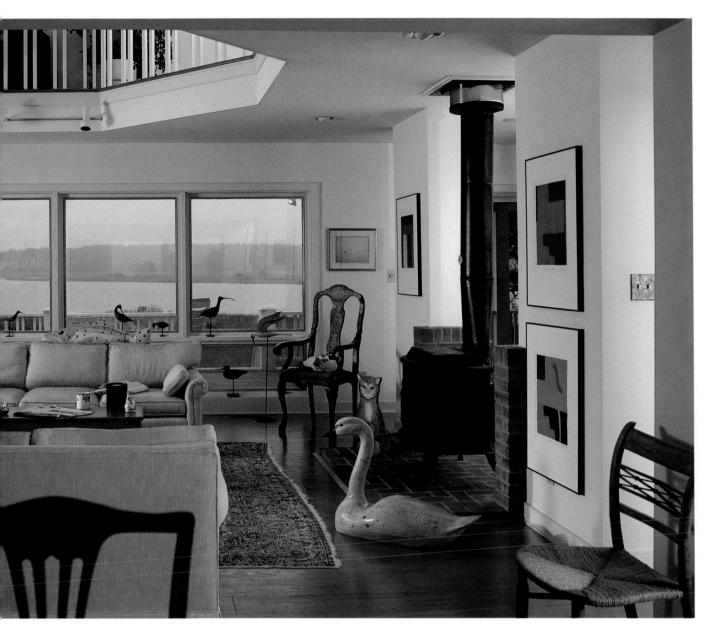

LEFT AND ABOVE: The house is basically one room wide, like many of the older houses on the Eastern Shore, so it can open up to the breezes. Behind the wood stove is a central stair hall that leads down to the outside and up to the balcony level. There on the upper level Sonda and Beman both have their offices, to keep them apart from the normal living patterns of the house. Columns on either side of the woodstove display monoprints by Linda Croxson of Locustville, who also painted the cat next to the stove. The columns are bookcases on the other side. The Dawes collect works by local artists. The large painting, partially visible on the stairway wall, is entitled *Sky Blue, Leroy Floyd of the Yugoslavian Army All-Star Team* and was painted by Philip Ward. Carvings on the window ledges were done by local carver Bobby Swaim.

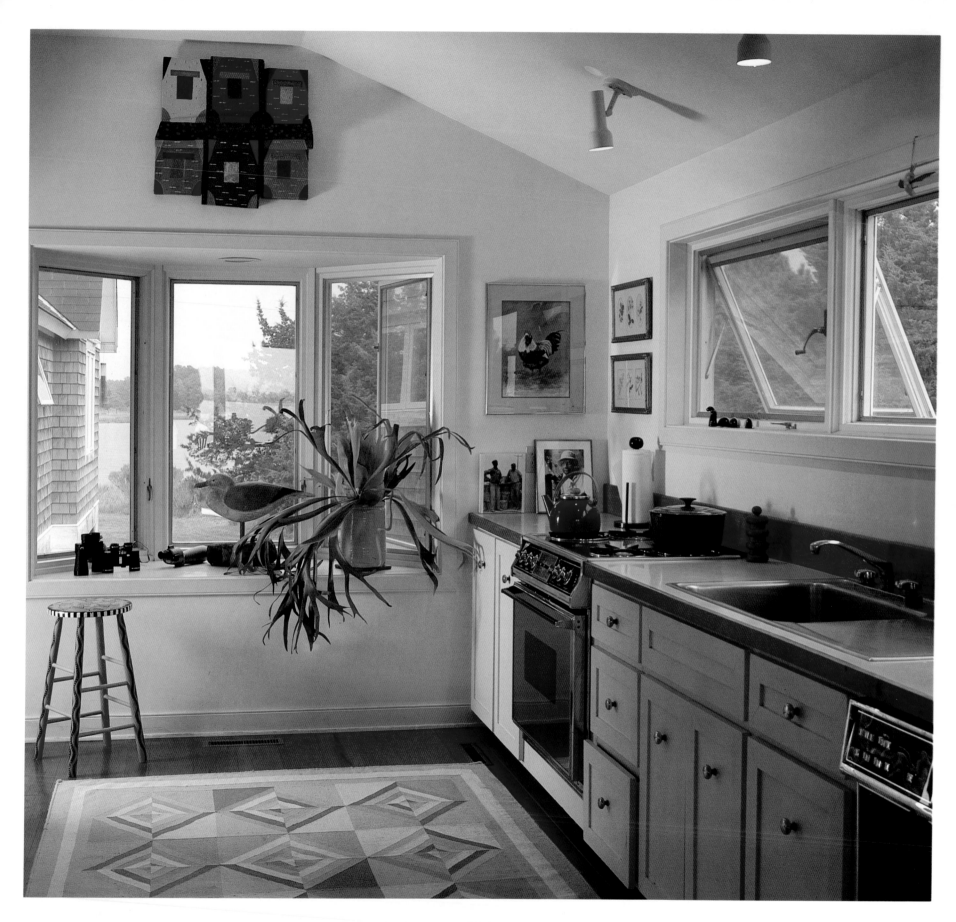

Another sculpture, *Dogs Who Eat Ice Cream,* by Philip Ward is over the kitchen window. The sea gull in the window was carved by Grayson Chesser.

———————————

The house has many decks, and the best is the one all the way at the top. In the distance is the dock that extends out into Back Creek.

DEEP CREEK PLANTATION

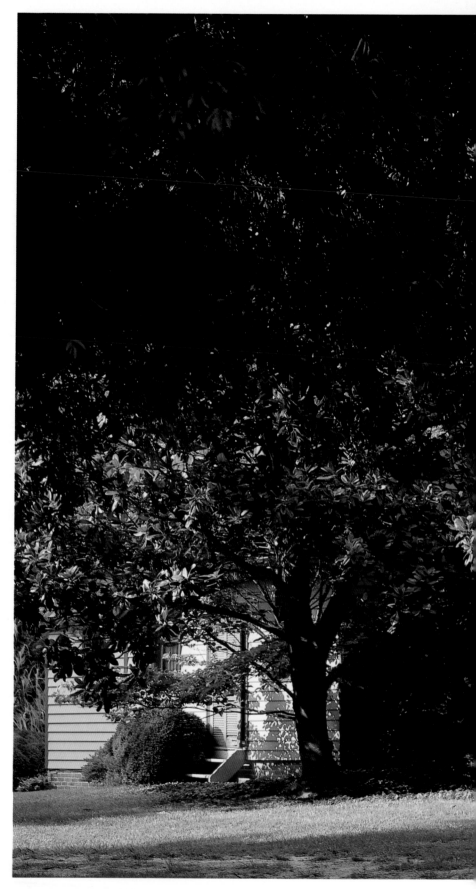

On the Eastern Shore of Virginia on Deep Creek is this frame plantation house with brick ends, built about 1755, perhaps as early as 1745, since that was the year Tully Robinson Wise purchased the land and also the year he married. The original structure consisted of one room upstairs and one down. The separate quarter kitchen must have been built around the same time and was connected to the original house by an open colonnade to protect the bearers of the food from kitchen to house in inclement weather and open to reduce the danger of fire. The Wise family owned the property for nearly 100 years. The large two-story part dates to 1812 when another Tully Wise enlarged the house and enclosed the colonnade making it into a large room.

In 1955 Brigadier General Chester and Teresa deGavre bought Deep Creek Plantation and began restoring it. Chester made new paneling for the fireplace wall in the drawing room. They were stationed across the Chesapeake Bay at that time so he would work on a panel during the week and bring it over and fit it in on weekends. The deGavres retired and moved here full time in 1965.

They purchased outbuildings and had them moved to the property and then restored. A former schoolhouse now serves as a guest house, and a little lawyer's office from the Accomac Green holds collections. The home itself is furnished with a combination of family antiques and handmade furniture, made by Chester deGavre. Avid collectors, the deGavres have made places to display their collections from all over the world.

RIGHT: The exterior of the two-story later part of the house and the little nineteenth-century schoolhouse–guest house to the left. The house was constructed of frame with brick ends, which was typical of the time on this part of the Eastern Shore. Next to the porch, a Chinese Chippendale garden bench matches the pattern of the screen door.

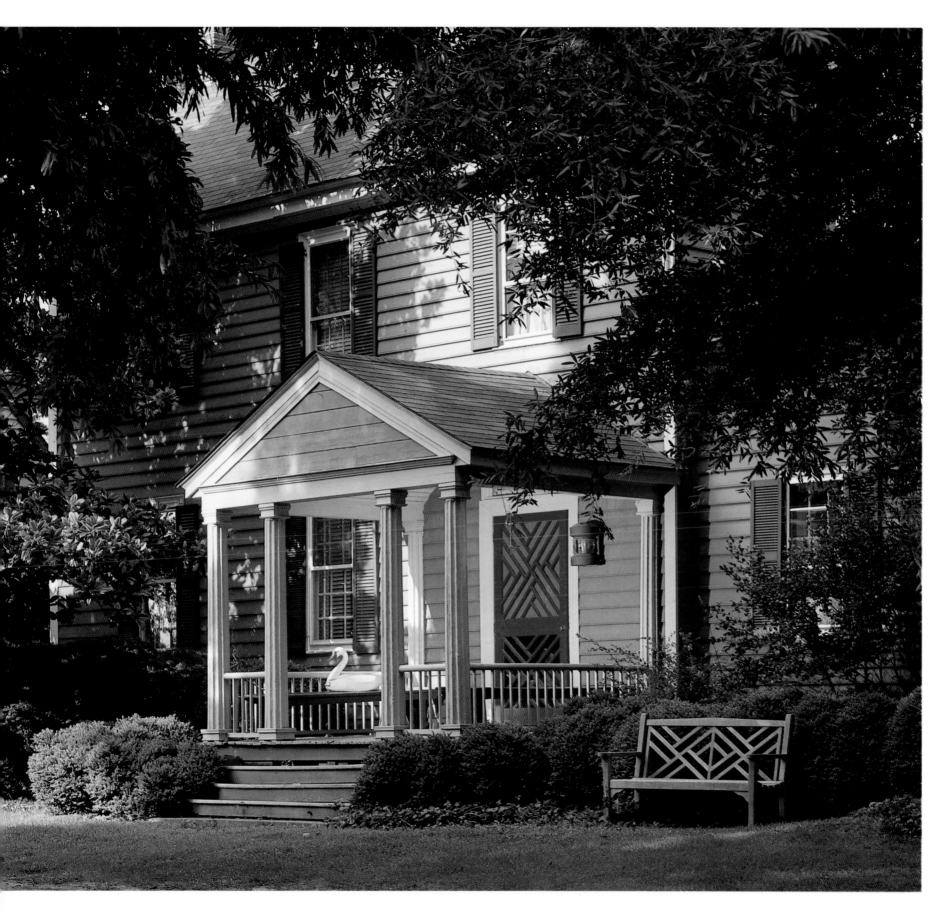

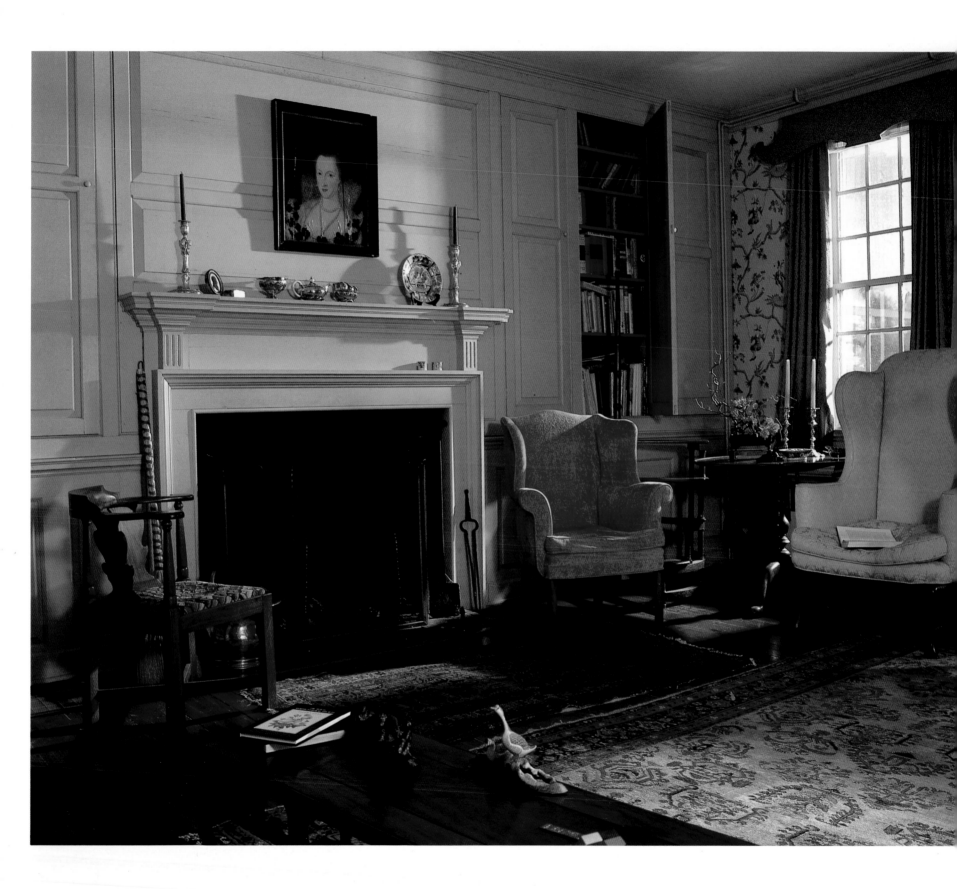

LEFT: In the drawing room, the fireplace wall had only bare wallboard above the chair rail when the deGavres bought the house. The original paneling had probably been sold by a previous owner who had fallen on hard times. Chester deGavre made the new paneling, adding bookshelves beside the fireplace and chimney. The portrait of Queen Elizabeth I is oil on wood and was given by the Queen to an ancestor of Teresa deGavre's who was Treasurer of the Royal Household and was also married to Anne Boleyn's sister. On the mantel is a vermeil tea set, c. early 1800s, and bronze *doré* candlesticks, c. 1840. Chinese pagoda pattern cornice complements the Chinese wallpaper. The round tilt-top table in the corner is a replica of a piece in the Metropolitan Museum of Art made by the General. Beside the yellow chair is an English inlaid Hepplewhite table. Above it is an eighteenth-century portrait of one of Teresa's ancestors.

BELOW: Looking from the drawing room through the hall to the dining room. The eighteenth-century marquetry secretary has a japanned scene in the center square and Prince of Wales feathers on the brasses. On the little table next to the door is a collection of bronze tobacco and snuff boxes and a fish plate. Beneath it is a Queen Anne stool with Bargello wool upholstery.

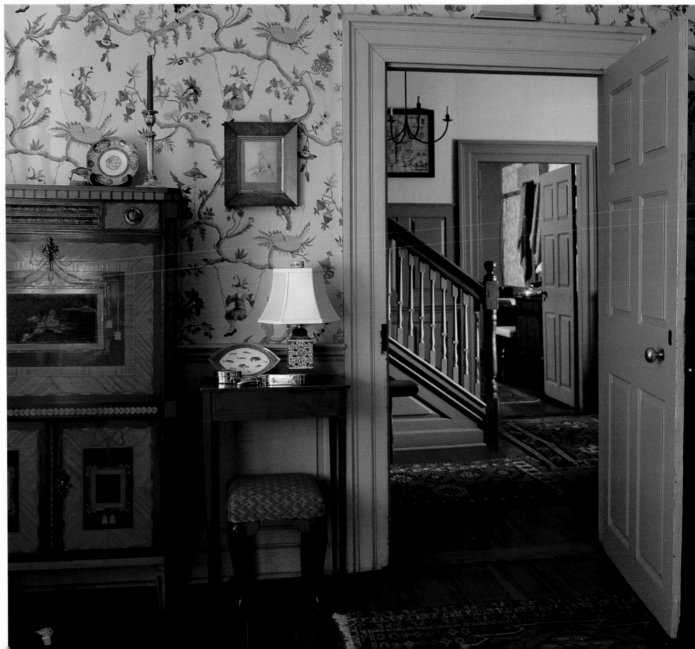

BELOW: The dining room is the original one-room downstairs part of the house. The fireplace wall is all brick, since it was originally the outside wall. The paneling on the chimney breast is the original. The stairs turn at the top up and over the chimney, which was originally an inside-outside chimney. The table of local walnut, a copy of a Hepplewhite table, was made by Chester. The chairs are eighteenth-century Irish Chippendale. On the far wall is an English Chippendale ladies' writing desk that Teresa brought with her from England when she moved here. The candlesticks on the table are old Sheffield silver.

The silver Victorian rose bowl that holds an arrangement of wildflowers picked from the fields belonged to Teresa's mother.

RIGHT: Chester deGavre has been carving decoys since he was twelve and made them for his own use. In the army, he began carving miniatures on maneuvers since they were small enough to carry in his pack. These represent only a few of his carvings of shore and upland game birds. His carvings have been displayed in museums and exhibitions around the country.

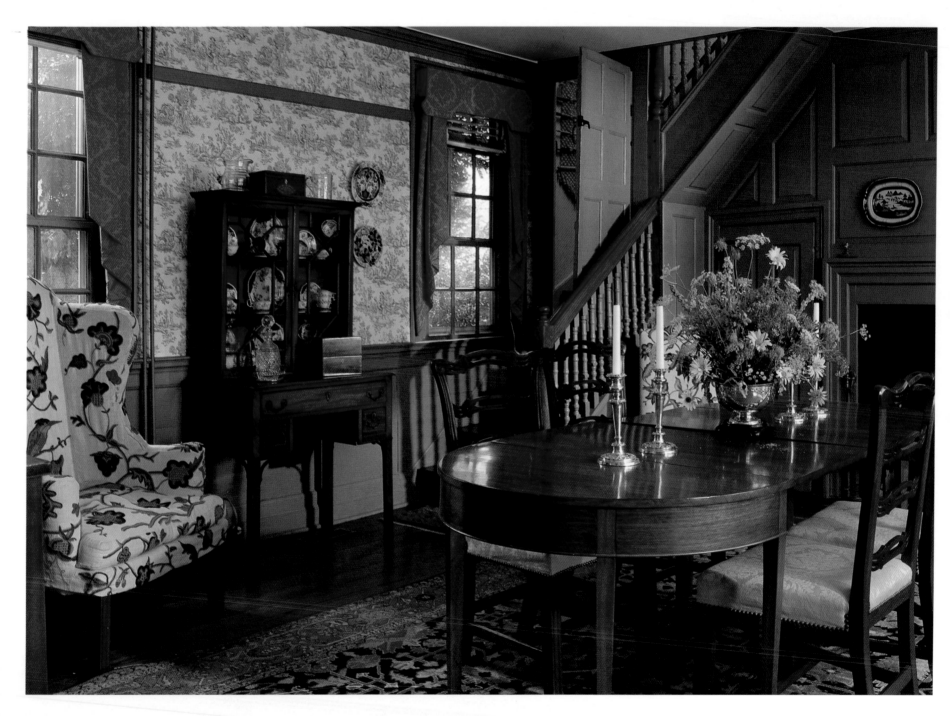

BELOW: The collection of spears and shields were brought back from Ethiopia by the deGavres from their tour of duty there.

BELOW: General deGavre's life-size carving of a great blue heron stands on a stump outside the house.

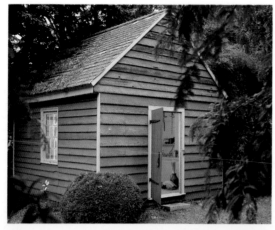

This late-eighteenth-century lawyer's office originally stood on the Accomac Green, the county seat. It had been moved several times when the deGavres found it being used as a shed, purchased it, and moved it here. The cove ceiling inside is unusual. The one-room building holds a collection of farm implements and hand tools.

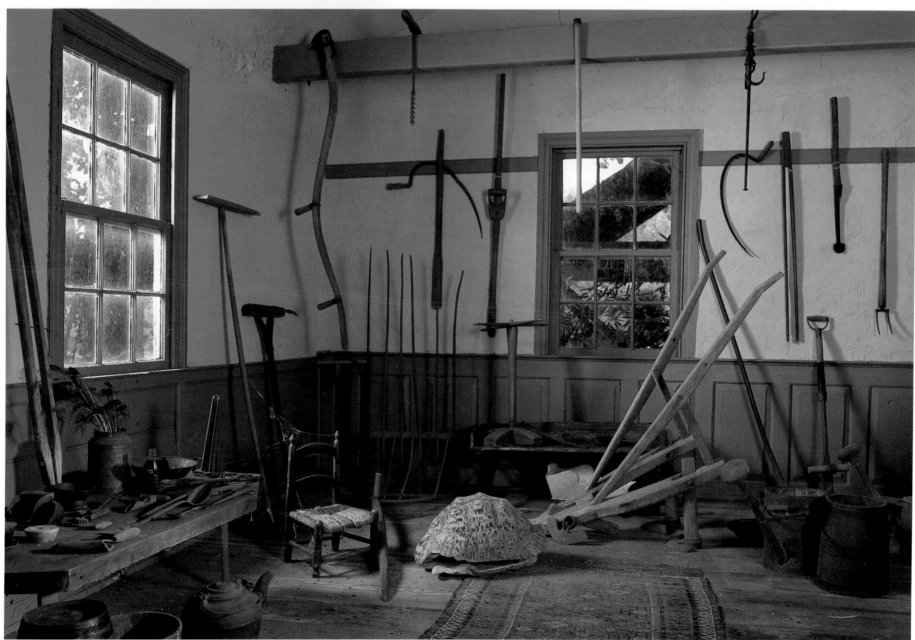

ABOVE: One of the farm ponds on the property that attract several species of waterfowl, some of which nest and stay year-round.

BELOW: Dwarf bamboo (*Arundinaria variegata*) grows near one of the ponds.

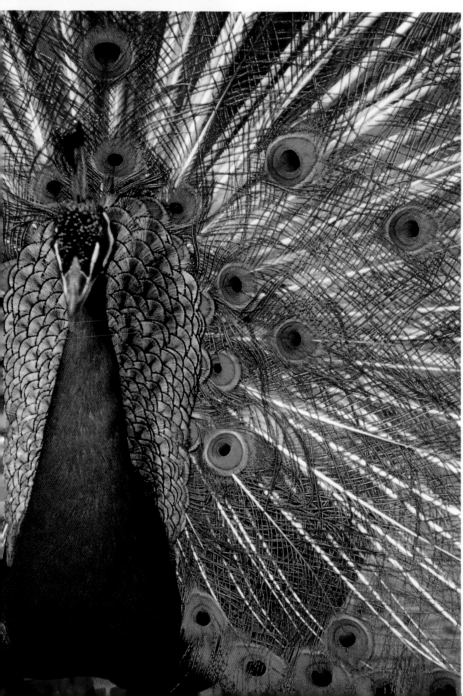

Farm animals and wild waterfowl live together on the farm. Peahens and their chicks are at home with several varieties of ducks and geese.

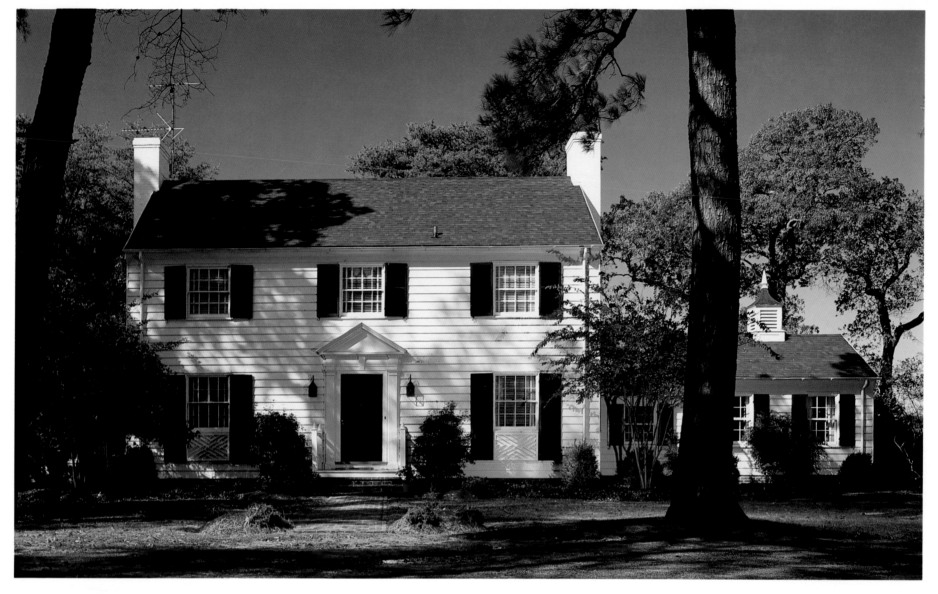

KENDALL GROVE POINT

This traditional house, built in 1952 by Benjamin Mears, is perfectly sited near the head of Mattawaman Creek on land that is part of Kendall Grove plantation. An early owner of the property, George Kendall, aquired the property to build a house for his bride, but he died before they could marry, and the land was bequeathed to her in his will. When she later married and built a house on the property, she named it Kendall Grove after her fiancé. Kendall Grove Point is built on the point behind the older house, very near the little town of Eastville, county seat of Northampton County. Its courthouse has court records that date to 1632, making them the oldest continuous records in the United States.

The home of Katherine Mears, the house is surrounded by careful landscaping, big trees, and wonderful gardens. Katherine has played an important role in the restoration and preservation of Virginia's historic sites, especially their gardens.

RIGHT: **Inside the front hall an English oak Queen Anne tea table, c. 1710, holds a flower arrangement that complements the Chinese wallpaper in the entrance hall.**

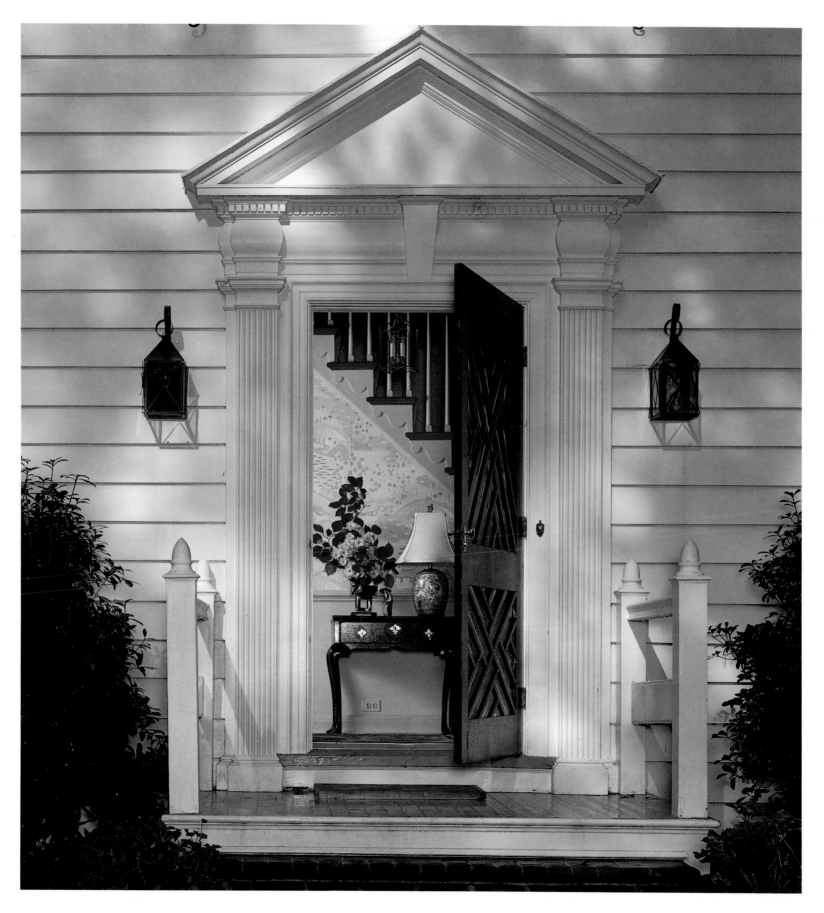

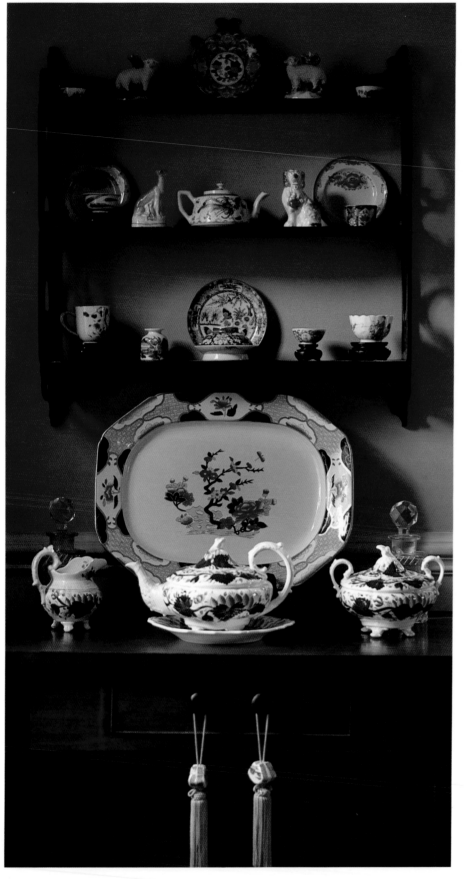

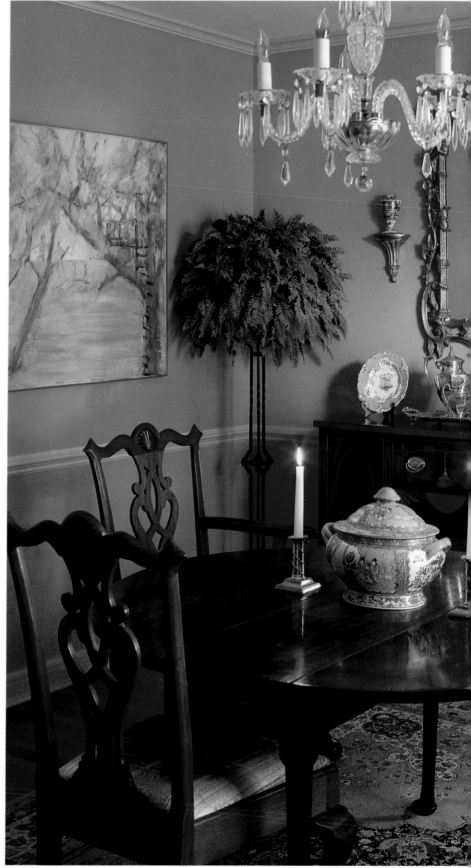

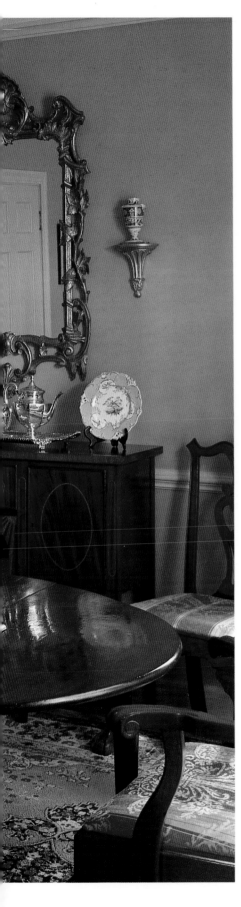

FAR LEFT: The Chippendale hanging corner cupboard holds a collection of porcelain. An Imari platter and tea set are arranged on the little table below.

LEFT: An English Queen Anne mahogany drop leaf table, c. 1735, holds a pair of silver candlesticks and a Chinese covered dish. The apricot color of the porcelain plates on the hunt board complements the color of the walls. The painting is by Dot Woodland of Alexandria, Virginia.

RIGHT: A collection of boxes covers the top of the coffee table in the living room and a Chinese lunch pail sits atop the desk behind.

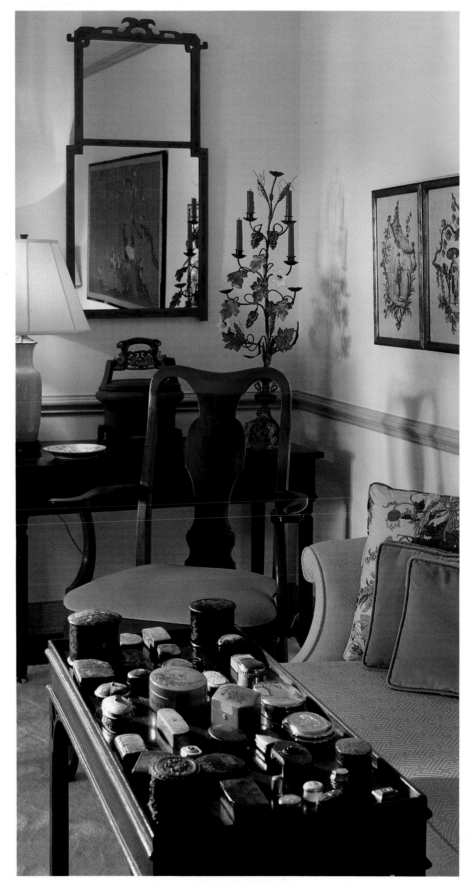

RIGHT: The large master bedroom suite is situated over the library extension and has generous windows on three sides. Simple shutters are used to keep out the too strong sunlight of summer or the cold winds of winter, but they open to allow a full range of water and woodland views. The colorful painting over the bed is by Lori Watson, an artist from Virginia Beach.

BELOW: The glass-enclosed sun porch room overlooks this part of Mattawaman Creek. The fenced-in garden is a recent addition and provides a soft and colorful frame for the creek and woods beyond.

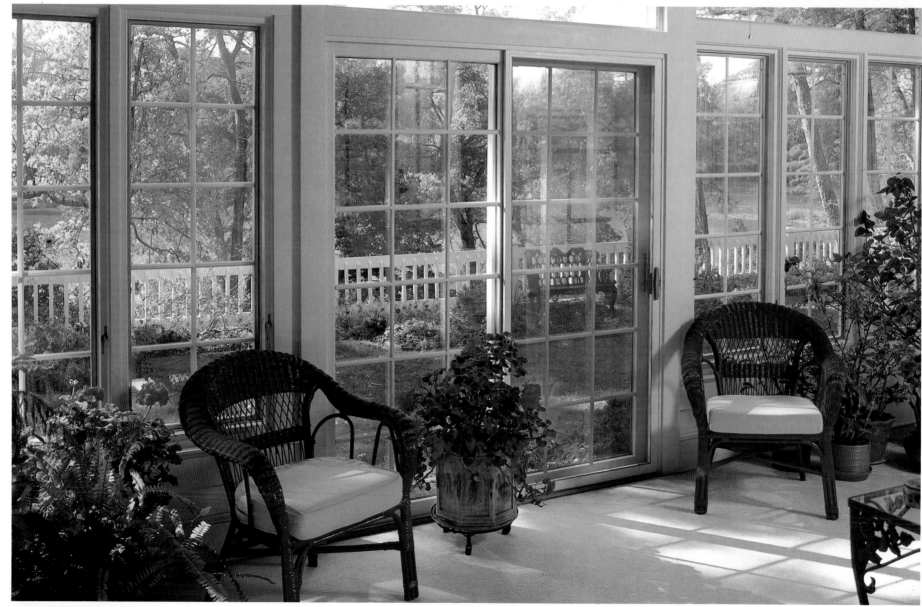

BELOW: The breakfast room extension to the kitchen provides another delightful place to enjoy the activities of the marsh along the creek just off the point where great herons and other waterfowl, along with deer, muskrat, and other creatures feed and play.

OVERLEAF: The late afternoon sun casts a golden glow over the porch and garden on the west side of the house. The creek bank is unusually high for this part of the Eastern Shore, which makes its views especially enticing.

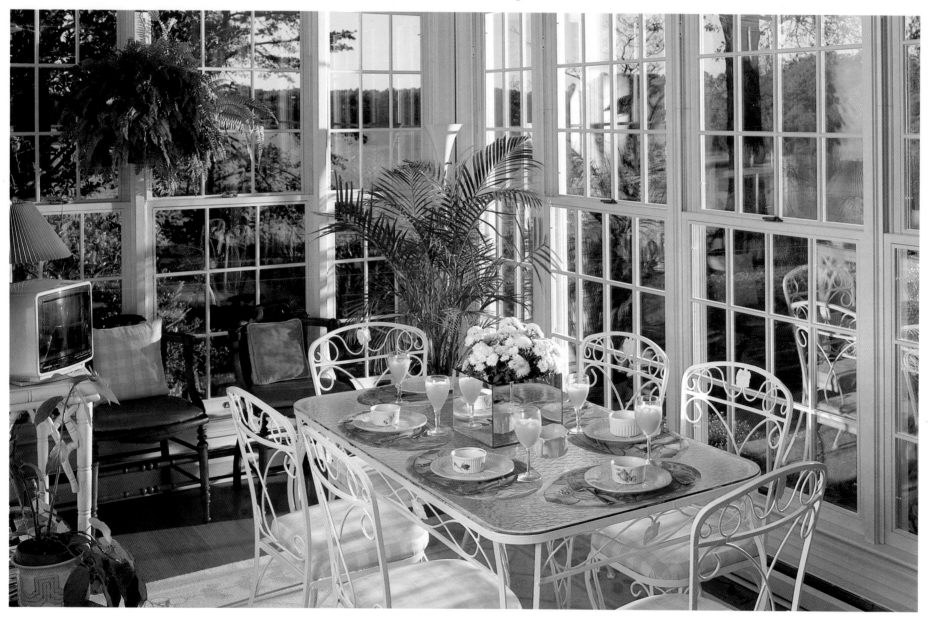

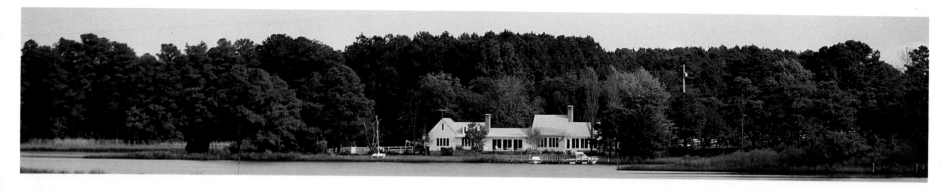

MILL POND POINT

In 1989, Fleet and Skip Davis decided to move from city to country life and renovate this little house on a farm. The old house, little more than a cabin, was literally falling down but was beautifully sited on this point in Warehouse Creek. The now shallow creek is so-called because it was once the location of a tobacco warehouse, so long ago that the creek was deep enough for cargo ships.

The first decision in renovation was to add a large library-living room and screened porch, which a year later, Fleet and Skip decided to enclose as a year-round porch room. Both rooms have huge fireplaces. The room that was formerly the living room was turned into the dining room, with a lovely water and sunset view. They added dormers to the attic over the old part of the house for additional bedroom space, and finally added a wing to the other end of the house for a separate master bedroom suite. Its windows open on the creek and the gardens.

Fields were cleared and fenced in for horses; the grounds surrounding the house were cleared of underbrush, tangles of vines, and poison ivy, then landscaped and planted with lush shrubbery and perennial borders. The house was completed in summer of 1990, and Fleet began clearing for the gardens as soon as the construction debris was out of the way.

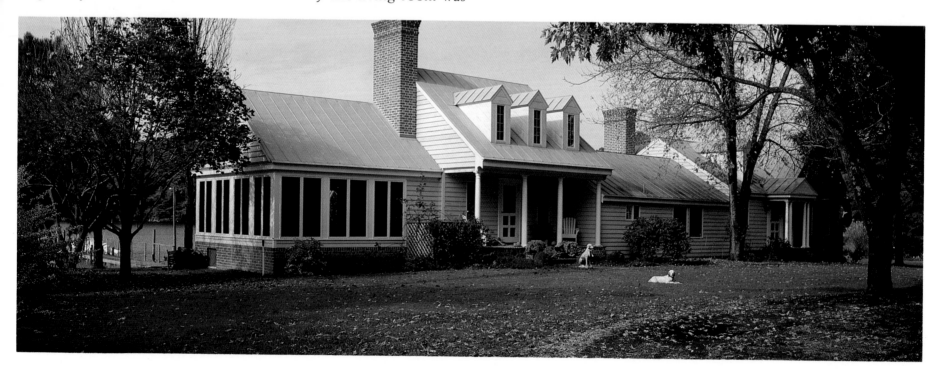

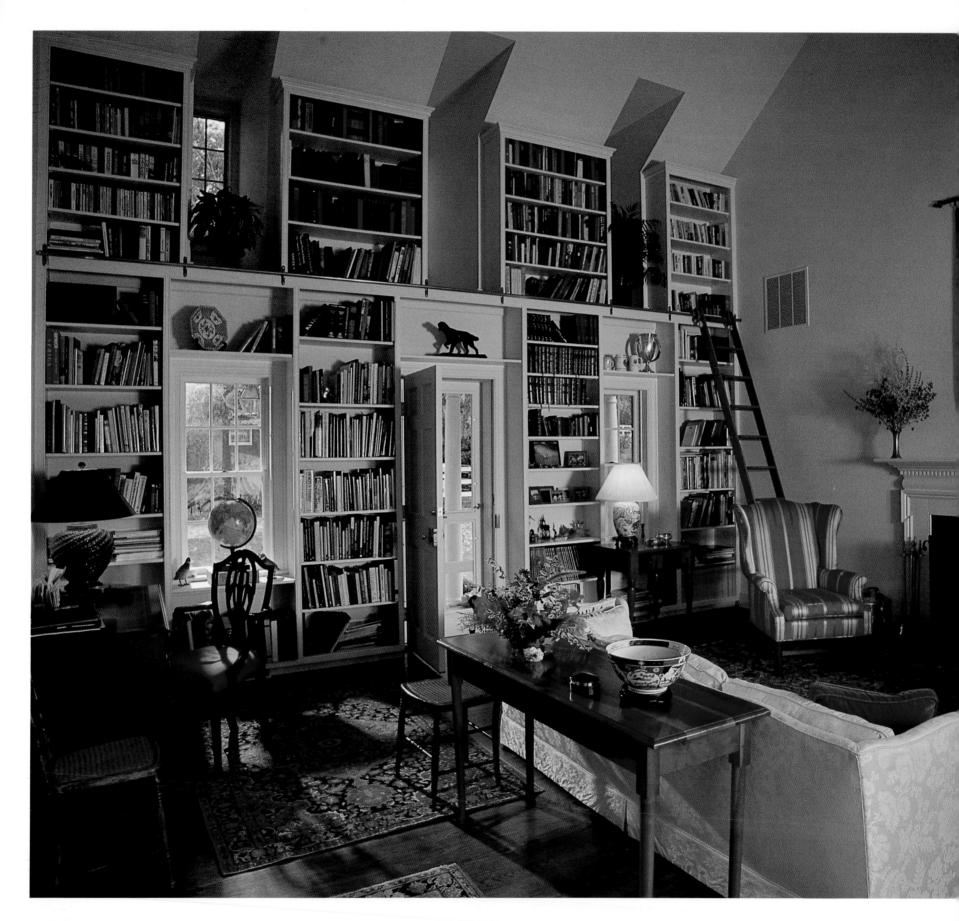

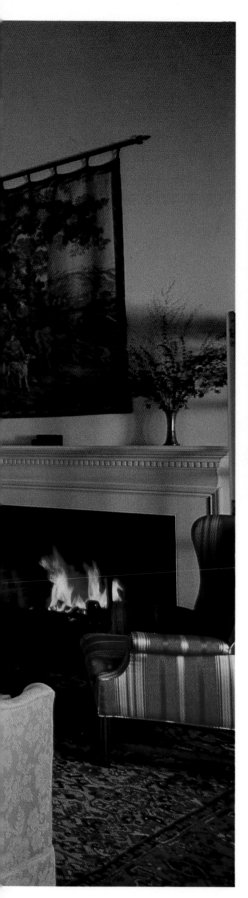

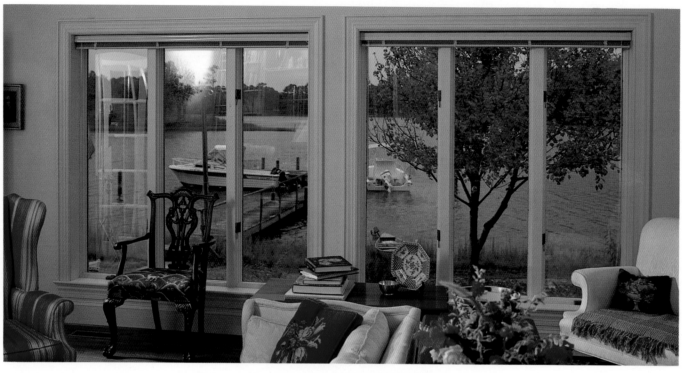

The two-story living room was designed with cathedral ceilings to give the room lots of light and an open feeling, especially on the water side. Dormers were added on the tall library walls for more light on this side of the room. The upper bookshelves are easily accessible from the sliding library ladder. On cold winter days, a roaring fire keeps the room warm. Above the fireplace hangs a Belgian tapestry. Various oriental rugs, a Hariz in front of the fireplace and two smaller Sarouks behind the sofa, contribute to the warmth and intimacy of the room. The sofa table is made of cherry wood that comes from Fleet's parents' home. A grandmother's chair, in the corner by the window that overlooks the water, is a centennial piece and belonged to Skip's family in Kentucky.

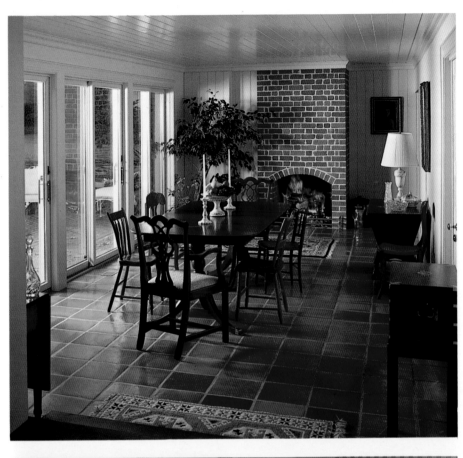

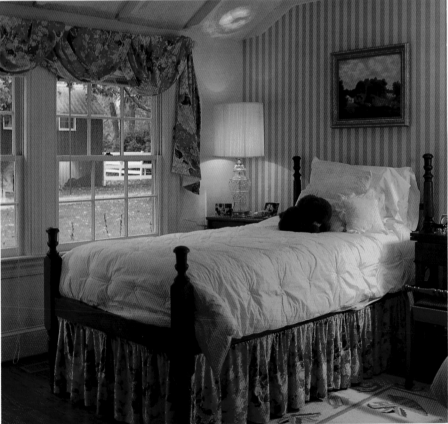

LEFT: The dining room with its terra cotta floor and wooden ceiling was once the living room of the old house. With sliding glass doors that open on the terrace, it is a light and airy room in summer and takes full advantage of glorious sunsets over the creek.

BELOW LEFT: The bedroom at the front of the house. Outside the window is the old red barn, which will soon be moved up the hill a little farther from the house.

RIGHT: Skip and Fleet cleared the old Mill Pond from its tangle of swamp grass and weeds and it now attracts ducks and other waterfowl. In summer lily pads are in bloom. On the far side of the pond are the remains of an old mill, which was still in use seventy years ago.

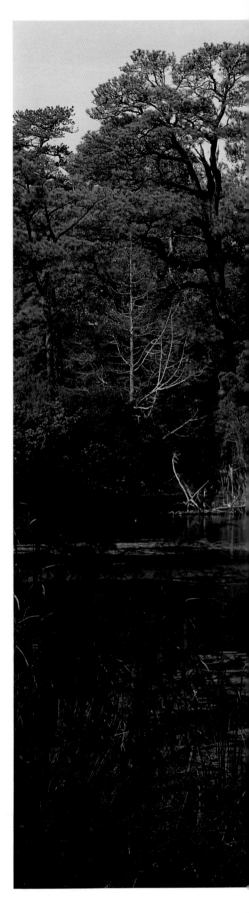

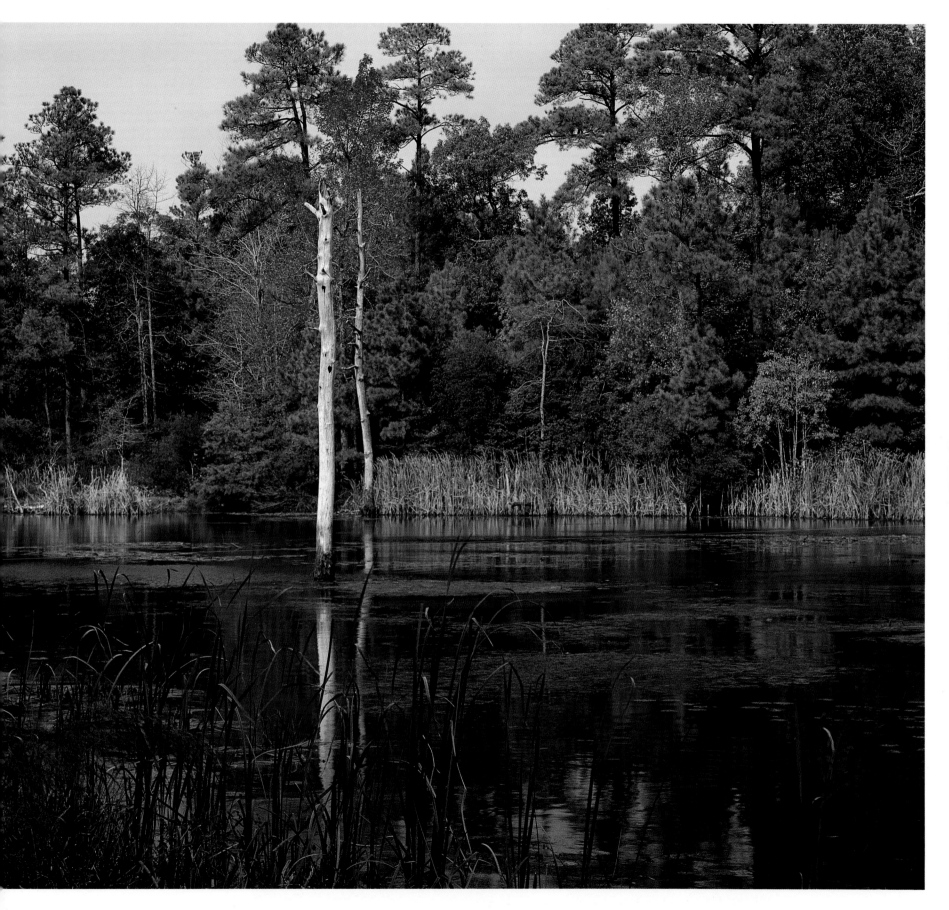

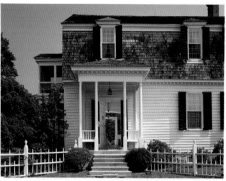

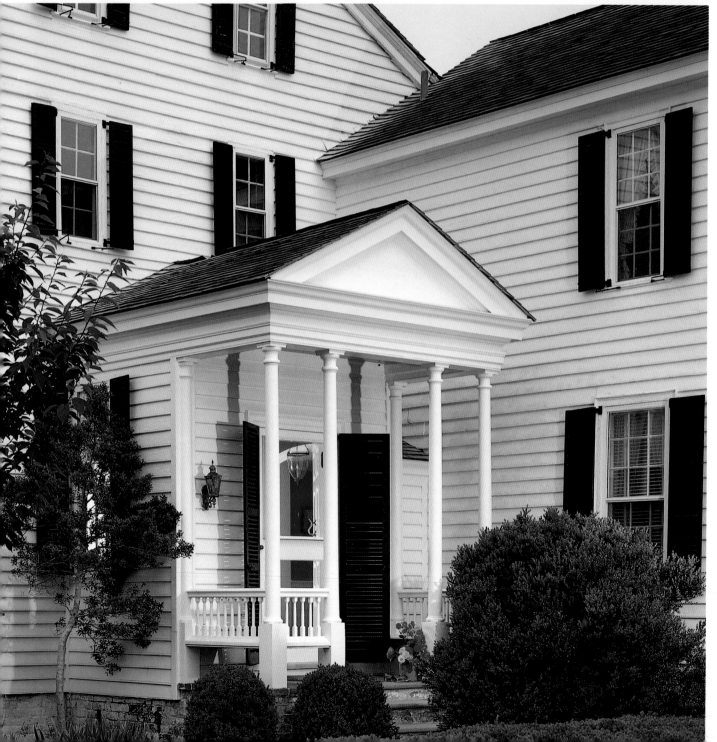

LEFT TOP: Original brass hardware used throughout the 1760 part of the house, from left: door handle; door knocker on the porch room door; brass British lion door knocker. ABOVE: The entrance to the formal front hall with a double porch on the west side. LEFT: The porch room entrance matches the porch to the front hall in size and line, but lacks the elaborate dentil molding and cornice detail.

BELOW: Original brass door hardware. RIGHT: Eyre Hall from the south. The 1760 "big house" is on the left. The original "little house" is between the two chimneys in the center portion; it appears elongated due to the added link to the newer big house. To the right of the original house is the present kitchen and breakfast room under the arched colonnade, which was originally an open passage connecting the quarter kitchen to the rest of the house.

EYRE HALL

Eyre Hall and the family that have owned and occupied it since its beginning share a long and eventful history on the Eastern Shore.

Like most early plantation houses, Eyre Hall began as a small house with two rooms upstairs and two down. Unlike most such houses, it has elaborate interior detailing, such as the molded arches down the hall that runs across the front of the original structure. Perhaps this is because the builder of Eyre Hall, Littleton Eyre, was a member of the Virginia House of Burgesses in Williamsburg, where in 1735, when he began Eyre Hall, building styles were quite established and often elaborate.

Littleton Eyre was a fourth-generation Virginia planter. His great-grandfather Thomas had settled at Golden Quarter on the Eastern Shore in 1623 and the land on which Eyre Hall stands was part of a patent signed by Governor William Berkeley in 1662 to "the three minor children of Thomas Eyre." The family continued to farm at Golden Quarter until Littleton came up the shore and built Eyre Hall. In 1760, Littleton increased the size of the house with the addition of the large two-and-one-half-story portion, which has an elaborate front hall, formal parlor, and library; a full second floor with a two-story porch on the west; and a simple third floor for extra sleeping and storage space. At that time a link was built to connect the original little house with the big house, but its function and dimensions are unknown.

In 1790, John Eyre, the grandson of Littleton Eyre, further expanded the house by enlarging the link to two full stories and to the full depth of the original house for a formal dining room downstairs and large bedroom upstairs. John also added the formal boxwood gardens, built an orangery of local brick, and planted many of the magnolias and crape myrtle, some of which are still in the garden. He elaborately decorated and furnished the house with the best fittings of the time. By the early nineteenth century, Eyre Hall was one of the grandest houses on the Eastern Shore.

The current owner, H. Furlong Baldwin, himself the tenth generation of the Eyre family at Eyre Hall, has carefully preserved and rejuvenated the house to its present beautiful condition.

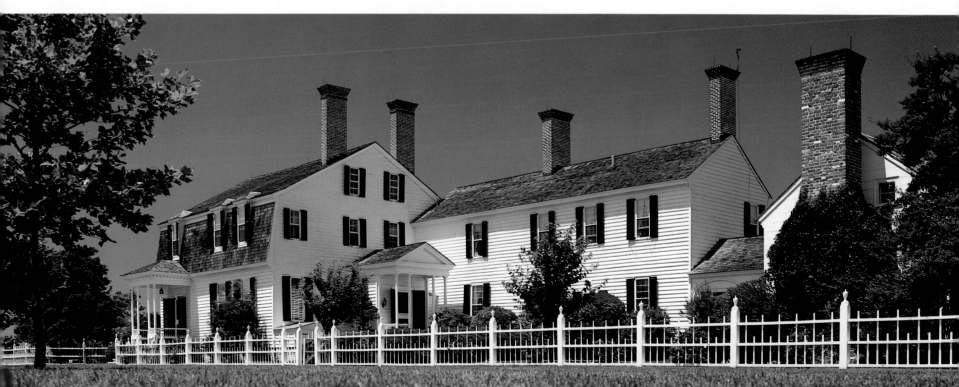

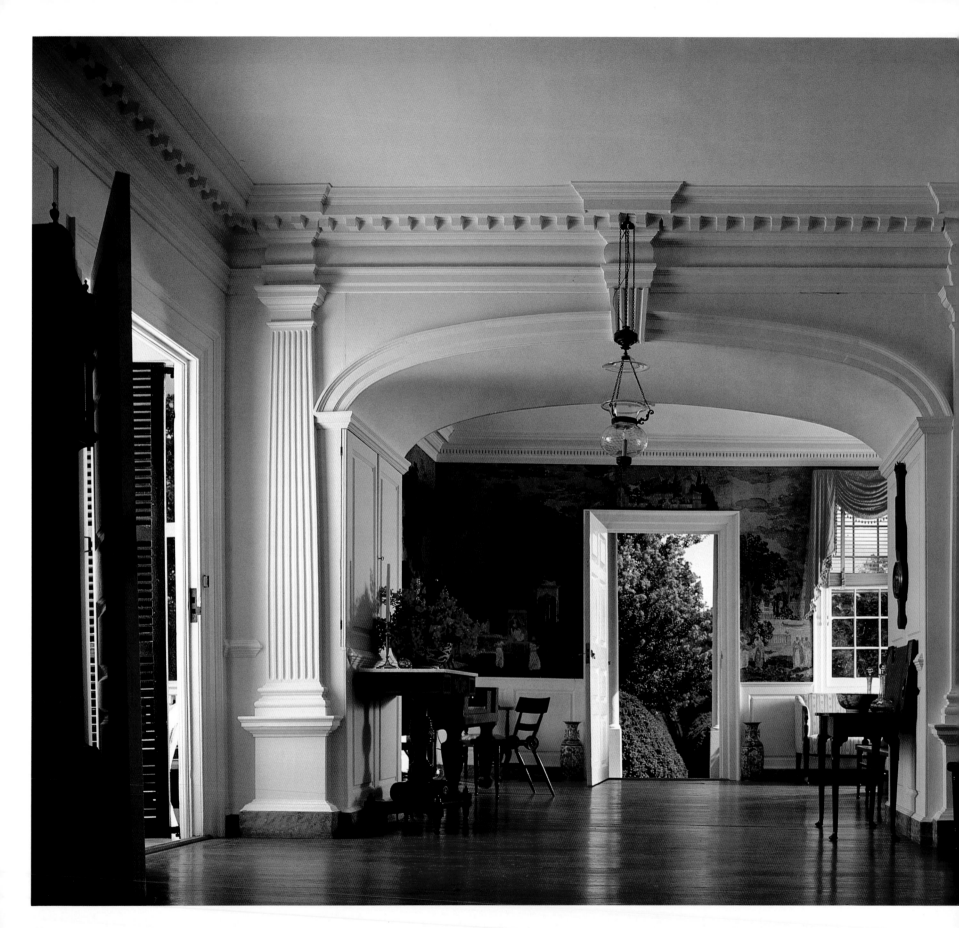

The formal front hall has twelve-foot ceilings and full paneling with dentil molding and marbled baseboards in the front half that match the paneling and moldings in the parlor. The unusually deep arch with tapered pilasters on either side separates the two parts of the front hall. The door in the back opens into the formal garden. The rear of the front hall has finer dentil molding and paneling above the chair rail. The furniture includes part of an extensive set of painted Baltimore chairs, c. 1810; a rare barrel organ, right foreground, made in London in 1804. In the arch on the right is a c. 1750 gaming table made in Williamsburg and attributed to Anthony Hay. In the back half of the arch on the left is a 66-key piano-organ with hand bellows which was made for the family in Baltimore, c. 1830, by Nunns and Clark.

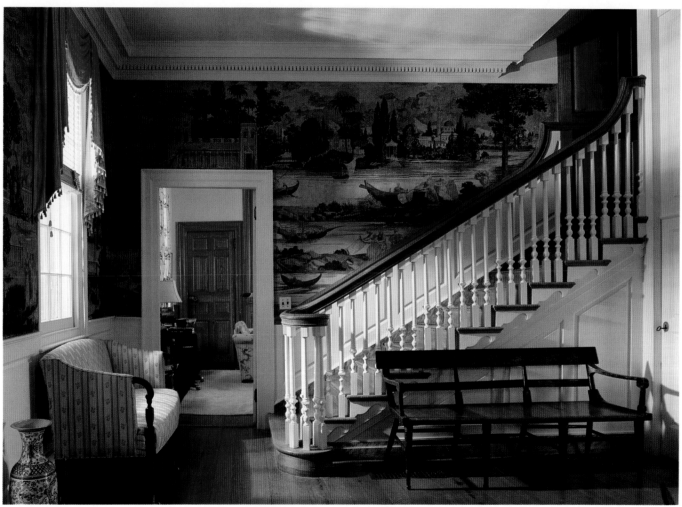

ABOVE: The stair hall forms the rear half of the front hall. The Banks of the Bosporus block print wallpaper was made in 1815 by Dufour et Cie. The bench in front of the stairs is an early-nineteenth-century painted Baltimore piece. On the left is an American Sheraton sofa, c. 1810. The door leads to the library.

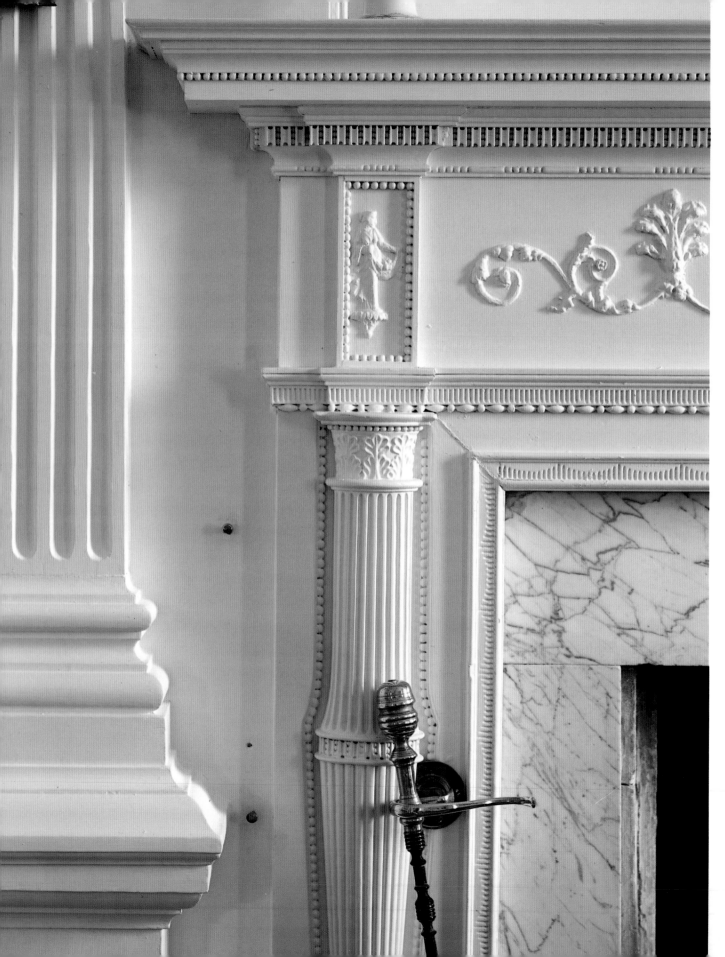

Detail of parlor mantel and fireplace in the 1760 addition to the house. The tapered pilaster detailing matches that on the arch in the front hall. The Adams-style mantel with its intricate beading and dentil moldings was a later addition to the room.

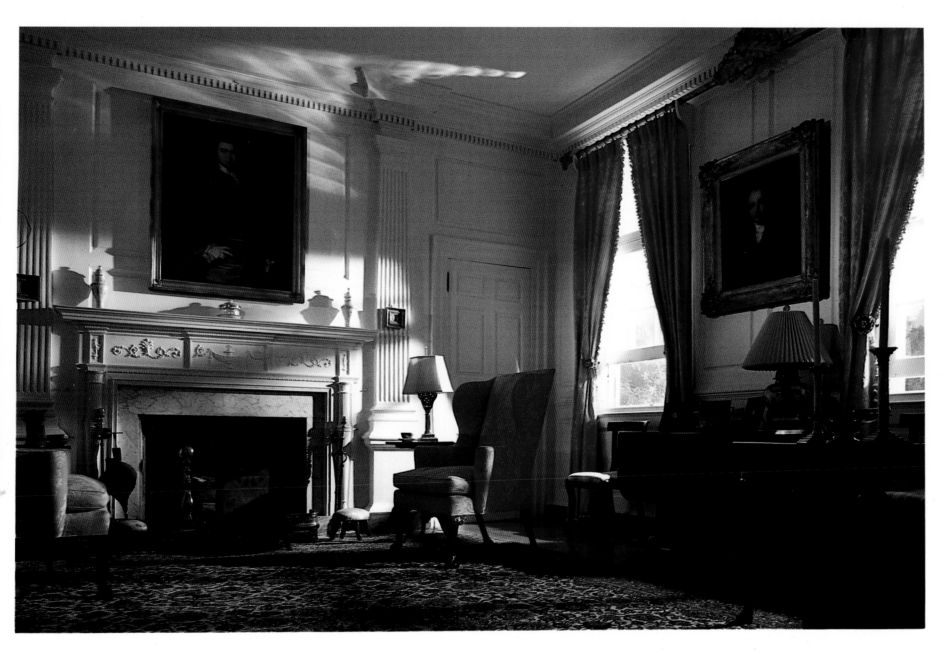

The grand scale of the parlor makes it the most formal room in the house. Above the fireplace hangs a Benjamin West portrait of Severn Eyre, member of the Virginia House of Burgesses. He was the son of the builder, Littleton Eyre, and the father of John, who lavishly furnished the house in the grand manner of the late eighteenth and early nineteenth century. A portrait of John Eyre, painted by Thomas Sully in the early 1800s, hangs between the windows on the right. The gilt wood curtain rod spans the length of the room. Below the portrait of John is one of a pair of Duncan Phyfe drop leaf tables, c. 1820.

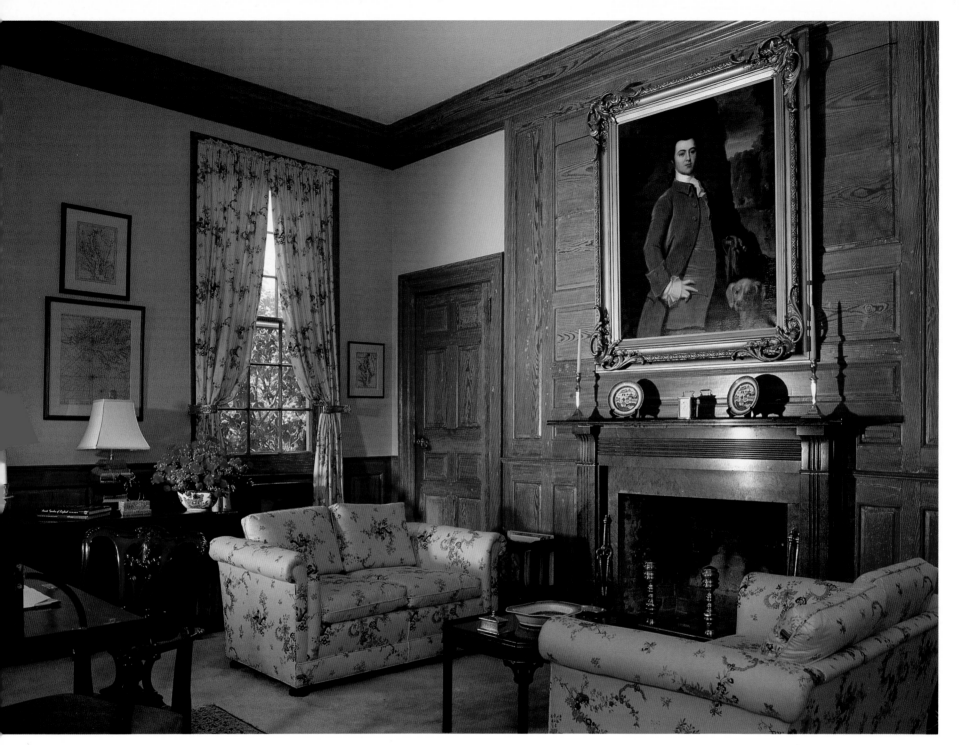

The paneling on the library fireplace wall was stripped in the 1930s by the present owner's parents, who left it unpainted to show the rich patterns of the heart wood. The portrait over the Federal black marble mantel is a signed Thomas Sully copy of the portrait of Severn Eyre by Benjamin West that hangs in the parlor. It was made for a daughter of the family who moved away from Eyre Hall when she married. On the walls are seventeenth- and eighteenth-century maps of Virginia, all showing Golden Quarter, which was the first Eyre family property.

RIGHT: English family silver on the sideboard. The tea strainer in front is inscribed "L & B Eyre," for Littleton and Bridget Eyre, the builder of Eyre Hall and his wife. The encircled "E" is the monogram designed for John Eyre and it appears on all the silver, crystal, and Chinese export porcelain he had made for the house.

BELOW: The dining room, with its Federal detailing in the molding and fireplace with decorative mantel and marble surround, dates to 1790. English Chippendale chairs surround the American Federal table. The 1692 English silver bowl with the flowers is called the Morning Star bowl, reportedly after a racehorse that was presented with this bowl full of champagne by an exuberant owner after a spectacular win. The portrait above the demilune table is Sally Eyre Taylor as a child, painted by Thomas Sully, c. 1830. The platters hanging on the wall to the right are part of the original Chinese export ordered by John Eyre in 1800. The pattern commemorates the death of George Washington and bears the Eyre monogram.

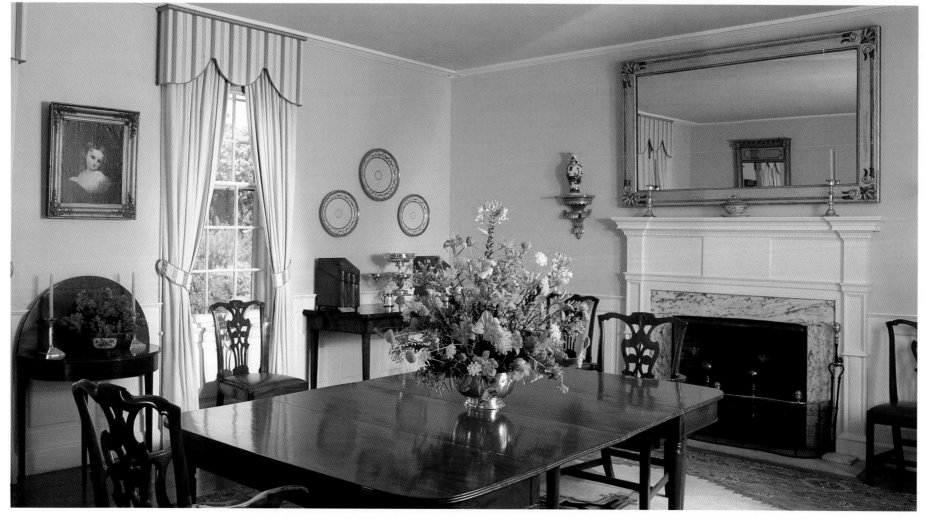

LEFT: The dining room table set for dinner. The candlesticks are English silver, c. 1790.

ABOVE: The hall that runs across the front of the original 1735 part of the structure. It appears that Littleton Eyre had plans for a grander house when he built his first small house with such elaborate molded arches. The double front door with its wrought iron hardware and wooden lock is on the left; the original stairs to the second-floor rooms are directly opposite. At the end of the hall is the dining room, which was created in 1790 when the link connecting the two parts of the house was enlarged.

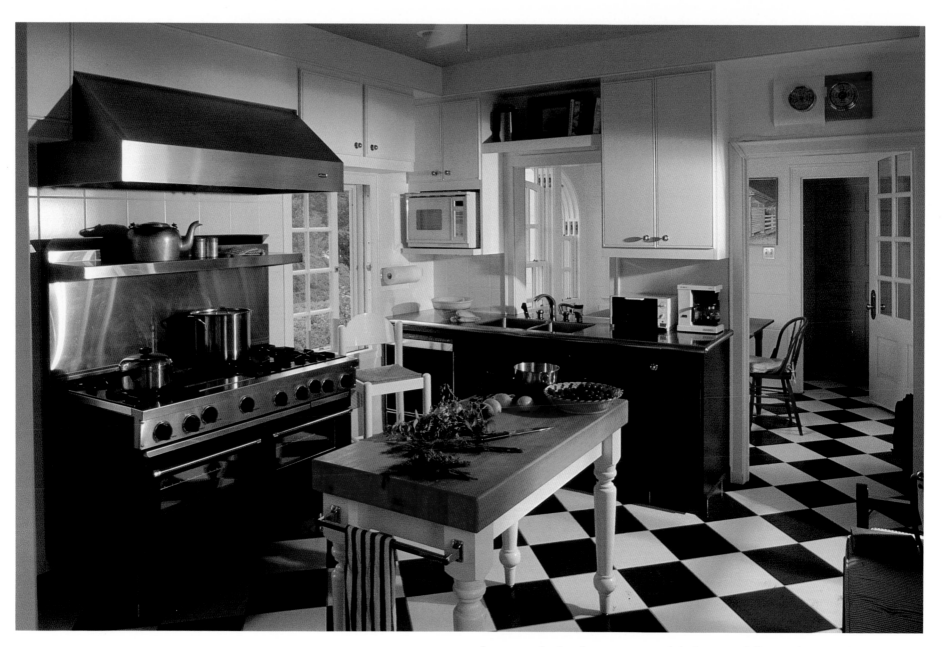

In 1990 the kitchen was remodeled into a fully modern work space with a sunny and airy breakfast room. The kitchen and breakfast room comprise the space under the former colonnade that connected the main house with the quarter kitchen.

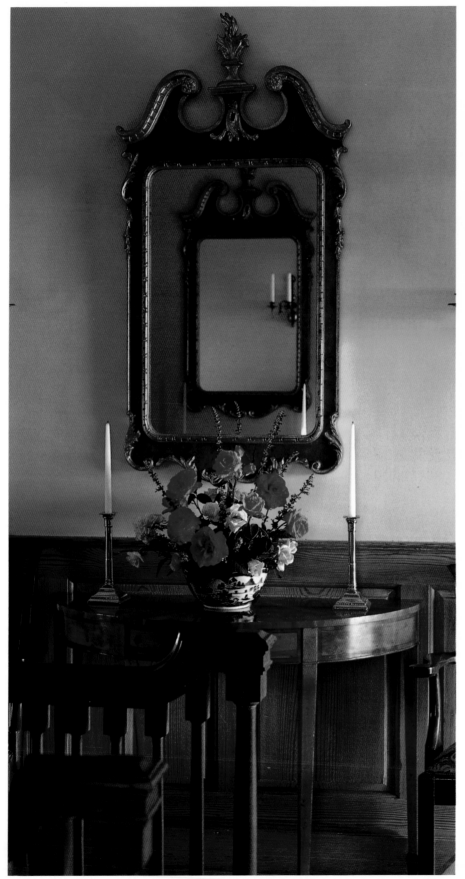

ABOVE: A set of Hogarth prints decorates the wall above an inlaid Baltimore bench with pierced, splayed splats, c. 1810.

LEFT: A late Georgian demilune table stands beneath one of a pair of mid-Georgian gilt and gesso mirrors at the top of the stairs in the upstairs hall. The chairs are American Chippendale.

BELOW: The upstairs porch looks west to Cherrystone Creek beyond the fields and crape myrtle.

An ornate gilt wood and gesso eagle is one of three that adorn each of the beds in the master bedroom, or parlor chamber.

The master bedroom and upstairs hall, beyond the door, have half-paneling and moldings like all the other rooms upstairs in the 1760 part of the house. A gilt nineteenth-century Empire mirror hangs on the far wall.

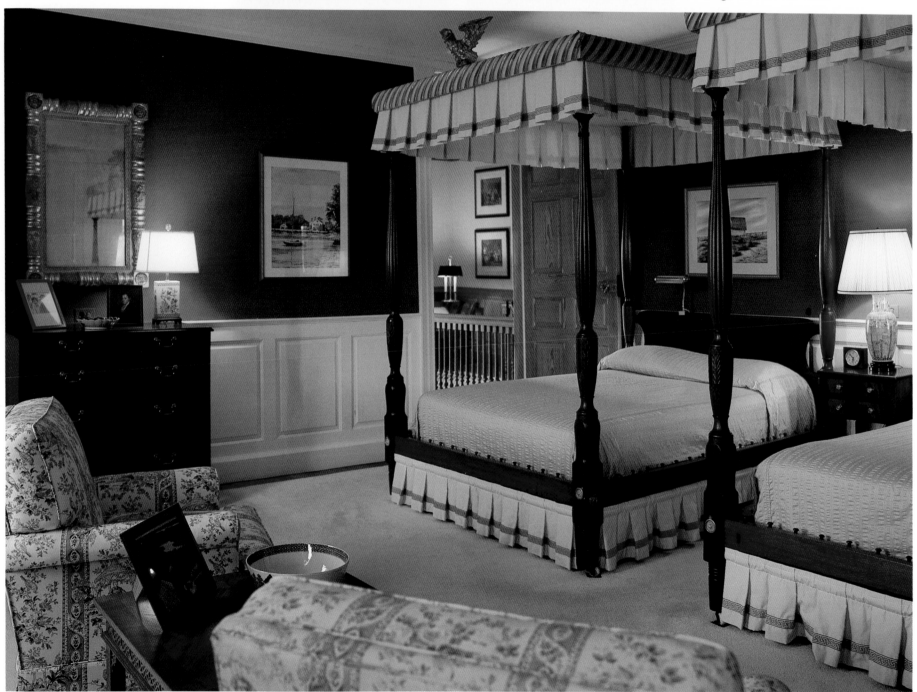

ABOVE: In early August a canopy of flowering crape myrtle (*Lagerstroemia indica*) floats over the formal boxwood garden.

LEFT: Eyre Hall from the south.

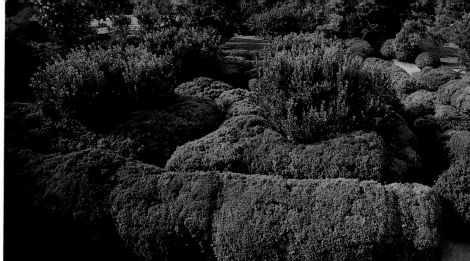

ABOVE AND RIGHT: From the bedroom window, the formal patterns of the boxwood, some of which are two hundred years old, can be seen reemerging in their original circles and diamonds. For the last several years the box has been carefully trimmed back a few inches a year as part of the restoration and refurbishing of the garden. Mixed in with the box are crape myrtle and magnolias.

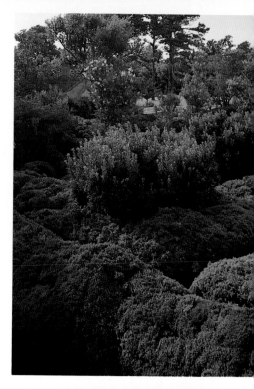

RIGHT: John Eyre, who laid out the formal gardens in the late eighteenth century, had the orangery built of local brick in 1819. The family burial grounds are to its left inside the brick and white picket fenced wall.

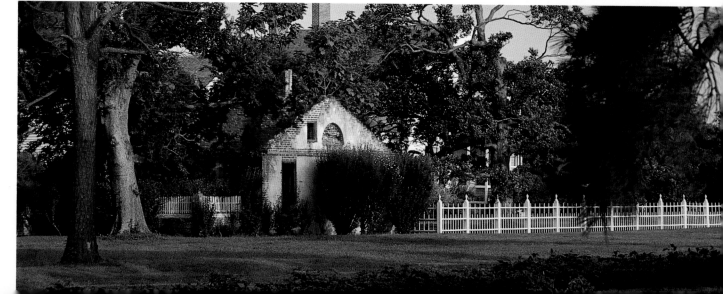

CREDITS

ARCHITECTS

John Milnes Baker, pp. 168–75
Phelps Barnum, pp. 62–69
Mark Beck, pp. 56–61
Michael Bourne, pp. 158–65
Jeremiah Eck, pp. 230–37
Wayne Good, pp. 136–47
John L. Graham, pp. 178–91; 216–23
Hugh Newel Jacobson, pp. 93–97
Christopher Osborne, pp. 70–81
Mike Quinn, pp. 36–47

BUILDERS/CONTRACTORS/DESIGNERS

Kenneth Martin, pp. 230–37
Clint Wadsworth, pp. 112–21
Hiawatha Wyatt, pp. 256–61
Wincester Construction Co., pp. 136–47

FLOWER ARRANGEMENTS

Caroline Benson, pp. 2–17
Maureen Boiardi, pp. 70–81
Debbie Bridges, pp. 38–41
Peggy Calvert, pp. 99–105
Fleet Davis, pp. 256–61
Jane Dean, pp. 158–65
Teresa deGavre, pp. 238–47
Joanne Effinger, pp. 168; 170–71
Catherine Fallin, pp. 200–207
Vicki Ferenbach, pp. 171–75
Mary Jo Harper, pp. 149–57
Marjorie Judd, pp. 18–27
Katherine Mears, pp. 269
Nancy Jane Reed, pp. 62–69
Anne Wyman, pp. 122–35

INTERIOR DESIGNERS

Albert Bromley, pp. 149–57
Peggy Calvert with Pat McMitt, pp. 99–105

Ann Geddes, pp. 62–69
Martha K. Graham, pp. 178–91; 194–99;
 201–207; 218–23
Walter Groff, pp. 36–47
Murphy/Francis Designs, pp. 168–75
Janet Richardson, pp. 158–65

LANDSCAPE DESIGNERS

Jan Alspach, pp. 36–47; 56–57; 112–21; 168–
 75
Caroline Benson, pp. 2–17
Kathleen Cowgill, pp. 2–17; 84–91
William Frederick, Jr., pp. 54–55
Andy Hobson, pp. 136–47
Virginia Sappington, pp. 84–91
Richard Webel, pp. 66–69
Wye Tree Landscapes, pp. 158–65

SELECTED GARDEN AND HISTORICAL REFERENCES

Boyce, Charles. *Dictionary of American Furniture.* New York: Henry Holt, 1985.

Clausen, Ruth Rogers, and Nicolas H. Ekstrom. *Perennials for American Gardens.* New York: Random House, 1989.

Dirr, Michael A. *Manual of Woody Landscape Plants.* 3d ed. Champaign, Ill.: Stipes Publishing Company, 1983.

Earle, Swepson. *The Chesapeake Bay Country.* Baltimore: Thomsen-Ellis Company, 1923.

Forman, H. Chandlee. *Early Manor and Plantation Houses of Maryland.* Easton, Md.: 1934.

———. *Maryland Architecture: A Short History from 1634 to the Civil War.* Cambridge, Md.: Tidewater Publishing, 1968.

———. *Old Buildings, Gardens, and Furniture in Tidewater Maryland.* Cambridge, Md.: Tidewater Publishing, 1967.

———. *Tidewater Maryland Architecture and Gardens.* New York: Bonanza Books, 1956.

Heriteau, Jacqueline. *The National Arboretum Book of Outstanding Garden Plants.* New York: Simon & Schuster, 1990.

Warner, William W. *Beautiful Swimmers: Watermen, Crabs, and the Chesapeake Bay.* Boston: Little, Brown, 1976.

Weeks, Christopher, ed. *Between the Nanticoke and the Choptank: An Architectural History of Dorcester County.* Baltimore: Johns Hopkins University Press, 1984.

———. *Where Land and Water Intertwine: An Architectural History of Talbot County.* Baltimore: Johns Hopkins University Press, 1984.

White, Christopher P. *Chesapeake Bay Field Guide: Nature of the Estuary.* Centreville, Md.: Tidewater Publishing Company, 1989.

Whitelaw, Ralph T. *Virginia's Eastern Shore: A History of Northampton and Accomack Counties.* Vol. 1. Richmond: Virginia Historical Society, 1951.

Wyman, Donald. *Wyman's Gardening Encyclopedia.* Rev. ed. New York: Macmillan, 1971, 1977.

PRODUCTION CREDITS

Design concept and layout by Taylor Lewis
Type design and mechanicals by Abby Kagan
Photography assistance by Greg Hadley
Copyediting by Erin Clermont
Proofreading by Susan Groarke, Nancy Inglis, and Pauline Piekarz
Composition by N.K. Graphics
Production coordination by Joanne Barracca
Printed and bound by Mandarin Publishers Limited